GARDENS OF REVELATION

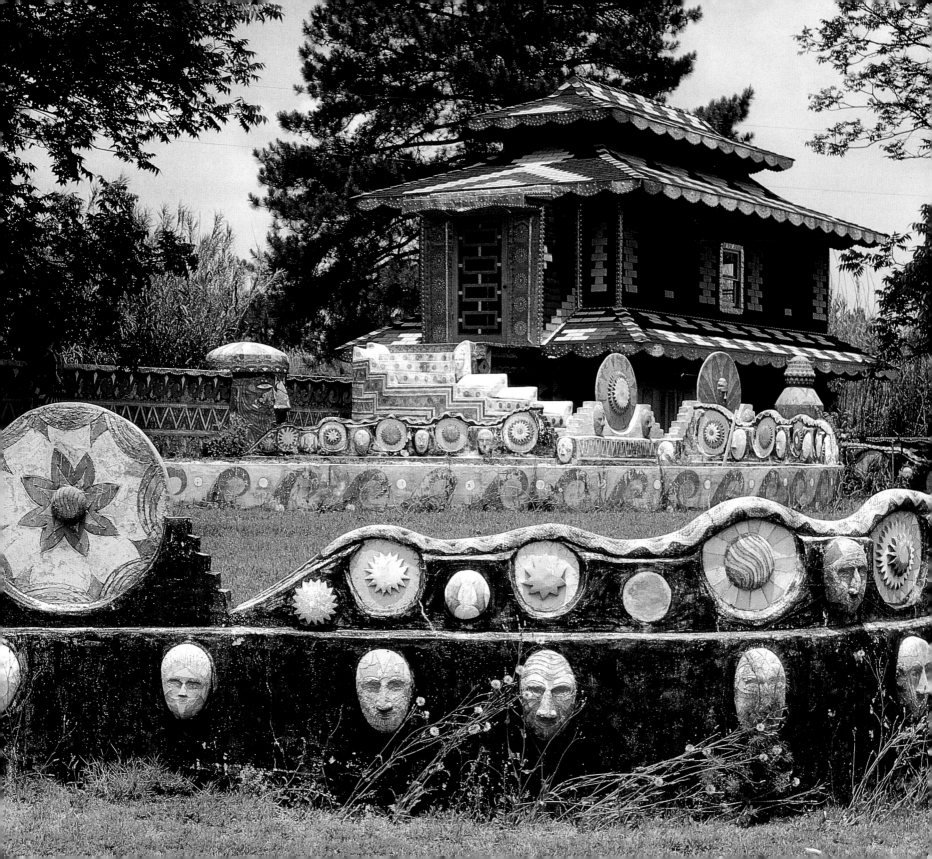

GARDENS OF REVELATION

Environments by Visionary Artists

JOHN BEARDSLEY

PRINCIPAL PHOTOGRAPHY BY JAMES PIERCE

ABBEVILLE PRESS PUBLISHERS

New York London Paris

FRONT COVER, FOREGROUND: Painted concrete miniatures of Christian shrines in the garden at Ave Maria Grotto, made by Brother Joseph Zoetl on the grounds of Saint Bernard Abbey, Cullman, Alabama.
FRONT COVER, BACKGROUND: Inside a gazebo at Watts Towers, Los Angeles, built c. 1925–54 by Sam Rodia.
BACK COVER: Minaret in the garden at Prairie Moon Museum, built by Herman Rusch in the 1960s and early 1970s along the Mississippi River in southern Wisconsin.
FRONTISPIECE: One of the temple buildings at St. EOM's Land of Pasaquan, Buena Vista, Georgia.

EDITOR: Nancy Grubb
DESIGNER: Patricia Fabricant
PRODUCTION EDITOR: Owen Dugan
PRODUCTION MANAGER: Lou Bilka

Gardens of Revelation: Environments by Visionary Artists was supported by a grant from the Graham Foundation for Advanced Study in the Fine Arts.

First edition
2 4 6 8 10 9 7 5 3 1

Library of Congress Cataloging-in-Publication Data
Beardsley, John.
Gardens of revelation : environments by visionary artists / John Beardsley ;
principal photography by James Pierce.
p. cm.
Includes bibliographical references (p.) and index.
ISBN 1-55859-360-8
1. Outsider art—History—19th century. 2. Outsider art—History—20th century.
3. Environment (Art) 4. Assemblage (Art) 5. Garden ornaments and furniture.
6. Spirituality in art.
I. Title.
N7432.5.A78B43 1995
709'.04—dc20 94-23573

Contents

❦

❦

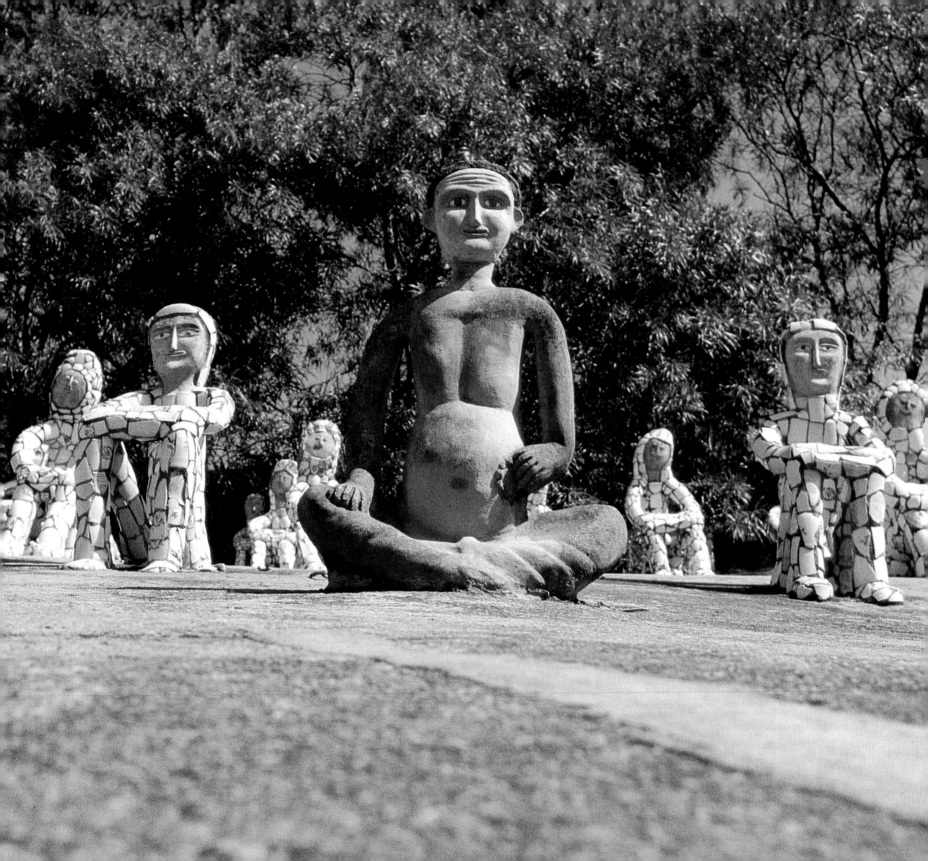

INTRODUCTION

Gardens of Revelation

*Anyone can do anything with a million dollars—look at
Disney. But it takes more than money to make something
out of nothing, and look at the fun I have doing it.*

Tressa Prisbrey, regarding her Bottle Village

OME MONTHS BEFORE I started to write this book, I was describing its contents to a skeptical acquaintance. "Just what," he interrupted impatiently, "will the book celebrate?" "That's easy," I retorted, "idiosyncratic genius, tenacious faith, and unalienated labor." I could have gone on—to personal conceptions of God, the rules of sex, and life after death—but I wasn't sure my listener could accept that any art in a secular age might aspire to say so much. I quickly realized, too, that there was little else that was "easy" about my subject, which was precisely why I found it so compelling. I had a general sense of what I would be describing: handmade environments that express a personal moral or religious vision, typically fabricated of found materials by people who aren't necessarily identified by themselves or by others as artists. These environments are made to surround and even engulf the home; they often have an obsessive character and are the result of many years of work. In form, they are various and extraordinary,

ranging from luminous bottle villages to garishly painted temple compounds, from mock castles to miniature cities, from sculpture gardens populated with biblical and historical figures to artificial caverns encrusted with geodes and stalactites. I knew that a few such environments had attained some renown and that anyone who had heard of the Palais Idéal in France, Watts Towers in Los Angeles, or Ave Maria Grotto in Cullman, Alabama—or had seen the Reverend Howard Finster on the talk shows—would have a general idea of my subject. But with the exception of a small group of dedicated enthusiasts, I was aware that most people would come to it with little prior knowledge and that the material would challenge credulity while testing the conventional language of art.

Among the many provocations of the subject is the fact that no one, it seems, will ever be able to name it adequately. Part architecture, part sculpture, part landscape, visionary environments seem insistently and purposefully to defy the usual

*1. A priest leads villagers in a religious ceremony at the Rock Garden, built by Nek Chand Saini (b. 1924)
on the outskirts of Chandigarh, India, beginning about 1965. Photo: Suresh Kumar, Indiano Photographers.*

categories of artistic practice. Likewise, they evade the normal descriptive terms: these creations display too great an indifference to the niceties of composition and technique to have earned admiration as fine art; but they are too individualistic and too loosely linked to tradition to have been accepted—in most academic circles at least—as folk art.[1] Many skirmishes have been fought on the semantic front and numerous alternative terms proposed: outsider, isolate, eccentric, grassroots, vernacular, naive. All such terms have advantages and limitations: all correctly imply a distance from the conventions of academic art and "high" culture, but all can be pejorative as well, especially in the way they reiterate the marginal status of these creations. Most, too, in stressing isolation or eccentricity over context, reinforce a tendency to ignore the social and cultural circumstances in which this art is born and of which it speaks, circumstances I will wholeheartedly explore.[2] In this semantic matter, therefore, I have opted—in the spirit of the artists about whom I write—to go my own way. I have named my subject "Gardens of Revelation."

I use both the words *garden* and *revelation* in very particular ways. A cursory look at the illustrations in this book will turn up few places that look like gardens as that word is now commonly understood: private spaces characterized by collections of plants, intended as places of refuge or leisure. How then do I mean the word? I use it in both the most humble and the most exalted of senses: to refer to the patch of earth from which we coax our food and to our prevailing metaphor for paradise. A garden is not defined simply by its physical characteristics: plants, walls, water. It is a more complex creature—a bounded space that can be brought under control, that might even be brought to some measure of perfection. In the domestic sphere, a garden is a space that its creator endows with particularly personal meanings that he or she wants very much, despite the private setting, to share

with the world. The garden is often where private speculation makes its first appearance before the public, where a person begins to define a conception of nature and a place in the world.

In all, my sense of the term is very like that evident in Maynard Mack's characterization of the celebrated garden at Twickenham by the eighteenth-century English poet Alexander Pope: "literally and figuratively, a place to stand, an angle of vision . . . a rallying point for his personal values and a focus for his conception of himself."[3] The garden, in other words, is not merely a physical entity, but an emotional, moral, and philosophical construct as well. As such, it can be one of culture's most significant forms of expression. Most contemporary gardens, however, are but the merest shadow of what the garden could or should be. The language of spiritual or philosophical rumination especially has gone out of most recent, all-plant gardens, dedicated as they are to function, decoration, or horticultural display. The gardens about which I write may be anachronistic, in that they represent the survival of an older, more powerful conception of the garden as a place of inquiry and moral assertion.

Several of these environments take an architectural character. Some contain covered, enclosed spaces: rooms, even towers. The architectural equivalents to such environments have been described by designations such as "fantastic architecture" or "handmade houses." I have chosen to separate house from environment, in part for practical reasons: my subject is already daunting enough. But I am also suggesting a distinction in character. Few of the environments seen here are meant primarily to be inhabited: they are above all artistic and symbolic places. Architecture, to make perhaps too coarse a distinction, is also artistic and symbolic but of necessity more functional. Robert Garcet, the former stonemason who has constructed a one-

hundred-eight-foot (thirty-three-meter) tower of the Apocalypse in Belgium, made this distinction plain to me. When asked if the tower was his home, he replied that it was "not my domicile, but the place of my philosophical habitation." The structures found in these environments are analogous to the symbolic forms we are accustomed to seeing in more elaborate gardens of the past: sculptural ensembles, grottoes and gazebos, temples of virtue and shrines to ancient worthies. Freed from utility, these forms can stand—like the gardens in which they are found—as clearer representations of an idea.

A garden, then, is both a bounded space and a representation. What is represented in these gardens is implied by the other term: *revelation*. A revelation is both something revealed and the act of revealing; in the case of these environments, something revealed to the artist and something revealed by the artist to us. I have already suggested some of what the artist wants to reveal to us: a moral or philosophical code, a vision of nature or a spiritual system. Some artists are impelled by the need to articulate a personal religious creed; others, to discharge a debt to God. Some even take their imagery or their content from the Revelation that begat so many other revelations: the awful vision of the Apocalypse recorded by Saint John the Divine on Patmos and contained in the final book of the Christian Bible. Not all, however, are millenarian or even sacred in character. Some honor the past, some are tributes to family and loved ones. Many express notions of patriotism or brotherhood, though both country and fellow man are conceived in personal terms: these artists often dissent from both political and social norms.

What distinguishes these environments above all, in other words, is what might be described as a form of rhetorical speech. This is an art of persuasion. Inscribed in various ways in all of these constructions is a strong sense of the maker's convictions.

These artists share a desire to demonstrate the sincerity and validity of their points of view. In some cases, these convictions are explicitly presented; in others, they are encoded in symbolic or spatial constructions. The main business of this text is to reveal what is being said in these environments, as well as how and why it is being said; secondarily, it is to speculate on some of the sources of each artist's language. This is facilitated by the fact that many of these artists have also been writers. Where this is the case, I will trace the connections between their visual creations and their written works. Considering these environments in rhetorical terms suggests an answer to one of the most frequently asked questions about them: why are they made? They are made for the same reason, it seems, that people create exhortatory works of any kind: because their makers believe they have something important to communicate.

With many of these environments, there is a feeling of revelation in the other sense: of something divulged to the artist. A number of these gardens seem at once summoned from the intellect and disclosed from the unconscious. By suggesting even a partially unconscious source for these creations, one is in danger of ignoring the various historical and social contexts that give shape to them, and of overstating their uniqueness. Yet relative to most art, whether courtly, bourgeois, or academic, these gardens seem to be unpremeditated, even involuntary creations. Their makers, though supremely motivated and self-confident, do not necessarily speak of the contexts from which their work springs. They often give testimony instead to the motivating force of dreams, visions, or divine commandments. Sometimes the motivation resembles conventional inspiration—"it just came to me" is a common refrain. But many visions are more elaborate, with the recipients being given a second chance in life to do something worthwhile for themselves and for others. We cannot

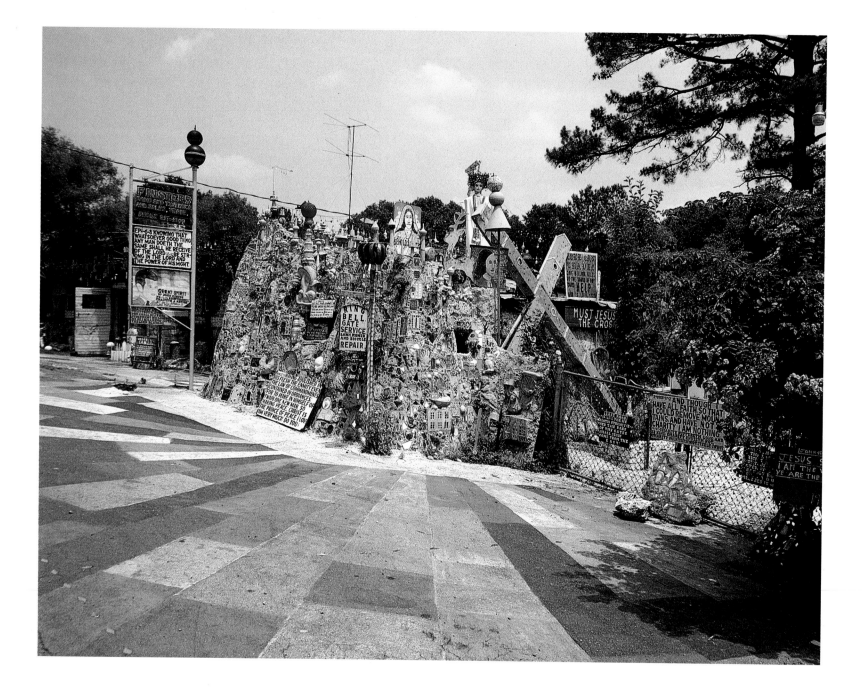

know if these visions are authentically experienced or invented by the artists as a kind of alibi to explain their differences from other people. Either way, they are a recurring motif in the lives and creations of these artists.

Because of the importance of personal revelation, there is nearly equal emphasis in this book on creations and creators. I tend to be more sympathetic than some to the notion that the biography of the artist, especially its psychological dimensions, is an important factor in both the generation and the interpretation of art. But in the case of these environments, it is absolutely crucial.[4] Howard Finster's experience as an itinerant Baptist preacher, for example, is essential to understanding the motivation behind his Paradise Garden near Summerville, Georgia (plate 2). More generally, one of the defining characteristics of these creators is biographical: they are all artistically self-taught. This educational disadvantage is perhaps artificial—we all learn from somewhere. But to my mind, there is an important distinction between learning in the academy and learning on the street—or in the woods. In the latter case, one is surely more innocent of rules.

Moreover, educational disadvantage stands for much larger circumstances in the lives of these artists. To greater and lesser degrees, they are all somewhat disenfranchised: marginalized by race or ethnicity, isolated by geography or culture, or deprived of economic and social status. Many of them, in other words, are—or were—poor and uneducated; African Americans or immigrants who spoke little or no English; or residents of remote communities. Many, too, have been elderly, at the end of difficult lives. Many worked at low-status and repetitive jobs; various

2. Howard Finster (b. 1915). Paradise Garden, c. 1960–1970s, near Summerville, Georgia. View of the main entrance.

of these artists were first postmen, loggers, farmers, custodians, quarrymen, carpenters, and factory workers. These are not people who have access to the usual forums for public address. Instead, they created these opportunities for themselves in their art, which allowed them to rise above the marginalization and alienation they experienced in their lives. But they often paid dearly for their rhetorical license. Many of them occupied ambiguous, even paradoxical, positions relative to their neighbors and their communities. Viewed as exceptional but peculiar, they were often isolated but eager to communicate.

The riddles of naming and the potentially disproportionate emphasis on biography were but two of the special provocations of my subject. I was also aware that I would be attributing substantial artistic merit to works that are often superficially—or deliberately—unbeautiful. Many of these environments are made of the coarsest materials: cement and common rocks, broken glass and tiles, and other kinds of brightly colored junk found along the roadside or at the local dump. While this confirms a widespread phenomenon among the economically disadvantaged, who must conserve and recycle to survive, it does not suggest the rich uses to which these materials are put. They are often arrayed in the most dazzling abundance and confusion. There is seldom any compositional hierarchy to these environments; there is instead a sense that all parts are equally important. Every space and every surface is treated with the same emphasis, so there is no rest from encrustation and elaboration. The stylistic vocabulary is often grotesque: both in the original sense—the implausible combination of animal and vegetal motifs—and in the modern sense, denoting the fantastically extravagant, the distorted, or the bizarre. Nor do many of these environments show any clarity in plan. There are few instances of conventional organizing devices: axes or cross-axes, bilateral or radial symmetry. Visual and spatial

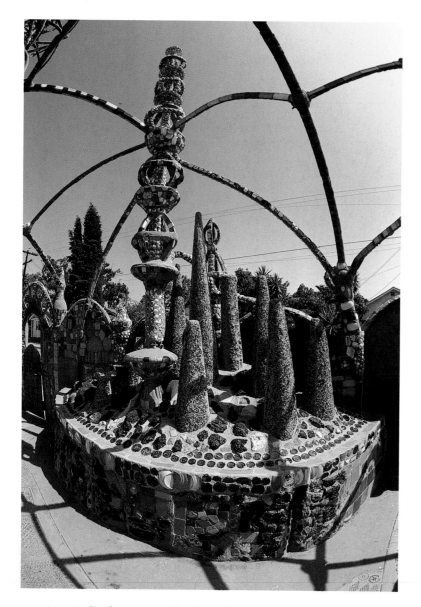

3. Sam Rodia (c. 1875–1965). Watts Towers, c. 1925–54, Los Angeles. Now administered by the Los Angeles Department of Cultural Affairs. A view of the cactus garden.

incidents are presented instead in what appears at first to be an entirely random or haphazard way.

I cannot, therefore, rely on conventional assumptions about beauty and must claim a deeper attraction for these spaces. Most compelling is the sense of entering another world, a world governed by its own rules and its own particular illogic, a world of demiurges. The grotto or the cave might be the paradigm for this kind of otherworldly space, but there are other models, like the labyrinth or maze. Various structural devices reinforce the sense of being in a dream space: miniaturization and gigantism are common, as are abrupt shifts in scale. Other kinds of contrast are frequently employed as well, as in the substitution of the artificial for the real or the juxtaposition of completely incongruous materials. Sam (or Simon) Rodia included a cactus garden within the walls of his Watts Towers in Los Angeles, but his cacti were entirely made of concrete and broken green glass (plate 3). Tressa Prisbrey, at her Bottle Village in Simi Valley, California, made several raised planting beds outlined with automobile headlamps (plate 4). In one, she upended an assortment of blue bottles, giving new meaning to the perennial border; in the other, she planted disembodied doll heads impaled on sticks (plate 111).

These structural devices are used in concert with spatial paradigms—grotto and maze—to provide rich visual and psychological effects. Together they render these environments perceptually and emotionally disorienting, challenging our assumptions about order. This was a point to which the Surrealists, especially André Breton, were particularly attentive. Indeed, as we shall see in the next chapter, Breton's concept of convulsive beauty provides almost as much aesthetic theory as we need to account for the profound appeal of these places. Despite threatening to dissolve into chaos, they seem consistently to transform base matter into gold.[5]

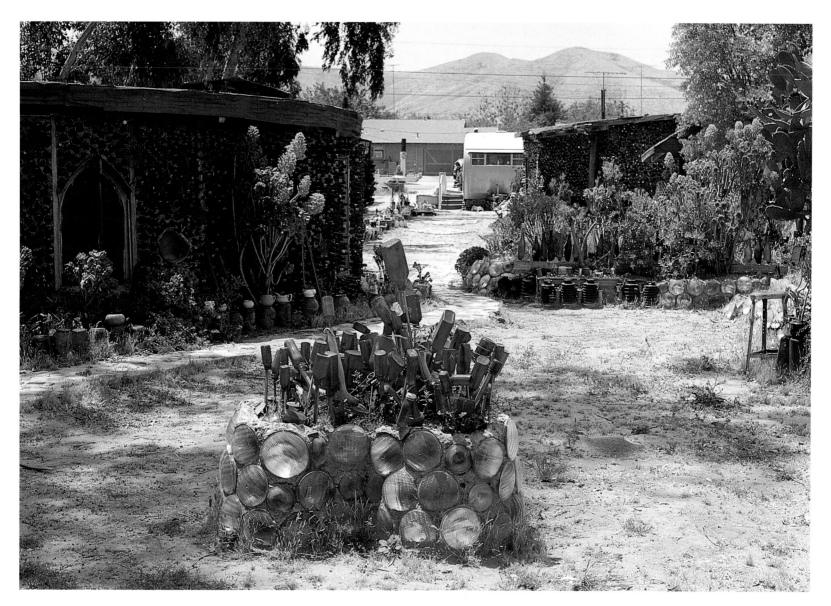

*4. Blue bottles in a headlamp planter at Bottle Village, built in the late
1950s and 1960s in Simi Valley, California, by Tressa Prisbrey (1896–1988).
Now owned by Preserve Bottle Village.*

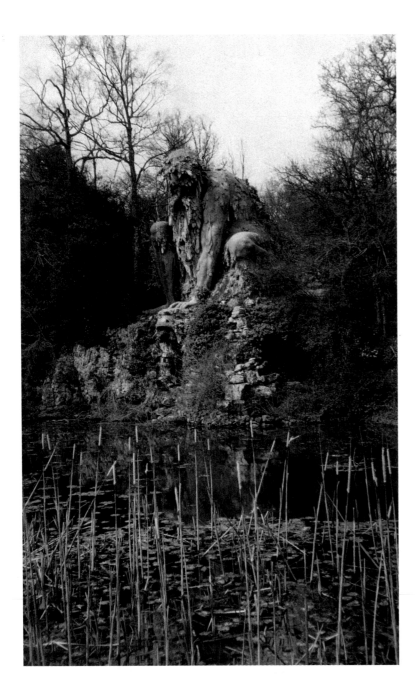

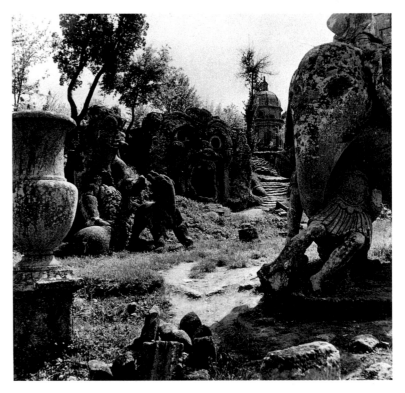

LEFT: 5. Giambologna's personification of the Apennines, c. 1580, at Villa Medici, Pratolino, Italy, is textured with a rough stone called spugna and rises thirty-five feet (10.5 meters) from an artificial mount.
Photo: John Dixon Hunt.

ABOVE: 6. Wrestling giants, exotic beasts, and a gaping hellmouth— probably an allegory of the struggle against temptation—are found in the sacro bosco (sacred grove) built by Pier Francesco Orsini in the third quarter of the sixteenth century at Bomarzo, Italy. Photo: Carl Lamb, c. 1950.

To the extent that these environments have been examined at all, they have often been presented as sui generis. In the catalog of a groundbreaking exhibition in the United States, the Walker Art Center's 1974 *Naives and Visionaries,* they are described as "a wholly intuitive expression, as unbounded by stylistic convention as by local building codes." One of the first important British exhibitions in this field, *Outsiders,* at the Hayward Gallery, London, in 1979, was subtitled *An Art Without Precedent or Tradition.*[6] Although visionary environments are certainly very individualistic creations, they reveal numerous links to their social contexts; they also suggest connections—some deliberate, some apparently unconscious—to numerous historical antecedents. The religious shrines of chapter 3, for example, can be linked to various pilgrimage sites in Europe, such as the grotto at Lourdes, while a recent essay has connected Rodia's Watts Towers, discussed in chapter 5, to elaborate towers and ships constructed in observance of the feast day of an Italian saint.

In a general way, the grottoes and follies of courtly and ecclesiastical gardens in Europe provide some basic prototypes for the more recent imaginative space. We might be tempted to see the ornate sculptures of Italian Renaissance gardens—the ferocious beasts and gaping hellmouth at Bomarzo (plate 6), for example, or the wildly textured personification of the Apennines at Pratolino (plate 5)—as the precursors to any number of grotesque fantasies. But only in certain instances can even an indirect lineage be traced between historical precedent and contemporary visionary art. I am particularly struck by the similarity between the grottoes of Renaissance Italy that are encrusted with natural history specimens, such as the Grotto of the Animals at Castello (plate 76), and those of the German-born priest Father Dobberstein (plate 69) on the one hand and Howard Finster on the other. Dobberstein's, which are examined in chapter

3, are closer to the original; he used petrified wood, stalactites, geodes, and all manner of semiprecious stones. Finster's is more unorthodox; his takes the form of a concrete mount embedded with a wild array of scavenged objects, including a jar containing a neighbor boy's tonsils.

There is a vast gulf between the courtly creations of Renaissance Europe and the visionary spaces of twentieth-century America, not only of time but of class. For the latter to be in any way connected with the former, one would have to look beyond the bounds of this study for intermediaries in vernacular wayside shrines throughout Catholic Europe and in the shell gardens of many a seaside village in England and France. The connection is not entirely implausible: by the latter half of the nineteenth century, mass-circulation magazines and postcards were making the language of courtly art—along with the creations of exotic cultures—more widely available. But it may be more fruitful to connect both the ornaments of Renaissance gardens and the modern visionary environment with the *Wunderkammer,* or cabinet of curiosities (plate 8), in which natural oddities were displayed in cluttered profusion to evoke the fullness of creation.

The impulse to collect something of everything lies behind the botanical garden and the original encyclopedic museum as well as the corner cupboard of a middle-class home. The historian John Dixon Hunt has specifically connected the cabinet of curiosities with many of the ornaments in Renaissance gardens, including the galleries, pavilions, and grottoes made for displaying everything from antique statuary to precious stones (plate 7). Particularly pertinent is his observation that "natural history exhibits (animals as well as plants) were a memory theatre of that complete world lost with Eden but recoverable by human skill."[7] Botanical gardens, menageries, and collections of minerals were created in an effort to bring the scattered pieces of creation back

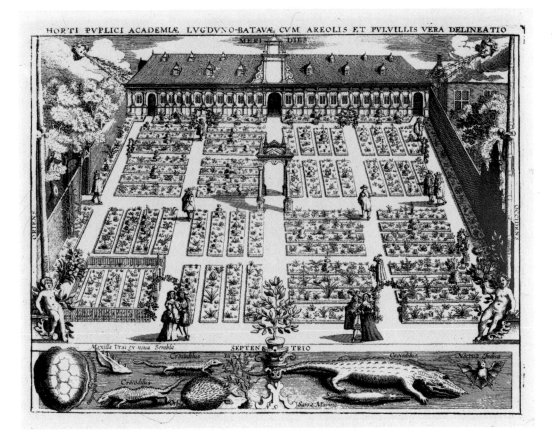

LEFT: 7. The garden as a cabinet of curiosities: an early seventeenth-century view of the hortus *at Leiden, the Netherlands, which joined botany with natural history. Private collection.*

OPPOSITE: 8. The cabinet of curiosities: Ole Worm's museum in Copenhagen, seen in a 1655 engraving, mixed ethnographic materials with unusual natural-history specimens. Private collection.

together. This was sometimes attempted in painting as well, as in Thomas Cole's *Garden of Eden* (plate 9), which features, along with the flora and fauna, a collection of gemlike minerals in what is presumably the river of life. The point of these efforts was not simply to evoke the original paradise but also to project the confidence that one could fully inventory and thus comprehend the wonders of God's creation.

Knowledge has since proliferated in inverse proportion to our faith in the principles of divine order; both our gardens and our museums have been secularized. Both have moved on to more specialized functions—natural history here, art there—as paring down has supplanted piling up. Most gardens and museums no longer evoke the cabinet of curiosities the way some visionary environments still do, especially those that are rich in found objects, historical artifacts, or mineralogical specimens, or those that evoke the Edenic myth. Some environments even began as museums or contain them as part of their purpose. The crucial point of intersection between the cabinet of curiosities and the visionary environment might be that neither is a dry, logical catalog of objects but an imaginative recreation of the world instead,

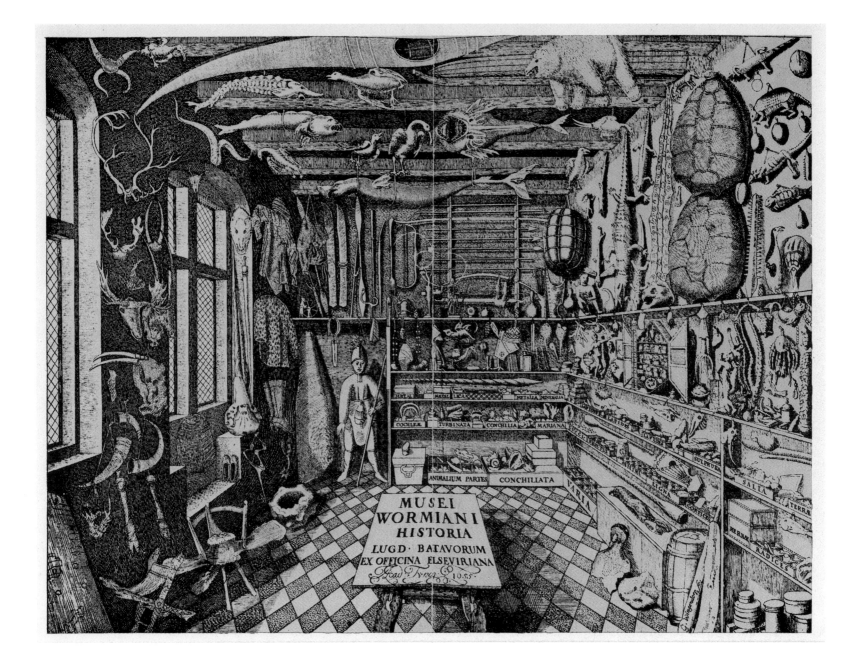

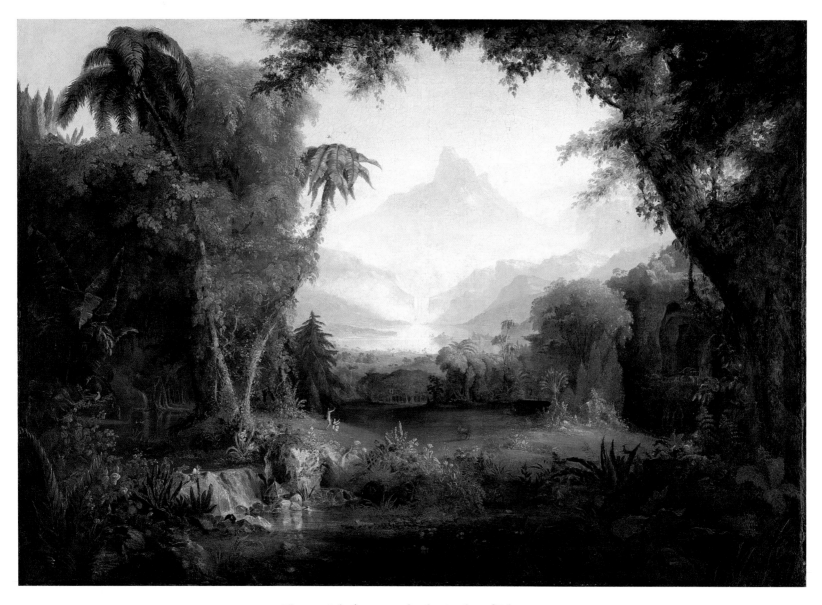

9. Thomas Cole (1801–1848). The Garden of Eden, 1828.
Oil on canvas, 38½ x 52¾ in. (97.8 x 134 cm).
Amon Carter Museum, Fort Worth.

full of strange juxtapositions and unplanned resonances. In this sense, visionary environments represent a survival in popular culture of a form long out of favor in the institutional world.

Visionary environments express other links to popular culture as well. They are an exceptional variation on a more ubiquitous form of yard art: the elaborate mailboxes and whirligigs, wagon-wheel fences and tractor-tire planters that adorn front lawns from Maine to California. They are distinguished from the more common forms of yard art, however, both by their rhetorical dimensions and by an entirely different magnitude of dedication. They are not the expression of a weekend hobby but grand schemes that are generally the culmination of decades of determined and often solitary effort. Visionary environments have a number of other popular relatives: eccentric habitations, for example, like Clarence Schmidt's extraordinary but now destroyed House of Mirrors near Woodstock, New York, or Albert and Gladys Christensen's more durable Hole in the Rock Home, carved out of sandstone near Moab, Utah. Vernacular commercial architecture sometimes takes an equally unusual form: tepee motels, for example, or donut-shaped restaurants.

More complex is the relationship of visionary environments to various forms of commercialized fantasy, like Disney theme parks. Both gardens of revelation and Disneyland involve entering another world, one in which themes from history or popular culture are explored. Both display a genuine flair for showmanship, whimsy, and unbridled fancy; both, in short, seduce by being "different" and fun. Both in some senses manifest a utopian vision of what life could or should be like.

On the face of it, the origins of Disneyland were fairly benign. Early publicity suggests that "Disneyland will be based upon and dedicated to the ideals, the dreams, and the hard facts that have created America. . . . It will be filled with the accomplishments, the joys, the hopes of the world we live in. And it will remind us and show us how to make those wonders part of our lives."[8] But if the promise of Disneyland was benign, the reality of proliferating theme parks is considerably more pernicious. Not only are they ruthlessly effective at separating people from their money by pandering to a desire to escape into a nostalgic past or a sanitized future, but they also substitute simulation for reality in a way that can only make people feel more alienated from their own circumstances. Moreover, they are symptomatic of a more general replacement of the particular forms of localized culture with a homogeneous, global, mass culture, a substitution that robs us all of diversity and, as Christopher Lasch has written, "gives rise not to enlightenment and independent thinking but to intellectual passivity, confusion, and collective amnesia."[9]

To my mind, visionary environments could not be more distinct from theme parks. For a start, there are pronounced economic differences. Theme parks are built with masses of capital; visionary environments with none. Tressa Prisbrey, who built and decorated her Bottle Village entirely from material salvaged at the local landfill, summed up this distinction with wit and insight: "Anyone can do anything with a million dollars," she proclaimed, "—look at Disney. But it takes more than money to make something out of nothing, and look at the fun I have doing it."[10] Moreover, theme parks exist primarily for commercial gain; visionary environments do not. This is not to say that the latter are entirely free of economic considerations: most visionary artists accept contributions to further their work; some even charge admission. But their principal concern is not to make money, whereas Disney promotes an ideology of consumption.

As important as the economic differences, however, are those of effect. There is nothing simulated about the visionary environment, no sense of being in a place that is a pastiche of somewhere

10. *Samuel Perry Dinsmoor (1843–1932). Garden of Eden, 1910s and 1920s, Lucas, Kansas. Now owned by Garden of Eden, Inc. Here Dinsmoor's view of American civilization is represented along the north side of his Cabin Home.*

else—whether Frontierland or Tomorrowland. Moreover, Disney practices a subtle form of social control by eliminating unruly aspects of life: first by admitting only those who can pay, and then by avoiding awkward subjects. Visionary artists, meanwhile, not only take all comers, but many also deal openly with such messy themes as sexuality and death. Visionary artists don't pander to their audience. They are emphatic about conveying their personal insights, regardless of whether or not they might be popular. Nor do their environments present a sanitized version of either past or future.

Visionary artists are typically quite patriotic, but it is the idea of America—the land of freedom and opportunity—to which they are loyal, not always the reality. In fact, they often explicitly or implicitly criticize social and political norms. Even those that address Edenic themes are careful to distinguish between biblical promise and contemporary practice. Samuel Perry Dinsmoor's Garden of Eden in Lucas, Kansas, for example, contains a sculptural group called the Crucifixion of Labor (plate 43), in which the working man is martyred by the banker, the doctor, the lawyer, and the preacher. In comparison to theme parks, in other words, visionary environments provoke and free the imagination rather than control it. They represent a stubborn resistance to the mass-marketed leisure purveyed by corporate culture.

There are, however, other links between visionary environments and popular culture that I believe to be more telling. In large measure, visionary environments owe their existence—in this country at least—to popular versions of patriotism on the one hand and to what might be called the cultural geography of religion on the other. The particular kind of patriotism conveyed by these environments allies itself more with the individual than

11. Rolling Mountain Thunder (1911–1989) honored Native Americans at Thunder Mountain Monument, begun in 1969 near Imlay, Nevada.

with the corporation or the state, celebrating folk heroes as much as national leaders. Fred Smith's Concrete Park in Phillips, Wisconsin (plate 51), might be taken as typical in this regard. It contains cement figures decorated with glass, among them Abraham Lincoln and the Statue of Liberty. But these national icons are outnumbered by the representations of nameless farmers and lumberjacks of the north country that populate Smith's park, along with the legendary woodsman Paul Bunyan and Sacajawea, the Native American woman who guided explorers Lewis and Clark through the Rocky Mountains.

With the celebration of the common person comes an appreciation for what it means to be self-taught: individuals are valued for their accomplishments rather than their social standing. As Smith said of Sacajawea, "The woman didn't need no compass. She was the one that opened up the whole country. That's why I got so many Indians here. I like Indians because they're damn smart people."[11] Like the visual language of the *Wunderkammer*, the celebration of the self-taught is somewhat anachronistic, associated with the values of the frontier. It represents another survival in popular form of a notion long out of favor in institutional culture. The preference for popular heroes is also associated in many of these environments with a longing for a brotherhood of common people. Chief Rolling Mountain Thunder's environment (plate 11) in Imlay, Nevada, is perhaps the clearest expression of this. Dedicated to Native Americans, it was intended as a symbol of the reconciliation of all peoples around the ideas of freedom and equality. "A family without unity is a nation in chaos," he announced on a sign that led to his monument. Celebrations of the common man and the quest for

12. Exterior view of the Grotto of the Blessed Virgin, built by Father Mathias Wernerus (1873–1931) during the 1920s in Dickeyville, Wisconsin.

brotherhood yield numerous paradoxes: these environments are made by people who are anything but common, and their exceptional natures often put them at odds with their neighbors.

Visionary environments have also been powerfully shaped by popular versions of American Christianity, especially in its more evangelical forms. They can be seen in the context of a great saga in which countervailing faiths spread across the continent and battled for converts, especially on the frontiers of the South and West. Some environments are the direct expression of a missionary spirit. The most obvious instance of this may be the numerous grottoes built by priests who followed the flood of Catholic immigrants into the Upper Midwest around the turn of the century; their shrines were a vivid way of attracting and holding their flocks. Many other environments are linked to old-time Protestant evangelism—another vast missionary enterprise.

Something in Baptist and Methodist evangelism especially permitted, even encouraged, the vivid expressions of personal faith that characterize visionary environments. To begin with, there is the emphasis on the conversion experience—the moment of rebirth—which places great value on revelation and on subsequent demonstrations of faith. There is likewise the phenomenon of the farmer-preacher: born again, baptized, and called to preach, all without the benefit of religious instruction in a seminary. (Howard Finster became such a preacher.) The literal and figurative distance from ecclesiastical authority, combined with the emphasis on personal revelation, led to a certain latitude in doctrinal differences and to a relaxing of behavioral restraints—at least with respect to religious expression.[12]

Further, this evangelical ferment contributed to the emergence of strongly sectarian religious subcultures in America. Typically organized around charismatic leaders, sects were especially vigorous in the nineteenth century and included the original

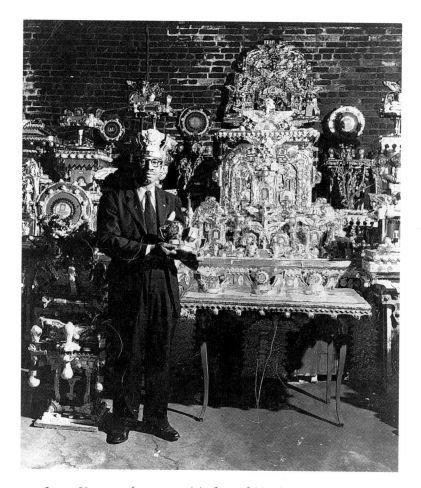

13. James Hampton (1909–1964) in front of his Throne, *wearing a crown as an emblem of his special status as Director of Special Projects for the State of Eternity. Photographer and date unknown.*

Mormons as well as Adventists, Shakers, and Swedenborgians, not to mention spiritualists and mesmerists. Some of these sects, like the Mormons, grew into established churches; others have been replaced in more recent years by groups such as the Jehovah's Witnesses and Pentecostalists. At the same time, even more

"underground" religious practices continued to flourish, like voodoo, an African-derived sect that entered the southern United States with slaves brought from the Caribbean; it too centered on charismatic leaders, known as doctors or healers.

These subcultures collectively express a heterodoxy in religious thought that is crucial to understanding many visionary environments. Finster may have sprung directly from the Baptist tradition of the farmer-preacher, but other visionary artists resemble more closely the charismatic, sectarian leader. St. EOM (Eddie Owens Martin), creator of the templelike compound in Georgia that he called the Land of Pasaquan, and Chief Rolling Mountain Thunder, who collected a band of followers who lived with him at Thunder Mountain Monument, can both be seen more clearly in this light. So can James Hampton, maker of the phenomenal indoor environment known as the *Throne of the Third Heaven of the Nations Millennium General Assembly* (plate 14), a glittering gold-and-silver-foil-covered setting for the Last Judgment. Martin and Hampton both went so far as to name themselves saints: the one St. EOM; the other St. James, Director of Special Projects for the State of Eternity (plate 13). They were leaders of sects of their own devising, charismatics without congregations. The spiritual authority they claimed for themselves was sometimes only self-avowed, sometimes acknowledged by neighbors and friends. The charismatic African Americans whose yard shows are examined in the last chapter fall well within the tradition of the diviner or healer; some covertly explore alternative faiths such as voodoo.

A number of other tantalizing parallels exist between the evangelical tradition and visionary environments. The more explicitly Christian of these artists demonstrate the literal, even fundamentalist, reading of the Bible that is likewise characteristic of the evangelical tradition. They make no effort to distinguish

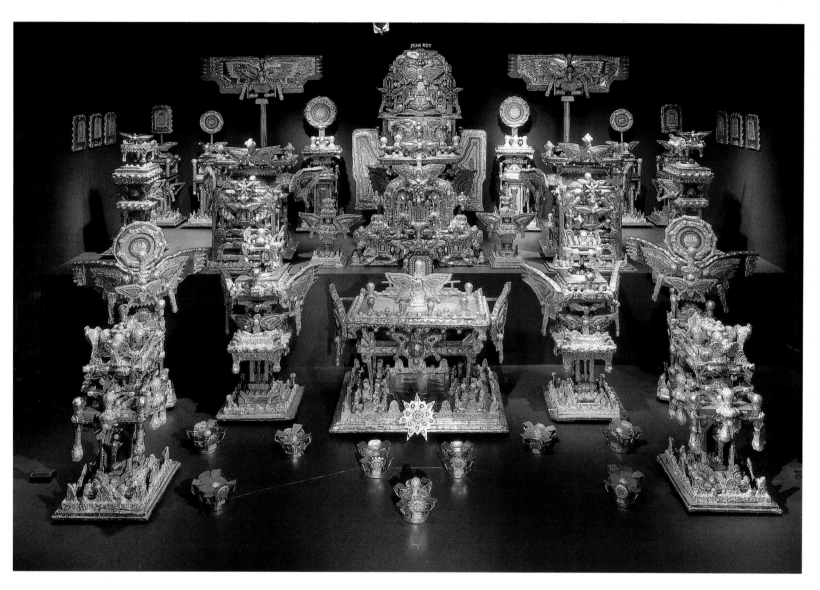

14. *James Hampton.* Throne of the Third Heaven of the Nations Millennium
General Assembly, *c. 1950–64. Gold and silver foil, colored paper, and plastic sheets over
wood, paperboard, and glass. National Museum of American Art, Smithsonian Institution,
Washington, D.C.; Gift of Anonymous Donors.*

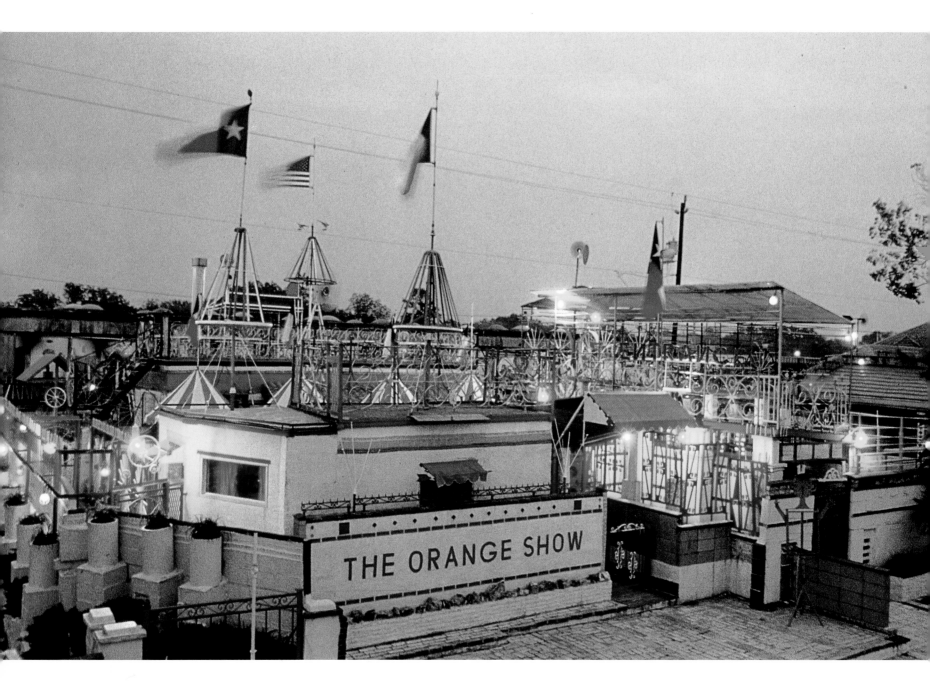

between miracles and historical events, between the Jesus of myth and Jesus the historical figure. (In a less rational age, it might not be necessary to issue this disclaimer.) They also convey a notion of religion in equal parts moralizing and miraculous. Several artists demonstrate a belief in the literal resurrection of the body and in the existence of an otherworldly paradise—and, though it is less frequently seen, in its inverse, hellfire and eternal damnation.[13]

The conversion experience in evangelical Protestantism is closely related, I think, to the vision or commandment that often initiates the artist's labors. In addition, evangelism helped create a climate in which the uneducated could claim moral or religious insight, and it allowed for spiritual vitality and—most relevant in this context—for flamboyant demonstrations of faith. What the religious historian Sydney Ahlstrom calls the "experimental atmosphere" of American Protestantism combined with the evangelical impulse to provoke dramatic testimony to spiritual convictions. This seems to me to go a long way toward accounting for many a visionary environment, especially in the South, where faith healing, prophesy, snake handling, and other idiosyncratic efforts to communicate with the world of the spirits are relatively common.[14]

In recent decades some of these revelations of personal creed have veered a long way from old-time religion. I am thinking here of Jeff McKissack's Orange Show (plate 15), which is dedicated to the life-giving properties of the eponymous fruit. But I wonder if the distance of the Orange Show from orthodox faith isn't itself an expression of the remarkable latitude in religious expression originally permitted within the evangelical tra-

15. *A night view of the Orange Show, constructed in the 1960s and 1970s in Houston by Jeff McKissack (1902–1979). Now owned by the Orange Show Foundation.* Photo: Paul Hester, 1984.

dition. This is no longer the case. As is evident to anyone who has watched the rise of the religious right, evangelism is now associated with intolerance of any deviation from political or religious orthodoxies. There is thus some irony in my association of visionary artists with evangelical traditions. They would probably now be shunned by the cultural group from which many of them emerged.

Those who are attentive to class distinctions will realize that in their religious allegiances these environments reiterate the economic and educational circumstances that have already been noted about these artists. There certainly have been privileged proponents of independence in religious expression: Ralph Waldo Emerson, for example, asked in the opening paragraph of his essay "Nature" (1836), "Why should not we also enjoy an original relation to the universe? Why should not we have a poetry and philosophy of insight and not of tradition, and a religion by revelation to us?"[15] But for the most part, neither evangelism nor the visionary environment is a high-brow, upper-class phenomenon. The forms of Protestantism more closely linked with the upper classes—Episcopalianism and Unitarianism, for example—have typically avoided the emotional display of faith characteristic of evangelism.

Meanwhile, those who are attentive to gender distinctions will note that the artists in this book are overwhelmingly male. This is a fairly accurate expression of the respective numbers of male and female environment builders. I suspect this disproportion follows from the realities of property ownership; it is probably also a function of the typical division of domestic labors: his outside, hers inside. But it might also relate to the traditional priority of men in the public sphere. Inasmuch as these environments constitute a form of public address, they are an expression of a traditionally male prerogative. That their rhetoric often

revolves around religious ideas only intensifies that maleness, considering the traditional lack of ecclesiastical authority accorded to women. Given the opposition to female clergy in most denominations, a situation that has only recently begun to change among Protestants and that is still unaltered among Catholics, women face more resistance than men to the expression of their religious or moral leadership. Combined with economic factors, this may have been enough to discourage the creation of more than a few environments by women. However, the relative absence of women builders does not mean that considerations of gender will be missing from the text. Indeed, many of these environments are emphatically gendered spaces, expressing (mostly male) ideas about the appropriate constructions of masculinity and femininity. In view of this lopsidedness, it will perhaps come as no surprise that several male artists in this study hold views of the opposite sex that most contemporary women are likely to find outdated, if not repugnant.

❦

While visionary environments have been powerfully shaped by popular versions of patriotism and religion, their interpretation in the literature of art generally follows another line, a line dominated especially by Surrealism and by Jean Dubuffet's notions of Art Brut. The appreciation of visionary art is part of a broader phenomenon in which twentieth-century artists looked away from academic art for examples of "pure" creativity, unmediated by cultural assumptions deemed to be constricting. The story of Pablo Picasso's exposure to African sculpture at the Musée d'Ethnographie at the Palais du Trocadéro in Paris and its impact on his 1907 painting, *Les Demoiselles d'Avignon* (Museum of Modern Art, New York), is just one of many instances in which

early modern artists sought to invigorate their work by looking at the productions of tribal cultures. At virtually the same time, they began to develop an appreciation for untutored artists in their own midst, including children and the mentally ill. In a well-known assertion of 1912 Paul Klee insisted, "These various things really should be taken far more seriously than are the collections of all our art museums if we truly intend to reform today's art."[16] Six years later, the Heidelberg psychiatrist Hans Prinzhorn began assembling a pioneering collection of art by mental patients, which grew to comprise some five thousand pieces and which became the basis of his 1922 book, *Bildnerei der Geisteskranken* (Artistry of the Mentally Ill).

For the Surrealists, notably Max Ernst and André Breton, mental illness became one of the most compelling paradigms of unmediated creativity. Ernst's studies at Bonn University had included psychology and psychiatry; he was introduced to the art of the insane around 1910 during a study visit to an asylum near Bonn. In 1919 he collaborated on an exhibition of Dada art in Cologne that included tribal objects as well as work by children and psychotics. And in 1922, when he left for Paris, he carried with him a copy of Prinzhorn's book as a gift for the poet Paul Eluard. This may have been the first copy of the book to reach the Parisian Surrealists, among whom it became a kind of underground bible.[17] Breton shared with Ernst a background in psychology. As a medical student in Paris at the beginning of World War I, he had been assigned to a neuropsychiatric center at Saint-Dizier to help treat the victims of battle shock. A 1916 letter from Breton to the poet Guillaume Apollinaire tells of his experiences with the mentally ill at Saint-Dizier and suggests that Breton was already assessing the impact of these experiences on his own creative life: "I instinctively feel my destiny is to put the artist to the same sort of test."[18]

When Breton composed the manifesto for his destiny, it was rich with references to what the historian Roger Cardinal calls "the psychic elsewhere." The *Manifesto of Surrealism* (1924) rejects "absolute rationalism" and "the reign of logic" as inimical to the free play of imagination, and it looks to children and madmen as exemplars of freedom. Crediting Freud with the recovery of the most important part of the mind—the unconscious—Breton privileged the functioning of the brain in its dream state over that in its waking state. He looked forward to "the future resolution of these two states, dream and reality, which are seemingly so contradictory, into a kind of absolute reality, a *surreality*, if one may so speak." And he laid the foundation for one of the modern era's most influential notions of creativity when he defined Surrealism as "pure psychic automatism," the expression in any medium of "the actual functioning of thought . . . in the absence of any control exercised by reason, exempt from any aesthetic or moral concern."[19]

The manifesto explores the idea of automatism chiefly as it applies to poetry, but it was not long before the notion was extended to other arts. The first issue of *La Révolution surréaliste* (December 1, 1924) included an article called "Les Yeux enchantés" (the enchanted gaze), in which Max Morise made the case for automatic creativity in the visual arts. Breton himself went on to write extensively about Surrealism and art, beginning with the first version of *Le Surréalisme et la peinture* in 1928. And although he was explicit about his debt to Freud and to his experience with the insane, his ideas were apparently also shaped by exposure to the phenomenon of the spiritualist medium or clairvoyant.[20]

It was within the context of Surrealism that visionary environments first began to attract significant notice. Breton was an early champion of the Palais Idéal, as was Ernst. The latter paid homage to Ferdinand Cheval in the form of a collage of 1929–30

now in the Peggy Guggenheim Collection, Venice. By 1936 the Palais Idéal was so firmly a part of the Surrealist constellation that it was reproduced in the catalog of the Museum of Modern Art's landmark exhibition *Fantastic Art, Dada, Surrealism*. It appeared in a section called "Fantastic Architecture," along with the work of lettered artists such as the Barcelona architect Antonio Gaudí and the German artist Kurt Schwitters, who built a series of grottolike chambers made from scavenged materials, which he called *Merzbau*.

After World War II, Jean Dubuffet emerged as the most vigorous supporter of artists outside the mainstream of culture. He began amassing material by such artists in 1945 and by 1947 was exhibiting selections from his collection in Paris. He developed his own designation for the work he admired, *l'art brut* (raw art), a concept he refined in a series of essays beginning in the late 1940s. Art Brut proved to be a remarkably elastic notion, embracing anything that Dubuffet felt displayed originality in defying cultural norms, including the work not only of children and the insane but also of visionaries, mediums, and various other untutored and popular artists as well—anything that was raw and authentically inventive, instead of cooked according to conventional recipes.

Dubuffet's most extended polemic against received values came in 1968 with the publication of his book *Asphyxiante Culture* (Asphyxiating Culture). To his mind, the word *culture* had two meanings. One referred to a knowledge of the past and resonated with ideas of indoctrination by the State and its agents: the academies, museums, and ministries. The other referred more favorably to the activity of the mind and to the creation of original art—both of which, in Dubuffet's mind, were being suffocated by the former. True creativity, inasmuch as it resisted the orthodoxies of cultural conditioning, was a challenge to the authority of the State and thus inherently antisocial, or at least

asocial. The greater the distance from authority, the more raw and fertile the art. "We must still mention the spirit of systematic refusal . . . the spirit of contradiction and of paradox, the position of insubordinance and of revolt—all precious compost for the budding of creation and enthusiasm. Nothing salvational ever grew but from this sort of rich soil."

As distinct from a Surrealist notion of pure, autonomous creativity, Dubuffet recognized that rawness was not a fixed state but a tendency; he acknowledged that we are all, to some degree, "impregnated" with culture. He also recognized the ambiguity of the marginal artist's position, wanting both individuality and contact with an audience: "If his production does not bear a very personal stamp . . . it contributes nothing. If, however, this individualistic spirit is pushed to the point of refusing all communication with the public, . . . its subversive character vanishes."[21]

Two of the first books to deal extensively with visionary environments, Roger Cardinal's *Outsider Art* (1972) and Michel Thévoz's *Art Brut* (1975), were deeply informed by the ideas of Dubuffet. *Outsider Art* begins with a discussion of *Asphyxiating Culture* and the way that conditioning has blinded us to art that defies the usual categories; Cardinal goes on to consider Clarence Schmidt's house, Rodia's towers, and Cheval's Palais Idéal, among other environments, as examples of authentic and original creativity. Thévoz codifies a definition of Art Brut as the work of mental or social outsiders who are independent of the usual system of schools, galleries, and museums, and whose "subjects, techniques, and systems of figuration have little connection with those handed down by tradition or current in the fashionable art of the day."[22] He also ratifies Dubuffet's notion that Art Brut is full of subversive energy, in open conflict with received culture. Thévoz's book includes an inventory of environments similar to Cardinal's.

In the United States, environments were also appreciated within the context of the evolving junk aesthetic. Inspired by artists such as Dubuffet and Schwitters, this phenomenon was celebrated in a major exhibition at the Museum of Modern Art called *The Art of Assemblage* (1961); photographs of the Watts Towers were included in the catalog. Mainstream avant-garde artists were pursuing their own environmental impulses at the same time, encouraged by contact with self-taught artists. Allan Kaprow, for example, was introduced to Clarence Schmidt in 1959 and began to create temporary installations of junk materials for gallery exhibitions in 1960. In 1966 he authored a book called *Assemblage, Environments, and Happenings,* in which photographs of Schmidt's house were interspersed with images of environments and performances created in the early 1960s by Jim Dine, Claes Oldenburg, and Jean Tinguely, among others.

The notions of Surrealism, Art Brut, and assemblage have all helped to create a context in which the environments of visionary artists have been recognized and celebrated; all three have their virtues and their limitations. Surrealism opened our eyes to the uncanny and to the marvelous in a variety of quarters, and it revealed some of the hidden springs of creativity in the unconscious. But it reinforced a tendency to confuse true psychosis with nonclinical forms of creative obsession; that is, to confuse madness with artistic freedom, a problem that continues to afflict interpretation of visionary environments. (For the record, few if any of the artists about which I write seem to fit the prevailing definitions of insanity, nor to my knowledge has any been institutionalized or clinically diagnosed.) Moreover, in the

16. Ferdinand Cheval (1836–1924). Palais Idéal, c. 1879–1912, Hauterives, France. Now owned by the Municipality of Hauterives.
Photo: John Gary Brown.

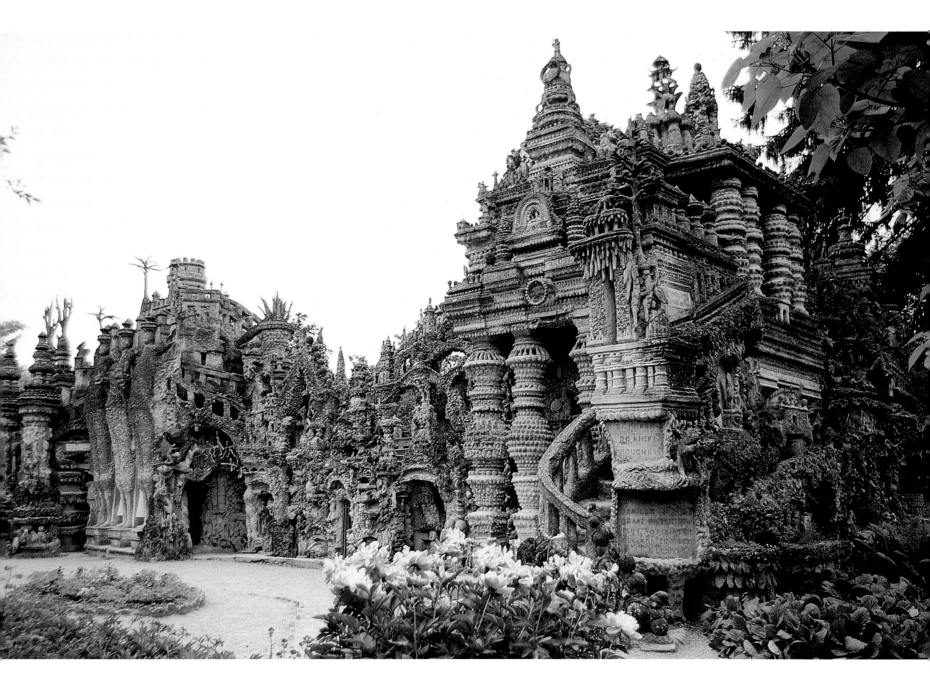

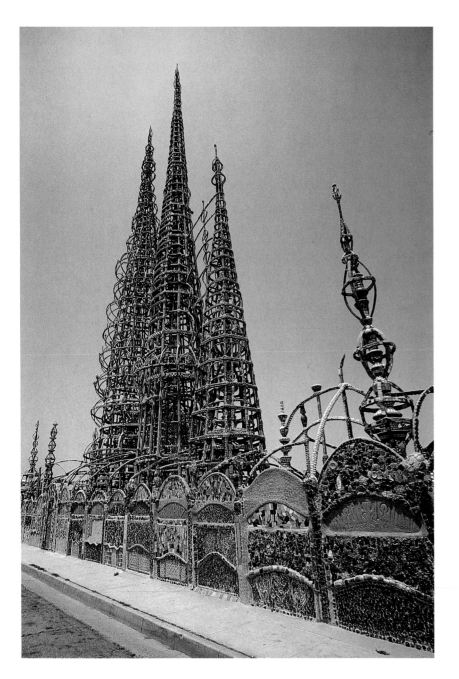

notion of "pure psychic automatism," Surrealism fostered an illusion that it was possible to be entirely innocent of received culture, a notion that Dubuffet began to challenge and that is in full retreat in much of the current literature on folk and visionary art. In its explicit atheism, Surrealism may also have blinded us to the sacred dimensions of many visionary environments.

For his part, Dubuffet can be credited with having introduced a still wider spectrum of untutored artists than did the Surrealists, and with exploring the ambiguous position of these artists relative to their audience and their communities. But I wonder if his inclusiveness didn't also dull our awareness of the distinctions among various types of rawness, as manifested by psychotics, mediums, or visionaries, for example. And in his extreme anticultural attitude, he may have encouraged a tendency to attribute radicalism to works that just as often manifest a deep social and ecclesiastical conservatism. The ideas of assemblage, inasmuch as they emphasized found materials and technique, may be said to have celebrated the aesthetic dimensions of these environments at the expense of more complex and thorough interpretations based either on their rhetorical intent or on their social and cultural contexts.

In recent years, visionary environments have attracted a greater variety of responses. Rodia's Watts Towers received widespread media attention when they were saved from demolition in 1959; they were the focus of an exhibition of photographs by Seymour Rosen at the Los Angeles County Museum in 1962. A pioneering profile of Rodia by Calvin Trillin appeared in the *New Yorker* in 1965. In 1968 *Art in America* published the first extensive photographic documentation of American envi-

17. *Sam Rodia (c. 1875–1965). Watts Towers, c. 1925–54, Los Angeles. Now administered by the Los Angeles Department of Cultural Affairs.*

ronments, a study of fifteen sites by an artist named Gregg Blasdel. Blasdel, who grew up in Kansas with an appreciation for various kinds of offbeat and vernacular art, brought a fresh perspective to the subject, as he was then unaware of ideas about Art Brut. Among the environments he featured in the article were several that define the genre in America, such as Dinsmoor's Garden of Eden and Fred Smith's Wisconsin Concrete Park. But he also included the grottoes by Father Wernerus in Dickeyville, Wisconsin, and by Brother Joseph Zoetl in Cullman, Alabama, one of the few times that Catholic shrines by self-taught artists have figured in this context.

Blasdel's article, which gave impetus to the Walker's *Naives and Visionaries* exhibition, called attention to the problems of preserving environments. Subsequently, groups such as SPACES (organized by Seymour Rosen in Los Angeles in 1978), the Kansas Grassroots Art Association, and the Kohler Foundation in Wisconsin have all worked tirelessly to identify and preserve visionary art environments. A few specialized publications have also appeared, dedicated to preservation and interpretation: SPACES and the KGAA have both published newsletters, and a new periodical called *Raw Vision* has recently begun publication in London.

Narratives about preservation are woven into this text; the survival of visionary environments is a particularly pressing issue. Michael D. Hall, an artist as well as a collector and scholar of folk art, writes, "For all their heroic size and formidable physical presence, the environments seem to be highly fragile and are vulnerable to vandalism and natural deterioration in a way that makes them among the most fugitive of folk art forms."[23] Our difficulties in reading the language of these environments, along with our general inability to accept them into the canons of fine, folk, or garden art, only compounds the problem. While we fiddle, Rome burns.

I will return to the story of the reception and interpretation of visionary environments at various points in this text. But I summarize it here because the balance of my narrative is not historiographic but typological and thematic, organized around the characteristics of the various sites: sculpture gardens, grottoes, and walled compounds, for example; or the notions of religion and patriotism. These types and themes are not mutually exclusive; some environments could be viewed in several contexts, and some fit into none with ease. But this organization seems the best way to look beyond the surface of these environments to grasp something of their motivation and meaning.

While my structure is thematic and typological, my chief questions are rhetorical. They concern the nature of the public utterance and the sources from which it springs. What is being said in these environments, how, and to what end? To what degree have these environments been shaped by historical and cultural contexts, and to what extent are they truly anomalous, outside of all known categories of speech? To these questions, I have hopes of suggesting some answers. But I am chastened by the thought that there are still more difficult questions that might be asked about these artists and their environments. What gift enabled these marginalized and alienated people to transform their circumstances through art? What determination allowed them to claim a forum for public address, which economic or political circumstances had otherwise denied them? What sustained their visions over the years of labor required to bring them to fruition? What gave them the self-confidence—the faith in themselves and in their missions—to persist in the face of a skeptical or even contemptuous audience? These are questions that I probably cannot hope to answer, except by example. But this may ultimately be the most wondrous and compelling aspect of my subject, and the one most worthy of celebration.

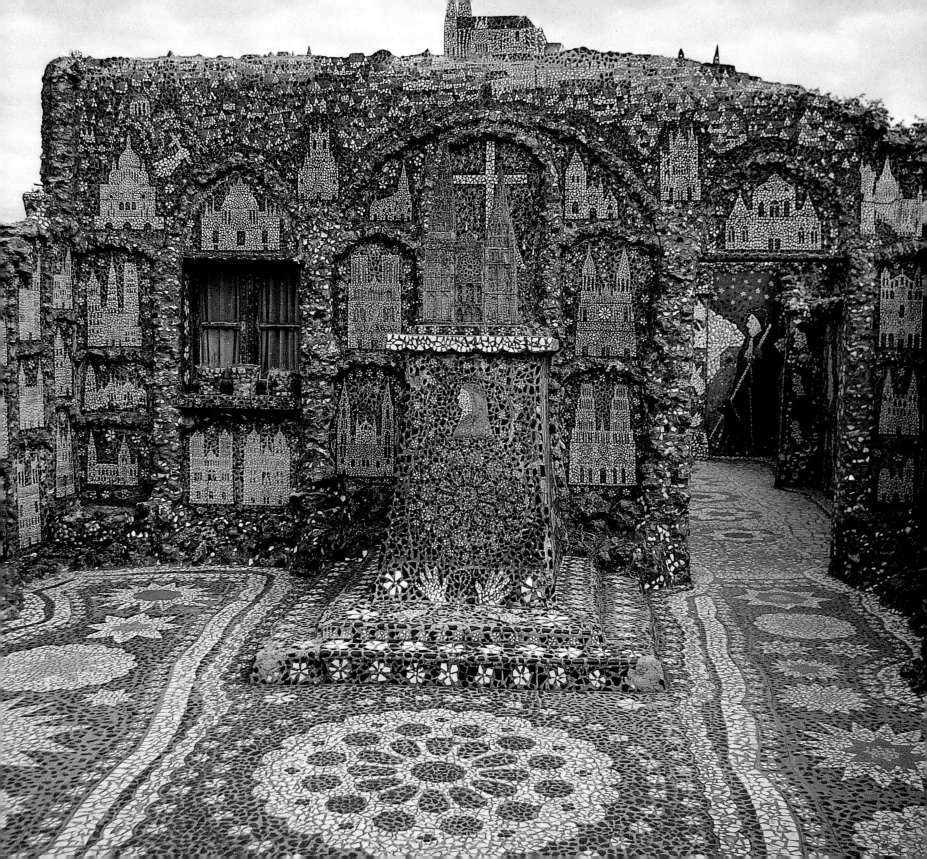

"The Marvelous Precipitate of Desire"

Without looking back you would grab the trowel
that breasts are made of
We would smile at you you held us by the waist
And we would take on the configurations of your
pleasure
Motionless beneath our eyelids forever as a
woman loves to see a man
After making love

André Breton, from "Facteur Cheval" (1932)

O NE DAY IN APRIL 1879, while making his rounds as a rural postman between several villages of the Drôme (south of Lyons, France), Ferdinand Cheval made a discovery that changed his life forever. His foot caught on a stone that he later described as "so bizarre and at the same time so picturesque" that the sight of it arrested him. He looked around and saw many such weathered and contorted rocks. "From this moment," he recounted, "I had no rest morning to evening. I was always leaving to find some stones."[1] He decided that "since nature has furnished the sculptures, I shall be the architect and the mason."[2] He began to amass a collection of stones in the garden behind his house in Hauterives that gradu-

ally, embedded in cement and reinforced with wire, grew into the fanciful monument known as the Palais Idéal (plate 16).

In the century since, Cheval's discovery has come to seem increasingly paradigmatic. Above all, it now exemplifies the enormous power of the found object to motivate the visionary artist. A chance encounter with a fragment of stone or a piece of broken glass is often the incentive to a life's labor. The Palais is among the oldest surviving, most extensive, and most extraordinary of architectural sculptures or garden ornaments created by a self-taught artist. It is also a virtual encyclopedia of the forms of visionary environments the world over: it is architecture and sculpture, grotto and temple. It is likewise an encyclopedia of

18. Raymond Isidore (1900–1964). Courtyard garden at Maison Picassiette, Chartres, France. This section, with the Black Tomb and a panorama of Chartres, was completed c. 1962. Now owned by the Municipality and the Musée des Beaux-Arts, Chartres. Photo: John Gary Brown.

their themes: religion and patriotism, brotherhood and equality, individual freedom and self-motivated labor. In different ways, the other environments in this chapter—Raymond Isidore's vision of heaven and earth in Chartres, Robert Garcet's tower of the Apocalypse in southern Belgium, Helen Martins's fantasia on Mecca in South Africa, and Nek Chand's imaginary kingdom in Chandigarh, India—all deploy similar kinds of structures and revolve around analogous ideas of a promised land.

Almost as important as the form and iconography of Cheval's monument itself, however, is the way it ratified the ideas of a later generation of artists. In particular, the Facteur Cheval and his Palais Idéal confirmed Surrealist ideas about automatic creativity. They also contributed to the formulation of Breton's conception of convulsive beauty, one of the most enduringly significant constructs of twentieth-century art and one that still sheds light on the imaginative power of visionary environments. In Breton's notions of convulsive beauty—in his ideas about the crystallization of desire and in his celebration of metamorphosis and incongruous juxtapositions—are the outlines of an aesthetic theory that can still help us comprehend the workings of the visionary artist's magic. Moreover, Breton provides what remains to my mind one of the best ways of accounting for the uncanny capacity of the found object—what he would call "the marvelous precipitate of desire"—to liberate the artistic imagination.

At the same time, the relationship between Breton and the Palais Idéal illustrates several profound ironies that have traditionally shaped the reception and interpretation of visionary environments. The local response to these places often differs greatly from the reaction they receive in more "cultured" circles; both may obscure the artist's original meanings and intentions. The artistically untutored are often most appreciated by those who have learned and rejected the canons of "high" art. While they are generally marginal in their own communities, they become central to conceptions of art that are very distant from their experience. This was certainly the case with Cheval and Breton; the Palais Idéal took on a life in Breton's imagination rather different from the one it led in Cheval's mind. For Breton, the Palais Idéal was itself a kind of found object, which impelled his creativity much as the marvelous stone had inspired Cheval's.

The creator of the fabulous Palais Idéal was born far from the cultivated circles in which he was posthumously celebrated. He hailed from Charmes, a small French village near Romans, where he was born into a farming family in 1836. His mother died when he was eleven and his father when he was nineteen; shortly thereafter he married a young woman from Hauterives named Rosalie Revol. The marriage seems not to have been particularly happy: his wife lived intermittently with her family over the next six years or so while Cheval worked as a baker in various places. His frequent absences have given rise to speculation that he went abroad, perhaps as a soldier to Algeria; the Moorish elements of the Palais Idéal are offered as confirmation of this journey. But there is no hard evidence that he ever left the region, and he was apparently exempted from military service despite being in good health. By the mid-1860s his itinerant life had become entirely fixed. He was by then a postman, and for the next twenty-five years he would cover over eighteen miles (thirty kilometers) a day on his unvarying route out of Hauterives. In 1866 a son was born to Cheval and his wife. In 1873 his wife died; five years later, he married again. Cheval's second child, a daughter, Alice, was born in 1879, his annus mirabilis. She seems to have been the real love of his life. She died in 1894; the span of her life coincided almost exactly with the years of his greatest productivity as an artist.[3]

The Palais Idéal seems to have first come to life in a recurring daydream, as Cheval trudged again and again over the same

ground on his postal route. "What could one do while walking eternally against the same background, unless one dreamed? I used to dream." He imagined escaping his routine by constructing a fantasy palace that would evoke the architectures of ancient and exotic cultures, with gardens, grottoes, towers, and sculptures, "the whole so picturesque that the image of it stayed vividly in my mind for at least ten years."[4] Apparently this vision had begun to fade, however, when it was suddenly revived by his fateful encounter with the marvelous stone in 1879.

Thereafter, Cheval scoured the countryside around Hauterives, which is rich in deposits of tufa, a porous limestone that assumes unusual shapes. He would pile up interesting stones along his route by day and go back to retrieve them at night, sometimes covering another nine miles (fifteen kilometers) in the effort. Initially, he brought the stones back wrapped in his pocket handkerchief but, as his momentum grew, he took to pushing a wheelbarrow over the distances. With the first of these stones, he fashioned a waterfall or fountain over a basin that he began to surround with cement sculptures of animals. As he related in a letter written in 1897, this took him two years. "Once I had finished, I found myself in awe of my work. Criticized by the people of the region, but encouraged by visiting strangers, I was not discouraged. I had made new discoveries of stones each one more beautiful than the others. At Saint-Martin-d'Août, at Treigneux, at Saint-Germain a species of little round balls. I set myself to work."[5]

And work he did, for some thirty-four years in all—unhindered by his awareness that local response to his efforts was

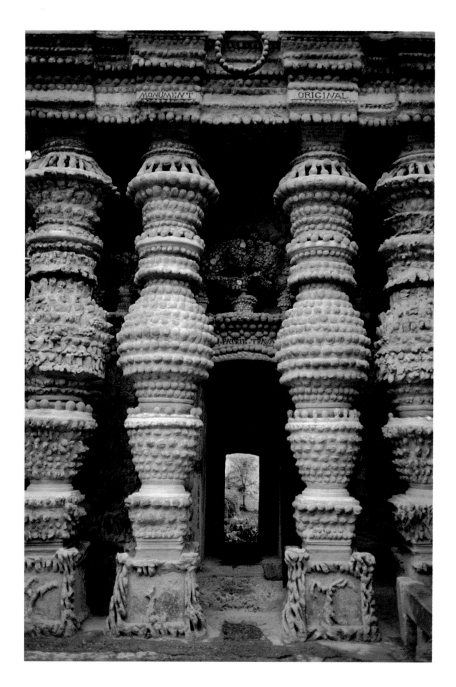

19. Ferdinand Cheval (1836–1924). The "Egyptian" tomb at the Palais Idéal, c. 1879–1912, Hauterives, France. Now owned by the Municipality of Hauterives. Photo: John Beardsley, 1991.

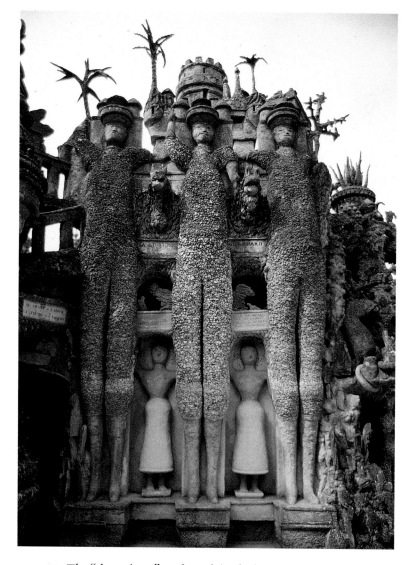

20. *The "three giants" at the Palais Idéal.* Photo: John Gary Brown.

decidedly cooler than the reactions of strangers. He built a second waterfall plus a grotto between the two; they form what he described as the middle of the monument, now the center of the east facade. Then, he recounted in the letter, "the idea occurred to me that with my little round balls . . . I could make myself a tomb whose style would be unique the world over, and that I could have myself interred in rock in the fashion of the Pharaoh kings; the form would be Egyptian." He excavated a subterranean chamber and installed tiled coffins, then over the tomb built a monument that rises to a height of some thirty-five feet (10.8 meters) to form the north end of the east facade (plate 19). On the front, four huge cylindrical columns decorated with round rocks support several layers of ornate entablature, all crowned with a large funerary urn. Cheval then added a complementary four-columned edifice described as a Hindu temple to crown the north facade, which rises above several other grottoes (plate 22). The rest of the north side he elaborated with shells, simulated vegetation, and row upon row of every conceivable cement beast, real and imagined: elephants, bears, birds, boa constrictors, crocodiles, lions, and what appear to be dragons, to name just a few (plate 21).

But he didn't stop there. Cheval's creation also grew to the south. He dug another crypt, this one for his tools: wheelbarrow, mixing bucket, and trowel. Over this he raised another monument, also in the "Egyptian" style. It is faced with "the three giants": Vercingétorix and Caesar, enemies in the struggle for control of ancient Gaul, and Archimedes, the Greek mathematician (plate 20). As befits their historic stature, these figures are heroically scaled; they are inlaid with blue-gray and reddish flint. These giants bracket two smaller figures, which Cheval described in his 1897 letter as mummies, but which were also known as the Druidess Veleda and the Egyptian goddess Iniza or Isis. Spiral stairs behind the giants lead up to the Tower of Barbary, which is

ornamented with representations of fig, palm, and olive trees—the elements that have given rise to the stories about Cheval's visit to Algeria.

This much of the Palais Idéal—the whole of the east and north facades—was completed within the first twenty years of Cheval's labor. They are much the better part of his creation. Between about the turn of the century and 1912, when he essentially quit work on the Palais Idéal, he completed the west and south facades, which are crude compared to the fanciful character of the earlier work. The west side is composed of a series of niches containing small, disappointingly literal replicas of architectural types—a Swiss chalet, a Hindu temple, and a medieval castle, for example; these must have been reproduced from magazines or postcards. At the far end is the facade of a mosque, which gives entrance to the "Palais Imaginaire": a vaulted chamber full of sculptures in bas-relief. This connects to a gallery that runs inside the entire length of the west side. It too is decorated with animal and vegetal forms, along with fossils and shells. At the north end, it terminates in what Cheval called the Gallery of Primitive Sculpture: more plants and animals.

Overall, the Palais Idéal grew to measure some 86 by 46 feet, and attained a height of 39 (26 by 14 by 12 meters). Though pieced together over several decades and in a multitude of idioms, it nevertheless achieves a remarkable coherence, particularly on the north and east facades. This is not due to the application of conventional beaux-arts organizing devices: symmetry, balance, proportion. Instead, the monument took shape through the inspired combination of found objects and the free adaptation of historical forms, with a richness of ornamentation providing the visual glue that holds the whole edifice together. In its most elaborate passages, it easily fulfills Cheval's ambition that it be described as "unique in the world." Yet however fanciful its out-

ward form, the Palais Idéal demonstrates connections to several basic types of symbolic garden structures. Having originated as fountains and a grotto, it quickly took on the character of a funerary monument as well, though Cheval was never buried in it. He apparently was denied permission, because he spent the last years of his life building another tomb, in the local cemetery, where he was interred when he died in 1924.

Almost from the start, the various parts of Cheval's Palais Idéal were swallowed up in larger symbolic purposes. His structure assumed the character of a garden temple, devoted both to the abundance and variety of nature and to an ecumenical embrace of the world's major religions. The Palais Idéal has numerous Christian elements: representations of Adam and Eve on the north facade, and a grotto of the Virgin and a Calvary scene in the entablature of the east facade. As we have seen, it also includes versions of Hindu and Egyptian temples and a mosque. But it is nature that is venerated above all. With its collection of marvelous stones, its shells and fossils, its profusion of vegetal forms, its ranks of animals, its elaborate grottoes, and its evocations of ancient sculpture, the Palais Idéal feels like a vast, chaotic cabinet of curiosities. It is not like an ordinary museum, where things are presented according to some rational scheme. Instead, all the parts of this temple of nature were filtered through Cheval's memory and reconstructed according to his imagination. As he wrote in an inscription on the edifice, "In the minutes of leisure allowed by my employment, I built this palace of a Thousand and One Nights wherein I have engraved my memory." John Dixon Hunt's observation on the cabinet of curiosities is particularly relevant to the Palais Idéal: it is a memory theater of the lost Eden, recovered by the postman's skill.[6]

Cheval added hundreds of inscriptions to his creation. In many he celebrated himself: his courage and perseverance, his

humble origins, and the wonder of his achievement. "All that you see, passerby, is the work of a peasant," or "the work of one man." Others proclaim the brotherhood of all people, the importance of liberty and equality, the virtues of hard work, and the supremacy of God and country: "God and the fatherland are our masters." This idea is reiterated in the inscription "God, fatherland, work" put in a place of particular importance over the entrance to the tomb.

In another inscription, written prominently under the Hindu temple, Cheval declared: "Out of a dream I have brought forth the Queen of the World." It was this aspect of Cheval's work—its expression of the unconscious, not its religious or patriotic dimensions or its connection to traditional garden elements—that attracted the Surrealists. Breton visited the Palais Idéal in the summer of 1931; he composed a poem about Cheval in 1932; and in 1933 he published a photograph of the site in an essay called "Le Message automatique." There he called Cheval "the uncontested master of mediumistic architecture and sculpture."[7] This designation is curious, inasmuch as Cheval was not apparently involved with mediumism, but it is an indication that Breton perceived the Palais Idéal well within the context of his idea that creativity was the expression of "pure psychic automatism," with a source in the unconscious and in dreams. In an extended version of "Le Message automatique," published in his book *Point du jour* in 1934, he described Cheval as "haunted" by the caverns of the Drôme, with their formations like "petrified fountains." By thus suggesting analogies between Cheval's work and the local landscape, Breton was not implying a conscious connection. Instead, he was inferring that the images of these caves were erupting unbidden from his unconscious.

Over the years the Surrealist embrace of the Palais Idéal may have contributed to a tendency to overlook certain aspects of Cheval's language while misinterpreting others. Missing from most of the literature on Cheval, for example, is a sense of the moral dimensions of his work. Cheval may have been motivated by dreams or unbidden memories, but his many references to God, the fatherland, and work reveal that his creativity was certainly not "exempt from moral concern," as pure psychic automatism was held to be. Moreover, the Surrealist enthusiasm for the art of children and the insane meant that Cheval was often tossed into this stew. Such was the case in one of the first articles on the Palais Idéal, which appeared in *Architectural Review* in 1936. "At the meeting place of primitive art and of the art of madmen and of children," the writer opined, "Cheval established a monstrous system of imagined memories." But Cheval was neither childlike nor mad. Indeed, he provided a lucid statement of his complete self-possession when he recounted in one of his notebooks:

> Gossip then began in the district, and it was not long before the opinion of the locality was established: "There's a poor mad fool filling up his garden with stones." Indeed, people were quite prepared to believe it was a case of a sick imagination. People laughed, disapproved, and criticized me, but as this sort of alienation was neither contagious nor dangerous, they didn't see much point in fetching the doctor, and I was thus able to give myself up to my passion in perfect liberty in spite of it all.[8]

Whatever Surrealism's drawbacks, Breton's idea of convulsive beauty still goes a long way toward accounting for the uncanny appeal of Cheval's creation. This is because the notion was evidently shaped in part by Breton's experience of the Palais Idéal. Some of the images in his 1932 poem about the Facteur Cheval figure prominently in the opening chapter of *L'Amour fou*, in which convulsive beauty was fully defined.[9] For Breton, this new

kind of beauty was to be found anywhere the imagination was liberated from the forces of rationalism and logic. As characterized in his book *L'Amour fou* (1937), "convulsive beauty will be veiled-erotic, fixed-explosive, magic-circumstantial, or it will not be." In Breton's mind, convulsive beauty was inextricably linked to eroticism. "I confess without the slightest embarrassment," he wrote, "my profound insensitivity in the presence of natural spectacles and of those works of art which do not straight off arouse a physical sensation in me, like the feeling of a feathery wind brushing across my temples to produce a real shiver. I could never avoid establishing some relation between this sensation and that of erotic pleasure, finding only a difference of degree."

Breton's language about the erotic dimensions of convulsive beauty is anticipated in his poem "Facteur Cheval" (1932). He seems to have felt this pleasurable shiver at the Palais Idéal, as expressed in the closing lines:

> *Without looking back you would grab the trowel*
> * that breasts are made of*
> *We would smile at you you held us by the waist*
> *And we would take on the configurations of your*
> * pleasure*
> *Motionless beneath our eyelids forever as a*
> * woman loves to see a man*
> *After making love*[10]

Sexualized imagery is present at the Palais Idéal in great abundance: not only in the swelling breasts to which Breton makes reference but also in phallic mushrooms, womblike grottoes, and pendulous serpents and elephant trunks. But it was not

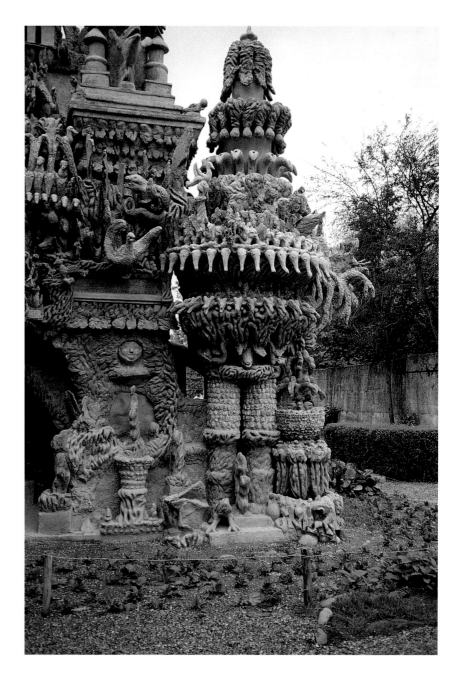

21. The northwest corner of the Palais Idéal. Photo: John Beardsley, 1991.

simply the literal image of sexuality that attracted Breton. He seems to have been compelled even more by the way in which the Palais Idéal conflated the erotic and the aesthetic. He saw the place as the configuration of both Cheval's pleasure and ours. For Breton, the experience of the Palais Idéal, and later of convulsive beauty, was analogous to the fulfillment of erotic desire.

Breton also found convulsive beauty in the merging of opposites. Specifically, he perceived it in the precise moment when motion is suspended. "The word 'convulsive,'" he wrote in *L'Amour fou*, "would lose any meaning in my eyes were it to be conceived in motion and not at the exact expiration of this motion." For Breton, the most exalted example of this "fixed explosion" was a photograph he came across of "a speeding locomotive abandoned for years to the delirium of a virgin forest." This precise image had earlier been connected with the creativity of Cheval. In one of the key passages in the poem, the postman is figuratively spliced into the missing photograph:

> *You remember you would arise then you would*
> *step off the train*
> *Without a glance at the locomotive preyed upon*
> *by immense barometric roots*
> *That cries out dolefully in the virgin forest*
> *with all of its mauled boilers*
> *Its stacks puffing hyacinths and propelled by*
> *blue serpents*

There are plenty of literal approximations of Breton's language at the Palais Idéal: funerary urns sprout plants, like the stacks puffing hyacinths; the north facade is animated by serpents. Overall, the place is an image of frozen motion. Again, however, Breton seems to have seen deeper parallels between Cheval's work and convulsive beauty. In the photograph of the locomotive

overwhelmed by the raw power of nature, there is the suggestion of imagination triumphing over reason, of the unconscious overwhelming the conscious. Cheval is pictured as coming to life at the moment of this triumph.

There is one other crucial dimension to convulsive beauty, the part that is "magic-circumstantial." "Such beauty," Breton writes, "cannot appear except from the poignant feeling of the thing revealed, the integral certainty produced by the emergence of a solution, which . . . could not come to us along ordinary logical paths." It is through the found object (*trouvaille*) that this revelation often occurs. "This *trouvaille*, whether it be artistic, scientific, philosophic, or as useless as anything, is enough to undo the beauty of everything beside it. In it alone can we recognize the marvelous precipitate of desire. It alone can enlarge the universe." Convulsive beauty arises, in other words, as a consequence of a chance encounter in the midst of daily life; it is the result of an involuntary act of perception that opens a window on a mysterious world. "The finding of an object serves here exactly the same purpose as the dream, in the sense that it frees the individual from paralyzing affective scruples, comforts him and makes him understand that the obstacle he might have thought unsurmountable is cleared."[11] The found object is crucial to the crystallization of desire. Such certainly was the case with Cheval; his dream had begun to fade when it was revived by a chance encounter with a stone.

The notion of convulsive beauty has continued to resonate in other responses to the Palais Idéal. Writing of a visit to the site in 1962, for example, novelist Lawrence Durrell found himself in

22. The north facade of the Palais Idéal. Photo: John Gary Brown.

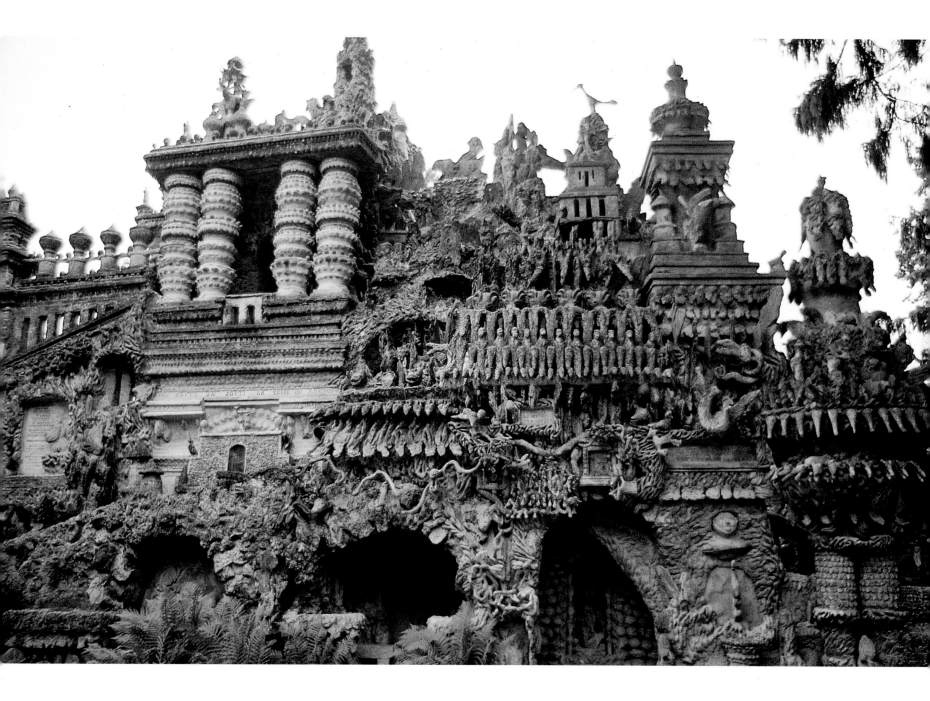

the presence of "one of the most *unexpected* of works. . . . I understood now why the Surrealists had claimed the Facteur Cheval as one of them . . . the juxtaposition of styles and modes was fantastic and gave one the requisite shock."[12] But the idea has a wider relevance: the aesthetic response generated by many other visionary environments also centers on the experience of shock or displacement. Visionary environments are generally made from materials that we recognize to have been wrested from their ordinary contexts and metamorphosed by the artist into something else entirely. Imagery can be highly imaginative, even hallucinatory; it is often characterized by incongruous juxtapositions. Visionary environments typically embody a kind of arrested chaos, a vigorous approach to creation that looks spontaneous. They suggest an activity that follows its own internal laws, in which the unconscious, especially as revealed in dreams, at times does seem to overwhelm the conscious. All this generates in us a sense of being out of our element or disoriented in the face of something extraordinary. Thus they often provoke the kind of shudder that Breton described as erotic and that we might also associate with the uncanny, with something marvelous but a little disturbing.

In many cases, moreover, these environments can be seen to have crystallized around the found object—"the marvelous precipitate of desire" that frees the artist's creative impulses. At the most obvious level, this generates some structural similarities among them: many involve mosaic or assemblage. But there are deeper analogies among environments that employ the found object. As the writer Paul Shepard noted of idiosyncratic assemblage, "This activity seems . . . to express a widespread quest that may . . . have no cultural boundaries." Breton suggested that it resolved some shared unconscious need; Shepard appears to concur. "The puzzle it tries to answer remains unarticulated and even unconscious."[13]

Shepard found a clue to the puzzle by drawing analogies between irrational assemblage and Claude Lévi-Strauss's characterization of the *bricoleur,* the jack-of-all-trades who works wonders with limited means. The *bricoleur* is Lévi-Strauss's model for the person who engages in a kind of magical, as opposed to scientific, thought: "Mythical thought is therefore a kind of intellectual 'bricolage.'" Lévi-Strauss himself noted that "attention has often been drawn to the mytho-poetical nature of 'bricolage' on the plane of so-called 'raw' or 'naive' art, in architectural follies like the villa of Cheval the postman."[14] He found the analogy worth pursuing, in that it illuminated the workings of mythical reflection. Like the *bricoleur* who works with whatever is at hand, notably materials not initially suited to the task, the magical thinker creates new myths from the odds and ends of old ones, from the shards of individual and collective history, or from observed phenomena and taxonomies in nature.

However we might account for it—psychology and anthropology are just two possibilities—the fact is that from the United States to Europe, from South Africa to India, we can find the phenomenon of the artist who collects found objects as if on an impulse and later uses them for some brilliant, unforeseen end. These objects are taken out of context, their power enhanced by disconnection. But visionary artists don't merely confirm analogies between the *bricoleur* on the practical level and the mythical thinker on the theoretical one. In some senses, they are both. Like the *bricoleur,* they use whatever material is at hand, combining unrelated fragments to a fresh purpose. But like the magical thinker, they often do so to create new myths from the shards of old ones. It is this form of magical tinkering—conducted on both the physical and metaphysical levels—that provides a connection among the wildly differing environments that follow, all of which, to varying degrees, precipitated around the found object.

In 1929 Raymond Isidore, a foundry worker in Chartres, France, bought a piece of land on a hill south of the city, hard by the cemetery Saint-Chéron. He had several years earlier married a widow eleven years his senior with three children, and he set about constructing a house for them. It was after he had provided for their shelter that he had his encounter with a found object that forever—as one had for Cheval—changed his life. "The house built," he recounted, "I was walking in the fields when I saw by chance bits of glass, porcelain debris, broken dishes. I gathered them, without a precise intention, for their colors and their sparkle." These found objects would soon enlarge his universe. "Then the idea came to me to make with them a mosaic to decorate my house."[15]

The desire within Isidore that was precipitated by the found object was an unusually powerful impulse to distinguish himself. Born in 1900, he was the seventh of eight children in a working-class family. Shortly after acquiring the house site in 1929, he left his foundry job to work on the local tram system. In 1935 he joined the city road crew, and from 1949 he was the caretaker at Saint-Chéron.[16] He apparently felt that none of this gave the true measure of his talents. As he later said, "They placed me as a sweeper at the cemetery, like someone they reject among the dead, while I have the ability to do more as I have proved." Yet doing more would cut both ways for him, as it had for Cheval: it would bring him as much ridicule as praise. People mockingly took to calling him Picassiette, which can be roughly translated to mean "the plate picker" or "plate stealer."[17]

But none of this would deter Isidore. He began piling up material in the corner of his garden, supplementing his field discoveries with things acquired at auctions, in quarries, and at the public dump. He began his mosaic work around 1938 inside the house, in the little room that was the combination kitchen and

23. Raymond Isidore. Interior of the Maison Picassiette, begun c. 1938.
Photo: John Gary Brown.

dining room. Then he moved on to the bedroom (plate 23) and the sitting room. He started simply, with starlike mosaic flowers, but soon began more complex pastoral scenes and postcard-inspired views—some of them painted, some made in mosaic—of tourist destinations like Mont-Saint-Michel or a desert oasis. His occasional lapses into picturesque sentimentality are more than countered by his obvious obsessiveness. He eventually covered every surface inside the house either with mosaic or painting, including the furniture, the stove and stovepipe, even the clock and his wife's sewing machine.

Isidore next covered the outside of the house and the small entrance courtyard, then turned to the garden. He felt himself possessed. "I pursued my work as if I were guided by a spirit, something which commanded me. . . . I imagine the motif I want to make, I spread my cement directly without a preliminary drawing, I modify, correct with my eye, and thus measure the advance

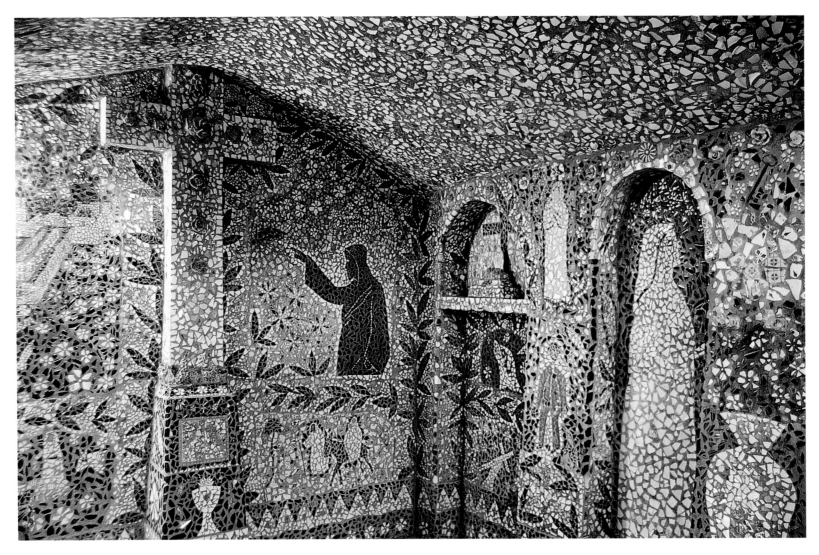

24. Interior of the chapel, Maison Picassiette, c. 1953–56.
Photo: John Gary Brown.

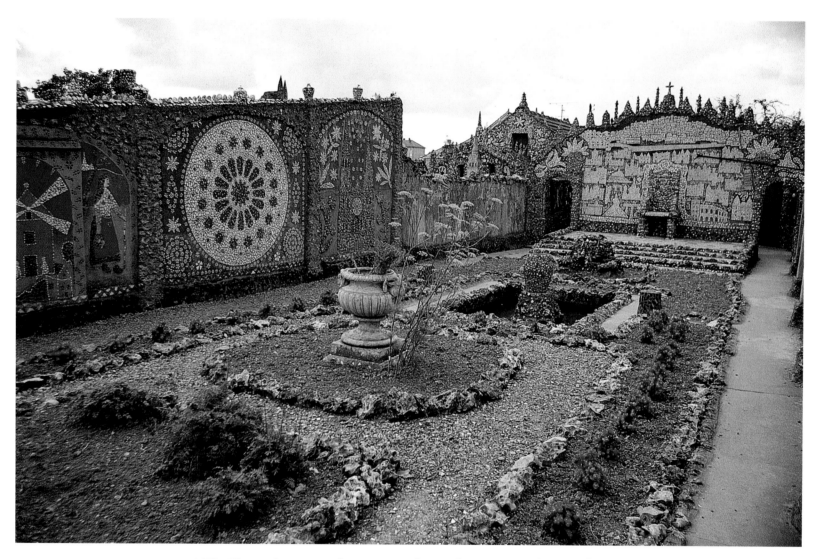

25. *The Throne of Heaven and a panorama of Jerusalem are seen in this view of the large garden at Maison Picassiette. Behind the wall is the Tomb of the Spirit.* Photo: John Gary Brown.

of my design." It is in these later creations, especially in the garden and the transitional structures between the house and garden, that the symbolic dimensions of Isidore's work became clearer. Between 1953 and 1956, for example, he constructed behind the house a chapel with a vaulted ceiling (plate 24). One end is decorated with a rose-encrusted cross, representations of Christ and the city of Jerusalem, and the usual plant and floral motifs, all set against a background of blue or rose-colored cement. The other end carries a pastoral scene and a representation of the town of Chartres. Isidore moved deliberately between such sacred and profane representations. "I make indifferently both religious subjects and atheistic things," he explained. Moreover, although his religious imagery was essentially Christian, he intended the chapel to be an expression of his particular creed. "This is the realization of my personal belief, not beliefs that are learned. I made my chapel for me. This is an act of faith, this is the spirit of belief."

The same duality evident in the chapel can be detected even more clearly in the garden, which was finished by 1962, two years before Isidore died. Its length is divided by a high wall; each side is symbolically organized around a tomb and a throne. One side represents the terrestrial world and the death of the body; the other, the celestial realm and the everlasting life of the spirit. On the terrestrial side, covered in a mosaic of dark green and black glass set in gray mortar, is a large sarcophagus topped with a three-dimensional replica of Chartres cathedral (plate 18). On the wall behind it are representations of other churches and a panorama of Chartres. The other side of the garden is dominated by an image of the New Jerusalem, the heavenly city of god, set in a blue field (plate 25). In a small structure behind this is another chapel, also predominantly in blue. Its roof is supported by a pillar, on which Isidore inscribed "GOD Jesus Mary Joseph / The Star of Bethlehem / Here Lies the Spirit." The so-called Black Tomb was not meant by Isidore as his resting place; it was a generic monument signifying the death of the body. The Tomb of the Spirit, by contrast, signified his belief in the eternal life of the soul. "According to me, one doesn't die. The body disintegrates, but the spirit lives forever."

Paired with each tomb is a throne on a raised platform. Isidore explained, "As there are two tombs, there are two thrones. The one facing the tomb, the black armchair, is that of the sweeper, the man of the cemetery, where I sat down to rest, my work finished, to see my town without leaving my house. The other is the throne of the spirit of heaven, of Jerusalem. I made it in blue; Chartres in black because it is on the earth." Isidore's distinction between the terrestrial and the celestial was not absolute, however; on the contrary, he hoped to cultivate a life of the spirit here on earth as well as in heaven. "I hope when they leave here people will want to live among the flowers and in beauty. I search for a way for men to escape their misery. My garden is the dream realized, the dream of life lived eternally in the spirit."

Isidore's insistence that he had fulfilled his dream recalls Cheval's self-confident assessment of his achievement: "Out of a dream I have brought forth the Queen of the World." Robert Garcet equally possesses a sense of his own accomplishment. In an abandoned quarry in the hills of southern Belgium, he has built a one-hundred-eight-foot (thirty-three-meter) flint tower as a testimony to true prophesy, to pacifism, and to brotherhood (plate 27). His ambition has been nothing less than to rewrite the history of the earth and of the human race and to revitalize the apocalyptic vision of Saint John. In a similar language of dreams and desire, Garcet expresses his belief in the power of each person to construct a monument to his own convictions: "Thus man draws himself a god with the brush of his prayers. He sculpts him with the chisel of his dreams, with the hammer of his

desires. The day there are no longer any poets, the gods will cease to exist."[18]

The rhetorical dimensions of Garcet's work are not immediately obvious, however. From a distance, La Tour Eben-Ezer looks like a large watchtower. It is foursquare and solid, with round towers at each corner (plate 28). Closer up, you discover its imposing height: it rises to seven stories from the depths of the quarry. You also realize it has a very odd surface, made of flint found on the site and in other neighboring quarries; the stone has the same bizarre shapes as the tufa that so arrested Cheval. Gazing up, you become convinced that there is more represented by this tower than first meets the eye. You see that it is crowned at the four corners with enormous winged creatures, which you realize—with a shiver—must be none other than the four beasts of Revelation. When you climb to the top, your assumption is confirmed: there are the lion, the ox, the eagle, and the creature with the body of an animal and the face of a human, all poised on the battlements in such a way that you can stand beneath them (plate 26). These beasts—made in place in concrete on metal armatures—are enormous and imposing, with wing spans that average about twelve feet (3.6 meters).

La Tour Eben-Ezer is the work of a quarryman who was born in 1912 in Ghlin, Belgium, into a working-class family with strong socialist leanings. He received little formal schooling but as a youth was an avid reader both of Jules Verne and of the Bible. He began working in the quarries in the 1930s and labored there for thirty years, first as a stonecutter and eventually as a foreman. After World War II, like so many of his neighbors, he had to rebuild the ruins of his life; he started with his house, which had been destroyed in 1940. Plans for La Tour Eben-Ezer seem to have taken shape in these same years: from the devastation, Garcet decided to raise a monument to brotherhood and

26. *Robert Garcet (b. 1912) with one of the winged beasts of Revelation at La Tour Eben-Ezer.* Photo: Clovis Prévost, 1985.

to the hope that, in the words of the prophet Isaiah, nation would no longer raise sword against nation. The tower was well under way by the early 1950s and completed in 1964. Garcet's tower is both literally and figuratively the expression of fraternity: without the help of friends, he acknowledges, he could never have completed it.

Like Isidore, Garcet was motivated by the desire for others to recognize his true gifts. "I built Eben-Ezer so that people would take me seriously." He is also equally clear about its philosophical

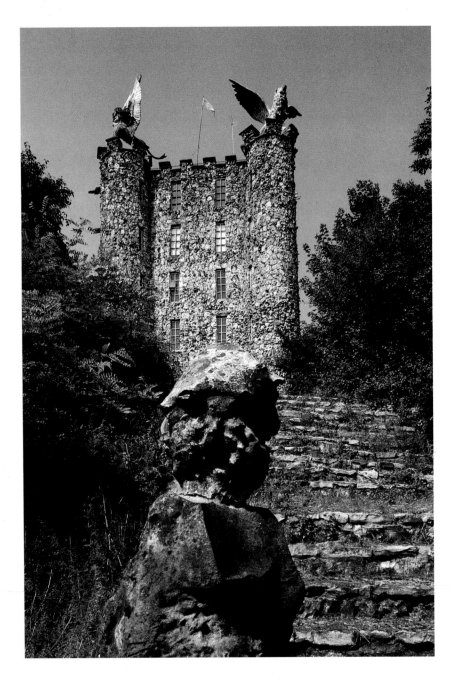

dimensions, which grew to encompass more than pacifism. Massive steps lead up from the garden to the primary entrance on the second level: inscribed to one side of the portal are the French nouns for *liberty, equality,* and *fraternity;* to the other the French verbs for *love, think,* and *create.* The nouns express what Garcet holds to be the natural rights and duties of man; the verbs address human potential. "The three verbs remind us that every being in the world capable of loving, thinking, and creating is a god without knowing it." In Garcet's mind, climbing the tower is a journey of self-discovery, an encounter with God and the god within. "Eben-Ezer is at once a place of revolution and a place of quest, a meeting place for mankind, a place for meeting with god. Like formerly in Mesopotamia and in the temples of Mexico, men climbed to the summits of towers to enter into contact with god, equal to equal."

Garcet subscribes to no orthodox religion: he calls himself a heretic and sees churches as an impediment to true revelation. But he acknowledges that he is a "Biblist" and that some of the roots of his philosophy can be found in biblical tradition. The title of his creation—La Tour Eben-Ezer—is a pun on the name of his village, Eben-Emael, but it refers more significantly to the biblical Ebenezer, site of a battle between Israel and the Philistines. As told in the First Book of Samuel, chapter 7, Samuel gathered the Israelites at Mizpah, where they were attacked. Samuel appealed to the Lord for help against the Philistines; "the Lord thundered with a mighty voice . . . and threw them into confusion; and they were routed before Israel." Samuel then made a gesture of thanksgiving: "Samuel took a stone and set it up . . . and called its

27 and 28. Robert Garcet. La Tour Eben-Ezer, c. 1950–64,
Eben-Emael, Belgium. Owned by Robert Garcet and the Musée
du Silex A.S.B.L. Photos: Clovis Prévost, 1978, 1985.

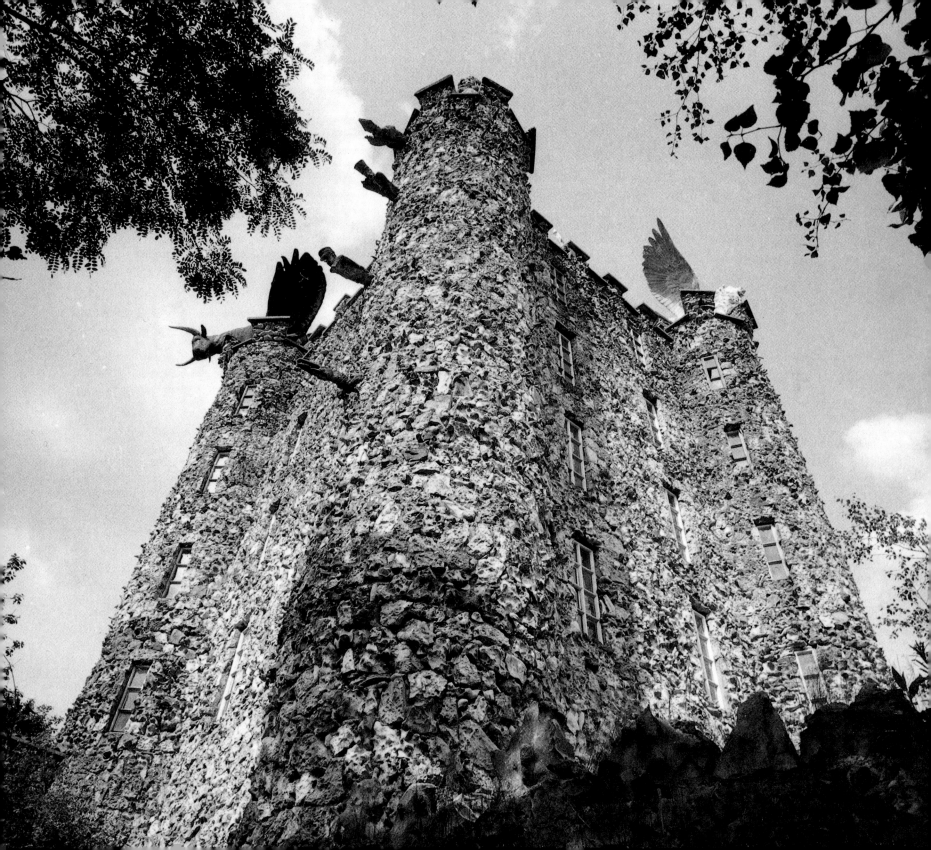

name Ebenezer, for he said, 'Hitherto the Lord has helped us.'" Ebenezer can be literally translated as "stone of help"; it thus signifies a miraculous deliverance. For Garcet, Samuel's Ebenezer was a symbol of a "victory without weapons." To one side of the base of his tower, within a curving hedge, Garcet has set up his own cluster of standing stones to underscore his pacifist message. He describes these stones, along with the tower itself, as another emblem of deliverance, of a "victory without weapons."[19]

Although he has taken the name of his creation from Samuel, the tower displays a still closer connection to the Book of Revelation. Specifically, the structure of the tower was generated by the numerology of the Apocalypse, in which the numbers four, seven, and twelve are especially significant. Garcet attaches an almost mystical importance to them. "Like the Apocalypse, Eben-Ezer is constructed according to the sacred number 7," a reference to the many sevens in Revelation: the seven churches of Asia, the seven seals, the seven plagues, the seven angels and their seven trumpets. Garcet's tower is 7.77 meters (25.6 feet) square on the inside. It is seven stories high, which signifies for Garcet the passage from earth to heaven: "The first floor is in the earth, the seventh is in heaven." The seven levels also allude to the seven millennia, or ages of history. Moreover, the tower is square, like the New Jerusalem described in Revelation; on its four corners, facing in four different directions, are the four beasts, "situated as the four winds of the heavens." The same four beasts form the faces of a central column inside the second level of the tower, which helps to support the entire edifice. On the outside, the tower is twelve meters (39.6 feet) square, which is meant to represent, on a reduced scale, the dimensions of the heavenly city, described as a square of 12,000 stadia.

Overall, we can read Garcet's tower as another image of the heavenly Jerusalem, described in the Bible as having walls of jasper and foundations adorned with every jewel. Although Eben-Ezer is built of a material that others would consider debris—the refuse of mining a not especially valuable stone—to Garcet it is precious. In his mind, flint makes up the bones of the earth and tells an alternative version of human history. He has seen in this stone the record of a civilization that existed seventy million years ago. He claims that he discovered the remains of their buildings in the floor of the quarry in which he labored for many years; although his archaeological evidence has since been destroyed by mining, he keeps in the tower a model of the city as he saw it. In fragments of stone—which he insists are handmade and proof that man has existed far longer than modern science will acknowledge—he has found evidence of the creativity of these most ancient people. Over the years, he has amassed an extensive collection of this flint art, as he calls it, which he displays in the tower. Such natural oddities—stones shaped like human faces, monkeys, or fish—were once common in cabinets of curiosities, but to Garcet they are not accidents.[20]

Garcet has told his version of history in numerous books as well as in the text of the tower. He knows that almost everyone is skeptical of his discoveries. This is just proof to him of the bankruptcy of science. In language that recalls Dubuffet, he denounces all forms of received culture. "Seventy million years before the science of shopkeepers, there were humans. . . . This lasted millions of years without violence. And then demons massacred the earth. Today, these demons have become the shopkeepers. . . . A contract exists between religions and shopkeepers so that truths don't leave the earth. Universities and churches have programmed us—that's all."[21]

Philosophical about his alienation from the ordinary world, Garcet is resolute in his convictions. "To know oneself to be alone and almost cursed is a terrible thing for the thinker. But to

be alone, inevitably, is to be strong: is to hear the song of the wind, the cry of the stones, the mysterious legend of the centuries." Like many other visionaries, he feels himself at once gifted and isolated by virtue of his special sight, uniquely capable of recognizing the marvelous in what others regard as dross. Like Cheval, he is aware that many perceive him as mad, but he is not deterred. Indeed, he provides particularly vivid confirmation of Breton's notions of the *trouvaille*. Garcet's discovery surely helped liberate him from convention—from what Breton called "paralyzing affective scruples"—and another world, the cry of the stones, was revealed to him.

Helen Martins, a similarly isolated individual half a world away, also had a desire that was liberated by a found object. The descendant of European settlers in South Africa, Martins was heir to many of the same cultural traditions as Cheval, Isidore, and Garcet. Like them, she used cast-off materials to challenge some of the conventions of her neighbors and to create her own image of a better world. According to her sister, Martins was lying sick in bed one night when she was in her mid-fifties; she was in her house in the remote village of Nieu Bethesda, in the arid Karroo region of Cape Province. Watching the moon shining through the window, she suddenly thought how dreary her life was and how desperately she wanted to change that. Soon after, she hit on the idea—like Isidore before her and like many others after—of using bits of colored glass to transform her surroundings into a brilliant mosaic.[22]

Martins began inside the house, adhering fragments of glass to geometric designs on the walls and ceilings; she eventually

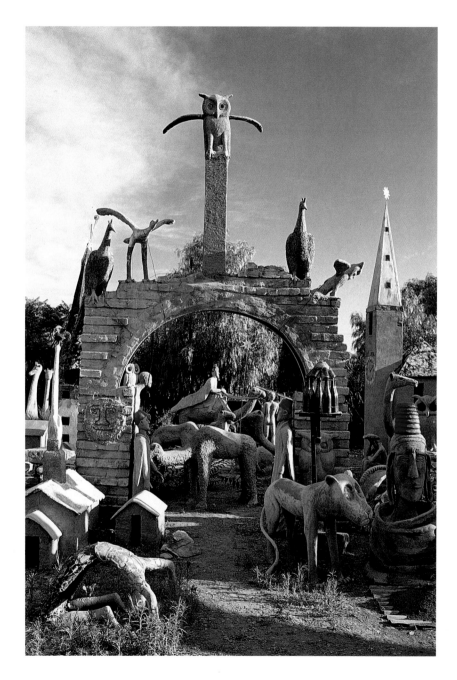

29. Helen Martins (1898–1976). Paradise Gate at the Camel Yard and Owl House, c. 1955–76, Nieu Bethesda, South Africa. Now owned by the Municipality of Nieu Bethesda. Photo: Roy Zetisky.

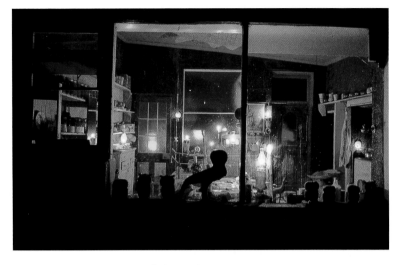

30. Interior of the Owl House. Photo: Roy Zetisky.

install large panels of colored glass inside the house. Now they helped make spires, towers, arches, and statues for the garden (plate 29). Many of the sculptures were made with the assistance of Koos Malgas, who worked with "Miss Helen," as she was known in the village, for about the last dozen years of her life. Ultimately, the garden became home to over three hundred sculptures, made of cement that was sometimes decorated with glass, all packed into a lot that measured only about 105 by 105 feet (32 by 32 meters). For the most part, the sculptures represent people and animals, the latter including owls, camels, and lambs in great abundance, along with peacocks with vividly colored glass tails. Among them are numerous representations of the moon, the sun, and the stars. There are some whimsical elements in the garden, including mermaids, several variations on the Mona Lisa, and a number of sun worshipers—small nude females with arms upraised. There are also figures that Martins called the Dutch ladies, who reach out in welcome (plate 32). Their skirts are made from tiers of bottles and their bodices from shards of colored glass; the same material forms jewelry on their wrists and fingers.

Other figures reveal an ecumenical spiritualism that was probably formed in conscious opposition to the narrow Calvinism of her neighbors. There are some Christian images, including shepherds, wise men, and Eve and the Serpent, but there are also representations of the Buddha. In addition, Martins was especially interested in Mecca and in the idea of pilgrimage. She had never been to Mecca and had no idea what it looked like, but she wanted to represent it in her garden nonetheless (plate 31). As recounted by a woman who was one of Martins's few friends late in her life: "She had an extraordinary correspondence with the Young Men's Muslim Association, asking them please to send

covered door frames and window frames and much of her furniture as well (plate 30). She augmented the glittering effect by specially placed mirrors in the shapes of stars, moons, hearts, and a cross, which reflected the sun and moonlight as they penetrated the house. By night, she arranged magical illuminations with multicolored paraffin lamps and candles in tinsel stands.

This is one of the few environments about which I write in detail that I have not seen, but those who have visited the dwelling, known as the Owl House, describe a sense of dislocation akin to Breton's conception of convulsive beauty. A South African art historian, for example, said of the house: "One of the many emotions registered is shock, then disorientation and claustrophobia. It is so unexpected and unfamiliar, and so filled with sensations, objects, and almost tangible pain. The color everywhere is overwhelming, as is all the reflected light."[23]

Martins then began transforming her yard, with a series of three African assistants. Two of them had earlier helped her to

31. Interior of one of Helen Martins's symbolic Meccas. Photo: Roy Zetisky.

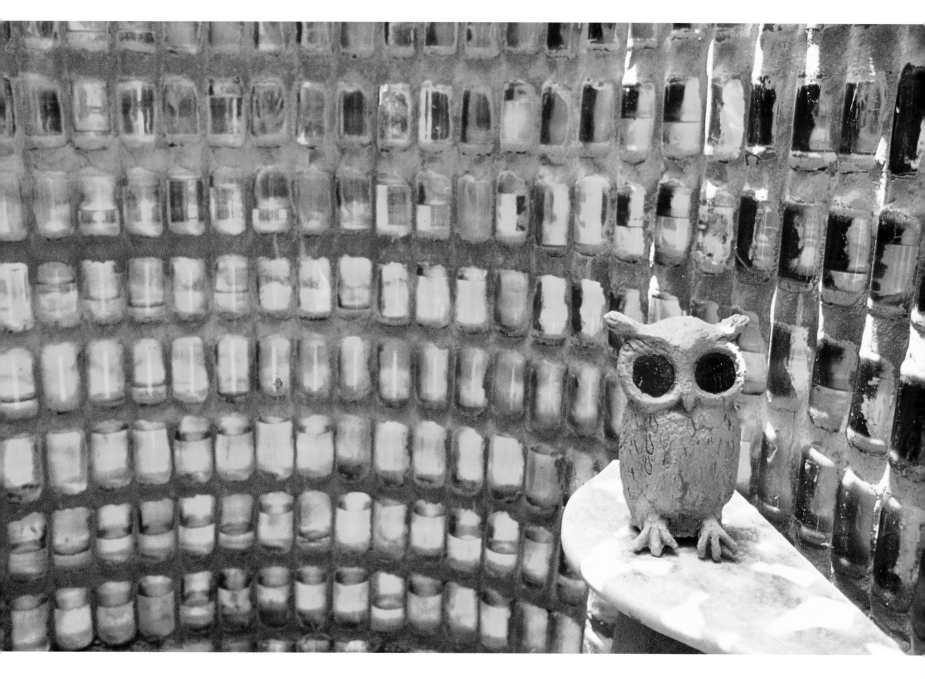

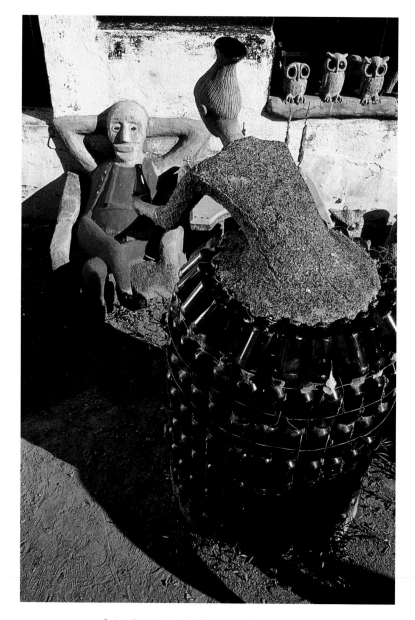

32. One of the "Dutch ladies" serving beer in the Camel Yard.
Photo: Roy Zetisky.

her a picture of Mecca, because she wanted to build it in her garden! Finally she built symbolic Meccas from beer and wine bottles." Altogether she built six such Meccas; for the most part they suggest mosques. But, the friend continued, "One is more of a Bethlehem with a manger, and all are topped with inverted colored brandy goblets to catch the light."[24] It was apparently the idea of pilgrimage to Mecca that inspired the primary motif in the garden: a frozen progression of humans and animals—wise men, shepherds, camels, and figures with arms outstretched—all symbolically questing toward the east, toward some promised land (plate 33).

Martins titled her environment herself in words fashioned from bent wire: A Camel Yard. Elsewhere, she inscribed "This is my world." Her determination to define her own world may well have resulted from the fact that she was perceived as something of a misfit by her more orthodox compatriots. As recalled by Athol Fugard, the South African writer who was a neighbor of Martins's late in her life and who made her the subject of his play called *The Road to Mecca*, the reactions of villagers "varied from veiled animosity to scornful tolerance of a harmless eccentric.... Without exception, the community was embarrassed by her."[25]

Their doubts about her may have predated the Camel Yard and Owl House. Born in 1898, Martins had a brief career as schoolteacher, followed by an unhappy marriage and a divorce. This may have been enough to make her an outcast in a deeply conservative society. After her divorce she returned to her childhood home to care for her elderly parents; according to Fugard, she was virtually confined to a darkened house with her dying mother for about ten years. It was after her mother's death, he reports, that Martins's inspiration came. "Metaphorically opening

33. Questing pilgrims in the Camel Yard. Photo: Roy Zetisky.

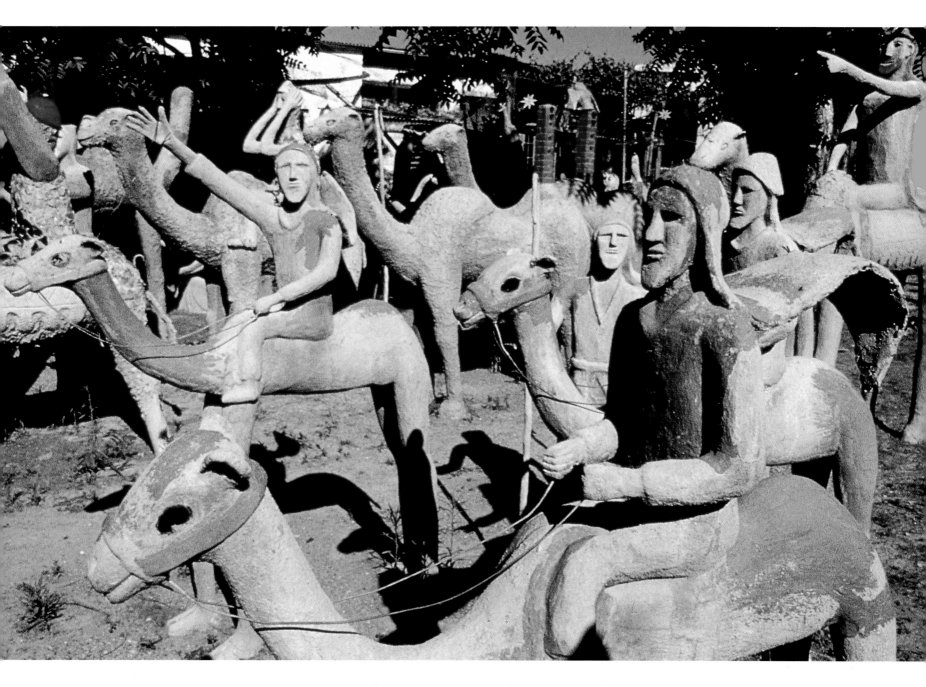

the shutters of the house one day and just watching the light come in: that was the real spark."

Whatever standing Martins may still have had with her neighbors was further eroded by the fact that around the time of her mother's death, she quit attending her Dutch Reformed church. Fugard points out that the Camel Yard only deepened her alienation; not only was it ecumenical in spirit, but it also violated Calvinist opposition to graven images. In her later years Martins grew ever more reclusive and unkempt, but Fugard insists that she was never mad. Instead, in his mind, she was on a creative and spiritual journey that left her completely isolated. As is true in many instances of creativity, he says, "something in the nature of a personal visionary experience is at the core of it." But that creativity carries a cost, which in her case was "social ostracism." Worried about failing health and diminishing creativity, she committed suicide by drinking lye in 1976. Left behind as a kind of epitaph, written in wire on the fence around her yard, are the following lines from "The Rubáiyát of Omar Khayyám," one of her favorite writings:

Ah moon of my delight who knows't no wane
The moon of heaven is rising oft again
How oft hereafter rising shall she look
Through this same garden after me (in vain).

After her death, Martins found her Breton in Fugard, who brought her work to the attention of a larger, more cosmopolitan audience. Just as the Palais Idéal was a kind of found object for Breton, unleashing his creativity, so was Martins's work an inspiration for Fugard, precipitating a play about the nature and consequences of creativity. But while Breton focused on the unconscious aspects of Cheval's imaginative life, Fugard was more attuned to the social dimensions of his subject. *The Road to Mecca* effectively captures the paradox that the artist's intentions, the local critical reception, and the interpretations of more worldly observers can all be very different.

Martins risked ostracism for her work; Nek Chand Saini of Chandigarh, India, has risked both social and legal opprobrium. A former roads inspector and warehouse and dump supervisor, Chand has created over the past several decades literally acres of sculpture inside massive walls made of scavenged rocks and porcelain-encrusted cement over coal-tar drums (plate 36). His figures include deities, humans (plate 1), and all manner of animals, ranging in size from miniature to life-size. For the most part, they too are made of concrete covered with found objects: broken crockery, wire, marbles, bottle tops, glass, even human hair (plate 34). Much of this material came from the dump that Chand supervised; some of it was salvaged from the dozens of traditional villages razed in the 1950s and 1960s to build Chandigarh, the new provincial capital of the Punjab and an emblem of modern India, commissioned by the government of Nehru and designed by Le Corbusier. Chand's work thus sets up an intriguing if unintended oppositional dialogue with modernism, which we will see again in a number of environments in the United States.

Chand was born in 1924 in Berian Kalan, a small village in the Gurdaspur district of the Punjab, and apparently spent much time as a child in a streambed near his home, building castles from stone and sculpting figures from clay. The partition of 1947 placed his village in Pakistan, and Chand (a Hindu) migrated to New Delhi, where he became a menial laborer in the department of public works. In 1951 he returned to his native region and joined the vast effort to construct the new capital. Like Cheval, he was haunted by a dream of building, and starting in about

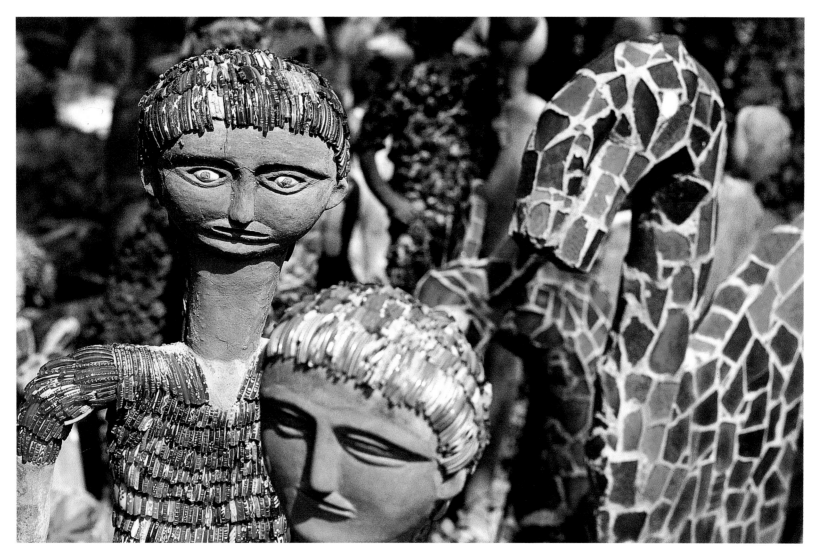

34. Innumerable humans and animals inhabit a peaceable kingdom at the Rock Garden, built beginning in 1965 by Nek Chand Saini (b. 1924) in Chandigarh, India.

Photo: Suresh Kumar, Indiano Photographers.

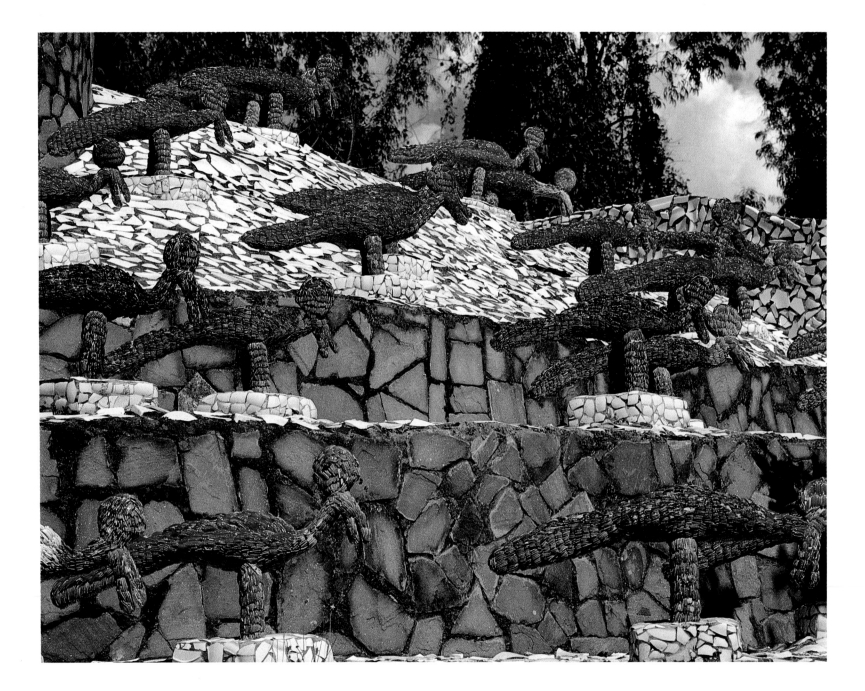

1958, he began making arduous journeys into the foothills of the mountains some twelve to eighteen miles (twenty to thirty kilometers) away to collect the rocks that would become his basic building material. At the same time he began sifting through the dump. It took him seven years to amass sufficient material to begin construction of the first phase of the garden in 1965.

Like Cheval's Palais Idéal, Chand's garden is a hymn to nature and an ecumenical tribute to the world's religions. "I wanted to build a holy place where the universal meaning of all gods, Jehovah and Christ, Buddha and Lord Krishna, is respected," he explains.[26] Its message may be international, but its roots are more localized. Chand's garden seems to have had its source in stories told to him by his mother. According to S. S. Bhatti of the Chandigarh College of Architecture, who has studied the garden in detail: "The conception of the Rock Garden is seeded in a mythological tale, and is guided by the theme of the 'immortal king' who is in full and eternal command of the affairs of his kingdom, free from fear, jealousy and war. All the denizens of this kingdom, whether they are human beings, birds or animals, have been endowed with immortality as a fruit of good deeds they had done in their mortal life."[27]

This myth provides the basic organization for the first segment of the garden, which covers approximately six acres. It is divided into courtyards or chambers, each containing troops of related figures or animals; these spaces are connected by streets and forecourts. Figures that populate these spaces include royal soldiers, royal musicians and dancers, ministers holding court, and schoolchildren at drill. There is a simulated rural habitat,

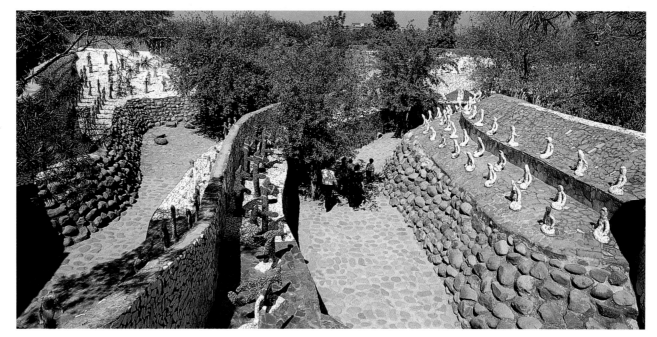

OPPOSITE:

35. Dragons are among the many beasts in Chand's Rock Garden. Photo: Suresh Kumar, Indiano Photographers.

RIGHT:

36. Dancing bears and their audience in Chand's Rock Garden. Photo: Suresh Kumar, Indiano Photographers.

including buffaloes wallowing in a pond, cowherds, and folk dancers. An animal kingdom includes monkeys, horses, elephants, and camels; nearby are dragons and dancing bears (plates 35 and 36). Interspersed with the figures are displays of found rocks that Chand considers exceptional. "Nature has created the form, not me," he explains. "I like stones very much. In every stone there is a human being or just a god, goddess and so on."[28] The inner-most parts of the garden are the most important—the king's chambers, including a court of private audience with a throne and nearby the king's retiring room and the queen's bath. Walls between various of these chambers are pierced with low-arched doorways, intended to create the appropriate reverential posture for those stepping through them.

Quite a few visionary artists exhibit a tendency toward re-clusiveness. But Chand had more than the usual reasons to work in secret. He had selected a site for his garden in the dense forest around Chandigarh, in a buffer zone that was supposed to remain undeveloped to protect the visual integrity of the city. What he was doing was not merely unauthorized but expressly forbidden; he was essentially a squatter. If discovered, his work would be destroyed. In time, he was found out. As Chand recounts: "The Chandigarh administration was clearing the jungle area from weeds, shrubs and wild creepers and they stumbled upon the incomplete fantasy garden of my dreams. I was apprehensive and fearful of the known arrogant onslaught of the bureaucrats. . . . To my good luck, the garden was also discovered by the right people. . . . They were the ordinary citizens of Chandigarh."[29] By popular appeal, Chand's garden was saved. It was officially inaugurated in January 1976, and the government created a new job description for Chand: "Sub-Divisional Engineer, Rock Garden," with a salary of 150 dollars a month and numerous unskilled assistants.

In the years since, Chand's garden has expanded in several phases. Behind the court of private audience rises a grand palace complex; and next to that, a village for the king's subjects. A large part of the extension was conceived as a tribute to nature, with a network of pathways leading through ravines and over bridges, past rock towers, streams, and cascades, with both human fig-ures and sculptures of trees worked into the naturalistic setting. The enlarged garden also includes temple facades, caves, a seven-hundred-seat amphitheater, and a café. It has been planted with numerous trees and flowering plants, many scavenged from dumps and nursed back to life. Though his work is not yet fin-ished, Chand has already created one of the largest and undoubt-edly the most visited visionary site in the world: over ten million people have seen it since it opened in 1976. His reputation has grown well beyond India: Chand was honored with an exhibition at the Musée d'Art Moderne de la Ville de Paris in 1980, and in 1985 he was commissioned to create an environment of figures at the Children's Museum in Washington, D.C.

In addition to its source in a folktale, Chand's garden dis-plays a number of specifically Indian characteristics. S. S. Bhatti notes that its spatial configuration, with transitions from narrow lanes to wide squares, is much like a traditional village of the Punjab, as is the careful integration of its architectural forms with the landscape. Bhatti observes in addition that Chand exempli-fies particularly well the resourcefulness of the squatters who have made homes and workshops for themselves on the margins of Chandigarh; in this sense, Chand is the most successful of many local *bricoleurs*.[30] The artist himself notes that the gar-den's ecumenical spirit is shaped by traditional Hindu values. "The garden preaches the lessons of religious tolerance and peaceful co-existence, the very basic fabric of the Hindu reli-gion." At the same time, it confirms Chand's vision of India. "To

stay as the largest democratic secular nation," Chand insists, "we must profess and follow tolerance toward others."[31]

Chand's garden and other visionary environments around the world introduce a number of the materials, techniques, and typologies that are relevant to a discussion of American environments. Cheval, Garcet, and Chand typify the artist motivated especially by the found natural object; Isidore, Martins, and Chand exemplify those who use cast-off materials augmented by inexpensive cement. Cheval, Garcet, and Isidore have used the *trouvaille* to construct variations on the garden temple, while Martins and Chand have created idiosyncratic versions of the sculpture garden. Variations on these two types of material and structure can also be found in America; examples of the sculpture garden assembled from salvaged materials and cement will be examined in the next chapter, while architectural forms constructed of natural substances, including the grotto and the garden temple, will be discussed in chapters 3 and 4.

More important, the themes introduced in this chapter will reverberate in the following pages. We will continue to witness the physical ingenuity and the metaphysical tinkering of the *bricoleur,* who transforms mundane objects while reworking the myths of nature and of popular piety. In aesthetic terms, what we will see can still be understood in the light of convulsive beauty. The shiver, the sense of arrested motion, and the feeling of the imagination freed by the chance encounter with the found object will all play a part in our psychological and perceptual responses. As in other lands, we will come face-to-face with something truly marvelous all across America: the phenomenon of marginalized people using cast-off materials to transcend the limitations of their particular circumstances, to celebrate the wonders of creation, and to dream of a still better world for all.

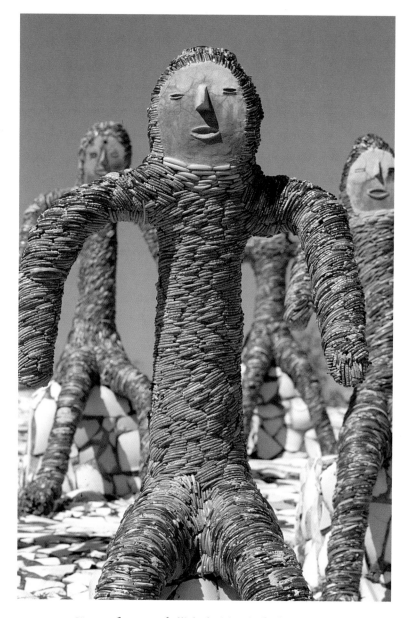

37. Human figures embellished with colorful broken bangles.
Photo: Suresh Kumar, Indiano Photographers.

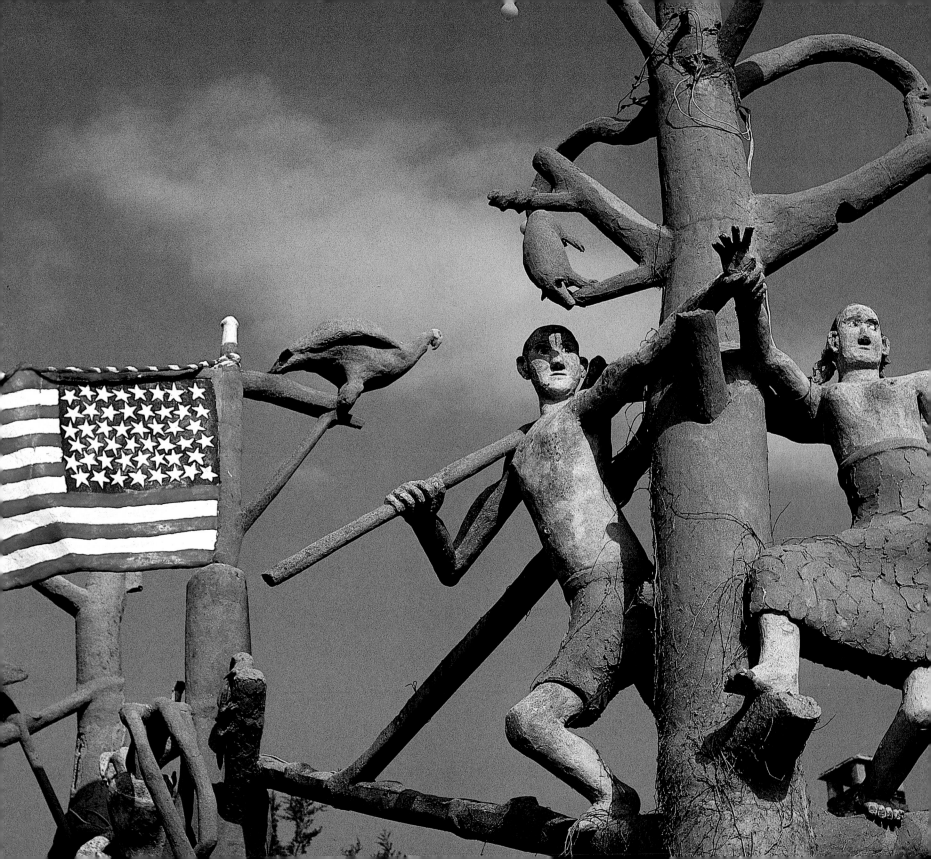

❧ 2 ❧

For God and Country

*This place created out of the dust out of love of
man, God, country.*

A sign at Thunder Mountain Monument

T HE LANDSCAPE AROUND Lucas, Kansas, is without obvious dramatic appeal, but it is a geographer's dream. The town lies just south of the geographic center of the lower forty-eight states, in what is known as the Smoky Hills region. There, rolling grasslands punctuated by occasional streams lie over deposits of greenhorn limestone. Timber is so scarce that when the area was settled in the latter half of the nineteenth century, pioneers fashioned their dwellings from sod or burrowed into earthen embankments. To secure fencing, farmers resorted to cutting fence posts from stone. This practice gave the region the nickname "post rock country."

In the fall of 1888 a Civil War veteran and farmer named Samuel Perry Dinsmoor arrived in the area. Dinsmoor was born in Coolville, Ohio, in 1843; he enlisted in the Union army at the age of nineteen and served for three years. After the war he settled in Illinois, where he taught school for a couple of years before becoming a farmer. While living in Illinois, he married Frances

Barlow Journey, a widow with two children; together they had five more offspring before moving on to Kansas. Dinsmoor had grown up on the western edge of Appalachia—Coolville is near the West Virginia border. His recollection of the domestic architecture of his youth might very well have been of the square-hewn log cabins so typical of that region, a form that spread west with the pioneers and that reached even into the forested areas of eastern Kansas. In any event, when Dinsmoor retired from farming and moved into Lucas in 1905, he fixed his mind on constructing a cabin home. But he was now in post rock country, with hardly a tree in sight. So he built his cabin out of the local limestone, cut to look like logs.

The Cabin Home was finished in 1907. Over a stone foundation Dinsmoor raised a three-story, eleven-room structure. The two lowest levels are made of stone logs notched to dovetail at the corners; the gables of the upper story are fashioned from cement made to look like wood. The lowest level, which is below

*38. Samuel Perry Dinsmoor (1843–1932). Cain and his wife fleeing the wrath of God,
c. 1908–12, Garden of Eden, Lucas, Kansas, 1910s–20s. Now owned by Garden of Eden, Inc.*

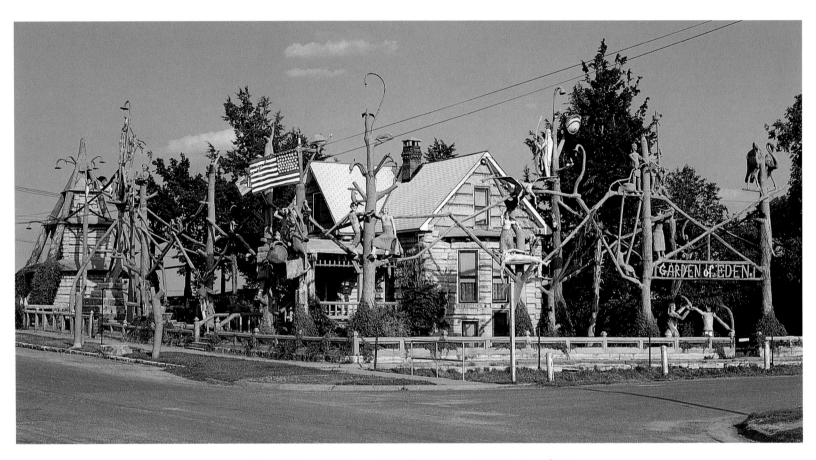

39. General view of Dinsmoor's Cabin Home and the Garden of Eden.

grade in the front, contains the kitchen; the bedrooms and bath are on the top floor. Dinsmoor intended the main floor between to be mostly for show. The walls are plastered and whitewashed; the windows and doors are trimmed with elaborately carved redwood, pine, and oak. No two doors or windows are the same size; no two are finished with the same pattern of trim. To this day, the house contains some furnishings made by Dinsmoor himself, of wood inlaid with checkerboard patterns.

Within a few years of completing the Cabin Home, Dinsmoor was hard at work on the enterprise for which he soon became more renowned: the Garden of Eden (plate 39). This is a half-acre landscape containing about 150 figures and thirty trees, all made by hand with concrete; it is one of America's oldest surviving and best-preserved visionary environments. The figures illustrate Old Testament stories on the west side of the house and Dinsmoor's views of politics and human nature on the north.

Both trees and figures were modeled in place with wet cement, even though some of the trees approach a height of forty feet and some of the figures are perched well above ground. Dinsmoor apparently used a scaffold and worked alone, except for an occasional helper who mixed cement. Sculptures were reinforced with steel and chicken wire, and carefully finished so that moisture could not penetrate the surface and cause them to deteriorate.

The garden must have been well along by 1913, when it was described by the *Kansas City Star* as "a mecca for tourists"; by 1918 the major sculptural groups on the west and north were finished, along with a stone-log mausoleum intended by Dinsmoor as his own tomb.[1] In all, Dinsmoor's creation might just qualify for the accolade he bestowed upon it in a booklet he provided for his visitors: "The most unique home, for living or dead, on earth. Call and see it."[2]

The accounts of Dinsmoor's life lack the customary narratives about the found object or the cathartic vision. Dinsmoor might thus seem to contradict the idea that visionary environments fulfill a desire that crystallized around a found object. Yet Dinsmoor emphatically belonged to the tradition of the *bricoleur* on both the physical and the intellectual levels. He was, as he knew, a supremely capable jack-of-all-trades who could make do with whatever was at hand, from limestone logs to inexpensive cement. At the same time, he was a thinker who created new creeds from shards of the old, formulating personal variations on widespread myths—notably, that of the promised land.

As its name suggests, Dinsmoor's Garden of Eden revolves around narratives of the original paradise, coupled with double-edged reflections on its latter-day American variant. In revealing Dinsmoor's particular religious creed and his views of popular history, it announces two of the major themes—God and country—that resonate in many other American environments as

well. That this blend of religion and politics should predominate in the United States is perhaps not surprising. Historically, these two cultural forms have been closely wedded in this country, creating what the historian Robert Bellah has termed a civil religion.[3] There are strong religious and moral dimensions to the American political model; concepts such as liberty, justice, equality, and the basic virtue and dignity of the individual are nearly sacred, and the country's defining texts—the Declaration of Independence and the Constitution—are regarded almost as holy writ. Both American politics and American religion can be found in ecstatic forms: there is, for example, an analogy between the founding Revolution on the one hand and spiritual rebirth as expressed in evangelical movements, on the other. Moreover, the country's political structure and its religious life rest on a set of shared assumptions, two of which—freedom of expression and freedom of worship—are absolutely crucial to the existence of visionary environments and are often embodied in them as well.

The constitutional protections of freedom of expression and religion are somewhat at odds with the notion that America is "one nation under God"; the resulting tension between individualism and conformism is an undercurrent in the lives and works of many a visionary artist. The civil religion expressed in visionary environments runs the spectrum from the innocently affirmative to the profoundly critical. At various times and to different people, the nation has been perceived both as a fragment of the original Eden and as the seat of the New Jerusalem —a kingdom of heaven on earth and the embodiment of a special covenant between a people and their creator. Almost from the first, however, the covenant was broken; the great promise of the nation etched its failings in sharp relief. This gave rise to a pronounced ambivalence among the more trenchant observers of our cultural life, a simultaneous affirmation and rejection of

American values. Quite a few visionary artists can be found in the ranks of those expressing this ambivalence. Many convey an awareness that promise and reality are out of joint, especially with respect to Native Americans, African Americans, and various other marginalized groups. But beneath this, most reveal a faith in the self-reliance and resourcefulness of the American people, and a belief in the basic virtues of the common person.

Some artists, like Dinsmoor, mix biblical and political morality in equal measure; others tilt more toward religion or toward popular notions of patriotism. Dinsmoor's work exemplifies one of the principal ways in which these themes are conveyed: through groups of narrative sculptures disposed rather informally around a garden. Moreover, Dinsmoor the man suggests something of the charismatic nature of the visionary artist in America, although he was more showman than prophet in the way he tried to win people over to his points of view. Though long dead, he continues to be a palpable presence in his garden.

The Garden of Eden was built around the three pillars of Dinsmoor's faith: the Bible, Freemasonry, and turn-of-the-century Populism, which he blended in his particular way. Dinsmoor's moral views seem to have been shaped by a close reading of the Old Testament, especially those parts explicating the fall of man and the covenant of the law as revealed to Moses. "If the Garden of Eden is not right," Dinsmoor wrote in his booklet, "Moses is to blame. He wrote it up and I built it." Genesis provided Dinsmoor with his basic conception of human nature: created in the image of God, morally fallible, but redeemed by the enlightened rule of law.

Freemasonry would have reinforced Dinsmoor's moral positions. According to Dinsmoor's obituary, he joined the Freemasons in 1866.[4] A secret fraternal order that evolved from medieval guilds of stonemasons, Freemasonry by the eighteenth century had adopted the rites and trappings of ancient religious orders and chivalric brotherhoods. It spread especially through the British Empire and typically drew its membership from Protestant groups. Although not expressly Christian, it emphasized morality, charity, and obedience to the law of the land. Moreover, it required of its members that they believe in a Supreme Being and in the immortality of the soul.

Populism, on the other hand, was a local phenomenon, contemporaneous with Dinsmoor's garden. Precipitated by widespread crop failures and falling prices for agricultural products, it

40. Samuel Perry Dinsmoor. Photographer and date unknown.

was an agrarian political movement that swept the Great Plains in the 1890s. Strongly antimonopolistic, it supported various kinds of economic, legislative, and tax reform. More generally, it expressed rural frustration with an economy that was increasingly urban, capitalist, and industrialized, and dominated by powerful eastern business interests.

Dinsmoor apparently pursued Populist goals by both traditional and unorthodox methods: he wrote letters to the editors of local papers and ran for political office, serving as a justice of the peace and a member of the school board. He also organized secret societies: in 1893 he became president of something called the United Order of Anti-Monopoly. From this pulpit, he railed —in language at once anticapitalist and anti-Semitic—against "shy-locks, money sharks, two-percenters, gold-bugs, land-sharks, monopolists and railroad magnates."[5] After 1896, when the Populists cast their lot with the unsuccessful Democratic presidential nominee William Jennings Bryan, they lost their political clout. But many of their goals—along with their antipathy to the large trusts—were embraced by the Progressives in the early decades of the twentieth century. Allegiance to both movements, as well as to the tenets of Freemasonry, can be detected in the Garden of Eden.

The primary entrance to Dinsmoor's garden is from the north, under a ranch-style gate carrying the legend GARDEN OF EDEN in handmade concrete letters. Just inside the gate are larger-than-life figures of Adam and Eve. Adam bears a strong resemblance to Dinsmoor himself, a connection reinforced by the fact that his loincloth carries Masonic emblems. Dinsmoor may have been implying that he was a latter-day Adam in a new Eden, an idea that may be connected to the cages that are found through the arbor behind Adam and Eve in back of the house. Here Dinsmoor kept a menagerie with some animals from the American paradise:

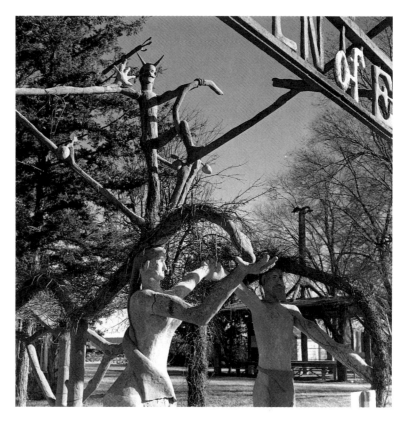

41. Adam and Eve flank the entrance to the Garden of Eden.

an eagle, coyotes, badgers, owls, and pigeons. Nearby he built stepped planters in which he grew flowers and strawberries.

Dinsmoor's ideas about the connection between America and Eden can only be inferred. But he was far more explicit about the troubles in both the biblical and the latter-day lands. Two snakes form the grape arbor behind Adam and Eve; one of them reaches up and drops the forbidden fruit in Eve's hand. This begins the narrative of the Fall and its terrible consequences, which is told along the western edge of the garden. To one side

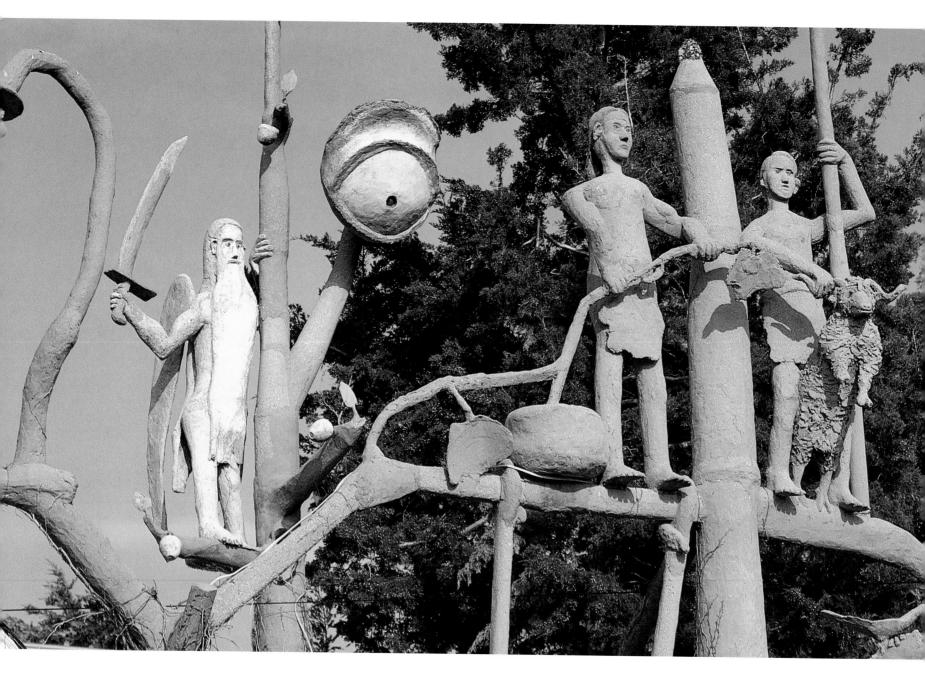

behind Adam and Eve lurks the devil (plate 41); opposite him is a guardian angel and the all-seeing eye of God (plate 42). Like many of Dinsmoor's sculptures, both the head of the devil and the eye of God are illuminated from within by electric light, so we know they are watching us, even at night.

Dinsmoor continued the narrative from Genesis with a series of figural groups placed above eye level in cement trees. First come Cain and Abel, offering their respective gifts: "a rotten pumpkin" and "a dandy little buck-merino." They are followed by an angel and Abel's wife, who loom over the bloody and disfigured body of the murdered shepherd. (The wives of Cain and Abel are among several additions that Dinsmoor made to the Genesis story.) The narrative culminates with the fleeing figures of Cain and his wife (plate 38), the latter carrying a carpetbag. These characters from Genesis are among Dinsmoor's most successful figures. They are finely detailed and display a variety of facial expressions, which are exaggerated to be visible from the ground. A range of textures is used to finish the cement: smooth for skin, scaled for clothing, and rough for feathers, fur, and hair.

Contemporary troubles are the subject of sculptures along the north side of the garden. The transition from past to present is signaled by a painted concrete American flag, made in about 1912, that turns on ball bearings. The flag waves over a complex group including a soldier, a woman, a baby, and a many-armed monster that resembles a scorpion or an octopus—Dinsmoor's emblem for corporate trusts (plate 10). The monster's limbs grab at everything in sight. Two of them clutch the soldier's knapsack and the baby; two more reach for parts of the globe that in Dinsmoor's day were very much in the news: the Panama Canal (then under construction) and the North Pole (explored by Robert Peary in 1909). "Another claw," Dinsmoor wrote, "is coming

around that limb after more chartered rights. . . . That flag protects capital today better than it does humanity. It drafted the boys but asked the money to volunteer. See the difference?"

Dinsmoor's sculptures here seem almost like political cartoons of the kind associated with Thomas Nast. The language is highly emblematic but very direct, drawing both on current events and popular iconography. Given their cartoonish character, they are properly read in one direction only—viewing from

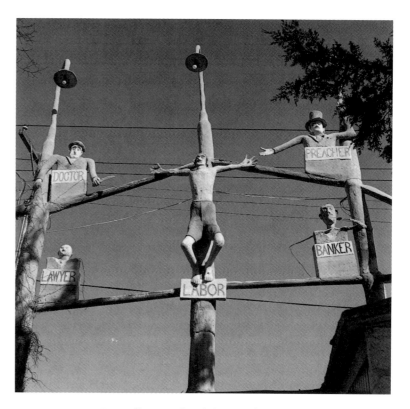

OPPOSITE: 42. *A guardian angel and the eye of God keep watch over Cain and Abel and other figures from Genesis at the Garden of Eden.*

ABOVE: 43. *The Crucifixion of Labor, Garden of Eden.*

the street, from right to left. The woman reaches for the soldier, presumably imploring him for help with her child. He takes aim with a gun at an Indian, who in turn is aiming with bow and arrow at a dog. The dog has treed a fox, the fox is pursuing a bird, the bird is reaching for a worm, and the worm is eating a leaf. "Now this," observed Dinsmoor crisply, "is modern civilization as I see it."

But all was not lost. Farther along the north side of the garden is the Goddess of Liberty Tree, which is Dinsmoor's view of American civilization as it should be. The flag-draped personification of liberty holds a light in one hand and a spear in the other. On the latter is impaled the corporate trusts. Below her, a man and a woman wield a saw marked "ballot"; they are cutting a limb inscribed "chartered rights." The group reiterates Dinsmoor's hope that the voters might eliminate monopolies. To either side, figures of a woman and an African American gesture at the scene. Dinsmoor seems to have been expressing his support for universal suffrage—women were granted the vote in 1920, about the time this group was made. And while blacks could legally vote at the time, they were effectively precluded from doing so by the poll tax, which was instituted in part to curb the power of the Populists in the 1890s.

At the back of the garden is a final, more pessimistic group, the Crucifixion of Labor (plate 43). Here, the martyred working man is surrounded by persecutors from the professional class, "the leaders of all who eat cake by the sweat of the other fellow's face." They include a banker, a doctor, a lawyer, and a preacher. The inclusion of the preacher among the evildoers might seem surprising, given Dinsmoor's attachment to the Old Testament. Yet anticlericalism and faith in individual revelation both had precedents in American Protestantism. Opposition to the church hierarchy could be an indication of a strong attachment to a personal God. Indeed, in his day, Dinsmoor was evidently perceived by some people as overly religious. As he recounts in his guidebook, when he was building the Garden of Eden, "They accused me of being bughouse on religion. I am bughouse good and proper, but not on religion, perpetual motion or any other fool thing that I cannot find out one thing about." As confirmed by his involvement with Freemasonry and his adherence to Old Testament doctrine, Dinsmoor was no atheist, but he clearly kept his distance from organized religion.

Next to the Crucifixion of Labor is Dinsmoor's other architectural masterpiece, the mausoleum, which early photographs suggest was built in the mid-1910s. Made of the same limestone logs as the house, it is fourteen feet (4.2 meters) square at the base and rises in three tiers; it was originally topped by another cement flag and reached a height of about forty feet (twelve meters). The mausoleum is framed on the outside in tepeelike fashion by cement-covered limestone beams. On the inside, only the lowest level contains a chamber; Dinsmoor and his first wife are both interred there. Dinsmoor apparently believed quite literally in the resurrection of the body. He arranged to have himself embalmed when he died and placed in a glass-topped coffin, from which he would "sail out like a locust" on resurrection morn. Over the mausoleum he sculpted an angel to carry him to heaven, should that be his destiny. At the foot of his tomb, however, he placed a two-gallon jug. "If I have to go below," he wrote, "I'll grab my jug and fill it with water on the road down. They say they need water down below." All in all, he concluded, "I think I am well prepared for the good old orthodox future."

As revealed in his writings, Dinsmoor was both humorist and showman. He catered both to the new automobile traffic and to those who passed through town by rail; he reportedly turned on the lights in the garden in time for the evening passenger train.

44 and 45. Two of the postcards that Dinsmoor sold at the Garden of Eden in the late 1920s.
LEFT: *Dinsmoor with his second wife and their two children on the porch of the Cabin Home.*
BELOW: *Double portrait of Dinsmoor looking at himself in his homemade cement coffin.*
Photographers unknown.

He gave tours to his many visitors, printed postcards for sale, and provided picnic facilities. He made his own cement coffin complete with Masonic emblems and, for a small charge, allowed visitors to take his picture lying in it (plate 45). While people admired the figures of Cain and Abel, he would sometimes make use of a speaking tube that ran from the house into the garden near them. "Cain, you son of a gun," his visitors would hear, as if from the heavens. "Where is your brother Abel?"

Dinsmoor also seems to have taken some pleasure in scandalizing his neighbors. Several years after his first wife died, Dinsmoor hired a young Czech-born housekeeper named Emilie Brozek. In 1924 they were married: he was eighty-one, she was twenty. They subsequently had two children (plate 44). Stories apparently circulated that he had consulted a nearby "doctor" of mixed repute, one John R. Brinkley, who had claimed to discover a way to restore a man's sexual vigor by implanting him with goat testicles. Some thought Dinsmoor was his patient. "True or not," the *Topeka Daily Capital* later reported, "it was valuable publicity for both of them and neither one minded."[6] Whether they were drawn to the Garden of Eden to see Dinsmoor or his creations, the visitors came in great numbers. Dinsmoor kept a careful running tally in his lifetime that eventually filled seven guest books. They show, for example, that by May 1921, he had welcomed 13,207 visitors to the Garden of Eden. By December 1924 the number had swelled to 23,762—not bad for rural Kansas in the 1920s.

Dinsmoor even planned to perform from beyond the grave. When he died in 1932, he was, as per his instructions, embalmed and placed in the mausoleum in the glass-covered coffin. "I have a will," he wrote, "that none except my widow [and] my descendants shall go in to see me for less than . . . $1.00. That will pay someone to look after the place, and I promise everyone that

comes in to see me (they can look through the plate glass . . . and see my face) that if I see them dropping a dollar in the hands of the flunky, and I see the dollar, I will give them a smile." Although admission has gone up to four dollars, you can still go into the mausoleum and see the old man under glass: his face is a little leathery and mildewed, but he is otherwise in pretty good shape for being sixty years on.

In other respects, too, the garden is in good condition. Although the house was turned into apartments after Dinsmoor's death and the garden was allowed to grow over with vines, the sculptures have proved quite durable. In 1967 the site was purchased by a couple who restored it and opened it as a tourist attraction; in 1976 it was added to the National Register of Historic Places. In the late 1980s the couple sold the site to Garden of Eden, Inc., a corporation established to preserve it. Many of the current shareholders are also members of the Kansas Grassroots Art Association.

Howard Finster is among those who have blended notions of God and country just as Dinsmoor did, but in a rather different idiom. Finster is a self-styled "man of visions" and pastor of the World's Folk Art Church, which he established; like Dinsmoor, he is part showman and part prophet. He describes himself as "a stranger from another world," "a second Noah" who came to earth "to point the people to the world beyond." It is his job, he says, to remind us of the biblical teaching that "without a vision, the people perish. I have that vision," he insists.[7] Finster has expressed his vision as a Baptist preacher, in the fire-and-brimstone language of the fundamentalist tradition to which he is heir. But he has also revealed it in paintings and sculptures and,

46. *A view through the gate at Paradise Garden, c. 1960–1970s, built near Summerville, Georgia, by Howard Finster (b. 1915).*

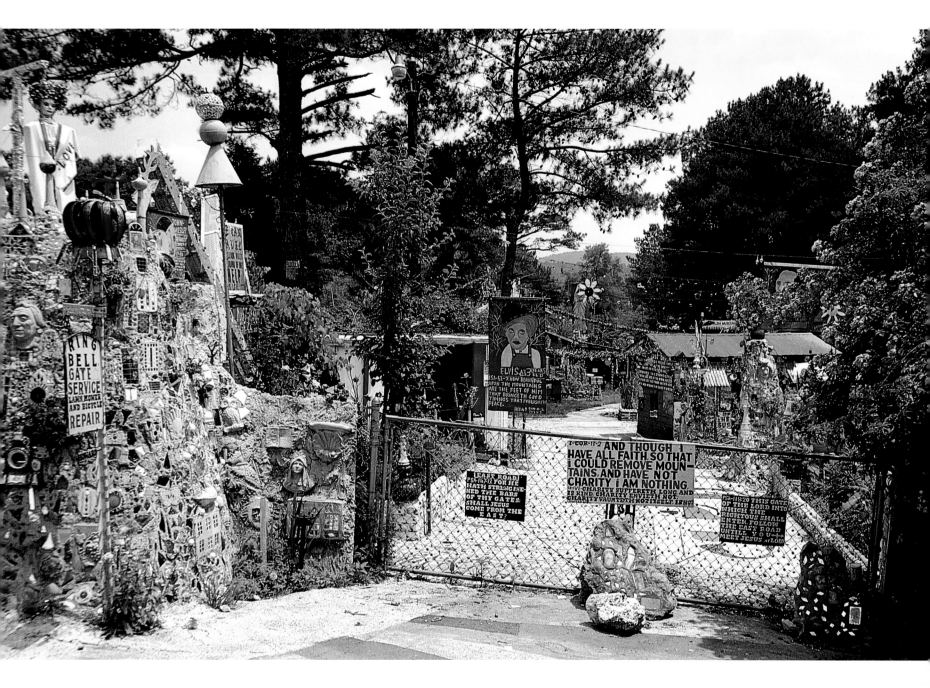

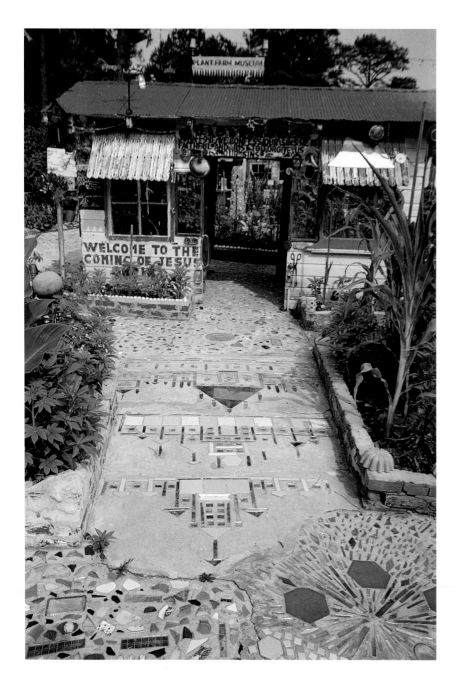

most remarkably, in his Paradise Garden, a rambling, even ramshackle creation in the pine woods of northern Georgia (plate 46). Like Dinsmoor's Garden of Eden, it resonates with ideas of a terrestrial as much as a heavenly paradise; it is more eclectic in its forms, however. It is a garden of sculpture, but it is also a cabinet of curiosities, a hymn to the wonders of creation and to the inventions of mankind.

Finster was born in 1915 in De Kalb County, Alabama, one of thirteen children in a poor farm family living at the southern end of the Appalachian Mountains. He attended school through the sixth grade; at the age of thirteen he was born again. A few years later Finster felt himself called by God and began a career as an itinerant minister. By about 1940 he had earned enough of a reputation on the tent-revival-and-river-baptism circuit to land the first of a series of jobs as pastor at country churches in northern Alabama and Georgia. In 1950 he settled down a bit, beginning a fifteen-year stint at Chelsea Baptist Church near Menlo, Georgia. He supplemented his pastoral income by working at odd jobs: as a mechanic, a carpenter, and a mill hand in textile factories. As if all that weren't enough, he also embarked on an ambitious building project. In the late 1940s in the northern Georgia community of Trion, Finster began work on what he called a "museum park" that included miniature houses, churches, and castles along with a full-scale building dedicated to displaying all the inventions of mankind. When he ran out of space in Trion, he moved to an old house in nearby Pennville. There, in the early 1960s, on some two acres of swamp, he began the present Paradise Garden.

"After I got started fillin' in that swamp," Finster later

47. The original entrance to Paradise Garden identified it as the Plant Farm Museum.

remembered, "it just come to me that the world started with a beautiful garden, so why not let it *end* with a beautiful garden?" He planted fruit trees, shrubs, and flowers, attracting wild animals, "to show all the wonderful things o' God's creation, kinda like the Garden of Eden"; an early sign identified his garden as the Plant Farm Museum (plate 47). Soon after he began work, he had a vision of a large man floating over the garden, commanding him to "get on the altar." He realized then that the garden was to be an extension of his preaching. This wasn't Finster's first vision, nor would it be his last. The most commonly repeated Finster story concerns a vision he had in 1976, when a dab of paint on his finger took the form of a face and spoke to him, telling him to "paint sacred art."[8] Thus began the career for which Finster is now most celebrated, as a painter and sculptor of religious images, usually accompanied by lengthy texts in a breathless evangelical tone.

Among Finster's first sculptural additions to his garden were cement mounds encrusted with broken glass, mirrors, and found objects of every kind. His whole garden feels like a cabinet of curiosities, with these cement shrines especially evoking that genre. Finster's shrines were built to display the inventions of mankind, but, like the allusions to Eden, they were also intended to glorify God. "The reason I wanted to represent the inventions o' mankind was 'cause mankind is made in the image o' God, and that's why we keep creatin' and keep inventin' things." The most prominent of Finster's cement creations is right out on the street by what was his lawnmower- and bicycle-repair shop (plate 48). About eight feet (2.4 meters) high, it is covered with bottles and shells, small religious statues, architectural fragments, cement

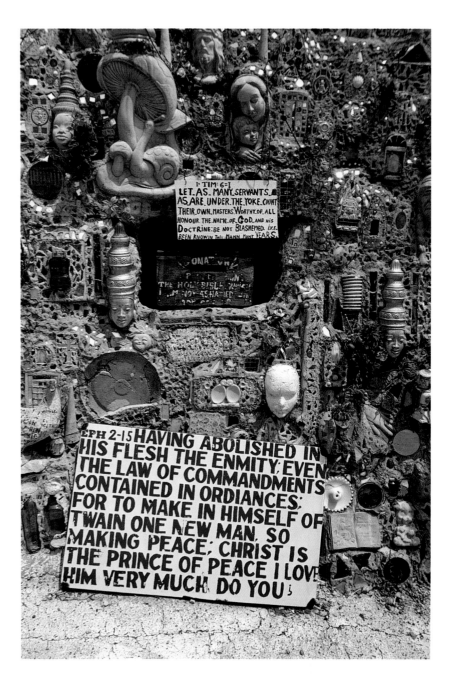

48. A detail of the concrete mound near the entrance to Finster's Paradise Garden.

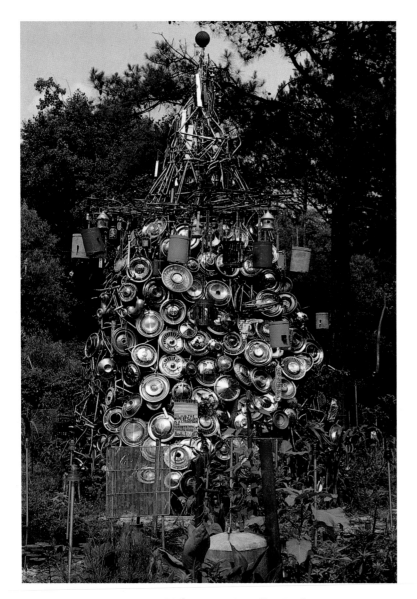

ABOVE: *49. Hubcap tree, Paradise Garden.*

OPPOSITE: *50. Howard Finster in Paradise Garden.*
Photo: Tom Patterson, 1981.

animals and toadstools, even the extracted tonsils of a neighbor's boy, preserved in a jar of formaldehyde (this to honor the invention of surgery). Eventually, the back of the mound was embellished with biblical quotations and a large cross.

The heyday of Finster's garden came in the years between 1965, when he retired from Chelsea Baptist, and the early 1980s, when the demand for his paintings began to usurp all his time. During those years Finster built cement paths into the garden and embedded them with glass, tile, and tools. He added more cement mounds, built houses of bottles and mirrors, constructed towers of bicycles and hubcaps (plate 49), and made painted concrete sculptures illustrating biblical stories. Finster put things anywhere he could: indoors and out, on the ground and up in the trees. He was trying to accumulate one of everything in the world, through his own collecting, through gifts from admirers, and by scavenging at local dumps. Echoing a familiar sentiment among visionary artists about their resourcefulness, he said: "I asked God, 'Why is it I'm a garbage collector? Everything I have is junk.' He said, 'You don't have anything. I want the world to understand that you can make something out of what other people throw away.'"[9]

Finster hung signs everywhere in his garden. Some were scriptural messages, others were like poems that illuminated his method: "I took the pieces you threw away and put them together by night and day, washed by rain, dried by sun, a million pieces all in one" (plate 50). Others told of his evangelical purpose: "I built this park of broken pieces to try to mend a broken world of people who are traveling their last road." Finally, he festooned the garden with hanging gourds and coffee cups, garlands and plastic bottles. And he hung paintings celebrating inventors, popular heroes, politicians, and musicians, from George Washington, John Kennedy, and Hubert Humphrey to Henry Ford (plate 133), Hank Williams, and Elvis Presley.

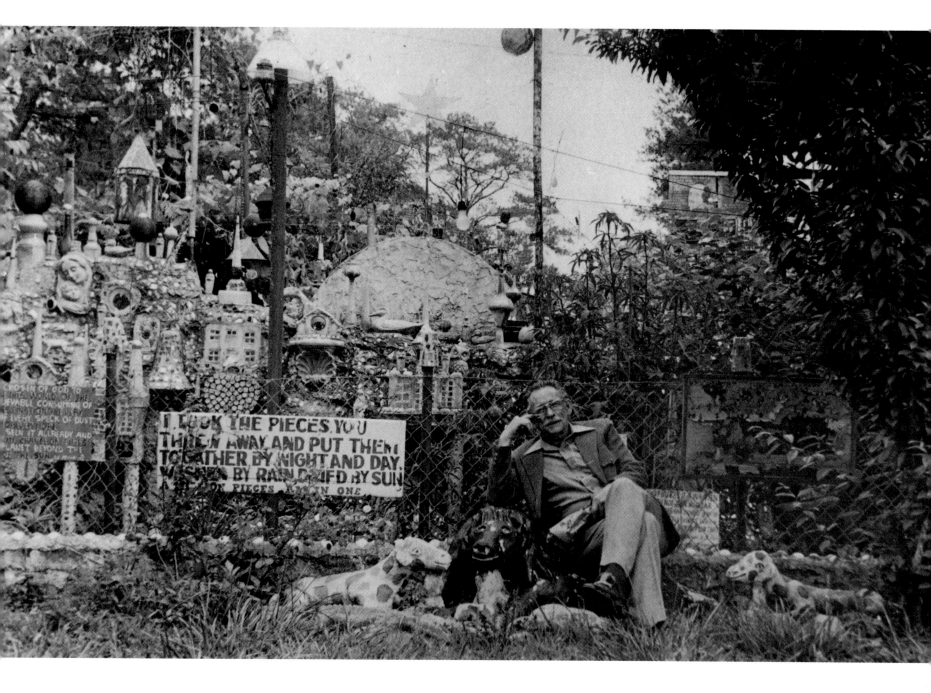

Finster was exposed to a certain amount of ridicule. As he tells it: "At first people . . . thought I was crazy for doin' this, and they laughed at me, just like they laughed at Noah when he was buildin' the Ark. . . . But I didn't pay no attention . . . 'cause I knowed what I was adoin.' I was followin' God's blueprint for my garden." Finster also took comfort from the fact that his garden was beginning to attract national attention; he was featured in *Esquire* in 1975, then *People* and *Life* magazines and the *Wall Street Journal,* and then on television. He noted wryly, "It was 'round about the time they had me on the Johnny Carson show that these people that lived around me stopped laughin' so hard."[10]

As is evident from his end-of-the-world scriptural language, Finster's main source of inspiration came from his fundamentalist Baptist beliefs. But he also raises a hymn to the popular faith in American ingenuity and know-how, by celebrating both inventors and their creations. Moreover, his garden can be seen in the context of other popular traditions, some of a local character. His garden might be considered an elaborate variation on the lawn decorated with old tires and whirligigs—yard art gone wild. It seems he may also have been inspired in part to begin his first environment at Trion by a visit he made in 1943 to Rock City Gardens, a popular tourist attraction on Lookout Mountain near Chattanooga, Tennessee.

In the early 1980s Finster acquired an abandoned church at the north edge of his garden. He spent about two years converting it into the shape of one of the heavenly mansions in his paintings by adding a round tower in three tiers—like a wedding cake—that culminates in a metal spire. He built a sun porch and studio off the back and filled the inside with inventions and with art—both his and that of other people he admired. He christened the structure the World's Folk Art Church as an expression of his commitment to ministering through sacred art—and as a knowing acknowledgment of the fact that he was now equally recognized in the contexts of the art world and of the church. Both his fame and the demand for his work continued to grow in these years, especially after the rock bands R.E.M. and Talking Heads commissioned album covers from him. He spent an increasing amount of time churning out copies of his paintings for a swelling market. Eventually his church constructing and his popularity would take their toll on the garden, a toll compounded by vandalism and his own failing health. By the late 1980s Paradise Garden was neglected and overgrown, with many of the elements falling into ruin. In 1991, in what seems to me like an act of renunciation, he had an elevated, covered walkway built above its remains, leading from the old shop at one end to the church at the other. This long, narrow gallery houses both his art and his memorabilia. Finster's garden, originally a museum of mankind and then the evocation of paradise, now seems like a museum devoted to its world-weary creator.

Finster's family and members of his community have recently begun talking of efforts to restore and preserve his garden.[11] Such efforts, if timely and well-considered, can make a difference, as they did at Fred Smith's Wisconsin Concrete Park. Smith provides one of the best instances of the artist whose version of civil religion tends more toward patriotic themes and popular history than to the biblical morality of Finster's garden. Like Dinsmoor, Smith was a literal and figurative tinkerer, using narrative groups of sculpture encrusted with salvaged material to carry his message, a celebration of the common people on the north woods frontier. Smith's Concrete Park introduces the type of environment that might best be described as the garden of history. I have chosen it in part for the ambition and virtuosity of Smith's work, and in part because it dramatizes the

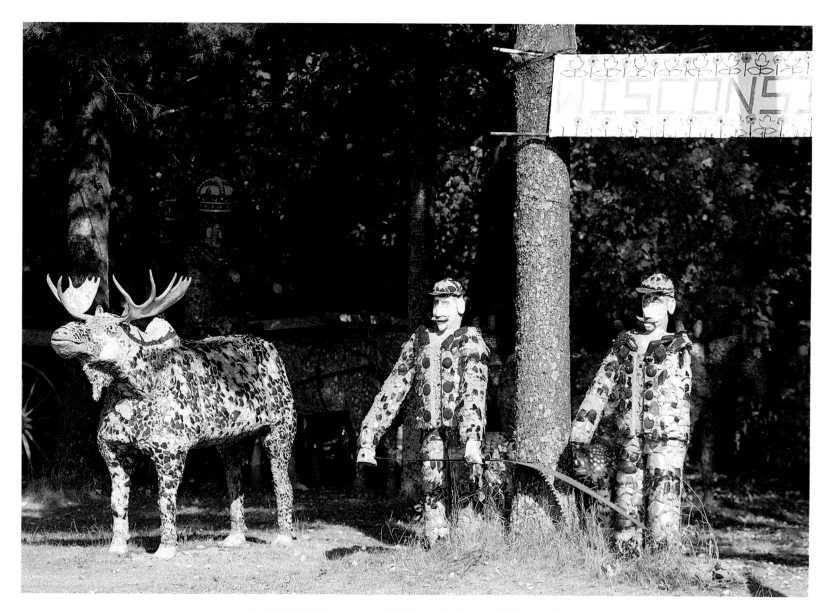

51. *Fred Smith (1886–1976). Wisconsin Concrete Park, c. 1950–64,*
Phillips, Wisconsin. Now owned by Price County.

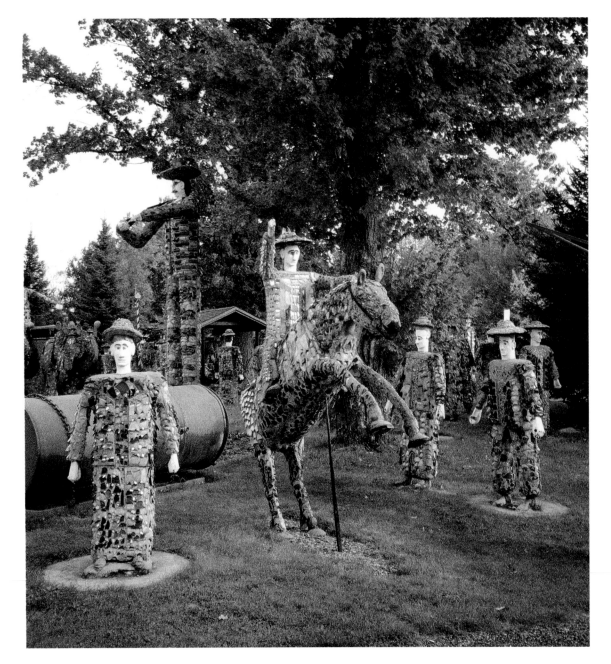

LEFT: 52. Kit Carson in a recent view of Wisconsin Concrete Park.
Photo: John Beardsley, *1991*.

OPPOSITE: 53. Double Wedding at Concrete Park.
Photo: John Beardsley, *1991*.

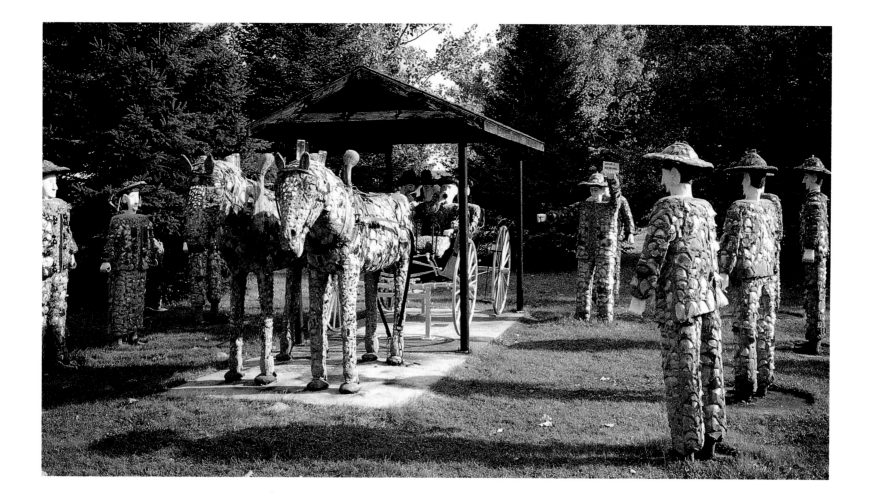

difficulties faced in the preservation of visionary environments and an all-too-rare instance of a (mostly) happy ending.

Fred Smith was born of German-immigrant parents in Price County, Wisconsin, in 1886. He became a farmer and a logger, homesteading on land just south of Phillips, the Price County seat. He was, by all accounts, indefatigable, cutting timber with his team of draft horses in the winter and working his 120-acre (forty-eight-hectare) farm in the summer, while cultivating ginseng and Christmas trees and building a rock garden on the side. He liked his fun as well: a self-taught fiddler, he played at local dance halls and socials. Probably in pursuit of both income and pleasure, he built a tavern next to his house in 1936 with stones collected from farm fields. He called it the Rock Garden Tavern and installed himself as proprietor. Smith developed arthritis in

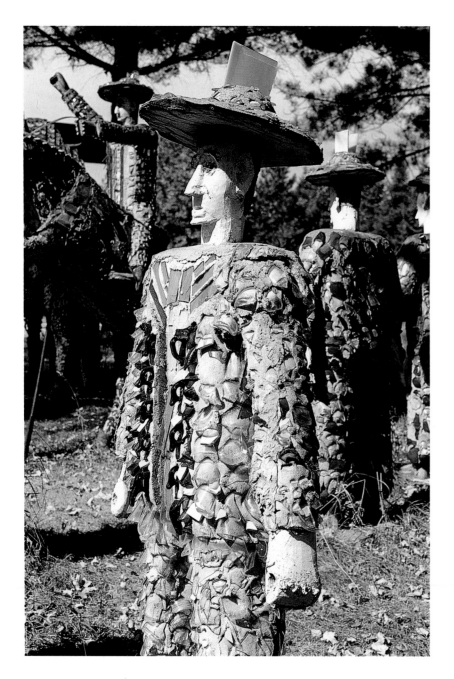

later life and retired in 1949 from heavy labor, but not from his creative pursuits.

In 1950, at the age of sixty-five, he began work on an environment of cement sculptures on about three acres (1.2 hectares) around his house and tavern. Smith's garden of history evokes memories from his own past and celebrates the popular heroes of frontier life and lore. It is populated first and foremost with the characters of the north woods close to his own heart: a pair of lumberjacks (plate 51), farmers plowing with horses or oxen, and the kerosene delivery man aboard his wagon, which is pulled by a team of draft horses (plate 134). Other figures are from frontier history, like Kit Carson astride his rearing horse (plate 52), or from legend, like the twice-life-size figure of Paul Bunyan, rifle on his shoulder and wolfhounds at his side.

Smith sometimes illustrated specific stories from local history, including a double wedding in 1900. His version of the tale incorporates a real buggy and figures clutching bottles of locally brewed Rhinelander beer (plate 53). He also tells a big fish story: two work horses are dragging the largest muskie you've ever seen. In an uncanny parallel to Helen Martins, Smith gave owls a place of prominence in his park: they surround the base of a weather vane. Other wild animals abound, especially deer, moose, and elk, providing a concrete variation on Dinsmoor's living menagerie. While these sculptures suggest again the idea of America as the new Eden, others are explicitly patriotic. These include a Statue of Liberty, a monument to Abraham and Mary Lincoln, and a relief depicting the raising of the flag on Iwo Jima. Unlike Finster, Smith made no claim to being a man of visions, but neither could he name any conscious source of inspiration for the

54. Multicolored shards of glass embellish the figures in Fred Smith's park.

wide array of his sculptures. "Nobody knows why I made them, not even me. This work just come to me naturally. I started one day in 1950, and have been doing a few a year ever since."[12]

Smith's words approach conventional definitions of inspiration, but his devotion to his task was anything but ordinary. By 1964, when he was disabled by a stroke, his Wisconsin Concrete Park numbered some two hundred human and animal figures, most decorated with shards of colored glass. He created his basic body shapes by setting rough wooden armatures wrapped in mink wire into molds that he dug in the ground, and then pouring on the cement. He next raised the forms into position; gave them heads, arms, and hands; and finished them with a layer of concrete decorated with glass, much of it salvaged from his tavern next door. Given his limited materials, he achieved a remarkable variety of effects. He incorporated bottles of various colors, along with mirrors, reflectors, and blue glass conductors. He used upended bottles to make horses' manes and angled shards to create reflections—and to shed water. Paul Bunyan wears a jacket decorated with automobile taillights and trousers with alternating stripes of clear and brown glass. Smith's technique is a variation on the tradition of mosaic that can be found among visionary artists the world over; it reminds us once again of the enormous power of the found object to unleash creativity.

Both in subject matter and technique, Smith's Concrete Park confirms a truism about visionary environments: they express a shared language in a personal idiom. Like many other visionary artists, Smith had a complex relationship with his community precisely because of the idiomatic character of his work. He was viewed with some skepticism by his neighbors, but he nevertheless thought of himself as creating something for them and for the larger public. He refused to sell any sculptures out of

his park, "cause it might spoil it for others." Like other environment builders, he welcomed contributions of materials and cash. Just inside the gate to the park, above his mailbox, hung a brightly lettered sign saying "Donations Appreciated." But he meant the gift to be reciprocal; in his mind, the park was "for all the American people."[13]

After 1968 Smith was confined to a nursing home; he died in 1976. By then, the park had begun to deteriorate. Moisture had invaded the figures, rotting the wooden armatures and cracking the cement. Fortunately, the site was purchased for preservation the same year by the Kohler Foundation of Sheboygan. With the support of the National Endowment for the Arts and the Wisconsin Arts Board, restoration began early in 1977. Cleaning, refooting, and patching of the figures was well under way when, on July 4, a violent windstorm swept through Phillips, devastating the park. As recalled by Don Howlett and Sharron Quasius, the artists who were heading the restoration effort: "All the trees in the heavily wooded park were uprooted or snapped off. Statues were smashed and scattered everywhere. . . . We were in shock."[14]

Turning disaster to advantage, Howlett and Quasius were now able to get at the source of the sculptures' deterioration rather than treating its superficial expression. They removed rotted wooden armatures, replaced them with steel, and welded the broken parts back together. They used epoxy to fill gaps where freezing water might cause breakage. They replanted the landscape with pine trees, in the hope that it might one day again resemble the inhabited grove that Smith had left behind. In the fall of 1978 the site was given by the Kohler Foundation to Price County as a park. Nine years later the sculptures were again damaged in a wind storm and repaired; conservation continues intermittently, with the result that Fred Smith's vision of a park for all the people endures to this day.

Other gardens of popular history have not fared as well. Many have been lost entirely, and some preserved only in part. Gone completely, for example, is Mrs. Pope's Museum, which once stood along the road between Meigs and Cairo, Georgia (plate 55). Built by Laura Pope in the years before her death in 1953, it was an environment of some two hundred cement sculptures that honored the heroes and victims of the two world wars, along with prominent southern women—some real, some fictional (like Scarlett O'Hara). It was dismantled after her death. Preserved only in part is John Ehn's Old Trapper's Lodge (made

about 1945–60), a collection of concrete figures celebrating backwoods pioneers and legends, which used to surround a motel in Sun Valley, California, near Burbank (plate 57). The motel was lost to sprawling Burbank development, and the sculptures were relocated to Pierce College in Woodland Hills. Meanwhile, Herman Rusch's Prairie Moon Museum and Garden, along the Mississippi River in southwestern Wisconsin, fell into hostile hands. Originally a collection of man-made curios and natural oddities in a garden of exotic architecture, including a castle tower and minarets behind an elegantly arching fence (plate 56), the place

57. *Two-Gun Rose, a miner-49er, and his daughter Clementine were among numerous frontier figures at the now dismantled Old Trapper's Lodge, built c. 1945–60 by John Ehn (1897–1981), in Sun Valley, California.*

became a dog kennel belonging to a person who was antagonistic both to Rusch's work and to the people who still occasionally came to see it. The Kohler Foundation recently secured title to the property and has plans to restore it.[15]

More fortunate has been the fate of several other gardens of history. The Desert View Tower near Jacumba, California, still stands; it was built by Burt Vaughn in the mid-1920s to commemorate the pioneers who opened the way across the treacherous

58. *Burt Vaughn, Desert View Tower, 1920s; and W. T. Ratcliffe, Boulder Park Caves, 1930s, Jacumba, California. Now owned by Desert Tower Corp.*

deserts of southern California to San Diego (plate 58). Still surviving too are the bizarre stone carvings at an adjacent site known as the Boulder Park Caves (plate 59). They were carved in the 1930s by a retired engineer named W. T. Ratcliffe, who came to the area to recover from tuberculosis. They include not only representations of snakes, lizards, and buffaloes, but also of skulls, which seem like memorials to the pioneers who died on the desert crossing. Both the tower and the carvings were named to the National Register of Historic Places in 1980, with the help of SPACES, the Los Angeles preservation group. A group of structures in New Mexico was similarly designated: the Shaffer Hotel and Rancho Bonito in Mountainair, near Albuquerque. Both were the creation of a man named Clem "Pop" Shaffer. He

59. *W. T. Ratcliffe, skull at Boulder Park Caves.*

60. *Clem "Pop" Shaffer. Rancho Bonito, 1940s, Mountainair, New Mexico.*

opened the hotel in 1924; it was decorated with brightly colored geometric patterns that appear to have been inspired by Native American art. In the late 1930s Shaffer bought 240 acres (ninety-six hectares) just outside town and built himself a patriotic red-white-and-blue log cabin and outbuildings decorated with Native American emblems and oddly shaped stones, many of which are grouped to represent animals (plates 60 and 61).

Celebrations of the American paradise extended to recognition of the continent's original inhabitants. One such homage to Native Americans is Ed Galloway's Totem Pole Park, an environment of concrete structures built between about 1937 and 1962 on a one-acre (0.4-hectare) site near Foyil, in Rogers County, Oklahoma (plate 63). It is another fortunate site. After Galloway's death in 1962, ownership of the place passed to the artist's son and daughter-in-law, Paul and Joy Galloway; the family gave it to the Rogers County Historical Society in 1989. Park structures are gradually being repaired and repainted by the society with the cooperation of the Kansas Grassroots Art Association.

Galloway was born in Missouri in 1880 and attended school through the eighth grade. As a teenager he enlisted in the army and served in the Spanish-American War; he was stationed in the Philippines. He was married in Springfield, Missouri, in 1904; his one child was adopted in 1916. He apparently demonstrated an aptitude for wood carving early in life and pursued it as an adult. Around 1914 Galloway carved a group of large sculptures that he evidently planned to submit to the San Francisco Panama-Pacific International Exposition of 1915. A fire in his Springfield workshop destroyed all but one of them: a tree trunk, seven feet (2.1 meters) tall, wrapped in snakes and lizards and rising from the back of a turtle. According to his daughter-in-law, he was on his way west with this carving, passing through Tulsa, when he encountered Charles Page, founder of a home for orphans and

61. Rock work on an outbuilding, Rancho Bonito.

widows in Sand Springs, Oklahoma. Page hired him to teach woodworking to the boys, and Galloway remained employed by the Sand Springs Home until he retired in 1937.[16]

At that point, Galloway and his wife moved to a modest sandstone bungalow that he built on his land near Foyil. Soon after, he began work on what he termed a totem pole: a tower in the rough shape of a tepee, made of cement over a sandstone and scrap-metal armature. It was completed and dated 1948 over its only door; it was originally ninety feet (twenty-seven meters)

tall and topped with a carved cedar telephone pole. The tower, eighteen feet (5.4 meters) in diameter at the base, ascends from the back of a turtle; it is decorated with some two hundred painted images in bas-relief (plate 63). Rising above the head and tail of the reptile are enormous predatory birds that reach halfway up the edifice. One has a spotted salamander in its beak, the other a snake. Three smaller birds ring the base of the tower, while the balance of its surface is taken up with images of Indian heads in profile interspersed with tomahawks, arrows, fish, salamanders, crayfish, medallions depicting western scenery, and still more birds.

The tower is crowned with four standing full-figure representations of Native American chiefs about nine feet (2.7 meters) tall. They are meant to portray Geronimo, the Apache, on the west; Sitting Bull, the Sioux, on the north; the Nez Percé Chief Joseph on the east; and an anonymous Comanche chief on the south.[17] These three leaders, along with the Comanche tribe, were associated with heroic, if violent and ultimately futile, resistance to the settlement of their lands. Two of these figures have a local relevance: the Comanche were indigenous to Oklahoma, and Geronimo was eventually removed to Fort Sill, Oklahoma, after his capture in 1886. Moreover, many of the profile heads wear feather headdresses typical of Plains Indians.

Overall, however, the tower has the feel of totems made by tribes of the Northwest coast. Its imagery probably comes from some popular photographic source: Galloway's daughter-in-law says he was a longtime subscriber to *National Geographic* and

62 and 63. Ed Galloway (1880–1962). Totem Pole Park, c. 1937–62, Foyil, Oklahoma. Now owned by the Rogers County Historical Society. Galloway's main totem rises from the back of a turtle and is covered with painted images in bas-relief. Photos: John Beardsley, 1992.

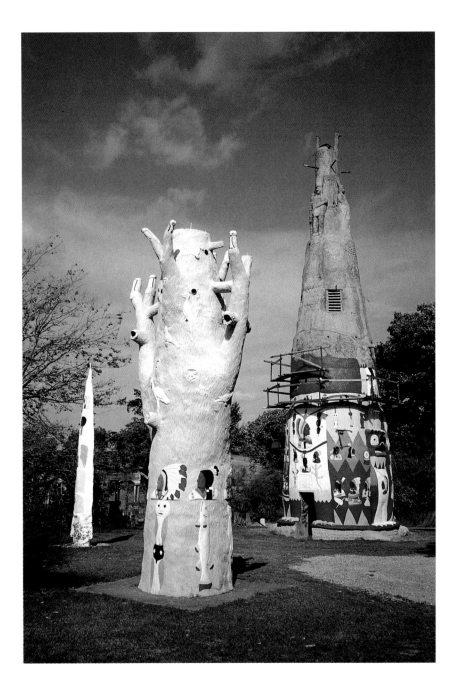

occasionally ordered additional pictures from the society. She and his son also contributed to his stockpile of images during the time he was making the tower. They lived in Alaska from 1942 to 1950 and often sent him postcards of totem poles and other Indian carvings. The beast on which the totem pole rests, however, seems to be a classical motif, drawn from ideas in ancient cosmology that the world rests on the back of a turtle (plate 62). The reptile also crops up in Renaissance gardens; there is one at Bomarzo with a female figure riding on its back. Whatever the specific source, the turtle was a lifelong device of Galloway's.

At the other end of his property, Galloway constructed a one-story, eleven-sided structure called the Fiddle House. This is decorated on the outside with totems and vines, and on the inside with painted landscapes. The building served as Galloway's workshop and gallery; until it was ransacked after his death, it housed his handmade furniture, fiddles, plaques, and relief carvings of all the presidents up to John Kennedy. The park also contains a number of subsidiary elements, including small totems, gates, and a large arrowhead decorated with Indian profiles, which his daughter-in-law says were meant to represent the "five civilized tribes." There is also a concrete tree trunk covered with the usual birds, fish, and Indian heads. This last element was evidently inspired by a jest made by Galloway's wife: she told him, paraphrasing the poet Joyce Kilmer, "Totem poles are made by fools like thee, but only God can make a tree." Galloway rose to the challenge, and fashioned a stout trunk and several large branches. While no one would mistake his tree for the real thing, he wanted birds to feel at home in it, so he left holes in the branches to provide nesting places.

Galloway's Totem Pole Park can be seen as a hymn to aboriginal America: its landscape, its first peoples, its animals. Galloway's basic themes are familiar. Like Dinsmoor or Finster,

he explored the popular myth of America as the new Eden; like Shaffer and Smith, he celebrated the original inhabitants of the American paradise. Yet Galloway's Eden is far more innocent than Dinsmoor's; its time is before the Fall. Similarly, despite his representations of vanquished Indian chiefs, it is free from the end-of-the-world rhetoric found in Finster's Paradise Garden. Galloway openly addressed neither the fate of the earth nor that of the Native American population. In a landscape indelibly linked with Indian wars and the Dust Bowl, his work might be interpreted as naively escapist—just another roadside attraction.

Galloway himself described his Totem Pole Park and Fiddle House as a "tourist attraction" and as "my hobby and my past time."[18] His daughter-in-law insists that it "was just a hobby, built on a whim," though she acknowledges that Galloway considered the park educational and was happy to show school groups around. Surely the monumentality of the tower, however, suggests that Galloway's purpose was both commemorative and instructive. His message is sharpened by the fact that the totem pole is crowned with figures who so heroically resisted the loss of their lands. I wonder if it might not be justified to see the Totem Pole Park as Galloway's memorial to a landscape and a people claimed and irrevocably changed by the westering course of empire. If so, it is another double-edged meditation on American civil religion.

Ambivalence about the nation and its treatment of native populations is the explicit theme of an environment constructed in Imlay, Nevada, by a man of Creek Indian descent, Rolling Mountain Thunder. He was born Frank Van Zant in Okmulgee,

64. *Rolling Mountain Thunder (1911–1989). Thunder Mountain Monument, 1969–89, Imlay, Nevada. General view with snowcapped Thunder Mountain in the distance.* Photo: Susan Orr, 1979.

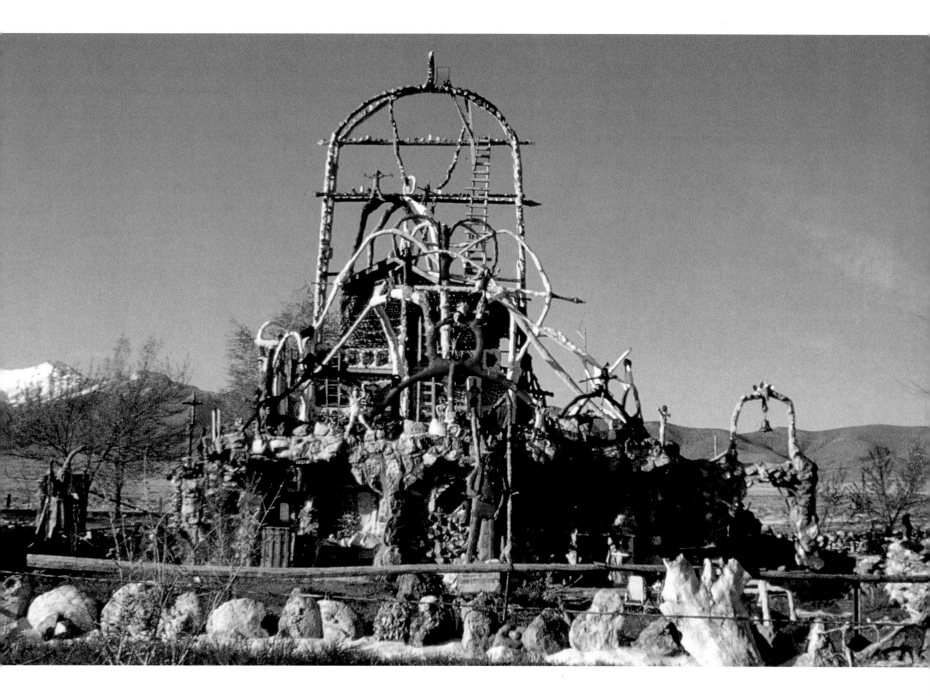

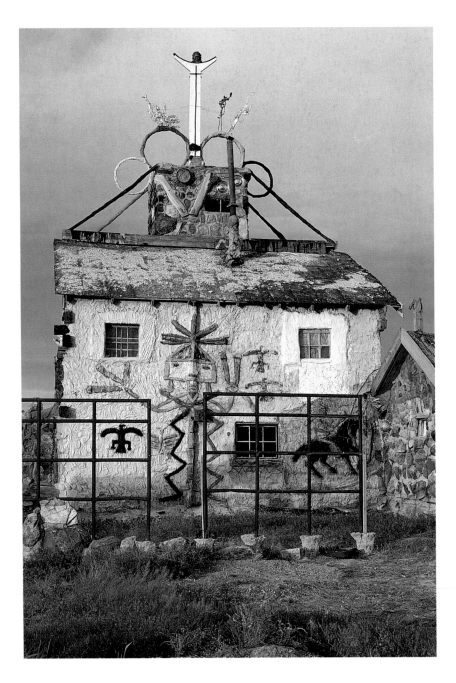

Oklahoma, on the eleventh day of the eleventh month of 1911; this was the start of an extraordinary odyssey. He dropped out of school and left home as a teenager when his father, a Native American, died and his mother (who was white) married a man with whom he didn't get along. He eventually migrated to California, like so many other refugees from the Dust Bowl. There he worked as a logger and a truck driver before becoming a police officer in Yuba City in the years before World War II. "I was restless," he recalled, "looking for something that kept on eluding me."[19] When war came, he served in the Seventh Armored Division of the First Army and was decorated many times for service in some of the fiercest battles in the European theater. He was ultimately disabled in combat and honorably discharged with a pension that helped to support him for the rest of his life.

After the war Van Zant began studying for the lay ministry and spent several years building up a Methodist congregation in Stockton, California. He also worked with juvenile delinquents, taking them to live with him in the Sierra Nevada to remove them from big-city temptations. Still restless, he gave up both ambitions to run a private security service in Marysville and Redding through much of the 1950s; feeling unfulfilled, he sold out and retired to an Indian museum he established in Yuba City. Meanwhile, his first wife died of leukemia in 1953, apparently the result of radiation poisoning: she and Van Zant used to sit in a lookout tower near Portola and watch the spectacular nuclear explosions over the Nevada desert. Van Zant himself developed chronic anemia.[20]

In 1965 his unsettled life began to change, precipitated by a dream of the Great Spirit that fits a classic category: it was the

65. The hostel (destroyed by fire in the late 1980s) for visitors to Thunder Mountain Monument.

vision of a second chance in life. "He came as an ancient Chief, clad in Indian garb, with a strong, lined face and a full eagle-feather headdress. He picked up a large stone mortar, the kind Indians use to grind corn. . . . Placing his fist about it, he appeared to squeeze, very gently. The mortar immediately fractured. He then gave it to me, saying, 'My son, this is your mortar of life. You can be done with it at any time, for you have done all that could be expected of you.'"[21] Yet Van Zant's most remarkable work still lay ahead of him.

In 1968 he found his way to the canyons of Thunder Mountain, near Imlay, Nevada, a site he identified as hallowed by an ancient Indian community. There he had another vision. "I heard the Great Spirit voice. . . . He says, 'You are the big eagle and the big eagle shall return to his nest.'" He saw himself as a bird-man with great wings soaring over Thunder Mountain, while below him he could make out the forms of his new young wife and children. "That was the thing that brought me up here," he insisted.[22] He would remain in the shadow of Thunder Mountain until his death in 1989.

The next year, Van Zant, now Rolling Mountain Thunder, bought five and a half acres (2.2 hectares) of land along nearby Interstate 80 and there began work on what became the Thunder Mountain Monument (plate 64). The principal architect and builder of the monument, he was also chief of a community that grew to include not only his own new family but also a fluctuating number of others who came for shelter or counsel, taking up residence with him or in the nearby canyons. The monument grew to include three buildings constructed mostly of local stone and cement, supplemented by found objects ranging from glass

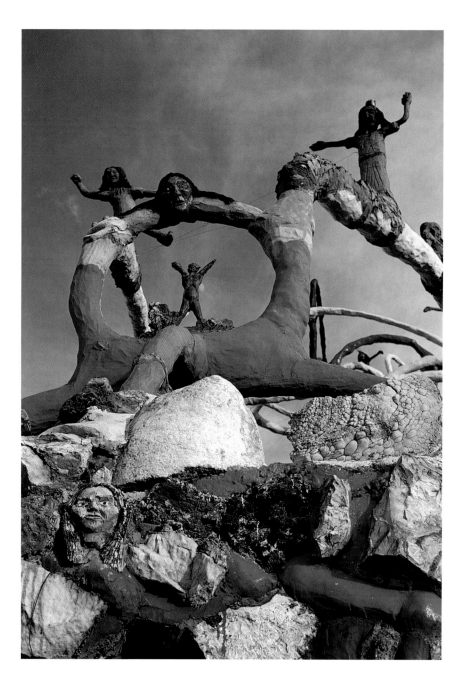

66. *"Children watchers" in the armature that rises above the house at Thunder Mountain Monument.*

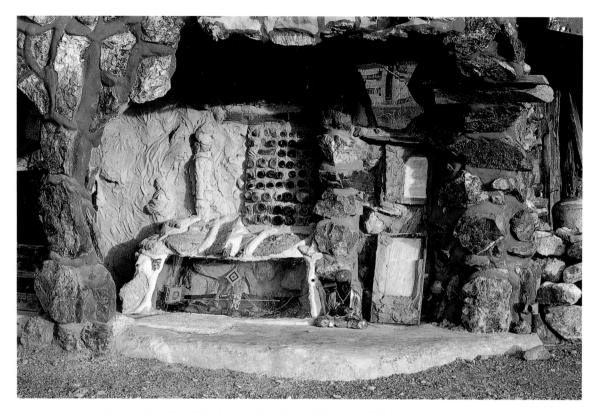

67. The exterior of Rolling Mountain Thunder's house, which includes a memorial to a Native American friend.

bottles and jars to cans, railroad ties, animal bones, and bicycle parts. Painted sculptures of Indians surrounded and ornamented these buildings. One, which functioned as a hostel, was embellished with pictographs and topped by a figure with arms outstretched, suggestive of the Great Spirit (plate 65). Another building was Rolling Mountain Thunder's home; it was elaborated with a superstructure that resembled a maze of flying buttresses. Eventually it was crowned by what resembles a large handle, built to suggest the form of an Indian carry basket "so

that the Great Spirit can pick the whole thing up and just carry us all away."[23]

Rolling Mountain Thunder initially wanted to create a place of refuge. "Being an outcast and a reject, I spent a lot of time on the road as a kid. . . . I'd always wanted to build something along a major artery where people could camp for free. I wanted to build a cathedral-like building where they could find their spirits, too, along with food and a place to sleep."[24] His monument was also a tribute to Native Americans. A legend at the base of a

standing male Indian figure proclaimed that it was a "monument to the West's earliest peoples." Numerous other sculptures of Indians populated the yard; full figures and faces (which he described as "children watchers," or protective spirits) embellished the buttressing (plate 66). Native American artifacts were enshrined in the monument, both inside and out (plate 67).

While Thunder Mountain Monument paid explicit tribute to Native Americans, it did so within a larger context of ideas about freedom and the brotherhood of all peoples. A sign along the approach to the monument announced, "This place created out of the dust out of love of man, God, country." Another read, "Theme: Idea of Free Man. Help Free America. A family without unity is a nation in chaos." Rolling Mountain Thunder's beliefs subjected him to ridicule and worse; his place was vandalized on several occasions. At one point in 1975 his wife was threatened with a gun and then dragged some distance beside a car before being dropped; her persecutors were not charged. Most prevalent, evidently, was the idea that he had established some kind of hippie commune. "No, we are not a hippie com-

mune," another sign declared. "We have furnished thousands of people free shelter and food and perhaps faith." Still another spelled out the "Thunder Nation Code," which included "total dedication to service to God and man."

As his signs reveal, Rolling Mountain Thunder reiterated in his own idiom some of the common themes of visionary environments. He shared with others a sense of his own resourcefulness and self-reliance, a capacity to turn dross into gold. There is an echo of Howard Finster in his observation that his environment grew "from cast-off materials, a monument to man's wasteful nature—and to what can be done with the things all of us, each day, throw away as trash."[25] He expressed a deep faith, but his God was once again a personal one, shaped by both Christian and Native American beliefs. And he was patriotic, but his loyalty was to a vision of America as it should be—unified in tolerance and diversity—rather than to America as he knew it. Implicit in his environment, as in so many others, was a challenge to Americans to live up to the promise of their civil religion by creating a nation truly consecrated to freedom, equality, and justice.

❧ *3* ❧

Grottoes of the Holy Book

Truth reaches the mind most easily by way of the senses.

Father Paul Dobberstein

HEN FATHER PAUL MATHIAS DOBBERSTEIN arrived in the tiny prairie town of West Bend, Iowa, in October 1898, the place had been in existence for barely sixteen years. It was the usual frontier settlement, with dirt streets, a few dozen buildings, and a population of just over two hundred. On the north edge of town next to a marsh stood a little wooden-frame structure: the Catholic Church of Saints Peter and Paul. Father Dobberstein was its youthful new pastor. He would remain the rest of his life in West Bend and leave behind in this ordinary village one of America's most astonishing popular devotional shrines (plate 69).

Dobberstein's shrine was not unprecedented, either in Europe or in the United States. Taking the form of a grotto complex within an artificial mountain, it was an unusually ambitious variation on a phenomenon virtually ubiquitous in the Catholic world: the replica of the sacred cave. These replicas were part of a larger practice of re-creating the important shrines of the

Holy Land in both the Old and New Worlds, to provide a vivid religious experience for those unable to make the pilgrimage to the Middle East. The articles of faith that Dobberstein was expressing were taken literally from Church tradition, but his choice of materials and his combinations of form reveal extraordinary imaginative prowess.

Why, of all the shrine types, did Dobberstein choose the grotto? The answer can only be inferred, in part from his writings, in part from the visual evidence. Dobberstein himself drew parallels between his work and the caves that dot the landscape of southern Germany, which played a role in the religious life of the common people there. But the grotto seems also to have held larger devotional possibilities for him. He evidently recognized it as an especially powerful form for luring and holding the faithful, and for attracting, educating, and perhaps converting the curious. This leads us back—ironically, it might initially seem—to the marvelous. Dobberstein seems to have wanted to inspire

68. *The Ave Maria Grotto, 1932–34, and the painted concrete replicas of Christian shrines that surround it were the life's work of Joseph Zoetl (1878–1961), a lay brother at Saint Bernard Abbey, Cullman, Alabama. Owned by the Benedictine Society of Alabama.*

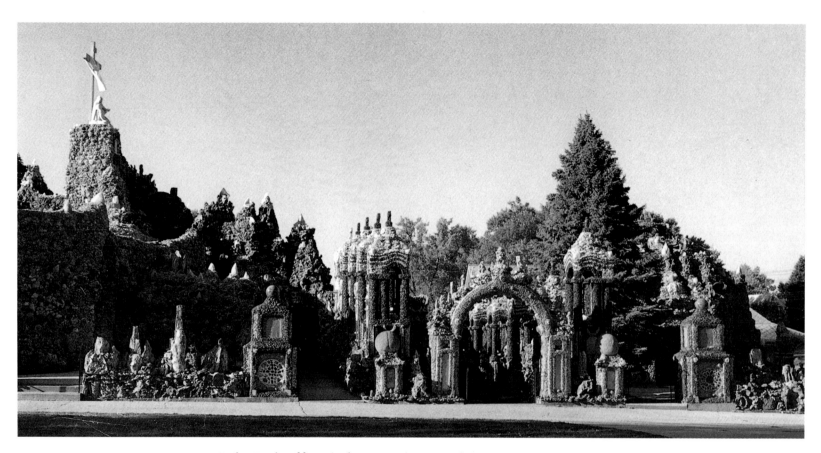

69. *Father Paul Dobberstein (1872–1954). Grotto of the Redemption, begun c. 1912,*
West Bend, Iowa. Owned by the Diocese of Sioux City, Iowa.

spirituality by providing an encounter with the wonders of crea-
tion in a space that was utterly out of the ordinary.

Dobberstein played a part in precipitating other instances of
grotto building in the Upper Midwest. For the most part, these
shrines also are found in rural communities far from other eccle-
siastical structures of any importance. But this was not solely a
midwestern phenomenon; there is a splendid grotto in Cullman,
Alabama, built by another German-born Catholic. Nor was it
entirely a German-American or even a Catholic practice; this
chapter ends with a look at some cave shrines in a Memphis
cemetery, which were a virtual collaboration between a Mexican
Catholic and an entrepreneurial Methodist. What all these places
share is a loyalty to a symbolic language encoded in the grotto,
which essentially disappeared in the twentieth century from

high-art gardens. In this sense, they represent another survival in popular art of a form long gone from academic culture. All, too, share a didactic, even evangelical purpose; all were intended to provide a strong devotional experience for a popular audience.

To some extent, the Catholic priests in this chapter do not fit the pattern of marginalization typical of many other visionary artists. After all, they were acknowledged leaders in their communities, with higher social standing than others who are introduced in this book. They had correspondingly greater access to the customary forums for public address. They were the guardians of established traditions; not coincidentally, both the forms and the content of their art show a greater reliance on ecclesiastical conventions. Yet there are parallels between these priests and other visionary artists: many of them were foreign-born; all were untrained as artists; and most were regarded as eccentric by people both within and outside their communities. Dobberstein, for example, was described by his successor as "a prophet without honor in his own country" and was viewed with skepticism by the hierarchy of the Church, by some of his own parishioners, and by some of his non-German, non-Catholic neighbors.[1]

Other priests experienced similar disapproval, especially from Church leaders, suggesting a schism between popular and official piety. Moreover, the decades in which Dobberstein and others of his kind were most active—the 1910s and 1920s—were the years in which anti-immigrant and anti-Catholic feelings were running at highest tide. In this context, these priests provided an affirmative voice to a whole community of disaffected people. Indeed, they confirm a familiar pattern among visionary environmental artists: they addressed the condition of alienation while trying to alleviate it—for themselves and for anyone else willing to look and listen. They made a gift of faith to a troubled and doubting world.

70. *Father Paul Dobberstein.* Photographer unknown.

Father Paul Dobberstein came a long way to take his post in West Bend. Born in 1872 in Rosenfeld, on the edge of the Black Forest in far southwestern Germany, he was educated in a local *Gymnasium* before emigrating to the United States in 1892. He left at the tail end of an agricultural depression that had led to massive emigration from the rural regions of Germany during the previous two decades, and arrived in America at the onset of a financial panic. He found his way to Naperville, Illinois, where he heard an appeal for German-speaking priests, who were wanted

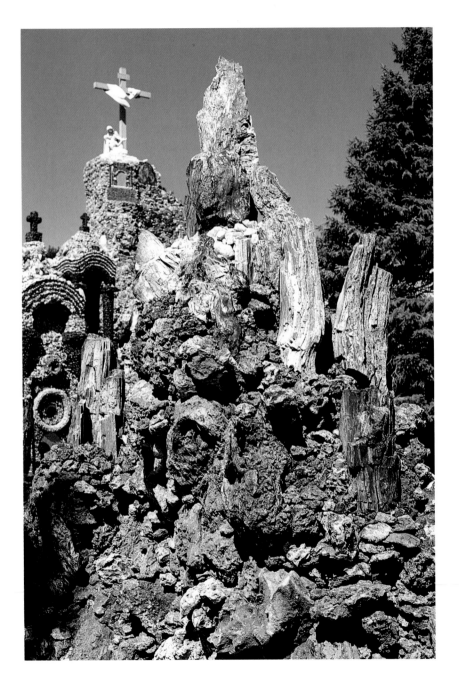

to attend to the pastoral needs of the German Catholic immigrants flooding the Upper Midwest. Scholarships were available, and Dobberstein soon began studying for the priesthood at the Saint Francis Seminary in Milwaukee. In May 1897, a month before his scheduled ordination, he fell gravely ill with pneumonia. Praying to the Virgin Mary, he vowed that if he recovered, he would build a shrine in her honor that would tell the story of the life, death, and resurrection of Christ. He was well enough to be ordained that June; in the spring of 1898 he applied for a pastoral position and was rewarded with West Bend.

Dobberstein set out at once to earn the loyalty of his mostly German parishioners, beginning with what one of them called "the gospel of the parochial school."[2] By the fall of 1899 he had erected the first Catholic school in the area and staffed it with Franciscan sisters. The next year, with the support of his congregation, he bought an adjacent house for a rectory; it came with eight acres (3.2 hectares) of land, including the marsh. This he set about converting into a large pond that became the centerpiece of a pleasant park for his parishioners to enjoy after church. The park was completed by 1906.

By then Dobberstein had announced his plans to build a shrine to the Virgin. Like the school, it would teach people about the Catholic faith; like the park, it would be an attraction for present and potential church members. Dobberstein, whose *Gymnasium* studies had included courses in geology, began combing the region for rocks and minerals. On vacations he ranged farther afield, making rock-hunting expeditions to the Black Hills of South Dakota or to the deserts of the Southwest. Typically, a few days after his return, a freight car would arrive in West Bend loaded with petrified wood, fossils, stalactites, cal-

71. Exterior of the Grotto of the Redemption.

cite, quartz crystals, jasper, malachite, turquoise, and other geological wonders. His parishioners supplemented these finds with boulders from their fields, and with agates and geodes collected beside local rivers.

By 1912 Dobberstein had amassed enough material to begin construction of the shrine. Working with Matt Szerensce, a recent school graduate who became his lifelong assistant, Dobberstein dug twenty-foot (six-meter) foundations and filled them with stones and cement. Over these, he gradually raised the form of a grotto. The exterior was constructed of rocks, petrified wood, and geodes, with an entrance dominated by an enormous Roman arch. Dobberstein used an ingenious system of prefabricated panels to shape the interior: he poured slabs of concrete and then embedded stones and minerals in them as they hardened. Next he raised these prefabricated sections into position, cemented them together, and covered the seams with more stones. The interior eventually took a triple-apsed form with a central dome; the lower walls of the apses were made of curved panels, the upper walls of rosettes.

As the grotto took shape, curious visitors began leaving offerings in boxes that Dobberstein set out; these contributions supplemented income he earned by selling pond ice in the winter and were used to cover the costs of cement and wages for Szerensce. From the start, the diocese insisted that the grotto pay its own way. As Dobberstein's pastoral assistant and later successor, Father Louis Greving, recounts: "The Bishop didn't pay much attention to it. He told Father Dobberstein as time went on and the grotto kept growing, 'You may not use parish funds to support your grotto building. You must pay for the grottoes as you build. Do not go in debt. But above all, you must not shirk your duty as pastor of St. Peter and Paul Parish.'"[3]

Because of Dobberstein's duties, compounded by World War I and the influenza epidemic of 1918–19, work on the grotto went slowly. It was also interrupted by the construction of a new church for the parish, which was completed in 1922. Meanwhile, he provided other attractions on the church grounds. On a summer trip to South Dakota in the early 1910s, he was given a black bear, which he kept in a pit by the grotto. Eventually, in the spirit of many a German Baroque park, Dobberstein collected quite a menagerie, including an eagle, swans, coyotes, and peacocks. "There was a carnival side" to Dobberstein, Father Greving admits, but he had an evangelical purpose. "Why did he have a zoo first? You don't have people reading the story in stone unless you first have the people. The bear brought the people. And what's a lake without fish? So he went to the game commission and got the lake stocked with pike and pickerel.... People would come to fish and they stayed to talk about the love of God."[4]

At long last, the first grotto, thirty-five feet (10.5 meters) tall and known as the Grotto of the Trinity, was dedicated in 1924. Intriguing on the outside, it is nothing short of dazzling within (plate 73). It is encrusted with all kinds of richly colored and textured materials, especially calcite and small stalactites. Arches are outlined in white and rose quartz; the dome is flecked with shiny stone, like mica or pyrite. In the central apse stands a white marble statue of the Virgin and Child, set against a star-studded field of malachite. In the apse to the left is a stained-glass window illustrating the Annunciation; in the apse to the right are the symbols of the Passion—the cross, crown of thorns, nails, sponge, and spear.

For Dobberstein, this grotto was just a beginning. He had embarked on a building project that would last, in the words of Greving, until "he laid down his trowel" in 1954. He would eventually complete not one but seven of a planned nine grottoes on the site, in and around a walled park that is dominated by an artificial hill some forty feet (twelve meters) tall (plate 71).[5] The

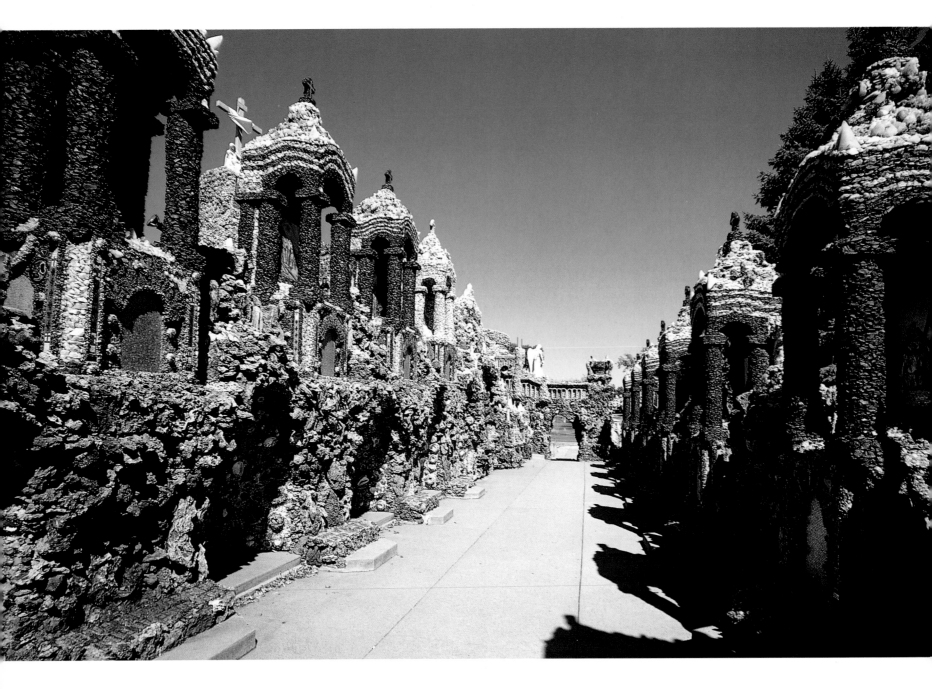

whole complex would come to be known as the Grotto of the
Redemption and would tell the story of the fall of Adam and
Eve, of Moses and the Ten Commandments, and of the redemp-
tion of humanity through the life and death of Christ. It would,
in Dobberstein's words, "tell, in silent stone made spiritually elo-
quent . . . the fundamentals of the Christian religion, to induce
the visitors here to be not only idle hearers, but also contem-
plative thinkers and courageous doers, of the word of Christ."[6]
Although he worked without plans, Dobberstein reportedly
visualized the whole composition from the outset. As Greving
recounts: "He told me that one evening as he was reflecting upon
the redemption story suddenly he saw in his mind's eye the
whole layout of the grotto as it now stands. . . . I have no diffi-
culty believing that. Already in that first grotto written in stone
is the inscription 'Grotto of the Redemption' which gives evi-
dence of an expanded plan."[7]

Dobberstein's opus is divided into two main sections, on
opposite sides of a central axis that runs north to south on the
site, from the lake to the church. At the north end of this axis
is the Garden of Eden, also known as Paradise Lost, showing
the expulsion of Adam and Eve. The rest of the central walk is
taken up with the Stations of the Cross: stone canopies covering
Venetian-tile mosaics that illustrate the episodes along Christ's
route to Calvary (plate 72). All these canopies stand on founda-
tions of stone and seashells; all but one are covered with brown
jasper. The canopy of the twelfth station, the Crucifixion, is
made entirely of white quartz, to symbolize the light of grace
attained through the death of Christ (plate 74). At opposite ends
of this axis, in other words, are the beginning and the end of

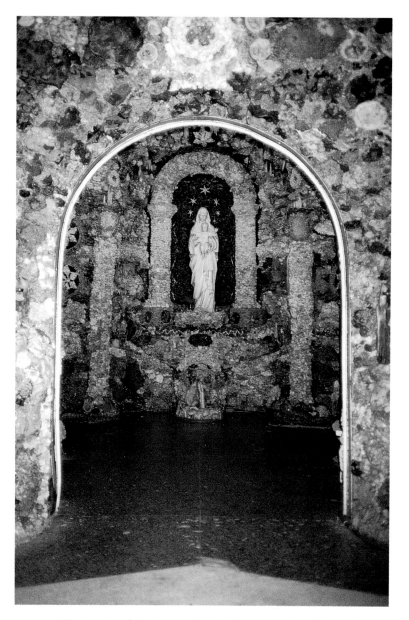

*72. The Stations of the Cross line the central axis at the
Grotto of the Redemption.*

*73. The interior of the Grotto of the Trinity, completed by Father
Dobberstein in 1924, is encrusted with calcite and quartz.*

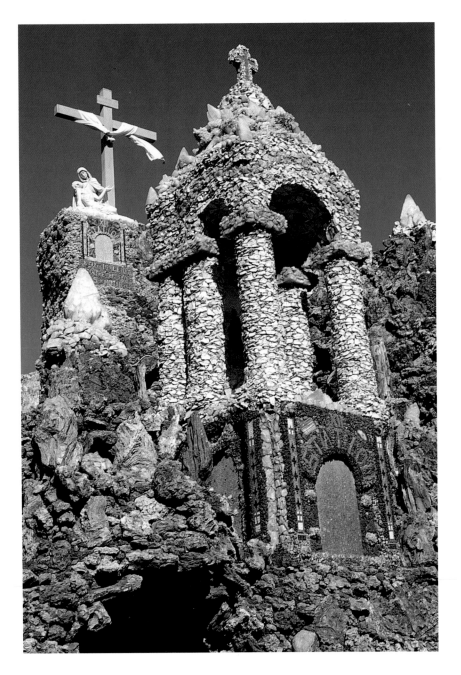

the narrative of the fall of man and the promise of salvation that Father Dobberstein wanted to tell in stone.

To the east side of the axis, inside a high wall of petrified wood, is a small park containing the Grotto of the Ten Commandments, which is capped on the outside with enormous pieces of rock crystal. On the inside, a figure of Moses is dwarfed by an arch of many minerals; above him hang two giant stalactites collected from the Carlsbad Caverns in New Mexico—before they were declared a National Monument. Dobberstein deliberately left a hole in the ceiling above one of these stalactites; rainwater runs down it and is forming a small stalagmite on the floor below.

On the west side of the central axis is the most imposing feature of the grotto complex, a forty-foot (twelve-meter) stone-and-cement mount containing the Grotto of Gethsemane and crowned with the thirteenth station, the Deposition. It also contains the grottoes of the Entombment (plate 75) and the Resurrection. The former is particularly striking; it is another triple-apsed space marked at the entrance by an imposing pair of pillars crowned by huge chunks of rock crystal. Inside is one of the better examples of marble statuary at the complex—the figures of Joseph of Arimathea and Nicodemus preparing to lower the body of Christ into the tomb. Like all the statuary, it was carved of Carrara marble; along with the figure of Moses, it is signed "Daprato Studios, Pietrasanta, Italy."[8] The most notable feature of the Grotto of the Entombment, however, is the tomb itself. It is completely lined on the inside with sliced and polished agates in riotous colors.

As the grottoes grew, so did their reputation. They were such an attraction for pilgrims and curiosity-seekers that in 1928

74. The twelfth station, representing the Crucifixion, with the figures of Mary and the dead Christ crowning Father Dobberstein's mountain of petrified wood.

*75. Looking into Father
Dobberstein's Grotto of
the Entombment.*
Photo: *John Beardsley, 1991.*

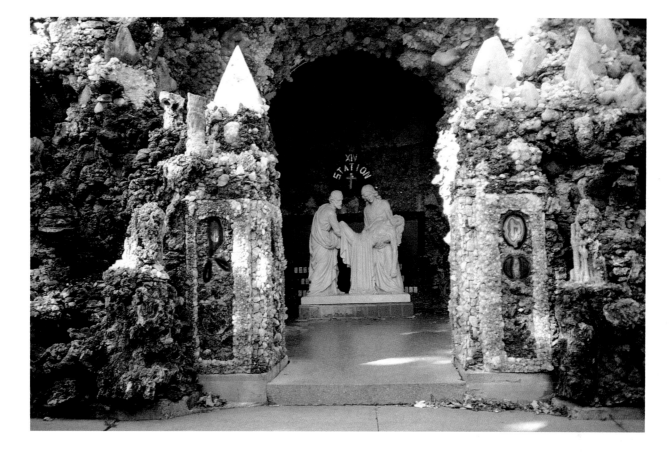

Dobberstein took time out from their construction to build a restaurant by the lake to feed his many visitors. Still making his rock-hounding expeditions around the West, now in a truck that Szerensce drove for him, he also apparently wrote to the National Geographic Society for information on where to get different kinds of minerals.[9] Donations of cash and stone arrived from around the world. He labored on the grottoes whenever he could, frequently late into the night. He even worked on them in the dead of the Iowa winter, washing rocks in his bathtub and assembling cement-and-stone panels that would be raised into position the following summer. Greving likes to tell the story of finding Dobberstein on numerous occasions with fingers that were cracked and bloody from constant exposure to water and wet cement. "I would say, 'Father, you better lay off for a few days to let those fingers heal.' And he would say, 'Ah, but there isn't any redemption without a little bit of blood.'"[10]

Dobberstein's dedication to his task and the growing enthusiasm for his shrine—within a few years of his death, it was

attracting some 100,000 visitors a year—suggest that he created an especially compelling variation on a popular devotional form.[11] As he knew, the grotto was a symbolic structure with many layers of meaning. Some of these would be legible to almost anyone, some would be intelligible chiefly to Christians, and some would resonate especially with his originally German parishioners. By peeling away the layers of the symbolic language encoded in the grotto, both in the general type and in Dobberstein's variation on it, we can begin to grasp its devotional significance.

In building these grottoes and placing groups of narrative sculptures in them to illustrate the life of Christ, Dobberstein was first of all alluding to the tremendously important role of caves in Christian history. Many of the crucial events in the life of Christ are typically represented as taking place in or around natural caverns: the Annunciation, the Nativity, the Agony in the Garden, and the Entombment, for example. Many of the major shrines of the Holy Land, such as the Church of the Nativity in Bethlehem and the Church of the Holy Sepulcher in Jerusalem, are built over caves associated with Christ. Moreover, the importance of caves has been reiterated throughout Christian history; some of the most significant and popular pilgrimage sites in Western Europe, such as Montserrat in Spain and Lourdes in France, are associated with caves. Greving testifies that Dobberstein was inspired to build his grottoes not only because of their association with the original Christian mysteries but also because of their connection with the miraculous caverns at Montserrat and at Lourdes.[12]

Writing in an explanation of the Grotto of the Redemption in about 1936, Dobberstein also made a connection between natural caverns and more informal kinds of popular devotion. The mountainous areas of Europe—including his native southern Germany, the Pyrenees, and the Apennines—are laced with limestone caverns that played a role in local religious life. According to Dobberstein, they had often been used in centuries past as shelters by shepherds tending flocks in summer pastures. They came to be decorated with religious emblems and served as impromptu places of worship. In Dobberstein's mind, the shepherds praying in these high mountain caves experienced "a more vivid and direct communication [with God] than those living out among all the cares and distractions of the noisy world." In his homilies, Dobberstein even compared these caves to the cupped hands of God offering protection to his flock.[13]

At the same time that he was affirming the sacred associations of caves, Dobberstein was also evoking the long history of building replicas of holy sites and reiterating the importance of these replicas in popular devotional practice, especially in pilgrimage. Lourdes, for example, inspired countless Old and New World replicas.[14] These replicas were just part of a more ancient phenomenon in which the shrines of the Holy Land were recreated both in Europe and in the United States. One of the first and still one of the most popular and extensive of such replicas is Sacro Monte, at Varallo in northern Italy. It was begun by a Franciscan monk, Fra Bernardino Caimi, whose plan, approved by the pope in 1481, called for an elaborate variation on the *via sacra*, or Stations of the Cross. A sequence of some forty chapels would tell the whole story of Christ, from his ancestry in Adam and Eve to the Crucifixion, strung along a path that would wind uphill to a replica of the Holy Sepulcher and the tomb of the Virgin Mary.

Sacro Monte presents the scenes of Christ's life in as vivid a way as possible. The chapels are filled with polychromed statues in wood or terra-cotta, frozen in dramatic positions. Often embellished with real hair and sometimes real fabric, they are posed in equally detailed painted landscape or architectural settings. The whole effect is one of inspired illusionism, meant to evoke

the feeling of witnessing the actual events. Sacro Monte's capacity to stimulate religious fervor inspired numerous variations on its theme, grand and small. The first several were nearby in northern Italy, but the phenomenon soon spread across Europe and to the New World.[15]

Dobberstein's grottoes share with these earlier replicas the desire to inspire a powerful devotional experience by making visitors feel that they are witness to a religious drama of a particularly emotional sort—the life and death of Christ. Dobberstein underscored this point when he wrote in his 1936 explanation of the Grotto of the Redemption, "To bring people of today, who live centuries removed from those blessed days into closer touch with the things of God, is the aim and effort of the builder." As a magnet for the faithful and the curious alike, the Grotto of the Redemption also evokes popular devotional patterns that are especially strong in Catholic Germany.[16] By providing a focus for pilgrimage activity in his region of the American Midwest, with its high concentration of German immigrants, Dobberstein was catering to spiritual needs that were strong in the religious tradition to which both he and his parishioners were heir. He was doing so in a rural landscape far from other popular shrines of any consequence that might have provided alternative outlets for pilgrimage activity.

But what of Dobberstein's particular variation on the grotto shrine? Many replicas of the sacred cave aim for a more naturalistic effect. Dobberstein, on the other hand, expressed the form in a highly contrived language, derived from Baroque church architecture on the one hand and suggestive of Renaissance grottoes of natural-history specimens on the other. In both instances, he seems to have drawn on this language to underscore the sacred character of the space he was creating, to help establish for his audience the sense of being in closer communication with God.

The language of Baroque architecture is evident at the Grotto of the Redemption both inside and outside. The entrance to the Grotto of the Trinity is dominated by an enormous Roman arch, while the interior is triple-apsed, with columns and vaults supporting a domed ceiling. In plan, Dobberstein's grottoes suggest connections to any number of centrally organized, domed, apsidal churches of seventeenth-century Italy. Moreover, his canopies over the Stations of the Cross look like streamlined versions of Gianlorenzo Bernini's baldacchino for Saint Peter's and even more like the one at San Paolo fuori le Mura in Rome.[17] There is also a specifically German precedent for Dobberstein's architectural language: by the eighteenth century the Italian Baroque—albeit in an even more highly ornamented form—had become the prevailing style for ecclesiastical building in the Catholic regions of southern Germany.

The link between Dobberstein's spaces and Baroque architecture is more than formal, however. The central plan and the many concave surfaces create an especially powerful sense of envelopment. This is frequently heightened by the illusionistic use of painting and sculpture, all of which is intended, as at Sacro Monte, to make the spectator feel like a part of some holy drama.[18] It is this theatrical aspect of Baroque architecture that Dobberstein exploited with particular effectiveness at West Bend: by sharing the space with the statues, visitors become participants in the narrative of Christ's death and resurrection.

Dobberstein's most potent device for drawing his audience into contemplation of God may have been his use of geological wonders. The grotto encrusted with natural-history specimens, like the centrally planned space, has numerous precedents in Italy and Germany. These artificial caverns, which derive ultimately from a classical source, began to appear in Italy during the early sixteenth century in both princely and ecclesiastical gardens.

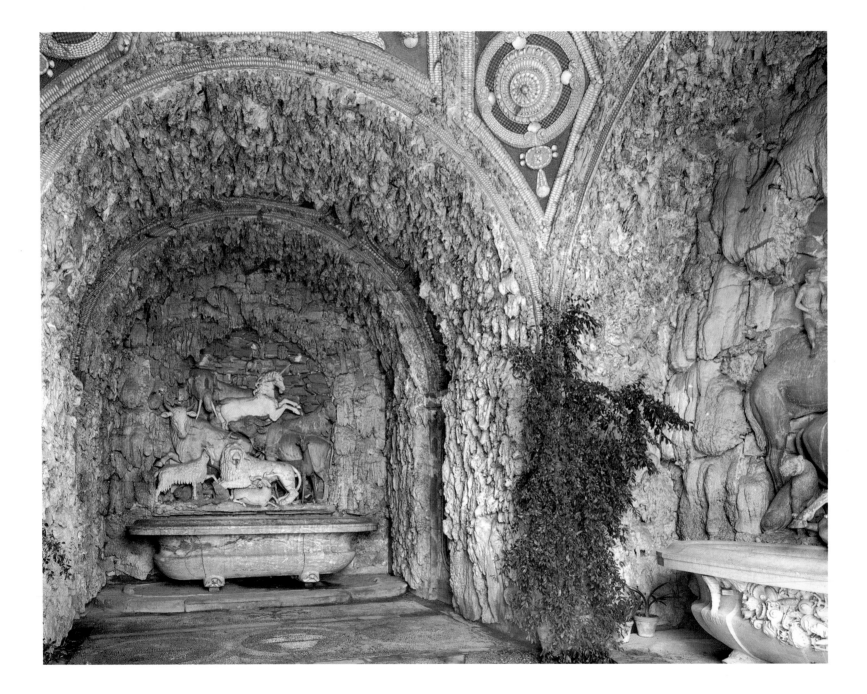

They are now most familiar through surviving examples like the Grotta Grande at the Boboli Gardens in Florence, which was completed in 1593, and the somewhat earlier grotto at Castello, Italy (plate 76). At the latter, fountains with animal sculptures are set in niches encrusted with shells, coral, and tufa, the whole representing the theme of a bountiful earthly paradise. Grotto building spread to Germany and reached its apogee there in the eighteenth century, with splendid examples embellished with shells and minerals at both the Old and New Castles at the Hermitage at Bayreuth, Germany; it continued into the nineteenth, as in the fabulous Venus Grotto built by the "mad king" Ludwig II at Linderhof. Despite considerable variations in form, these grottoes, like the cabinets of curiosities to which they are related, shared in an effort to evoke the plenitude of God's creation.

In Dobberstein's mind, marvelous materials were the visible expression of the glory of God and the surest way to reach the hearts and minds of both the faithful and the potentially converted. "Truth reaches the mind most easily by way of the senses," he wrote in the explanation of his grottoes. "The heart of man is usually more quickly reached through the eye than through the ear." Although not explicitly evoked, Dobberstein's writing resounds with centuries of church teachings about ornamentation. Early Christian doctrine suggested that a knowledge of God might be achieved through meditation on His material creations; the wonder of the physical world could suggest the perfection of the spiritual realm.

In Dobberstein's case, the array of geological wonders was meant to evoke the glory of God by recalling both the lost Eden

76. The Grotto of the Animals, mid-1500s, at Villa Medici, Castello, Italy, with its sculpted beasts and stalactites from local hills, evokes the many wonders of creation. Photo: Ralph Lieberman, 1985.

77. The river of the water of life outside Father Dobberstein's Grotto of the Garden of Eden

and the promise of the New Jerusalem—the two paradises at the beginning and the end of Christian history that bracket the narrative about the Fall and the Redemption. We are explicitly shown the expulsion from paradise in the Grotto of the Garden of Eden. The coming of the heavenly city is less plainly seen, but it is implicit in Father Dobberstein's construction. Looking at his jasper and malachite, turquoise and calcite, it is hard not to be reminded that the Book of Revelation is replete with descriptions of the minerals that will embellish the promised land. The New Jerusalem, we are told in chapter 21, will be adorned with every jewel; the walls will be of jasper, the gates will be made of pearls, and the streets of pure gold. That Dobberstein may have intended to evoke the New Jerusalem is suggested by this parallel: in chapter 22, John is shown the river of the water of life, bright as crystal. Just such a crystal stream erupts from the walls outside Father Dobberstein's Grotto of the Garden of Eden (plate 77).

In all, Dobberstein's Grotto of the Redemption is a place to encounter the marvelous in explicitly sacred terms: to experience the wonders of creation, to be reminded of the original Eden, and to catch a glimpse of paradise. Its effect lies largely in the sense of dislocation that is associated with the marvelous. In the flat prairie, Dobberstein built something completely anomalous: a mountain of petrified wood and rock. In a landscape of limitless vistas and little visible shelter, he fashioned a refuge that combines human art and natural curiosities to create a particularly sanctified spatial experience.

Beginning in the 1920s Dobberstein was commissioned to build some nine other smaller shrines and memorials in Iowa, Wisconsin, and South Dakota, in public parks and at Catholic churches, cemeteries, and convents.[19] Moreover, he seems to have played a part in inspiring similar shrines by other priests. One of the most familiar is the Grotto of the Blessed Virgin at Dickey-

ville, Wisconsin (plate 78), part of a larger ensemble known as Holy Ghost Park that was built in the 1920s by Father Mathias Wernerus. Father Wernerus was also born in Germany, in 1873 at Kettenis, a small village in the Rhineland. He began studying for the priesthood in Europe but emigrated to the United States in 1904. Like Dobberstein, he completed his studies at Saint Francis Seminary in Milwaukee, where he was ordained in 1907. He became pastor of Holy Ghost Parish in Dickeyville in 1918 and served there until his death in 1931.

The Dickeyville grotto reveals numerous technical and artistic connections to the Grotto of the Redemption. The materials are similar, including petrified wood and moss, stalactites, various kinds of crystals, and numerous shells such as conch, abalone, giant clams, and scallops. The building method was also similar: the grotto was raised over a deep foundation of rock and cement and constructed of prefabricated cement panels encrusted with decorative elements. As at the Grotto of the Trinity at West Bend, the entrance to the Dickeyville grotto is framed by a Roman arch and the interior is dominated by a Carrara marble statue of the Virgin and Child, set against a star-studded field of blue and surrounded by stalactites, marble, rock crystal, and a wild array of colored stones.

Wernerus was heir to the same broad cultural traditions as Dobberstein. But the connections between his work and that of Dobberstein are apparently more direct than that. Greving reports that "Father Wernerus came to West Bend and consulted Father Dobberstein about the kind of cement he used, where [he got] the material, and also worked with Father Dobberstein for a week or two to learn the technique of hiding the cement."[20] This must have been in the early 1920s, when the Grotto of the Trinity was nearing completion. Although Wernerus was apparently inspired to begin building at Dickeyville by a desire to memorialize

three soldiers from the parish who died in World War I, his first construction evidently dates from 1925. The grotto was dedicated in September 1930.[21]

The proportions of Wernerus's grotto are squatter than those of Dobberstein's, and in general, his manner is cruder. But in some respects, Wernerus's work is an imaginative variation on that of his mentor. Wernerus made use of a wide range of cast-off materials, including broken tile and glass from a kiln in Kokomo, Indiana, as well as discarded plates, cups, saucers, and vases donated by parishioners and visitors. These shards are an important element in what to my mind is the most interesting fea-

ture of the grotto: a representation on its rear exterior of the tree of life, which bears the twelve fruits of the holy spirit (faith, peace, joy, charity, and goodness, among others). The trunk of the tree is made of petrified wood, with each of the twelve fruits done in a different kind or color of glass, tile, or stone (plate 79). This mix of natural and cast-off materials is also found in several delightful cement urns around the church, from which spring clumps of tile-and-glass flowers.

The grotto at Dickeyville is only one of two principal elements in a park dedicated both to religious and patriotic themes —two themes that are announced at the entrance to the grotto.

78. Father Mathias Wernerus (1873–1931). Grotto of the Blessed Virgin, 1920s, Dickeyville, Wisconsin.

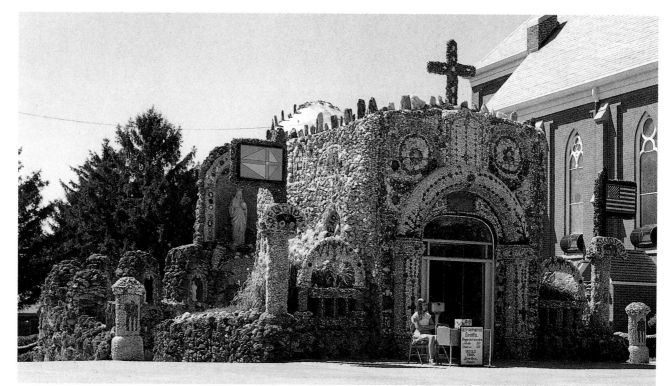

79. The tree of life, with a trunk of petrified wood, on the rear exterior of the Grotto of the Blessed Virgin.

To one side is a representation of a papal flag with the word *religion* beneath it; to the other is an American flag with the word *patriotism*. The patriotic motif is developed in the park's other main feature: an ornate, semicircular wall made of shells and glass flowers, at the center of which stands a statue of Christopher Columbus in a large arch. At either end of the wall are statues of George Washington and Abraham Lincoln. These statues are relatively banal, but Wernerus's setting for them is quite effective and the shrine is nicely set off against an arc of arbor vitae trees. Shell fences are used throughout the park, notably around the flower beds that connect the patriotic shrine with the grotto.

The work of Dobberstein and Wernerus may in turn have inspired other creations. In the late 1920s a group of stone shrines was begun by Father Philip J. Wagner in Rudolph, Wisconsin; he created a landscape of maple and evergreen trees punctuated with stone niches devoted to various saints and sacred events, all arrayed around a fabulous construction called the Wonder Cave (plate 81). Father Wagner was born in Festina, Iowa, in 1882, to a farm family of German descent. At the age of fifteen he was hired out as a farmhand; after five years of manual labor he resolved to become a priest. He entered a Jesuit school in nearby Prairie du Chien, Wisconsin, in 1903, and went on to study for the priesthood in Innsbruck, Austria, from 1911 to 1915. During those years he toured extensively in Europe: to Paris, Florence, and Rome, to Germany and Greece. He also made pilgrimages to Lourdes and to the Holy House of Nazareth at Loretto, which was said to have been miraculously transported to Italy.

It was during his visit to Lourdes in September 1912 that Wagner was apparently first inspired to build a shrine to the Virgin. In his autobiography he offers two accounts of this visit. The first recalls that "the trip was not too prayerful; it was taken more in a sightseeing way," although he drank and bathed in the waters

six times. In a later chapter, however, devoted specifically to his work on the grotto shrines at Rudolph, he maintains that he had been ill at the time and had prayed to the Virgin for help. "If my health should be restored, I promised to build a shrine to Our Lady. . . . Taking baths in the miraculous springs, my condition slowly improved, my strength returned, my courage revived."[22] The former account is probably more accurate; the latter, so like Dobberstein's, may have been created later to soften resistance to the project among parishioners and the church hierarchy. According to the grotto guidebook, some parishioners felt that Wagner's work was a folly. One of them apparently told the priest, "You are no more fit to build [a grotto] than I am to run a chicken farm, and I don't know a thing about chickens." The bishop of La Crosse, who ordered Wagner to cease work on the project in 1949, complained that a permanent church building for the parish had not yet been completed, "while the most elaborate developments are going on in this series of caves which to me are perfectly nonsensical."[23] Wagner put up a church the next year, then went back to work on his grottoes.

Wagner began his collection of shrines in 1928, with the help of Edmund Rybicki, who assisted the priest until the latter died in 1959.[24] In an open, flat meadow behind the parochial school that

housed the temporary church, they first erected a Lourdes group, with a Carrara marble figure of Saint Bernadette kneeling before the figure of Mary in a stone niche. Over the next thirty years they planted dozens of trees and added numerous other religious and patriotic shrines, including a wooden chapel devoted—appropriately enough—to Saint Jude, patron of the impossible, and a stone construction honoring the nation and the state of Wisconsin. The focus of their efforts was the Wonder Cave: an artificial hill made of stone; planted with shrubs, flowers, and vines; and crowned with a statue of Christ with arms outstretched.

The truly wondrous aspect of this structure is its interior. Again, the sense of crossing a threshold to another world is exceptionally strong. You stoop to enter; the door is only about four feet high. Then you follow a narrow path that winds around the inside of the hill for about a thousand feet (three hundred meters). At first, the interior is illuminated by white light that shines through perforations in aluminum sheets shaped into religious insignia such as the cross, a prayer book, and a rosary. Later, you encounter groups of small polychrome statues set into painted niches and illuminated with colored light, which illustrate Catholic doctrine or episodes in the life of Christ. After wandering in dark, almost claustrophobic spaces, you are suddenly released into a two-story chamber, with a nearly life-size, polychrome figure of Jesus in prayer (plate 82). This is a re-creation of Christ's night of agony in the garden at Gethsemane; opposite him are the sleeping figures of Peter, James, and John, while above him appears the comforting angel. Christ kneels under a simulated night sky by a huge log that Wagner had brought into the cavern. With its dramatic lighting, naturalistic details, and painted figures and background, this space is reminiscent of the chapels at Sacro Monte. The intent

81. Father Wagner's Wonder Cave. Photo: John Beardsley, 1991.

82. Interior of the Wonder Cave: Christ in the garden at Gethsemane. Photo: John Beardsley, 1991.

was the same: to create an emotional experience that would inspire popular devotion. As with Dobberstein's work, however, it is the grotto setting, with its sense of being out of the ordinary world, that proves the most compelling part of this experience.

Wagner worked with stones that he collected primarily from local fields and forests; some were given by farmers. The largest rock weighed about eighty tons (seventy-three metric

tons) and was incorporated into the patriotic shrine (plate 80). The many plants used to create a verdant garden setting were given to the parish over the years by Ebsen Greenhouses in Wisconsin Rapids. Wagner embellished his shrines with tile mosaics and chunks of melted colored glass. The source of the latter provides a clue that Wagner was in touch with Wernerus; their glass came from the same place. "I heard that I could obtain colorful glass leftovers from Kokomo Opalescent Glass Company. . . . I ordered a few barrels of green, white, blue, red, and yellow glass and melted it into lumps."[25]

Anecdotal evidence suggests that the German-American priests of the Upper Midwest, beginning with Dobberstein, encouraged each other in creating spectacular local variations on the sacred cave, using natural-history specimens as their principal ingredient. While they are responsible for what appears to be the densest concentration of stone grotto shrines in this country, there is another remarkable example, known as the Ave Maria Grotto, at Saint Bernard Abbey in Cullman, Alabama. Created in the 1930s by a lay brother, Joseph Zoetl, it is the centerpiece of a garden filled with miniature replicas of all the important—and many of the lesser—churches of the Holy Land, Europe, and North America (plate 83).

Brother Joseph was also a German immigrant. He hailed from Landshut, Bavaria, quite close to Munich, where he was born in 1878. At the age of fourteen he was recruited by the Benedictines for a new monastery they were establishing in Alabama; he arrived in Cullman in February 1892 with the hope of becoming a priest. But whether because of physical infirmities—he became severely hunchbacked as a young man—or because he was not an adequate student, he did not attain the priesthood. Instead, he was invited to stay on at Saint Bernard Abbey as a lay brother. There he remained for most of the rest of his life, even-

tually, in 1912, becoming responsible for the abbey powerhouse, with its steam boilers and generators.

Brother Joseph's artistic inclinations seem to have surfaced as early as 1905, when he created a small grotto setting for a cement statue.[26] After his appointment to the powerhouse, the pace of his artistic activity picked up, and by the late 1910s he was building small architectural replicas in cement. His "Little Jerusalem," installed near the brothers' recreation area, began to attract such crowds that the abbot told him to hold off on additional creations until he could find a place for them that would not bother the monks. Brother Joseph apparently already knew where he wanted the little buildings to go: in an abandoned quarry on the monastery grounds, which had been excavated for building materials. But the abbot demurred.

So Brother Joseph found another outlet for his creativity. One of the brothers ran a store on the grounds where he sold religious articles to help raise money for mission work. Sometime in the early 1920s he bought five hundred small statues at a bargain price and gave two of them to Brother Joseph to shelter in grottoes of glass and tile. The two sold instantly, so the brother returned with the other 498. It was the start of an extraordinary enterprise. Brother Joseph kept count of his miniature grottoes until he reached five thousand; he then stopped counting but kept making the settings for another fifteen years. Most of the proceeds went to support missionary work, but Brother Joseph's share of the earnings, for which no purpose had been established, reached 3,200 dollars in the first seven years.[27]

83. An old quarry was reclaimed to become the setting for the Ave Maria Grotto, 1932–34, and the painted concrete replicas of Christian shrines created by Brother Joseph Zoetl (1878–1961) at Saint Bernard Abbey, Cullman, Alabama. Owned by the Benedictine Society of Alabama.

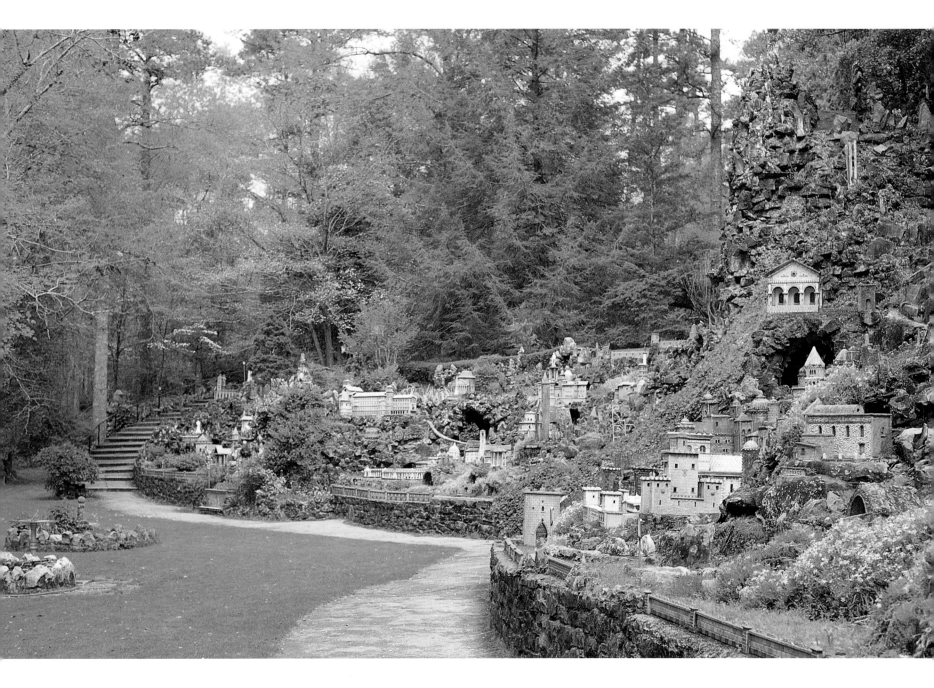

84. Brother Joseph Zoetl. Photographer and date unknown.

Brother Joseph to Cincinnati to look at grottoes there, including one (destroyed in the late 1980s) at Good Samaritan Hospital's Marydale Gardens. Meanwhile, the quarry at Saint Bernard Abbey was being readied. Under the direction of Father Patrick O'Neill, a crew of ten men cleared the site, moved dirt, planted shrubs, and laid out paths. O'Neill was reportedly helped in this task by William Cowls Dickson, a professor of landscape architecture at Peabody College in Nashville, who apparently executed some sketches.[28] By the time Brother Joseph returned to Cullman in late June 1932, the quarry was ready.

First, the Little Jerusalem was moved. Then, using postcards, travel brochures, and encyclopedias as sources, Brother Joseph made numerous other painted concrete replicas. He had a stock of materials to use in decorating these miniature buildings, much of it sent by people who had admired and purchased his little grottoes: cut glass, shells, costume jewelry, marbles, broken tile, reflectors, birdcages, glass floats from fishing nets, and even toilet-bowl floats. And he had his earnings from the little grottoes to purchase whatever other materials he needed, especially cement.[29] To make the miniatures, he worked in the powerhouse on a slab of slate that had once been a pool table. His tools were simple—just trowels, knives, a straight edge, and paintbrushes. Once the replicas were complete, they were moved by wheelbarrow to the quarry and carefully positioned by Brother Joseph, with the shrines of the Holy Land to the right of the grotto, those of Europe and the New World to the left. Work on these miniatures continued without interruption almost until Brother Joseph's death in 1961.

Meanwhile, construction began on the central grotto (plate 85); it was finished by 1934. The cavern rose to twenty-seven feet (8.1 meters) at the apex and was built mostly of rock taken from the quarry and reinforced with cement. Brother Joseph had help placing the heavy stones, but he embellished the interior himself.

Impressed by his creativity (and perhaps by his financial accomplishments as well), in 1932 the abbot reversed his decision about Brother Joseph's plans for the quarry and told him to go ahead. By then Brother Joseph was fifty-four and beginning to feel his age. Nonetheless, the abbot was determined not only that Brother Joseph should put his miniature Holy Land replicas in the quarry but that he should build a large grotto as well. He sent

He told the workmen where to suspend rods and railroad spikes, which he then coated with cement to resemble stalactites. He had the benefit of someone else's misfortune in decorating the grotto: on April 29, 1933, a freight car carrying marble derailed near Cullman; the marble was shattered and the quarry owner gave it to the abbey. Brother Joseph used it liberally, both inside and outside the grotto, along with colored glass, shells, and polished stones. In February 1934 three Carrara marble statues, carved in Italy, were placed above and behind a mosaic altar in the shrine: Our Lady of Prompt Succor, flanked by Saint Benedict and Saint Scholastica. These seem to have been ordered the previous year by the abbot from Pustet's, a religious-goods store in Cincinnati.[30] On May 13, 1934, the grotto was blessed as an oratory chapel by the bishop of Mobile and the grounds were opened to the public. The grotto was placed on the National Register of Historic Places in 1984, and it now attracts some sixty thousand visitors per year.

The elements of Brother Joseph's work remain just as he left them. Along a path that descends to the former quarry are several wayside shrines and a replica of the Benedictine Abbey church in Montserrat, Spain. Several buildings of importance in Brother Joseph's life come next: a replica of Saint Martin's in Landshut, Bavaria, said to have the tallest brick tower in the world; copies of Saint Bernard Abbey buildings, including the powerhouse in which Brother Joseph labored; and a miniature of the 1849 Cathedral of the Immaculate Conception in Mobile, with its domes re-created in toilet-bowl floats. These are followed by replicas of several California mission churches.

A small grotto made of marble and containing a statue of Saint Teresa of Lisieux (the saint affectionately known as the Little Flower) marks the transition to the Roman area of the garden. Front and center in this section is the replica of Saint Peter's,

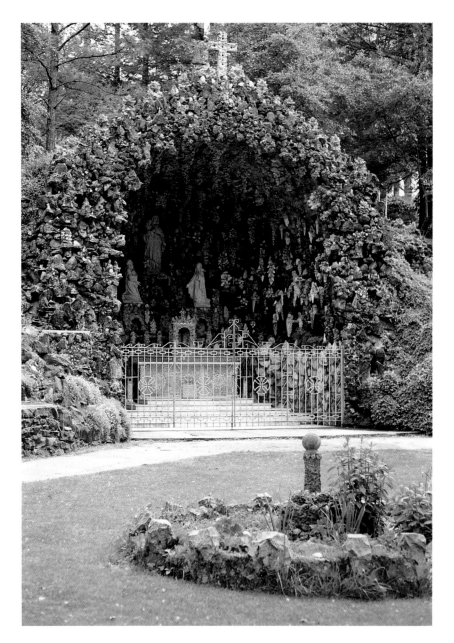

85. Ave Maria Grotto.

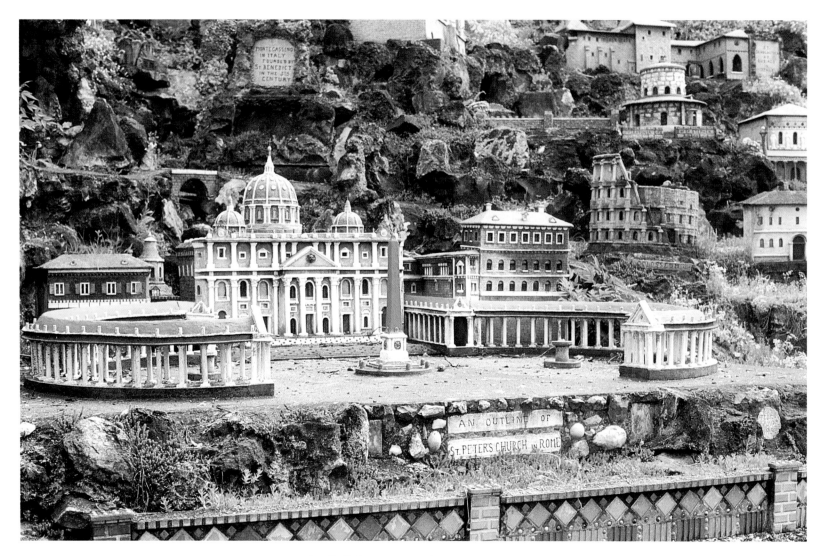

86. *A detail of the Roman garden at Ave Maria Grotto,*
with its replica of Saint Peter's.

with its dome made over a birdcage and its columns cast in laboratory test tubes (plate 86). Arrayed up the hill behind it are versions of numerous classical and medieval structures in Rome and its surroundings, including the Pantheon, the Temple of the Vestal Virgins, the Colosseum, Monte Cassino Abbey, Saint Scholastica at Subiaco, and San Paolo fuori le Mura. These miniatures are arranged on stone ledges and surrounded with flowering plants and shrubs. They are well proportioned themselves and with respect to each other; their spatial relationships are managed with considerable deftness, notwithstanding changes in both depth and elevation. It seems clear that they were located to achieve an intriguing compositional effect rather than a historically accurate geography of Rome. And as a composition—of architectural miniatures, plants, and stonework taken together—this part of the garden is especially fine.

Immediately to the right of the main grotto is another notable section, illustrating the shrines of the Holy Land. This group includes Brother Joseph's renditions of the Gate of Herod, the Temple of Jerusalem, the Fortress Antonia, and the cave of Gethsemane. Three crosses mark the site of the Crucifixion, while an empty tomb beneath this Calvary alludes to the Resurrection. Another small grotto, this one dedicated to Saint Joseph, separates this Jerusalem from the relocated Little Jerusalem that was Brother Joseph's first work; by comparison to the later ones, these first miniatures seem very crude. A path that leads from the Little Jerusalem out of the quarry passes several more Old Testament miniatures created entirely out of Brother Joseph's imagination: the Tower of Babel, Noah's Ark, and the Hanging Gardens of Babylon. Although Brother Joseph's replicas were mostly religious, a few address patriotic or historical themes, as at Wernerus's Holy Ghost Park. Scattered along the path leading to and from the quarry are a miniature Statue of Liberty, an American flag, and memorials to alumni of Saint Bernard Abbey College who were killed during World War II and the Korean War.

It is doubtful that Brother Joseph was in contact with the German-American priests of the Upper Midwest. Instead, the existence of his grotto and collection of religious replicas reinforces the idea that the practice of creating reproductions of holy places, especially caves, was widespread in the Catholic world. That the phenomenon of grotto building was even more pervasive is confirmed by a remarkable group of concrete sculptures found in a wooded glade in Memorial Park Cemetery in Memphis. Set in an artificial rock outcrop punctuated with *faux bois* tree trunks and bridges, they were made to resemble a rock-cut tomb, a crystal cave, and stone spires. The concrete work was the inspired creation of an itinerant Mexican-born artist named Dionicio Rodriguez, who was employed for several years in the mid-1930s by the cemetery's owner, E. Clovis Hinds.

According to his granddaughter, Katherine Hinds Smyth, Clovis Hinds was descended from "pioneer Methodists who trekked across the mountains from North Carolina" and settled in Tupelo, Mississippi. Hinds, born in 1868, ran an insurance company in Tupelo that he moved to Memphis in 1916. Over the next few years he traveled widely; on one of his trips he met Hubert Eaton, founder of the Forest Lawn Cemetery in Los Angeles, one of the first cemeteries in the United States to use flat, ground-level markers instead of headstones. Hinds was moved by the experience to plan a similar cemetery for Memphis; in 1924 he sold his business and bought fifty-four acres (21.6 hectares) on the east side of town that became the nucleus of Memorial Park.

From then until his death in 1949, Hinds devoted himself to the design and development of his cemetery. Katherine Smyth remembers her grandfather as "deeply religious and a pillar of the church in Tupelo. After he moved to Memphis, he joined a

87. Dionicio Rodriguez (1891–1955) at Abraham's Oak, Memorial Park Cemetery, Memphis, c. 1935. Photographer unknown.

church, but never darkened the door. He spent every Sunday at the cemetery, romancing sales." To facilitate his job, he retained the landscape architect John Noyes, an associate of George E. Kessler of Saint Louis; together they created a picturesque, park-like environment of rolling meadows and mature oaks embellished with new stands of cherry and Chinese elm. Hinds also hired a local stonemason, Fred Andrews, to construct fountains, reflecting pools, and bridges of Arkansas fieldstone. In 1935 he engaged Rodriguez to further beautify the cemetery.

Rodriguez was apparently born in 1891 in Toluca, Mexico, about fifty miles (eighty kilometers) from Mexico City.[31] At the age of fifteen he started work in a foundry, and the next year he began training with an Italian artist who specialized in concrete reproductions of rocks, ruins, and ancient buildings. By the mid-1920s Rodriguez had emigrated to San Antonio, Texas, which became his home base until his death in 1955. In San Antonio he became associated with the Alamo Cement Company and did some work at their headquarters and in local parks. Word of his skills must have spread quickly, for by 1932 Rodriguez had been hired by an Arkansas developer named Justin Matthews, who was building a replica of an old stone mill as the centerpiece of a park in his new housing development in North Little Rock. Rodriguez completed the interior of the mill with *faux bois* details and embellished the surrounding landscape with several bridges—one seemingly made from the tangled limbs of a locust tree—along with railings and benches, an enormous waterwheel, and sluiceways (plate 88). His most spectacular achievement at this site is a thirty-five-foot (10.5-meter) single-arch bridge made to look like rough stone dripping with stalactites and held up by the entwined branches of two persimmon trees (plate 89). It was apparently on the strength of these sculptures that Rodriguez was hired by Hinds, for postcards of them were found in the latter's scrapbooks.[32]

For Memorial Park Cemetery, Hinds first commissioned a wishing well and a version of Ponce de Leon's legendary fountain of youth under an imitation thatched roof. Evidently pleased with the results, Hinds then set Rodriguez to work on what became

88. Dionicio Rodriguez. Concrete sculptures including faux bois *bridges and a waterwheel at "the Old Mill," c. 1932, North Little Rock, Arkansas. Photo: Bob Compton, 1994.*

89. Concrete bridge by Dionicio Rodriguez, made to look like stone and entangled tree branches, North Little Rock. Photo: Bob Compton, 1994.

the cemetery's central group: the Cave of Machpelah, Abraham's Oak, and the Pool of Hebron (plate 90). They are set into a long outcrop of simulated rock that Rodriguez placed against the side of a hill above a small watercourse. The pool is lined with naturalistic stone benches and contains a fountain made by Rodriguez. The Cave of Machpelah has a front made to resemble stone blocks under a crenellated cornice; inside are two tombs under what looks like a roof of hand-hewn logs. Abraham's Oak is the hollow and broken trunk of an ancient tree, open on both sides and containing a pair of benches. This group is approached over a finely detailed rustic footbridge.

For the most part, these structures illustrate a narrative from the book of Genesis. Abraham's Oak alludes to the trees at Mamre under which the patriarch, as told in chapter 18, received the divine visitors who announced that his aged and previously barren wife Sarah would bear a son. The Cave of Machpelah, mentioned in chapter 23, was purchased by Abraham to be his family's tomb. Both Mamre and Machpelah were near Hebron, which, like many a town in the arid mountains of the Holy Land, had a pool or common well to provide water for its people.[33]

Just down the hollow from Abraham's Oak, Rodriguez's rocky outcrop is abruptly punctuated by two tall spires. One is the focal point of an area called God's Garden; the other marks the entrance to the Crystal Shrine Grotto (plate 91). This artificial cavern, which runs about twenty feet (six meters) back into the hillside, is constructed mostly of quartz selected by Hinds and Rodriguez during visits to caves in the Ozarks. The space is held up by two columns made to look like crystalline stalactites; smaller stalactites hang from the ceiling. Around the perimeter, ten niches contain scenes that depict the life of Christ; several have settings fabricated or painted by Rodriguez, although the figures are by other artists. Most interesting are the Nativity, in

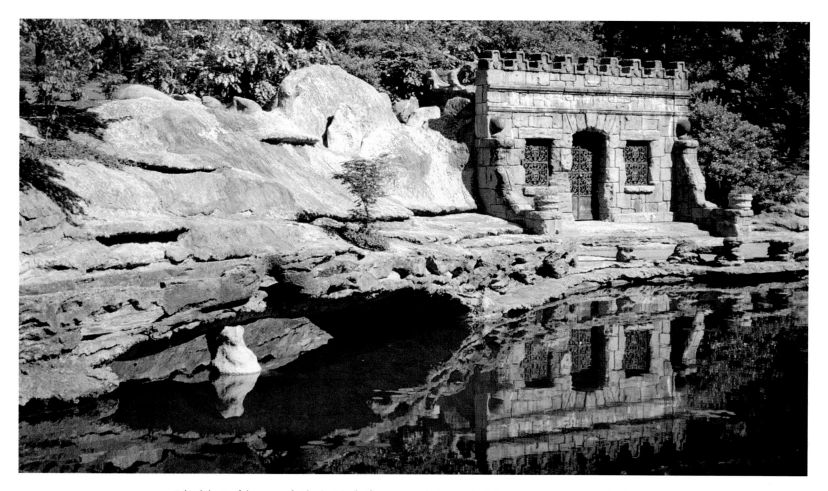

90. Dionicio Rodriguez and Clovis Hinds (1868–1949). Pool of Hebron and Cave of Machpelah, 1935,
Memorial Park Cemetery, Memphis. Now owned by Memorial Park, Inc. Photo: John Beardsley, 1993.

a *faux bois* manger with a thatched roof, and the Crucifixion, depicted in a painted, rocky landscape.

Because of its many details and the use of scavenged rock, Rodriguez apparently labored on the grotto until 1943. But otherwise, his work at Memorial Park seems to have been finished during a couple of summers in the mid-1930s. Contemporaneous accounts reveal that he worked very quickly. An article from the June 20, 1935, edition of the *Memphis Commercial Appeal* reports that Rodriguez, who is described as "a stumpy little brown man from Mexico City," was just sixteen weeks into

his work and had already finished the rustic footbridge and Abraham's Oak. "Now he's sweating in the bottom of the pool of Hebron. And when that is completed, he will dig into the Cave of Machpelah."[34]

Rodriguez spoke very little English and was reticent about his technique. The basic construction was fairly standard: cracks in some of the sculptures reveal that he worked over an armature of steel rods and wire mesh, which he covered in rough concrete and aggregate. But he finished it with concrete colored according to his own formulas, which he did not share. A former cemetery employee, interviewed by Katherine Smyth, reported that "Rodriguez had a tent in which he mixed his colors. He used gallon jugs, and when he had emptied one, he broke it. He was very secretive and would not let anyone see the names on these jars."[35] Manipulating this tinted concrete with handmade tools and table utensils, he achieved remarkable details. The net effect is realistic to the point of being deceptive: the knotty planking on the rustic footbridge seems to be held down by real spikes; the handrails appear to peel real bark.

Rodriguez was a virtuoso at his art, but he was well within the tradition of the European picturesque, which derives ultimately from eighteenth-century England. By the early nineteenth century, pattern books had appeared in Britain and on the Continent describing how to make rusticated garden structures and furnishings to enhance both private and public grounds. These included rude wooden shelters, log and rock bridges, and naturalistic grottoes made from stone and tree roots. Although these structures were originally made from real stone and logs, it was soon discovered that concrete could be made to resemble these materials at less expense and with greater durability; *faux bois* elements were subsequently incorporated into the landscape of public parks in nineteenth-century Europe. It was in the tradition of

such rusticated concrete work that Rodriguez seems to have been trained in Mexico City.

Rodriguez may have been responsible for the basic stylistic language used in the sculptures at Memorial Park, but Hinds was an avid reader of the Bible and probably determined the subject matter of the principal group, including the Tomb of Machpelah and the Pool of Hebron. According to his granddaughter, Hinds had visited the natural rock formations at the Garden of the Gods near Colorado Springs, which were evidently his inspiration for God's Garden at Memorial Park. Hinds apparently also specified the curious mixture of coffin types in the Cave of Machpelah. To either side are stone sarcophagi, as might be expected. But in a niche between them lies an enormous cement log, evidently an allusion to the oak-tree coffin—the tomb of a Bronze Age chieftain—that was unearthed in Denmark during the 1930s.

Some of the sculptures at Memorial Park replicate earlier works by Rodriguez and thus can be attributed entirely to him. Abraham's Oak is a variation on an untitled tree-trunk shelter in Lakewood Park, North Little Rock; Hinds probably requested a copy, to which he attached the biblical title. The bridges are likewise variations on earlier pieces. But the genesis of the idea for the Crystal Shrine Grotto is more perplexing. Katherine Smyth says that family lore attributes it to Hinds. Given his interest in geology, this is likely to be true. Hinds's scrapbooks contain numerous postcards of caves that he visited on his trips through the West. His correspondence also reveals that he was closely involved in the selection of materials for the grotto—in a letter to the Diamond Cave Corporation in Jasper, Arkansas, he insisted on receiving mostly "beautiful, clear crystals, and the balance in desirable stalactites."[36] But given the pervasiveness of cave shrines in the Catholic world, the concept may have been familiar to Rodriguez as well. Moreover, grottoes are a popular form of grave decoration

among Mexican Americans in Texas, and there are cavelike elements in Rodriguez's previous work.[37] The large bridge at the Old Mill in North Little Rock is decorated with stalactites (plate 89), and artificial caverns are part of the language of the picturesque in which Rodriguez was trained. So Rodriguez might also have suggested the creation of the crystal shrine. In any event, it seems that the sensibilities of artist and patron were unusually well suited to each other. Indeed, the sculptures at Memorial Park are really the outcome of a creative collaboration between them.

Like so many other grotto shrines, the caves at Memorial Park were meant to rekindle faith by suggesting the immanence of God in nature. "What could be more educational and a better incentive to true piety and devotion to both young and old," Hinds speculated in his scrapbook, "than to step out of the [world] into an unbelievable fairyland of Nature's sculpturing and religious art?" The same appeal to popular piety has inspired still more grotto shrines in America, some contemporaneous with the work of Dobberstein and other artist-priests, some spawned in their wake.[38] Together they testify to the surprising resilience of the grotto form—and of religious replicas in general—in vernacular culture. The form has all but disappeared from typical modern gardens, dedicated as they are to leisure, function, or virtuoso horticultural display. The grotto lingers only in the backwaters of the popular ecclesiastical landscape, evoking biblical history in some instances, Christian mysteries in others, and in every case, the wonders of creation. Here and there, the grotto survives to represent the marvelous in particularly sacred terms, marking the threshold to a spiritual realm that more worldly gardens have largely repudiated.

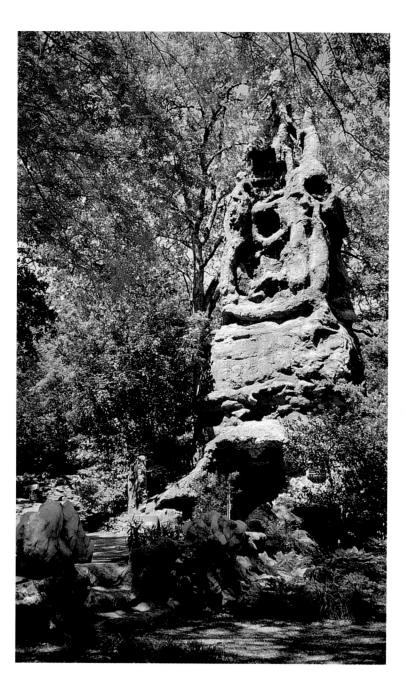

91. Entrance to Rodriguez's Crystal Shrine Grotto, completed 1943, Memorial Park Cemetery. Photo: John Beardsley, 1993.

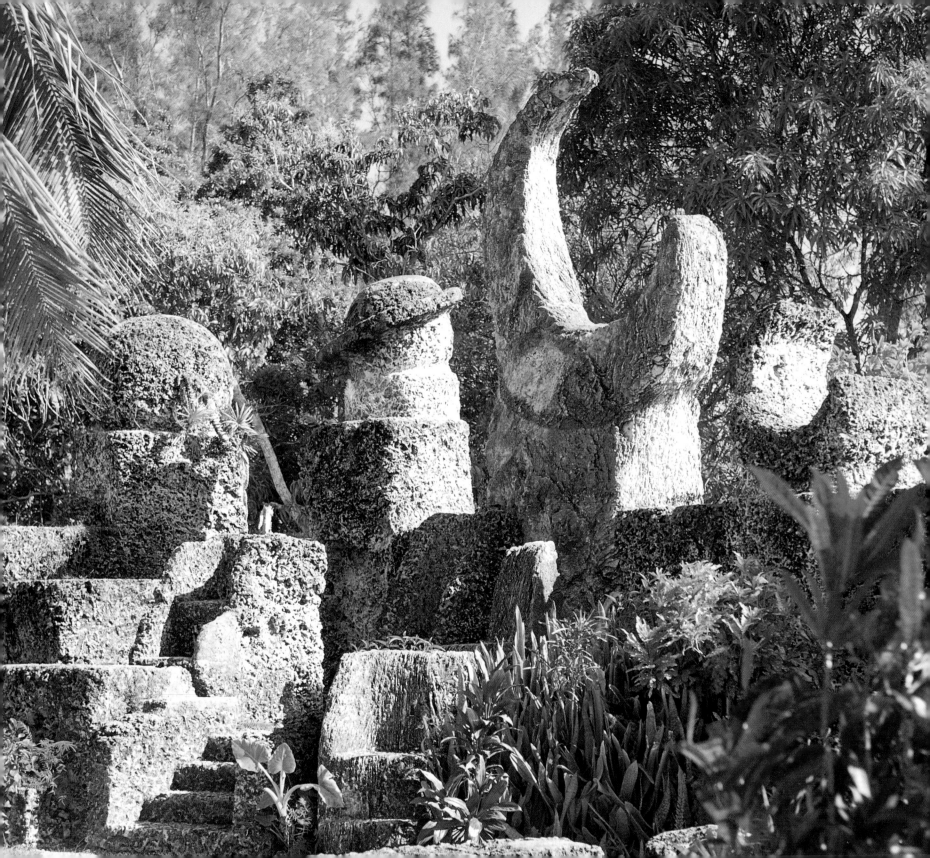

4

Loving Well and Living Right

Whatever it is, it's not nothin' local. But it sure is pretty.

A neighbor of St. EOM's, on his Land of Pasaquan

O N THE EVE OF HIS WEDDING in a small village near Riga, Latvia, in 1912, Edward Leedskalnin was jilted by his fiancée, Agnes Scuffs. He was twenty-six, she was sixteen. Later in life, he insisted that her motive for jilting him was as crass as it was obvious. In his volume of political and moral philosophy titled *A Book in Every Home* (1936), he wrote: "I will tell you why I did not get the girl. . . . The trouble was that I did not have the money."[1] Agnes may have had other reasons: not only was he ten years older, but his writings reveal that he was headstrong and opinionated, characteristics that may have sabotaged his romantic ambitions.

Whatever the truth of the matter, this would prove to be a crucial event in Leedskalnin's life. Soon after being spurned, he left Latvia and emigrated to Canada. He eventually found his way to Washington State, where he worked in logging camps. Somewhere along the way he developed a case of tuberculosis and was advised to seek the warmer climates. So he moved on:

first to California; then to Texas, where he worked on cattle drives; and finally to South Florida. Around 1920 he bought an acre (0.4 hectares) of land south of Miami in Florida City, then an isolated community.

Much of South Florida lies on thick deposits of oolitic limestone, commonly called coral rock. Sometime in the early 1920s Leedskalnin—who was born into a family of farmers but trained as a stonemason—began to mine the rock under his property and carve it into massive, blocky forms. Working alone and using only simple tools—wedges made from truck springs, block and tackles, winches, tripods, and a homemade wheelbarrow—the five-foot, one-hundred-pound man raised pieces of rock weighing as much as twenty-eight tons (25.5 metric tons) and fashioned them into many of the elements now found inside the walls of a fortress known as Coral Castle (plate 93). These include rocking chairs, tables, beds, a moon fountain, representations of the planets Mars and Saturn, and a forty-foot (twelve-meter)

92. *Edward Leedskalnin (c. 1886–1951). The throne room and planets at Coral Castle, Homestead, Florida. Many of the massive stone carvings inside the walls of Coral Castle were made in the 1920s in Florida City and moved by Leedskalnin to their present site in Homestead in 1936.*

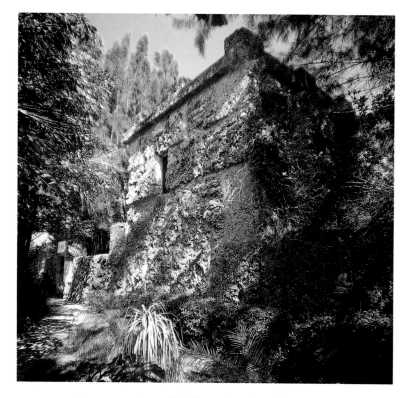

93. Exterior walls of Coral Castle, after 1936.

obelisk pierced near the top with a six-pointed Latvian star. He was making himself a home in the hope that his beloved might one day come and join him. He told the curious that he was "waiting for Sweet Sixteen."[2]

In 1936 Leedskalnin decided that Florida City was becoming too populous, so he bought ten acres (four hectares) near Homestead, about ten miles (sixteen kilometers) away. He wanted to take his home with him, so he borrowed a neighbor's tractor and hitched it to the chassis of an old truck and, piece by piece, hauled the stonework to his new land. There he excavated still more rock, much of it in four-by-eight-foot blocks that were three feet

thick and weighed about thirteen thousand pounds apiece (1.2 by 2.4 by 0.9 meters; 5.9 metric tons). He raised these into position to form the walls of an enclosed compound. In one corner he built a two-story tower with his tool shop downstairs and his bedroom above. Entrance to the compound was through two stone gates, one weighing three tons (2.9 metric tons), the other nine (8.2 metric tons), both of which pivoted on a single axle (plate 94). Pride in his engineering gave Leedskalnin the title for his environment, which he called Rock Gate Park. (The name was later changed by new owners to Coral Castle.) There he continued to live until his death in 1951, perfecting his domestic arrangements and writing books about bodily health and the proper conduct of life, while ostensibly still waiting for Sweet Sixteen.

Leedskalnin's values, like those of the other artists to be encountered in this chapter, were anything but orthodox. Indeed, with Coral Castle, we move away from the explicitly Christian or patriotic garden toward one that expresses a more personal construction of faith—so personal, in fact, that the environments in the pages that follow bear little thematic or iconographic relation to each other. In order to find the thread that connects them, we have to look more to motive than motif: these are all profoundly symbolic spaces in which their creators sought refuge from the world, creating a safe place in which to articulate idiosyncratic variations on political and moral philosophy, notions of wholesome living, or ideas about love.

Despite their iconographic dissimilarities, these environments share some structural characteristics, for which the fortress and the walled village provide the most compelling paradigms. Indeed, the wall is the central rhetorical strategy in this chapter. A double-edged device, it plainly shuts out the world, symbolically breaking the conventions of the surrounding landscape and culture. But it also invites inspection, by its very presence draw-

ing attention to the mysteries it might shield. The more unusual and emphatic the walls, the more powerful this effect of attraction and repulsion. The device is strengthened by elaborate gates and portals, a variation on the threshold-to-another-world represented in the last chapter by the grotto. But the world within, in this case, is not so comforting. These gates and portals convey the implicit caution to beware the challenge to your moral and philosophical assumptions.

These walled compounds suggest that their builders experienced even greater feelings of alienation from their communities than did the artists of previous chapters. Indeed, they were more likely to be perceived as crazy and, in truth, several of them ranged pretty far from conventional behavior and opinion. But this is not to say that these creators were entirely free of historical influences or values shared with their neighbors, for they continued to take many of their cues from external sources or circumstance. Some of them had quite definite ideas about the way the United States ought to be governed, which constitute a quirky variation on the civil religion of the second chapter. Others, in their quest for healthful living and longevity, explored a variation on the Edenic theme, the myth of eternal life in an earthly paradise. In their idiosyncrasy these artists illustrate once again a deeper congruity among visionaries, many of whom seem ultimately to spring from the strongly sectarian tradition of religious practice in this country. Although these environments are not easily categorized as religious, their makers are among countless Americans who have rearranged the constellations of the moral universe to fit their own cosmology. In their very dissimilarity, in other words, these artists are alike.

Coral Castle today remains much as Leedskalnin left it: the various functional and symbolic creations inside the walls are still in their original configurations (plate 92). Some reveal an interest in astronomy, such as the Polaris telescope and the sundial. Others have a local relevance, such as the table in the shape of Florida. Most, however, are emblematic of love or related to domestic life in some way. These elements include a heart-shaped table and several love seats, which come in two types: side-by-side for good days, and back-to-back for spats. Against the east wall is a throne room, with chairs for Leedskalnin, his longed-for bride, and their children. Nearby are their beds, likewise carved in coral with stone pillows; they too come in a range of sizes, from cradle to twin (plate 97).

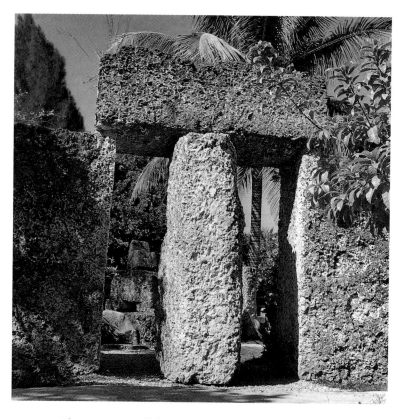

94. Nine-ton gate, which pivots on a single axle, at Coral Castle.

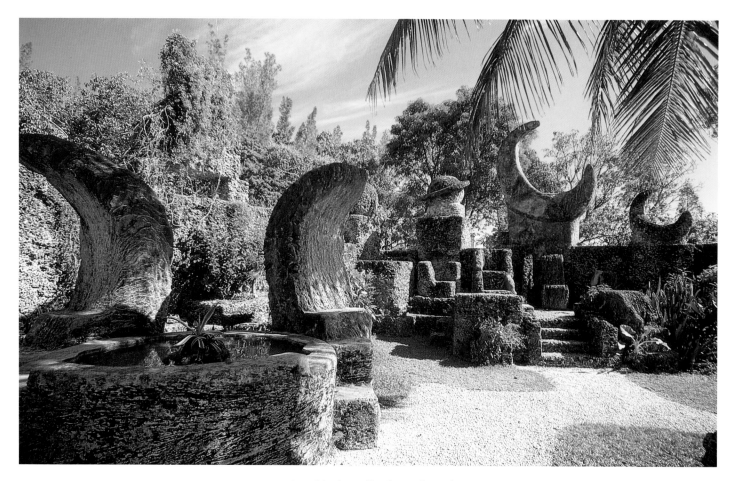

95. Inside the walls of Coral Castle.

An extremely practical man, Leedskalnin provided for his basic comforts; he dug a well, built a barbecue, and made a pressure cooker out of the rear axle housing of an old Ford. He felt he should take the sun to keep his tuberculosis in remission, so he made a coral couch perched on a brake drum, which he could turn in any direction toward the healing rays. He even carved himself an outdoor bathtub and smoothed the inside with cement.

This he filled with water each morning; it was solar-heated during the day and ready for bathing by late afternoon.

Both inside and outside the walls of his castle, Leedskalnin created gardens of vegetables, fruit trees, and flowering vines. Among visionary artists, in fact, he was unusually attentive to plants. He used both species native to South Florida and numerous subtropical exotics as well, including Dade County pines

ABOVE: 96. The Feast of Love Table; behind it, Leedskalnin's two-story tool shop and residence.

RIGHT: 97. Behind the stone beds at Coral Castle rises an obelisk marked with a six-pointed Latvian star.

together with royal and silver-leaf palm, tung nut trees, sapodilla, hibiscus, and agave. In the center of the Feast of Love Table, he planted ixora, a small shrub, so he wouldn't have to provide fresh flowers every day (plate 96). He produced almost all his own fruits and vegetables and trapped rabbits for meat; he purchased only a few staples such as milk, eggs, crackers, and sardines. Notwithstanding this frugality, he reportedly had an income derived from dividends of public-utilities stocks that he owned.[3]

If Leedskalnin was unusual among visionary artists in his horticultural interests, he was more typical in his relations with his neighbors: he was reclusive but welcoming. He apparently wanted no one to see how he worked and did most of his rock cutting and carving at night. The gates were kept closed at all times, but he hung a bell by the front entrance. To this day, it instructs

you to ring twice: any more or any less, and Leedskalnin wouldn't answer. If you rang twice and he wasn't busy, he'd be happy to take you for a tour of his castle, provided you made the appropriate donation through a slot in the wall: a dime in the early days, later a quarter.

Coral Castle is ostensibly a monument to Leedskalnin's love for his Sweet Sixteen. But his writings, notably *A Book in Every Home*, reveal that Sweet Sixteen was no longer the particular girl of his youth, but his notion of the ideal maiden. Leedskalnin had several requirements of any possible bride. She should above all be a virgin. A girl is tender and impressionable, he thought, and should not be "soiled" by the attentions of any man other than her permanent mate. "As soon as a girl acquires experience the sweetness begins to leave her right away," he insisted. "All girls below sixteen should be brand new." It was up to their mothers, Leedskalnin believed, to protect them from the attentions of eager young men. He even went so far as to suggest that a mother might make herself available instead: "She, herself, could pose as an experimental station for that fresh boy to practice on and so save the girl."

Leedskalnin's rule of sex was quite rigorous: "I want one hundred percent good or none." As a consequence, he ruefully admitted, "I always have wanted a girl but I never had one." This rule was just one part of Leedskalnin's conception of the proper conduct of domestic life. Home education should develop refinement and self-respect. Restraint should be observed, especially in smiling. "The teeth only should be shown. As soon as you show the gums, it spoils the good effect. . . . Especially should a girl be careful not to show too abnormally big mouth."

A small section of *A Book in Every Home* is devoted to Leedskalnin's political views, which suggest social Darwinism at its worst: briefly, the strong should lead and the weak should die.

"All people are independent," he wrote, "so you see everybody will have to take care of themselves and if they cannot, they should perish and the sooner they perish the better it will be." Government should be run like the army, with its main duty the protection of property. This ought to be taxed relative to its size: "big property, big taxes, and small property, small taxes." Only those who paid taxes ought to be able to vote, with the weight of the vote relative to the amount paid by the voter in taxes. Those too weak to make their own living and thus pay taxes ought not to vote at all, for they will just use the vote "to take property away from producers and stronger people."

Although obviously outspoken, Leedskalnin was willing to entertain the thought that not all his ideas would be palatable to everyone. He left every other page of his book blank, with a note to the reader that "if for any reason you do not like the things I say in this little book, I left just as much space as I used, so you can write your own opinion opposite it and see if you can do better."

Leedskalnin's views of domestic manners and politics were hardly his most unorthodox. He wrote pamphlets on perpetual motion, magnetism, and his research into electricity. He disputed the existence of electrons and claimed that it is not chlorophyll but water that converts sunlight into energy. He also asserted that internal magnets control the operation of our muscles. "We get magnets from the food we eat. The acid and other digestive juices dissolve the food and liberate the magnets to be used for other purposes."[4]

How, it might be asked, are Leedskalnin's writings inscribed in his environment? Although his notions of magnetism are not legible in Coral Castle, his larger enthusiasm for science can be seen in the astronomical components. His domestic and political views can be even more readily perceived, in details large and small. He imagined his Florida-shaped table to be a place where

the governor and state officials could sit while discussing how to raise taxes. His hierarchical conception of the family is evident in the throne room, where his chair is in front of those for his wife and children. His ideas about discipline can be detected in something called the Repentance Corner, a stocklike arrangement that insured that both Sweet Sixteen and their children would be properly punished for any infraction. Vertical stones were cut with holes large enough for their heads; if they misbehaved, Leedskalnin planned to put their heads through the openings and wedge them into place with a board. He set a stone bench in front of the Repentance Corner, where he planned to sit and talk sense into them.

More generally, the fortress character of Leedskalnin's environment reveals his ideas about independence, self-sufficiency, and the protection of property. It was his literal expression of the old chestnut that "a man's home is his castle"; he created a fiefdom in which he could be the undisputed lord. The walls would protect him and his property (including his wife and children) from being dirtied by the outside world. In a curious way, Leedskalnin's creation is analogous to another castlelike monument that rose nearby in the years just before he came to South Florida: Vizcaya. The latter, patterned on a sixteenth-century Italian villa, was built on Biscayne Bay in Miami between 1914 and 1916 by International Harvester cofounder James Deering, with the gardens completed some years later.

Both Vizcaya and Coral Castle included house and grounds; both featured fountains, sculpture, and architectural elements hewn from coral rock. More significantly, both embodied ideas about dominion over others: Leedskalnin over his family, Deering over the farm buildings called the Village, once an integral part of his estate. It may be that Leedskalnin was inspired by Deering to build a similar testimony to his irrepressible ego;

Coral Castle might be seen as the poor man's Vizcaya. Although far more modest than Vizcaya, it is an equally fantastic horticultural, architectural, and sculptural environment that embodied Leedskalnin's cultural ambitions no less than Vizcaya did Deering's. And though we may find Leedskalnin's political and domestic views a little dated, we can take comfort from the fact that he—unlike Deering—was innocent of any real power over others. We can celebrate Leedskalnin's work while being relieved that his opinions were forever contained within his walls.

For the most part, the environments in this chapter bear few obvious visual similarities to each other. Harry Andrews's Chateau Laroche (plate 98), however, is a partial exception: it is a historically more accurate but socially more pessimistic version of Coral Castle. Essentially the same fortress type, it too was built almost single-handedly as an expression of fierce self-sufficiency. It stands on a steep slope above the Little Miami River in Loveland, Ohio, not far from Cincinnati. The castle measures 96 by 65 feet (28.8 by 19.5 meters) and rises to a height of 36 feet (10.8 meters); it stands on an acre and a half (0.6 hectares) of land that includes terraced gardens and an orchard. It was begun in 1929 as a pair of rough rock shelters for the boys in Andrews's Sunday school class, who came out to camp, fish, and swim on the site. The place was not much used during the Depression, but later in the 1930s and into the 1940s Andrews "returned to the job of really constructing a Castle," as he wrote in a brochure about the site.[5] The rock shelters evolved into the bases of two massive towers, with the balance of the castle rising behind them. Andrews worked only on weekends until he retired in 1955; most of the castle was completed between that date and his death in 1981.

Andrews was born in 1890 in upstate New York. He was unusually well educated: he graduated from Colgate University

in 1916, then after serving as an army medic in Europe during World War I, he stayed on to study medieval architecture at Toulouse and Heidelberg Universities. When he returned to the United States, he pursued a doctorate, first at the University of Pennsylvania and, beginning in the mid-1920s, at the University of Cincinnati. He never completed his degree but went on to a career as a teacher and a school superintendent. In the 1930s he worked for Cincinnati's Department of Public Works, supervising the construction of the Columbia Parkway and Viaduct. Simultaneously, he worked—probably as a volunteer—for the Department of Immigration; he wrote the text for a handbook on citizenship for new immigrants. Later, he served as an editor at the Standard Publishing Foundation, which produced religious and inspirational literature. It was from this last position that Andrews retired in 1955.[6]

The form of Andrews's castle is essentially Norman, with round arches, crenellated battlements, and square towers—one of which is corbeled. The outside is constructed of limestone rocks hauled by the pailful from the river; the inside is largely built of countless concrete bricks that were cast in one-quart (0.9-liter) milk cartons. The lowest level contains an underground dungeon, while the main floor has three rooms: a large living area, a kitchen, and a tiny office. Stairs in a corner tower lead to the upper levels. The second floor is dominated by a council chamber with a bay window and a porch. In one corner is a washroom; in a second, under a domed ceiling made of rock, is Andrews's bedroom; in a third is a ladder that leads to a tower room (described as a prison for hostages). The stairs in the fourth corner lead to the roof, known as the English fighting deck.

The castle is set in a terraced landscape, with retaining walls of stone and homemade cement blocks. Fill for the terraces came mostly from the excavation of the dungeon. Andrews began extensive gardens, with vines, shrubs such as winged euonymus (sometimes called flame bush), and perennial flowers including peonies and iris. He incorporated small hothouses into the terraces for cold-weather production of flowers and vegetables, and at the top of the garden he planted fruit trees and berry bushes. All this is arrayed above a massive stone wall along Shore Road, built with as many rocks as the castle itself and pierced by an arched gateway with stairs that lead up to the castle (plate 99).

Although it began as a simple shelter for his Sunday school class, Andrews's castle gradually evolved into a representation of his moral and political philosophy. "Chateau Laroche was built as expression and reminder of the simple strength and rugged grandeur of the mighty men who lived when Knighthood was in flower," he wrote in the introduction to his brochure. "It was their knightly zeal for honor, valor and manly purity that lifted mankind out of the moral midnight of the dark ages, and started it towards a gray dawn of human hope." But the castle was not only a tribute to the past: it was also the visible expression of Andrews's conviction that the ancient chivalric orders needed to be revived to save America from moral degradation. Chateau Laroche became the headquarters of an organization he established known as the Knights of the Golden Trail. "Present human decadence," Andrews wrote, "proves a need for similar action. Already the ancient organization of Knights has been re-activated to save society. Any man of high ideals who wishes to help save civilization is invited to become a member of the Knights of the Golden Trail, whose only vows are the Ten Commandments."

98. Harry Andrews (1890–1981). Chateau Laroche, begun 1929, Loveland, Ohio. Now owned by the Knights of the Golden Trail.
Photo: John Beardsley, 1993.

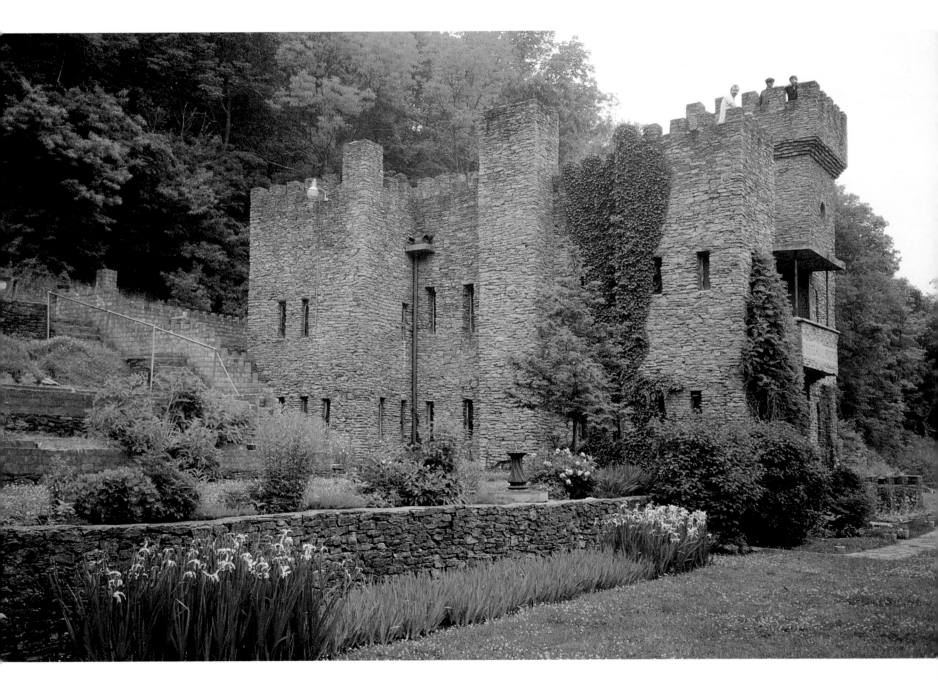

99. Entry to the gardens at Andrews's castle is through a thick stone retaining wall. Photo: John Beardsley, 1993.

On several occasions Andrews was the victim of adolescent pranks and robberies, which he recounted both in his brochure and in a newsletter he published called the *Golden Grail*.[7] While those were no doubt disturbing events, they do not really explain his pessimistic view of civilization. Andrews was a conscientious objector during World War I; one of the current officers of the Knights of the Golden Trail speculates that his experience of the war affected him deeply.[8] But even this does not explain his gloomy assessment of the American population, which he perceived to be increasingly dominated by a "lower grade" of people. His language is evocative of the anti-immigration sentiment of the 1920s; it could be that some of Andrews's ideas were forged in that crucible and reinforced by his service for the Department of Immigration. Whatever the source, Andrews's ideas sound particularly extreme today. He insisted that "we can, and must encourage the reproduction of the better grade of people, and discourage the reproduction of the lower grades. . . . God intended us to fill and rule the earth, not to overflow it with semi-human beings and waste its resources."

In Andrews's mind, salvation lay in the cultivation of pure young men. As he wrote in the conclusion to his brochure, "Nothing that God ever made on the earth is more awe inspiring and heart warming than the sight of a noble youth just budding into manhood, clean minded, honest, honorable, gentle, living in God's image, and humbly conscious of His approval. . . . It makes one want to bow in reverence of the Creator's handiwork. . . . Thank God there are such young men. They also are saviors of mankind." While the vows of his knights began with the Ten Commandments, they did not end there; Andrews had numerous other prescriptions for clean living. His knights were not allowed to smoke or drink, and he repeatedly cautioned against premarital sex.

One of the instructional columns in his newsletter suggests that it was not just premarital sex that was dangerous, but sexuality in general. Explaining his particular view of the difference between "homosex and heterosex," Andrews wrote: "Homo— means man with man or woman with woman. Hetero—means either or both, not choosey. The latter often leads to adultery." Masturbation was evidently sanctioned, or even taken as proof of manliness. In another newsletter Andrews went into detail about the function of the Cowper's glands, which contribute to the production of seminal fluid. "Whenever you have an erection (bone on) and are about to ejaculate," he concludes, "you can see a drop of this clear fluid at the end of the penis. Probably you have already noticed it, unless you're a puny weakling."

We can deduce from his writings that Andrews's castle, like Leedskalnin's, was much more than a nostalgic re-creation of a historical type. Andrews constructed an architectural environment that resonates with his ideas about strength, manliness, and purity. He selected his castle type from northern Europe; we can assume he associated it with those he deemed to be a "higher grade" of people. Its thick walls and small windows express a powerful desire to shut out a world perceived as depraved. Details of the castle emphasize security and surveillance in equal measure. While Andrews may just have been trying for historical accuracy with some of these details, he seems to have gone out of his way on others, notably the portals: the main door is built with three layers of wood and is filled with nails; upstairs, there is a spy hole on the second floor to see who is at the door. Moreover, he commended the castle to the readers of his brochure as a secure environment. The roof deck, he said, was a good place for parties because "chaperones or cicerones can keep an eye on all that goes on." Those even more psychologically minded than I might argue that Andrews's fortress is the embodiment of deep paranoia or sublimated erotic impulses. Be that as it may, Chateau Laroche is certainly the representation of his wish to be sealed off from a threatening world in the company of his noble youths, the saviors of mankind.

Although in outward form it could hardly be more different from Harry Andrews's castle, Eddie Owens Martin's Land of Pasaquan (plate 101) shares some typological similarities with Chateau Laroche. It too is a fortified structure that articulates feelings of differentness, albeit in a way less condemning of the outside world. Martin built a compound surrounded by a high wall, within which stood a cluster of temple- and pagoda-like structures, totems, and lesser walls, all decorated with bas-reliefs and painted friezes of full figures, faces, torsos, landscapes, and flowers along with round designs that resemble mandalas or prayer wheels. Everything is painted in the brightest colors of the Sherwin-Williams palette; the net effect, as Martin's biographer Tom Patterson aptly says, is like "a psychedelic Assisi in the Southern pines."[9] The Land of Pasaquan stands on four acres (1.6 hectares) outside Buena Vista, in Georgia's Marion County. It was the center of a sect of Martin's creation; as the anointed leader, he called himself St. EOM (plate 100). The place had its origins in a vision Martin experienced in 1935, in which he heard a voice that declared: "You're gonna be the start of somethin' new, and you'll call yourself 'Saint EOM,' and you'll be a Pasaquoyan—the first one in the world."[10]

Martin was born in 1908 in Glen Alta, a hamlet in Marion County near Buena Vista. He was the sixth of seven children in a family of poor sharecroppers. His home life was fairly desperate: though he would later remember his mother with affection, his father was often drunk and abusive, beating him violently and with distressing regularity. He worked hard as a child, attending school only half the year so he could help plant and harvest

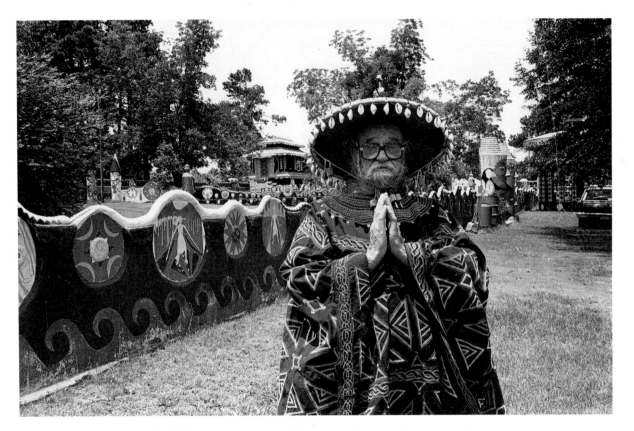

100. St. EOM (1908–1986) in full ceremonial dress. Photo: Guy Mendes, 1984.

crops of sugarcane, cotton, and corn. From the outset the young St. EOM seems to have known that he was destined for something different. At the age of thirteen or fourteen he slipped out of the house on the night of a full moon. He knelt in a thicket with a tasseled piano scarf tied over his head and prayed to God to make him different from anybody else in the world. "And by God," he later recounted, "I think I succeeded in that prayer."[11]

Soon after, at the age of fourteen, Martin left home for New York, where he would live for most of the next four decades. He quickly found his way into the homosexual demimonde, surviving at first by selling his only asset: his body. Initially working downtown and Times Square, he later catered to the carriage trade on Fifth Avenue. Meanwhile, he haunted the speakeasies and the clubs in Harlem and made a minor sensation at drag balls, appearing at one in nothing but a G-string and a feathered headdress, his naked body entirely painted in gold. Life got more difficult with the Depression, and he took to riding the rails—to Chicago, to the West Coast—in search of better trade. Eventu-

ally he returned to New York and found a procurer, who sent him out on calls. All this is told in his no-holds-barred autobiography, narrated to Tom Patterson, right down to the details of his aptitude for oral sex. "I was what you call a 'union girl,'" he explained. "I could take it to the hair."[12]

In 1935 he began to experience visions. The first—which took the classic form of the offering of a second chance in life—came on one of his periodic visits to Georgia, where he had been returning almost yearly to help his mother with the crops since his father died in 1928. (She was now living on her own farm, purchased with her savings.) On this particular visit, he fell ill and was too sick to rise, when he saw

this great big character sittin' there like some kinda god. . . . His hair went straight up, and his beard was parted in the middle. . . . And when I saw him I knew I had reached the end of my spiritual journey. And this great big man said to me, "If you can go back into the world and follow my spirit, then you can go, but if you can't follow my spirit, then this is the end of the road for you. . . ." So I said, "Well, I'll do what you say." And then my spirit come back to me, and the next morning I began to get my strength.

Back in New York, he felt regenerated. "It was then I decided to be myself, regardless of the cost. . . . I listened to that inner voice, and I recovered, 'cause I had just had a new revelation." Soon after, he had his vision about becoming St. EOM, the Pasaquoyan. Later, he would explain that the word was derived from a combination of the Spanish *pasa* (a form of the verb *pasar*—"to pass") and "a Oriental word that means 'bringin' the past and the future together.'" Pasaquoyanism, though hardly

codified, was a homemade blend of Pre-Columbian, Native American, and oriental beliefs. "Pasaquoyanism has to do with the Truth, and with nature, and the earth, and man's lost rituals." Man's ancient connections with nature and the earth, St. EOM believed, had been sacrificed to greed. "His love of soul and spirit and the earth will not be fully realized until he finds that he can communicate with his whole and natural body, including his hair and his beard."[13]

The art of the hair and the beard were central to St. EOM's world view. Around 1938 he saw a film on the Sikhs of India and learned of their tonsorial practices: letting the hair grow and binding it in a turban, and braiding the beard in two parts and weaving them up into the hair, a practice he adopted. He looked to ancient and oriental art, especially Indian, Mayan, and Egyptian sculpture—often in books at the library of the Metropolitan Museum of Art—for confirmation of his belief that other cultures were more attuned to the importance of hair. He came to see hair as a kind of spiritual antenna, a body's connection with the intangible universe, and gravitated especially to representations of bound hair rising straight up from the head, as well as to depictions of people being pulled up by their tresses. He took to putting rice starch in his hair, which he felt enhanced its powers of spiritual reception. It also helped the hair stand up, which he thought was essential for both spiritual and physical health.[14]

St. EOM's views on hair brought an end to his days as a hustler: he was just too weird for the trade. Even the hookers kept their distance from him now, he said. For a few years he survived as gambler and small-time marijuana dealer, for which he ended up serving nine months in the federal prison in Lexington, Kentucky, in 1942–43 (a place, as he told it, of easy sex and abundant weed). Back in New York, he settled into a life of waiting tables in bars and reading tea leaves at the Wishing Cup Tearoom, while

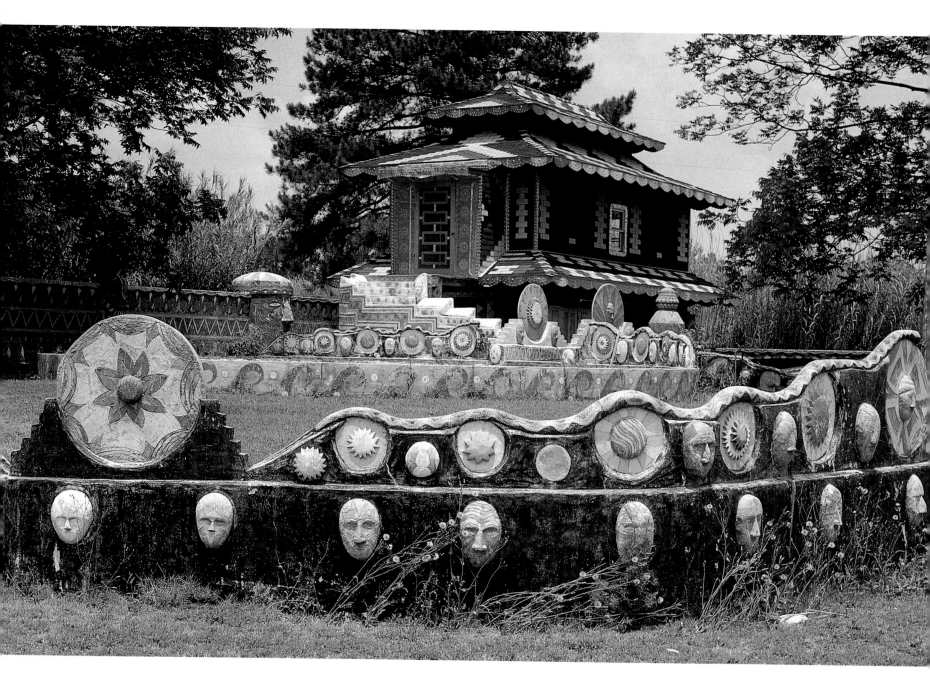

pursuing his interest in oriental religions, ancient art at the Metro-politan, and tribal culture at the Museum of Natural History. He started making paintings of his own—scenes of ancient temples, for example, and heads with upswept hair.

In 1957 St. EOM had another vision that commanded him to go home. "I looked out the window of the tea room where I was reading, Lord, a shining bright light fire came to my eyes and spoke to my inner soul and said, leave here and go home to the South. . . . This light will guide you and show you the visions that I wish to create through your spirit."[15] By then, his mother had died and had left him her house and four acres. Within a few years St. EOM began transforming the place into the Land of Pasaquan, following the dictates of his inner light. He hired a succession of local African American men to help with the con-struction of the walls, which were made of stone or brick and faced with cement. These he would elaborate with designs, made in concrete over chicken wire, that he began to paint in brilliant colors after a visit to Mexico in 1967.

Eventually St. EOM put an addition on the house, which he covered with mandalas. He also transformed a well house into a two-story pagoda, with a curved stair that led down to a sand-covered performance space (plate 101). The walls provide the essential architecture of the garden, however, and create a sequence of different spaces. High walls, along with a screen of bamboo, separate the house from the road; large totems mark the primary entrance (plate 102). These walls create tight, more for-mal, spaces near the house; they gradually give way to lower walls and more open spaces in the more sheltered areas of the garden. In places, they also separate areas of different elevations; stairs between levels are framed by smaller totems. The walls are also the chief decorative element in the garden and contain some very effective passages. While some are embellished only with

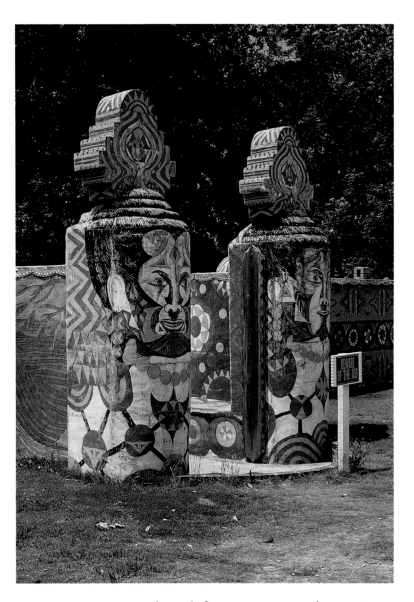

OPPOSITE: *101. St. EOM's Land of Pasaquan, 1960s and 1970s, Buena Vista, Georgia. Now owned by the Marion County Historical Society.*

ABOVE: *102. Entrance to the Land of Pasaquan.*

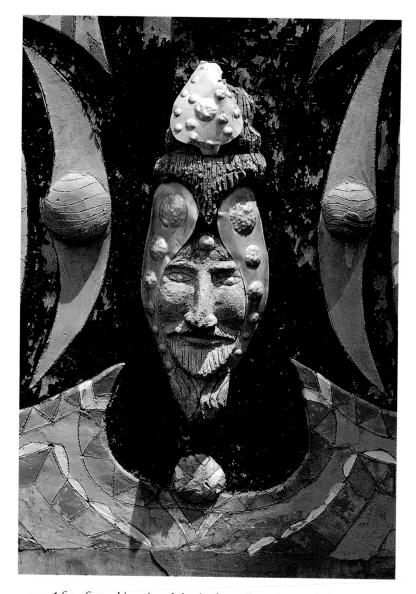

103. *A face framed in snipped tin, in the walls at the Land of Pasaquan.*

painted designs, others combine color with faces, stars, wheels, and other elements in bas-relief; some heads are even framed in embossed tin (plate 103).

St. EOM's imagery, like his philosophy, suggests free variations on eclectic sources.[16] Everywhere are heads with upswept tresses, illustrating his ideas about tonsorial art. Many of his recurring images allude to cosmic energy; the garden is full of representations of the sun, stars, planets, waves, atoms, and prisms of light. Figures on totems are meant to evoke mythological characters from the lost worlds of Atlantis or Mu; they represent men in a natural state, growing long hair and beards. Some of St. EOM's massive heads look Olmec; some of his sinuous figures suggest Shiva, the Hindu lord of the dance who is also the god of destruction. A couple of his recurring motifs are explicitly associated with Indian religions and, more particularly, with the practice of yoga. He used the yin-yang emblem frequently; less common is an hourglass shape with a circle in the center, which represents the navel, the center of balanced energy in the body. There are numerous allusions in the garden to fertility and human sexuality as well. Several undulating walls are topped with a snake band; the serpent is a nearly universal emblem in creation mythology. Occasionally, you come across slim-hipped female torsos with full bosoms; more commonly, as might be expected, you find trim-waisted males with pendulous penises (plate 104).

"I built this place to have somethin' to identify with, 'cause there's nothin' I see in this society that I identify with or desire to emulate. Here I can be in my own world, with my temples and designs and the spirit of God." Despite his desire to shut out the world, people began to beat a path to his door. St. EOM was generally ostracized by polite society, but people came just the same to have their fortunes told or their spirits healed: a 1977 letter recounts his frustration at interruptions from "nervous

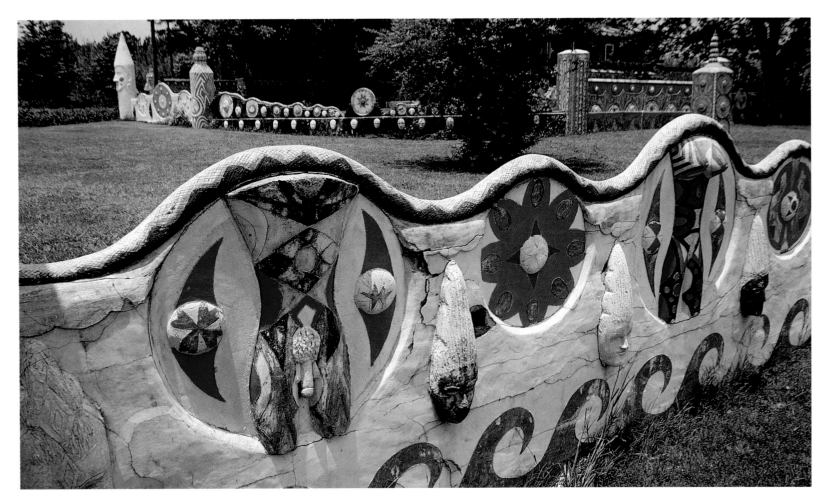

104. The walls at the Land of Pasaquan are decorated with brightly painted bas-relief sculptures.

army wives."[17] Beginning in the free-love, long-hair, back-to-nature years of the late 1960s, others came to find out about the character who had anticipated it all; some looked to him as a leader. "I could've had a cult goin' here, man, but the people that I saw comin' to me . . . I just didn't feel like puttin' up with 'em." Besides, he knew others would accuse him of "tryin' to corrupt their youth."[18] So he lived alone inside his sanctuary from the greed and intolerance of the world until failing health led him to hire a live-in assistant, Scotty Steward. As his health continued to deteriorate, in the spring of 1986 he elected to take his own life with a single bullet to the head. He left his Land of Pasaquan to the Marion County Historical Society; they have

hired a caretaker and put up a fence to protect it from vandals. They have done some restoration and repainting on the site and are raising funds to further the work.

Jeff McKissack's Orange Show (plate 105) is also the expression of one man's ideas of living right. It was constructed in the 1960s and 1970s in a working-class neighborhood a few miles east of downtown Houston. McKissack, a retired postman and lifelong bachelor, built the place on land across the street from his house on Munger Street. Although situated on a mere tenth of an acre (four hundred square meters), the Orange Show looks like nothing so much as a vast amusement park, with flags flying in the breeze, wind vanes, striped umbrellas and awnings, Astroturf decks, wagon-wheel railings in bright primary colors, multi-hued brick and tile walks and walls, fountains, a wishing well, and even a miniature steamboat set in a shallow concrete basin, surrounded by an amphitheater with cast-iron tractor seats.

Although McKissack meant his environment to be entertaining, it had a more serious message: it was conceived as a monument to the orange. McKissack insisted that within the rind of this fruit lay all the secrets of health, happiness, and longevity. Signs throughout his environment—some of them painted, some inlaid in tile—testify to his faith. "Love oranges and live," says one, outlining the basis of his creed. In case his audience was doubtful, McKissack stationed mannequins and cutouts of various trustworthy characters around his environment to provide corroborating evidence. Near the figure of a virile-looking, axe-wielding character in a flannel shirt, McKissack hung the sign "Woodsman love orange." Near a smiling clown, another legend proclaims, "Clown found happiness by drinking cold,

105. A general view of the Orange Show, Houston. Now owned by the Orange Show Foundation. Photo: Barry Moore, 1982.

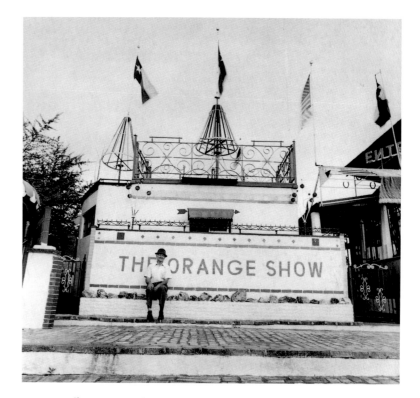

106. Jeff McKissack (1902–1979) at the entrance to the Orange Show, which he constructed in the 1960s and 1970s. Photo: Ken Hudson, 1978.

fresh orange juice every day." Still another assures, "Clowns never lie."

McKissack's homilies on the orange are interspersed with more general observations on health and good living. An exhibit area within the Orange Show includes a display with gas tanks, pipes, and faucets that looks like a miniature oil refinery; it illustrates McKissack's theories about nutrition (plate 107). He conceived of the body as a complex chemical plant. Fruit, nuts, and vegetables, he explained, take chemicals out of the ground and store them; by eating these foods, you get the chemicals necessary

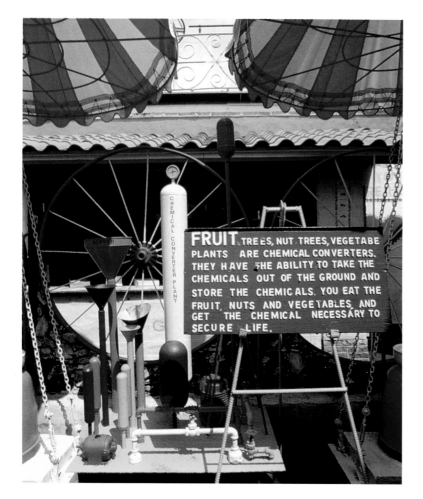

107. One of McKissack's exhibits at the Orange Show explains body chemistry. Photo: Paul Hester, 1984.

for life, with the result that you enjoy good health and energy. McKissack also wrote extensively on health in his notebooks, which he first published in 1960 under the title *How You Can Live 100 Years . . . and Still Be Spry.* Full of information on diet, exercise, and diseases, the book was intended as a guide to "the sound

fundamental principles of good living."[19] It is an enlightened document, anticipating many of our current health maxims: the dangers of smoking and a high cholesterol level, for example, or the benefits of exercise and a high-fiber diet.

The Orange Show was built primarily of material that McKissack spotted on his postal rounds in Houston or collected from antique and curio shops on his way to Hot Springs, Arkansas, where he went every year to take the waters. Some of it—brick and block, floor and roof tiles—was salvaged from buildings that were torn down or renovated in Houston's relentless modernization during the oil boom years of the 1960s and 1970s. But the inspiration for the Orange Show seems to predate his scavenging by several decades: McKissack drove a truck during the Depression, delivering oranges from Florida to the Atlanta farmers market. This was just one of his many trades. He hailed from Fort Gaines, Georgia, where he was born in 1902. After receiving a degree in commerce from Mercer University in 1925, he moved to New York to work in a Wall Street bank. He lost this job in the Depression, moved back to the South, and began driving trucks. In 1942 he enlisted in the Army Air Corps and was honorably discharged less than a year later; during his stint he was trained as a welder. After the war he used his G.I. Bill funds to become a licensed beautician. Having moved to Houston, he began work for the Postal Service around 1950 and soon moved to the house he built on Munger Street. From there he operated a number of sideline businesses while still working for the post office. He started a plant nursery, which he closed in the mid-1950s; in 1956 he received a building permit for a beauty salon but gave up on this idea as well. Some years later he wrote on the permit: "Beauty salons went out of style and many closed down. Had a better idea—the Orange Show."[20]

McKissack confidently predicted that 90 percent of the people in America would want to visit his creation, and he personally opened it to the public on May 9, 1979 (plate 106). Despite his efforts to publicize the Orange Show, however, the numbers didn't quite materialize. Nor did his prescription for health keep him alive for a full century. He died just seven months after inaugurating the Orange Show, a few days shy of age seventy-eight. He willed the place to a nephew, who subsequently sold it to a private organization established to acquire and preserve it. It is now operated by the Orange Show Foundation, with support from the City of Houston derived from the municipal hotel tax.

There are several paradigms for McKissack's space. The Orange Show is a crazy quilt of stairs, passageways, and small chambers that suggests a maze. Its exhibit area recalls the museum-like displays at Finster's Paradise Garden or Rusch's Prairie Moon Museum and reiterates the origins of many environments in collections of curiosities. The Orange Show is also hidden behind walls. As with those at other environments, McKissack's walls express his ideas about independence and self-sufficiency; they also denote his self-consciousness about being different from his neighbors. In addition, like the walls of Harry Andrews's castle, they pertain to ideas about purity, and it is possible that McKissack intended to suggest analogies between the walls that protect the Orange Show and the rind that protects the fruit. The orange epitomized purity and was associated in McKissack's mind with other representations of this enviable state, notably steam power and young women. "Purity," one of his signs proclaims, "the orange is absolutely pure. It grows right out of the bloom, protected by the rind."

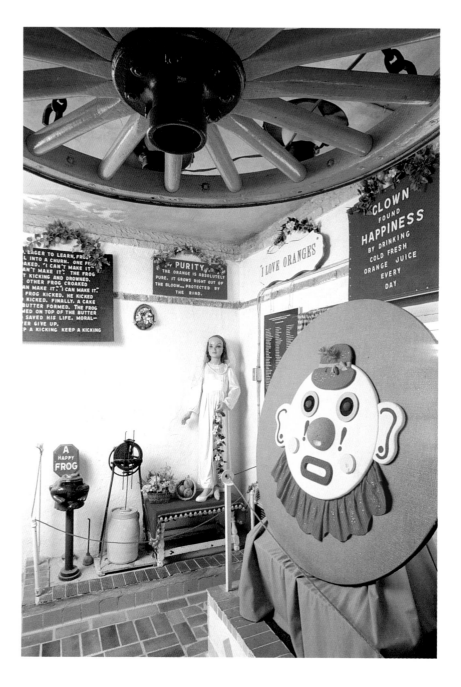

108. The Orange Show contains museum-like spaces with displays about health and happiness. Photo: Paul Hester, 1984.

McKissack made explicit the connection between oranges and steam on the one hand and virginity on the other. He constructed a steam engine near the amphitheater, which was to be used to power the showboat around its circular basin. He also built a steam-driven farm buggy. "I associate steam with oranges because both of them produce energy," McKissack told a reporter. "People are interested in steam. It don't pollute the air and it's good for economy reasons." McKissack also associated the goodness of the orange with adolescent girls. Next to one of his signs advertising the purity of the fruit is a mannequin of a young girl in a long, white satin gown (plate 108). "Dressed up as a bride," McKissack said, "representing purity."[21]

With Leedskalnin and Andrews, McKissack numbers among the unmarried men with definite ideas about the importance of purity in women. A completely different sense of womanhood is expressed—not surprisingly—in one of the few monumental environments in the United States actually built by a woman. Those who are somewhat familiar with Tressa Prisbrey's Bottle Village (plate 109) may be surprised to find it presented in the context of the Orange Show, the Land of Pasaquan, Chateau Laroche, and Coral Castle, with their more obvious philosophical dimensions. Bottle Village, after all, is ostensibly an assortment of handmade buildings that were fashioned from cement and scavenged glass bottles for a more modest purpose: to house a collection of seventeen thousand pencils and an only slightly less amazing number of dolls. On the face of it, Bottle Village would seem to be entirely whimsical, the expression of an unusual hobby rather than a rhetorical statement. But it shares some important characteristics with the other environments in this chapter. For one thing, it reveals some typological similarities with them: it is a walled compound containing not only glass-bottle buildings but also a number of shrines. For another, the writings and statements

of Tressa Prisbrey, or Grandma Prisbrey as she was commonly known, suggest that she built Bottle Village in part because she too wanted to express her ideas about the proper conduct of life, which were rooted in her sense of responsibility to her family. Moreover, Bottle Village was Prisbrey's expression of a prickly self-sufficiency, a value she shared with her male peers in defiance of conventional gender assumptions.

Tressa Prisbrey was born Thresie Luella Schafer in 1896 in Easton, Minnesota, the last of eight children in a farm family. In 1908 they moved to a homestead near Minot, North Dakota, where her father also worked as a blacksmith. At the age of fifteen she married a fifty-two-year-old man, the ex-husband of one of her older sisters. Family accounts insist that the headstrong Tressa was just getting her way, but she remembered it differently. "I was sold," she later said in a film called *Grandma's Bottle Village*, in exchange for an addition on her parent's house and a new set of furniture.[22] Her husband died twenty years later and left her a widow with seven children. She worked as a waitress in Minot for a while then eventually moved to the Pacific Northwest, where she worked as a parts assembler for the Boeing Corporation during World War II.

After the war Tressa moved to Simi Valley, California, where one of her sons and her sister Hattie had settled; she lived in a trailer on Hattie's land. A couple of years later she met Al Prisbrey, a construction worker who became her second husband; together they bought in 1955 the third of an acre (1,300 square meters) in Simi Valley on which Bottle Village now stands. Tired of moving around, she took the wheels off their house trailer when they got it to the property. As she told it in a manuscript

109. Tressa Prisbrey (1896–1988). Bottle Village, late 1950s and 1960s, Simi Valley, California. Now owned by Preserve Bottle Village.

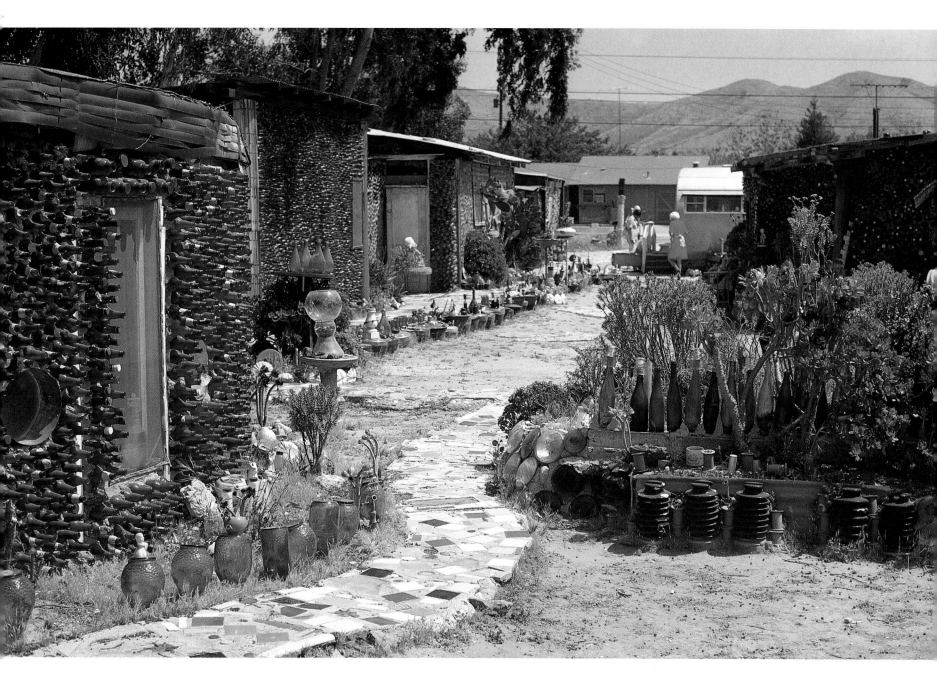

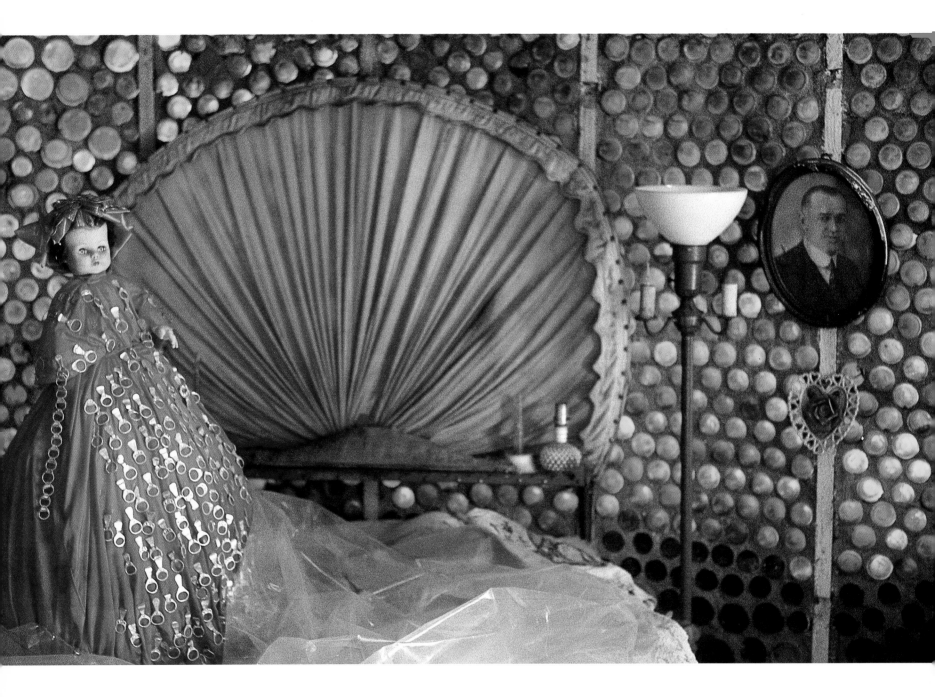

about Bottle Village written in about 1960, "I hid the wheels, so we had to stay put."[23]

In the same manuscript Prisbrey explained that Bottle Village got started because she needed a place for her pencils. Cement block was too expensive, so she began collecting bottles at the local dump. There may have been more than an economic motivation in her use of recycled glass; an account of Bottle Village provided by its current owners (a preservation committee) makes reference to a friend of Al Prisbrey's who claims that she was using her husband's discarded bottles to shame him about his drinking. There may be some truth to this: her husband had little part in the construction of Bottle Village or in her subsequent narratives about it.

Prisbrey used the bottles first to fashion a wall thirty feet (nine meters) long, then to build a six-by-twelve-foot (1.8-by-3.6-meter) pencil house. Even at the outset, her motivation was probably more complex than the casual account about housing her pencil collection would suggest. Her constructions may well have been another way of insuring that she would never again have to move. As she continued her trips to the dump, she amassed some 550 dolls, for which she then built an eight-by-nineteen-foot (2.4-by-5.7-meter) dollhouse made of fifteen thousand bottles. She worked quickly over the next few years and added numerous other structures, including Cleopatra's Bedroom, which she decorated with quilts and gold-painted venetian blinds, and the Round House, twenty-four feet (7.2 meters) across and sunk two feet (sixty centimeters) into the ground so she wouldn't have so much trouble putting on the roof. The Round House was decorated with a round bed, a round dresser, round mirrors, and a round fireplace with a fire screen made with

110. Interior of the Round House, Bottle Village.

intravenous feeding tubes. Prisbrey's construction technique was extremely simple: the bottles were laid in courses and joined by mortar. But she achieved remarkable light effects, especially in the buildings whose bottles were set with their necks pointing out. These buildings glowed inside with the color of their bottles: green, amber, or blue (plate 110).

The buildings were mostly strung along one side of the 300-by-40-foot (90-by-12-meter) lot, under a group of eucalyptus trees. An open area at the front or street end was covered in mosaic made with broken tile and crockery along with guns, license plates, tools, lids of pots and pans, and even a plaque with a recipe for French dressing. Outside Cleopatra's Bedroom, the paved plaza gave way to a narrower walk lined with a fence made from discarded television picture-tubes. Nearby, after a visit to Las Vegas, Prisbrey made mosaics of the four suits of playing cards. She scattered planters throughout the landscape, outlined with automobile headlights. One of the garden's only macabre elements is a planter festooned with doll's heads impaled on broomsticks, which looked like shrunken heads (plate 111). Most of the other planters contained cactus in numerous varieties. "I don't care much for cactus myself," Prisbrey admitted in her manuscript, "but I don't have a green thumb and if I forget to water the cactus, they just grow anyhow. . . . They remind me of myself. They are independent, prickly, and ask nothing from anybody."

Prisbrey also constructed a number of shrines. One, called the Little Chapel, was decorated with antlers and housed one of her largest dolls. Another was the Shrine of All Religions (plate 113). As she related in the film, she attended a Catholic church but only occasionally, because Bottle Village had been vandalized several times and she worried that people would steal from it while she was gone. Out of respect for the many faiths of her visitors, she constructed an interdenominational altarpiece,

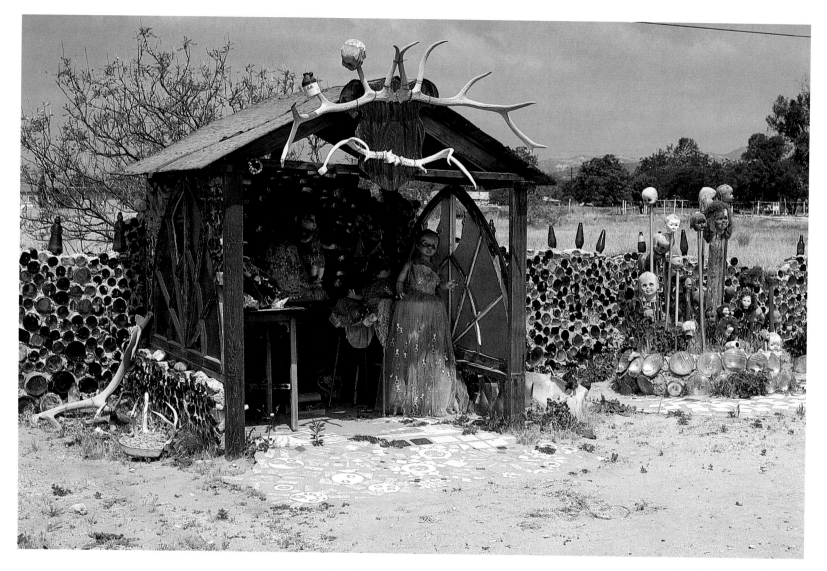

111. Little Chapel and doll's head planter, Bottle Village.

using blue milk of magnesia bottles for a base. Above, she adorned two niches with found statues of the Madonna and Saint Francis and a third with the six-pointed Star of David. She also had a small chamber she sometimes called the Meditation Room.

Prisbrey often dissembled and presented her work as just something she did to keep busy in her old age. Using herself as an example in her manuscript, she declared, "If you think you are slipping, just get a hobby that will take your mind off of how you feel and give yourself something to look forward to." But her dissembling hid a deeper motivation for at least some of her creations, which addressed the various needs of several generations of her family. Some were built to entertain her grandchildren, for whom she was often responsible. One was a Rumpus Room for them to play in, made of 180,000 green bottles and decorated outside with antlers, inside with two hundred painted gourds. It contained a jukebox, old records, and a "rinky-dink piano." She also built what she called a School House at the back of the garden.

Next to the School House was a building constructed with a more somber purpose. This was the Shell House, built for a son who returned home, ill with cancer, at age fifty-seven. Prisbrey put it up in two days after he wrote to say he was coming. When he died five months later, she did it over in pink and filled it with shells. An even more poignant story concerns a heart-shaped planter made for a sick daughter. As Prisbrey told it in the film, "I had my daughter staying out here. She was only thirty-five and dying of cancer and she liked roses so well so I said, 'I'll go down to the dump and get you some headlights and make you a rose garden.' So I did. I put twenty rose roots in there because I wanted them to bloom before she died. Well, she lived a year, but she seen 'em. The morning she come out to see her roses, they died the same morning she did."

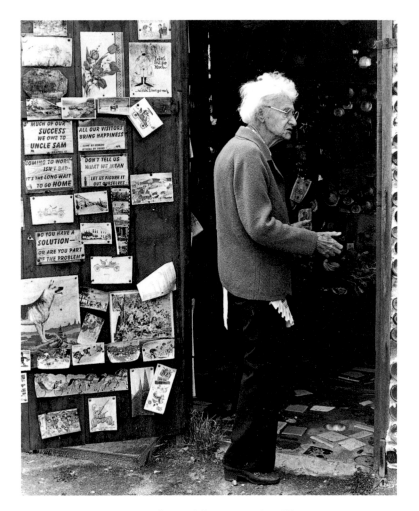

112. Grandma Prisbrey at Bottle Village.
Photo: Amanda Devine, courtesy of Preserve Bottle Village.

Prisbrey sustained many such losses: of her seven children, she outlived all but one. "I lost four boys and two girls," she acknowledged in the film. "It's kind of hard on me now." Bottle Village may have been, in part, a way of alleviating her feelings

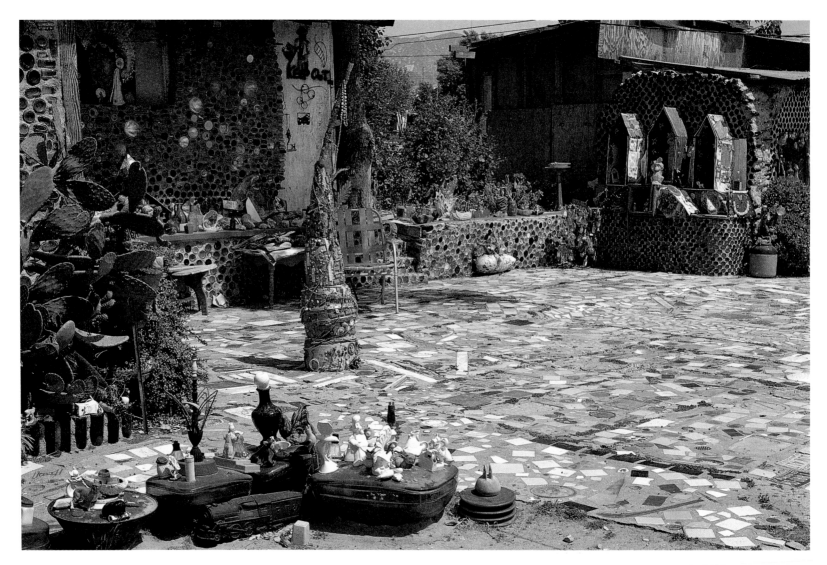

113. Television-picture-tube fence and Shrine of All Religions, Bottle Village.

of loss. In an unguarded moment, she once suggested as much: "After my kids died, I kept building houses and it kept me from getting too lonely."[24] So much of the Village was built as an act of charity for her family that a sense of selfless love pervades it. As they needed them, she put up buildings for their entertainment or refuge. In addition to expressing her resolve not to be moved and her determination to "ask nothing from anybody," the walls of Bottle Village might thus be seen as Prisbrey's way of enveloping her children and grandchildren in a sheltered environment. And while she could be self-effacing about her work, she also knew its true worth. As she said in the film, "If you've got ambition, you can do somethin'. And I must have had ambition."

Ambition she certainly had in good measure, along with a notably generous heart and a great sense of humor. Like many other visionary artists, she took pride in her ability to make something out of nothing and in her capacity to have fun, notwithstanding all the trials in her life. She liked to amuse those who stopped by Bottle Village with increasing frequency in her later years. In her manuscript she related how when her cat had kittens, she would dye the little ones pink and explain to her visitors that it was the result of feeding the mother pink food.

Despite her irrepressible spirits and seemingly limitless energy, old age eventually caught up with her. Her husband died in 1968, and a few years later she was forced by illness and economics to sell Bottle Village. She moved in with a son in the Northwest but she disliked having nothing to do, so at the invitation of its new owner, she came back to her old place as a care-

taker. This lasted until 1982, when a developer bought the land and evicted her. She was moved to a nursing home and died in 1988. Meanwhile, a group called Preserve Bottle Village acquired the place in 1986; they have developed a preservation plan and are trying to raise money to carry it out.

Like the other builders of walled compounds, Tressa Prisbrey was something of a loner against the world who took great pride in her self-sufficiency and her solitary accomplishment. Within her walls, she took care of her flock, but she felt somehow different from those who lived outside. She knew she was perceived as odd at times. In the film she remembered being challenged by a passerby with the question, "Are you the crazy woman who built this place?" She also knew that Bottle Village paradoxically brought her recognition but deepened the gulf between her and her neighbors. Like Helen Martins, she was an independent character building her own world. This was an act that, for women even more than men, was perceived as a challenge to orthodox behavior. "I don't like to live alone, but I don't have anybody to boss me around," she observed in the film. Her ambivalence can be taken as characteristic of all the creators of these walled environments. None of them necessarily wanted to be alone. Although they expressed divergent views of loving well and living right, they typically reached out to others. But the strength of their convictions, as seen both in their statements and in the rhetorical language of their environments, proved too great for ordinary companionship. Like Robert Garcet, they found themselves alone and almost cursed by their visions.

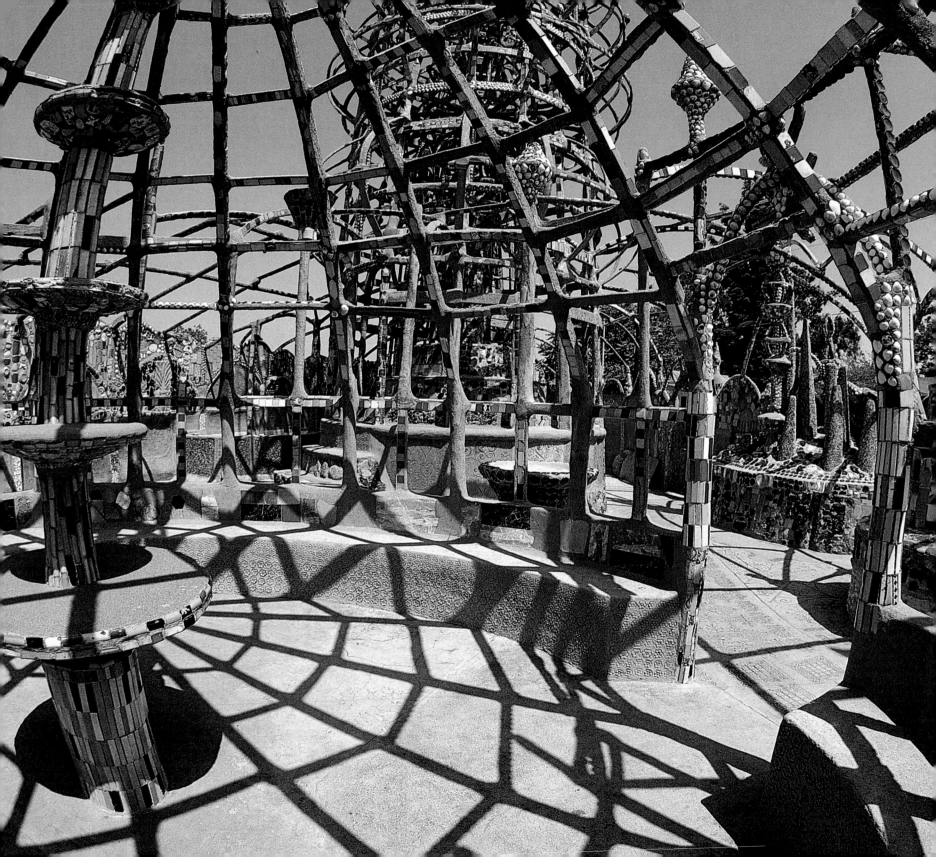

5

The Forest of Spirits, the Ark of Dreams

No seas, weather fair, the keel was laid on the ways at 11:30
hours by myself. . . . We dedicated the ship to the glory of
God, taking note of how perilous the times now are.

Kea Tawana

S AM RODIA'S WATTS TOWERS, which rose on the south side of Los Angeles in the second quarter of the century, are America's most familiar yet most enigmatic visionary construction (plate 17). Rodia, an Italian-born laborer who spoke little English, was deeply reticent about his creation. His motivation and the meaning of his forms have consequently eluded precise interpretation. But it is possible to weave together enough visual and documentary evidence to say with confidence that the towers exemplify an extraordinary triumph over adversity, born in part of the immigrant's distance from a past home and disaffection from a present one. Rodia's towers might even be taken as a paradigm of the environment that affirms self-worth in the face of extreme disadvantage.

Nearly every visionary creation embodies a kind of alchemy in which dross is turned to gold. Usually the magic is worked around the found object, which is transmuted from junk into art. But in the creations of some of America's most dispossessed —unassimilated immigrants, rural blacks, or inner-city poor— another kind of transformation sometimes takes place, in which disappointed expectations are metamorphosed into exalted ambition. This phenomenon is especially common among immigrants in California—which is not so surprising, given the enormous power of its myth. In a nation that migrated west with Edenic expectations, California has long represented the last best hope for everyone; this surely correlates to the extreme sense of disappointment it sometimes seems to engender and to the extraordinary leaps that people occasionally make to rise above their circumstances there.

The environments of the severely disadvantaged often express a desire for physical or spiritual deliverance, sometimes in metaphors of voyaging. Rodia's creation, for example, contains the explicit representation of a small boat (plate 115), while the towers overall have the feel of a great ship. Similar tropes turn up in the work of two African American men in rural Virginia

114. Sam Rodia (c. 1875–1965). Watts Towers, c. 1925–54, Los Angeles. Now
administered by the Los Angeles Department of Cultural Affairs.

and a Japanese American woman in downtown Newark, New Jersey, one of America's most blighted inner cities. Indeed, the latter provides the most explicit use of the ark as a metaphor for psychic survival.

But the effort to rise above the painful particulars of life takes other forms as well. Few of the environments in this chapter assume an obviously religious character, but some of them can be seen nevertheless as efforts to summon a world of sympathetic spirits in especially vexing circumstances. This motivation is notably powerful among African American artists and surfaces in the remarkably similar yard shows by Lonnie Holley in Birmingham, Alabama; by the late Fox Harris in Beaumont, Texas; and by the "crossover" artist Tyree Guyton in Detroit—all of which have ordinary objects that are endowed with ritualistic significance and that serve as visual incantations.

The desire to challenge or transform difficult personal circumstances is but a shade different from the feelings of alienation explored in the last chapter. By and large, the artists in both instances are similarly marginalized, and their motivations are overlapping but distinct in some important ways. In its most extreme form—Harry Andrews, for example—alienation can lead to a determination to shut out the world. The effort to master difficult circumstances, by comparison, is not typically so reclusive. At the risk of drawing too crude a generalization, the difference between the two motivations is the difference between turning away in one instance and either transforming or figuratively moving on in the other. The fortress builders of the last chapter strike me as in some way trapped, the voyagers and spiritual diviners of this one as more free. Indeed, the latter are not typically as bound by a rigid set of beliefs; few cleave to a codi-

115. Apex of the garden at Watts Towers, with "the ship of Marco Polo."

fied set of principles. Again, these thematic and typological distinctions are neither tidy nor simple, and some environments in this chapter could have found their way into the last one, and vice versa. Jeff McKissack's Orange Show and Rodia's Watts Towers, for example, are both walled compounds, and both contain representations of ships.

Indeed, while Rodia's towers are representative of my final theme, they recapitulate some earlier ones as well. Rodia had a dream of distinguishing himself, like Raymond Isidore or Robert Garcet. "I had it in my mind to do something big," he often said, "and I did."[1] Like many dreams before, his was realized through the intercession of the found object, the marvelous precipitate of desire. His something big was an environment dominated by three enormous, thin-ribbed towers, the tallest of which reaches nearly one hundred feet (thirty meters) in height. They are made of cement-covered steel rods encrusted with a colorful mosaic of seashells and debris, including broken bottles, tiles, and plates. Although the towers are the most dramatic element of Rodia's creation, they rise from an elaborate garden on a triangular lot adjacent to the remains of his house at 1765 East 107th Street in Los Angeles. Built over a period of thirty years between the mid-1920s and 1954, the whole environment is enclosed by a scalloped wall with mosaic and bas-relief designs (plate 117). Inside are numerous ornamental garden structures built in the same openwork form as the towers, including several smaller spires, a gazebo (plate 116), planters, and a fountain. At the apex of the site is a mosaic boat, which is an analogue for Rodia's larger garden. Overall, it resembles a ship, with the exterior walls coming to a point and forming the bow and the towers rising like masts in the middle.

116. Inside a gazebo at Watts Towers.

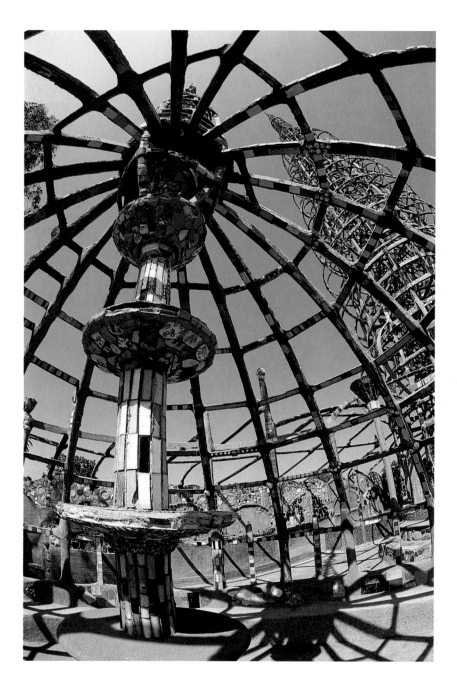

117. Detail of the exterior wall at Watts Towers.

Rodia's environment is found, as its name would suggest, in the Watts section of Los Angeles, now a low-income, predominantly black neighborhood still most familiar to outsiders as the site of particularly violent riots in the summer of 1965. When Rodia began construction of the towers in the mid-1920s, however, Watts was still rural. Rodia, whose original given name was Sabato and whose family name is sometimes spelled Rodilla, was born about 1875 into a family of landed peasants near Naples.[2] He emigrated to the United States at the age of fourteen, joining an older brother in the Pennsylvania coalfields; the family apparently sent their sons to the United States to avoid Italy's compulsory military service, which began at age fifteen. After his brother was killed in a mining accident, Rodia migrated west,

eventually finding his way to Seattle, where he was married in 1902. Soon after, the family moved to a town near Oakland, where Rodia worked as a quarryman, road builder, and cement mason. Apparently not much of a family man, he began to drink heavily, with the result that his wife left him in 1909, taking their two sons with her. (The marriage ended in divorce in 1912.) Rodia spent the next decade on the move before turning up in Long Beach in about 1918, where he worked in construction.[3] A few years later he moved to Watts; it was sometime thereafter that he began building the towers. Although the dates 1921 and 1923 are inscribed on them, Rodia didn't receive title to the property on 107th Street until 1929.

Rodia's lot abutted the train tracks that ran from Los Ange-

les to Long Beach. These tracks proved useful as he worked; he slipped the steel rods under them to bend them. His structure was born in part of necessity—the hoops of the towers are like rungs of ladders, spaced so that Rodia could climb up them, carrying his tools and materials with him. He hung horizontal ribs from vertical shafts that run up the outside of the towers and braced them with spokes that radiate from a central spine. Overlapping pieces of rod were joined by metal mesh and chicken wire and then packed with cement; the surface was finished with found objects. Rodia took the trolley to the beach to collect shells; he scavenged for tiles and bottles; and other refuse was supplied by neighborhood children. Some of the more decorative ceramic tiles apparently came from Malibu Pottery, where Rodia reportedly worked sometime during the years it was in business, 1926–32.[4] Despite the magnitude of his work, he consistently varied the details of form and surface design. One of the towers, for example, is a clean-lined spire, while another is a stack of bulbous hoops (plate 118).

To what end were these towers built? Rodia himself never gave a precise account, either written or spoken. The only scrap of text in the environment is a mosaic inscription reading "Nuestro Pueblo." This can be translated to mean "our town" or "our people"; it could even be a reference to the original name for Los Angeles, El Pueblo Nuestra Señora la Reina de los Angeles. Rodia typically never explained the term. The best guess might be that it is an assertion of the creator's complete sense of self-identification with his creation, like Helen Martins's declaration, "This is my world."

So we must look to the visual evidence in the towers themselves for hints of their rhetorical intent. Folklorists I. Sheldon Posen and Daniel Franklin Ward have found a clue to Rodia's symbolic language in analogies to towers and ships built to cele-

brate the feast day of an Italian saint. In Nola, a small town near Naples in southern Italy, there is a yearly festival to honor Saint Paulinus, a fifth-century bishop and now patron saint of the town who, along with many of his compatriots, was enslaved by the Vandals. During the festival tall, thin, ornamented towers called *gigli,* built by each of the town's major guilds, are danced through the street along with a galleon bearing a statue of the saint. Essentially, the festival reenacts the return of Paulinus and his people from captivity in North Africa. The festival was transplanted to Brooklyn, where a group of immigrants from Nola settled after the turn of century. But what Rodia knew of this tradition he might well have learned in Italy: he came from a village called Rivotoli, very near Nola in the province of Campania. The visual evidence suggests that he brought knowledge of the *giglio* with him; as Posen and Ward point out, Rodia's towers resemble those made in Nola, in structure, size, and proportion. Moreover, Rodia combined the form of the towers with that of the ship, as does the festival in Nola.

But as Posen and Ward acknowledge, analogies between Rodia's environment and structures built to honor Saint Paulinus raise as many questions as they answer. "Since there is now evidence of just *what* he was building in his yard," they write, "there are realms of speculation as to *why* he did so." They offer several ideas. As the builders of *gigli* were community leaders, they speculate that Rodia might have been hoping to earn respect or appreciation. He might have been intending to demonstrate prowess at construction. "Perhaps his motives were religious," they continue, "a personal and unverbalized love for a saint or a labor for the greater glory of God; or they might have been biographical, an attempt by an immigrant to reproduce something from his homeland, perhaps influenced by the experiences of a childhood long ago and far away."[5]

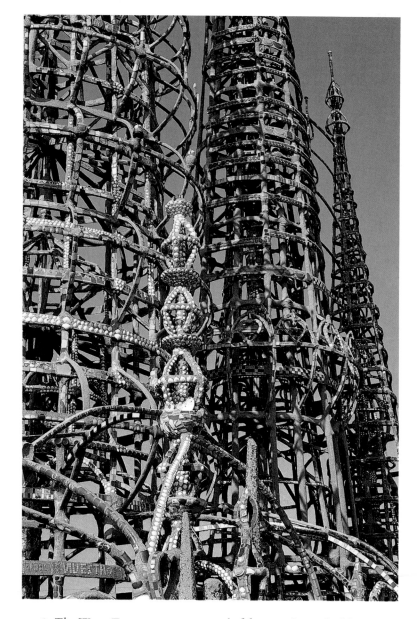

118. The Watts Towers were constructed of bent steel coated with cement and embedded with broken tile, glass, and shells.

Given the strongly evangelical tone that can be detected in many other environments, it is tempting to attribute some powerful religious motivation to Rodia. But this is frankly problematic. According to his more conventional relatives, Rodia was bluntly anti-Catholic; his divorce alone suggests that he had lapsed from the faith of his fathers. His brother-in-law told *New Yorker* writer Calvin Trillin in 1965: "He's been an anarchist all his life. He used to sing anti-church songs with that drunken gang of his and make his sister cry."[6] So it is doubtful that his towers represent an unverbalized love for a saint or that, in some more general way, they constitute an unrecognized Catholic shrine. This is not to say, however, that Rodia's towers are entirely without a spiritual, even a religious, dimension. There is evidence that Rodia was involved with various evangelical movements during the years he was at work on the towers. He told Trillin that he served as a preacher at a nearby Pentecostal church, "after I quit drinking." Stories are often related in the Rodia literature that the church used his fountains for baptisms. Handbills cited in a recent study of the towers reveal that Rodia also preached at tent revivals of a Mexican group called the Cry of Christian Freedom; his favorite sermon was titled "True Freedom: Freedom of Spirit and Soul."[7] So we might be justified in identifying some religious dimension to Rodia's towers after all. They may have been a metaphor for the liberation of spirit and soul that he celebrated in his sermons, which he expressed in the form of the *giglio* because of its associations with freedom.

The idea that the towers represent a quest for the liberation of the spirit finds some confirmation if we look into Rodia's personal circumstances. This is also problematic, in that biographical details are very sketchy; when he spoke of his life, Rodia often gave conflicting information. But the superficial contradictions don't disguise some larger consistencies. We can piece

together enough of Rodia's life in America to know that he was never entirely assimilated: he remained illiterate; he wasn't particularly fluent in English; and he demonstrated few outward signs of upward mobility—the legendary reward for the immigrant's hard labor. Instead, he voiced numerous reservations about his new homeland, many born of strong political sympathies for the working poor. His speech was peppered with talk of oppressed classes and minorities, of the poor fighting rich men's wars, of the unfairness of taxes. He was openly put off by emancipated women on the one hand, and by greed and materialism on the other. With apparently unintended irony, given his own record in this regard, he also denounced the degeneration of family life in America.[8] All this suggests that Rodia was deeply disillusioned and perhaps looking for a way to free his spirit from feelings of disaffection. Given that he never felt at home in his new land, it may have been a comfort to him to build something that resonated with the traditional values and popular culture of his native Italy.

Testimony from Rodia himself suggests that he fits the paradigm of the marginalized person creating an image of self-worth. He told Trillin that he started building the towers after he quit drinking, perhaps as dramatic evidence of his new sobriety. As dissolute as he had been, he may have wanted to prove that he could be correspondingly accomplished. "A man has to be good good or bad bad to be remembered," he told writer Jules Langsner in 1951.[9] This provides confirmation of the idea voiced by Posen and Ward that Rodia was trying to earn respect. He was certainly aware of the magnitude of his achievement. In a 1953 film on the towers made by William Hale, Rodia says: "I never had a single helper. One thing, I couldn't hire any helper, I had a no money. Not a thing. If I hire a man, he don't know what to do. Millions of times I don't know what to do meself. I was a wake up all night because this was all a my own idea."[10]

As in so many other instances, however, Rodia's effort to distinguish himself cut both ways. He was well aware of the range in opinion. As he said in the 1953 film, "Some of the people they say 'What is he doing?' Some of the people they thinkin I was a crazy and some people they say 'He's a gonna *do* something.'" In his own mind, Rodia seems to have been like the heroes he admired whose names came up regularly in his conversations: Julius Caesar, Joan of Arc, Christopher Columbus, Amerigo Vespucci, Guglielmo Marconi.[11] Many of his heroes were Italian; a number were explorers, which might relate to his ship imagery. There are frequent reports that Rodia called the small boat found at the apex of his garden the Ship of Marco Polo or the Ship of Columbus and the three main towers Nina, Pinta, and Santa Maria. To the extent that Rodia identified with his explorer heroes, the towers might represent the vehicle of his own imaginary voyages of discovery.

This much we can say with confidence about the towers: the symbolic language encoded in these lofty spires is complex and enigmatic. Beyond that, we can only speculate, based on the visual evidence, on the few spoken hints Rodia gave us, and on our own intuitions. From this we each hazard our own guess. To my mind, the towers were the ark of Rodia's deliverance from a life in which he was not entirely comfortable. They were his metaphor for the liberation of the spirit and the soul and a symbol of his quest for recognition. They were the ship on which he sailed in his dreams.

In 1954, for reasons that he never explained, Rodia gave title to the towers to a neighbor and moved away. By then nearly eighty years old and in failing health, he may simply have been exhausted. But he seems also to have been caught up in changes he couldn't understand or accept, as Watts became increasingly black and urbanized. Mutual suspicion and hostility grew between

Rodia and his neighbors. One told Trillin: "New kids in the neighborhood started bothering him. They'd throw rocks at him and call him crazy." It was generally assumed that Rodia had gone away to die, but he was found five years later in Martinez—in northern California's Bay Area—by two men, William Cartwright and Nicholas King, who had bought the towers with the idea of preserving them. He wouldn't say why he had left. Indeed, he wouldn't talk about the towers at all. King remembers his saying, "If your mother dies and you loved her very much, you don't talk about her."[12] Once or twice before his death in 1965, Rodia broke his silence about the towers, but he never returned to see them.

In the wake of his departure, vandalism began. Rocks were thrown at the towers, fracturing the cement; mosaic was ripped off the walls to look for treasure rumored to be hidden within them. Rodia's house burned down in 1955. Meanwhile, the neighbor to whom Rodia gave the towers sold them to a man who wanted to turn them into a taco stand. He applied for a building permit and was rewarded with a demolition order; the city Building and Safety Department had decided they were dangerous. The order was still hanging over the towers in 1959 when they were acquired by Cartwright and King. The two men quickly established a Committee for Simon Rodia's Towers in Watts; they fought the demolition order with the aid of an engineer named Bud Goldstone and a lawyer named Jack Levine, both of whom volunteered their time and services.

The city scheduled a hearing; it went on thirteen days before the Building and Safety Department said the towers could remain if they withstood a stress test devised by Goldstone: a five-ton (4.5-metric-ton) load, equivalent to a seventy-mile-an-hour wind, for five minutes. Despite grave fears among some committee members that such a test would destroy the towers,

they agreed to the city's terms. The towers held, the bureaucracy relented, and the committee began conservation work. Ironically, the city that fought so hard to destroy the towers was given title to them in 1975. Ownership passed to the state in 1979, which funded badly needed repairs in the amount of 1.2 million dollars; this work continues. The towers are now administered by the Los Angeles Department of Cultural Affairs.

Another immigrant garden (plate 121) in California provides a more explicit variation on the theme of disappointment. Its creator, Baldasare Forestiere (plate 119), came to the United States in 1900 at the age of twenty-one from Messina, Sicily. His family had been citrus growers there, and he emigrated with dreams of establishing his own citrus plantation in California.

119. Baldasare Forestiere.
Photographer unknown.

120. *Baldasare Forestiere (1879–1946). Underground Gardens,*
c. 1908–46, Fresno, California.

Forestiere excavated a series of living chambers (plate 120), some enclosed with glass doors and skylights, which looked out to patios that were open to the sky. The spaces eventually included a kitchen, two bedrooms, a living room, a study, and a bath, along with a chapel. In the patios, Forestiere built planters in which he established citrus trees; he adjusted the size of the opening above to allow in the optimal amount of light and rain. Many of his trees were grafted to bear various kinds of fruit that would ripen at different times. These trees were part of a pattern of self-sufficiency: Forestiere also had a shallow pool near his kitchen for fish he caught and planned to eat, along with an underground vegetable garden. By 1924 an account in the *Fresno Bee* related that Forestiere had been at work for sixteen years and had roughed out some fifty rooms.[13]

Laboring in the construction of the New York City aqueduct system, he saved enough money to move west; in 1905 he bought seventy acres (twenty-eight hectares) in Fresno. But his land turned out to be solid rock under a thin veneer of topsoil, and what was left of his dreams of a citrus grove withered in the extreme heat of the Fresno summer. So he went to work as a laborer in a vineyard, and in his spare time he used his subterranean construction experience to make the best of his situation. With nothing but a pickaxe and a wheelbarrow he began digging what became the Underground Gardens.

121. *Forestiere's Underground Gardens were richly planted with grapevines and grafted citrus trees that often bore several kinds of fruit.*

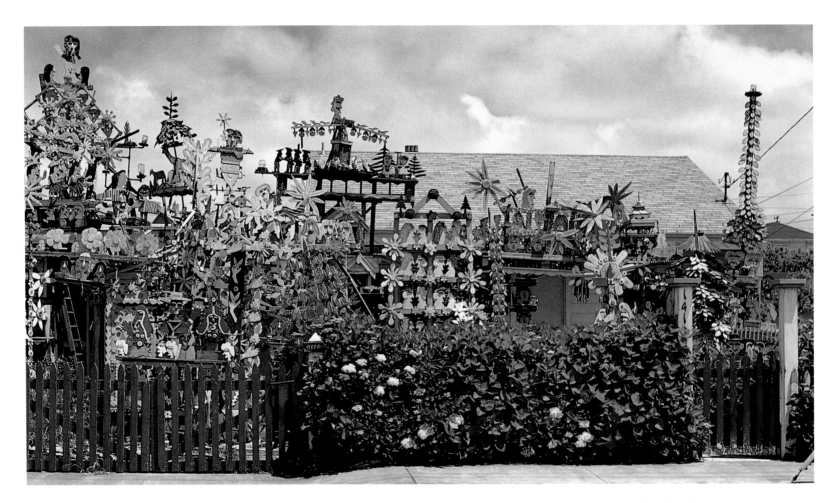

By then, too, the paper reports, Forestiere had hit on the idea of turning his gardens into a public attraction. He had originally hoped to have a family, but several efforts to coax a woman into an underground life with him failed.[14] So Forestiere evolved plans to open an Italian restaurant. In the late 1920s he began to dig an 800-foot (240-meter) automobile tunnel so patrons could drive into the premises. Over the next twenty years he finished this tunnel as well as pantries, a kitchen, and service

tunnels. He excavated a large hall for the dining room and created a prototype for the tables, each of which would have a living tree for a centerpiece. But Forestiere died in 1946 before his opus was complete.

Family accounts reveal that Forestiere experienced difficulties not only with the soil and climate in his new home, but with American politics as well. He was friends for many years with some Japanese American farmers, who shared his interest in graft-

ing. During World War II, when they were interned and their property seized, Forestiere became deeply disillusioned. "Besides being spiritual," his nephew recalls, "Forestiere held individual freedom very dear. He concluded that freedom was a gift from God at birth and governments take it away little by little."[15] As a consequence, Forestiere abandoned his plans to become an American citizen. Like Rodia, he found freedom not in allegiance to the nation's political institutions but in his own creativity.

In a less pronounced or poignant way, the garden of Romano Gabriel in Eureka, California, also represented nostalgia for a past home and disappointment with the present one. Gabriel was another Italian immigrant; born in 1888, he came to the United States in 1913. After serving in the army in World War I, he settled in Eureka, where he worked as a carpenter. Sometime around 1940 Gabriel began to combine his skill at carpentry with an avocation for gardening. He apparently found Eureka too cool and wet for year-round flower beds, so he cut out shapes from discarded fruit crates and other wooden boxes, painted them bright colors, and began to plant them around his house (plate 122). His construction eventually took the form of a dense, elaborate forest that obscured his house, with branching treelike forms supporting wooden flowers and figures, many with moving parts (plate 123). The figures displayed great whimsy: they included hula dancers, bearded musicians, and horses with brush

122 and 123. Romano Gabriel (1888–1977). Wooden Garden, begun c. 1940, Eureka, California.

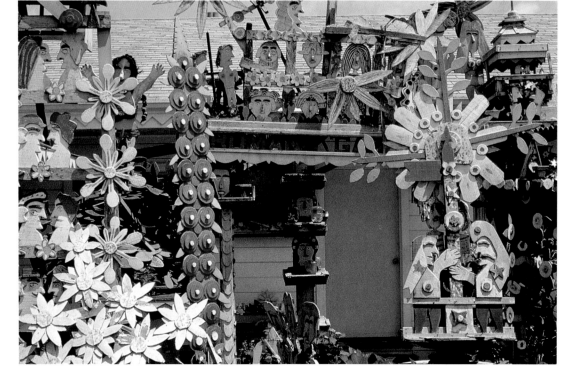

tails. Some were evocative of Italy: carabinieri, salami, marching soldiers, and priests, for example. Gabriel's garden began to deteriorate after his death; it was eventually moved with private support to an intersection in Eureka's old town, where it is now housed in its own display building.

The language of disappointed expectations or frustrated ambitions is often expressed most poignantly—as at the Watts Towers—in metaphors of voyaging. This language is not confined to California or to immigrants; it is found among others who have not shared equally in the American dream. Two African Americans in Virginia, for example, Walter Flax and Leslie Payne, both used the language of travel to transcend the limitations of their circumstances. Flax, who grew up near the port cities of Norfolk and Newport News, had a lifelong fascination with ships. He came of age during World War I watching battleships and freighters come and go on the Chesapeake, and he dreamed of going to sea with the navy. But "when that first war came," he reported, "I wasn't smart enough. When that second war came, I was too game-legged."[16] So he served on land as a handyman instead, commuting to his jobs by bicycle. Over a period of perhaps as many as five decades, his seafaring ambitions were transmuted into an armada of small ships, ranging in size up to about twenty feet (six meters) in length, that he built to surround his two-room cabin in the pine woods near Yorktown (plate 124). Fabricated out of scrap metal and wood, the armada included battleships and cruisers, tugboats and submarines. By the time he quit building in the 1970s, there were some one hundred ships in various stages of construction and decay; the armada was swallowed by the forest after Flax died in 1982. Toward the end of his life, he finally got to go to sea: the commander of the USS *Kennedy*, an aircraft carrier, heard of Flax's fleet and in 1978 took him on board for a short cruise.

In an analogous way, Leslie Payne dreamed of flight. He knew enough of boats: he worked most of his life in the fishing and crabbing fleets on the Chesapeake. As a teenager during World War I he was witness to an airshow in his native Northumberland County; he carried with him for the rest of his life the memory of the biplanes he saw. In his later years he fabricated in his yard near Reedville several small-scale replicas of them, each about fifteen feet (4.5 meters) long. They were built of sheet metal with struts and wires to brace wings, tails, and landing gear; they were painted and decorated with flight decals and flags. At least one could actually move: it had a seventy-five-horsepower engine that propelled the plane around the yard and on nearby roads. Although his air fleet never took off, it was the vehicle for a number of imaginary voyages that Payne took, sometimes in the company of neighborhood children. Flight preparations and itineraries were recorded in log books, Polaroids, and collages; the photographs show Payne and his flight attendants dressed in caps and goggles, ready for departure.[17] As with Flax, the lack of real opportunities gave rise in Payne to poignant and powerful fantasies in which he triumphed over his disadvantage.

The form of a ship was used once again in an ambitious but ill-fated assemblage that rose from the ruins of Newark's Central Ward in the early 1980s (plate 125). Newark, like Watts, was devastated by riots in the late 1960s; much of the desolation, especially in the Central Ward, was left unreconstructed for years. Its derelict buildings, though an eyesore to most people, were a gold mine to a woman named Kea Tawana, who began salvaging materials from them: timbers, slate, and stained glass, along with ornamental plaster and thousands of bottles. She stockpiled her finds in a city-owned vacant lot on Camden Street and began dreaming of building an ark. Construction began on August 8, 1982, when she noted in her ship's log: "No seas, weather fair, the

124. Walter Flax (d. 1982) with his armada of wooden ships near Yorktown, Virginia.
Photo: Joshua Horwitz, c. 1975.

keel was laid on the ways at 11:30 hours by myself. . . . We dedicated the ship to the glory of God, taking note of how perilous the times now are."[18]

Tawana had ridden the rails to Newark, arriving on a boxcar from Georgia in 1953. The daughter of an American civil engineer and a Japanese woman, she was born in the late 1930s in Japan, where her mother reportedly died during wartime bomb-ing. She came to the United States with her father after the war; he subsequently died in a displaced-persons camp, leaving her an orphan. She was placed for a time in foster homes in Arizona, but by the age of twelve she was living as a hobo. According to Tawana, she found refuge and tolerance in black communities, where she would remain most comfortable as an adult. But her self-image, like that of many other visionaries before her,

continued to be that of the cast-off person. There is an echo of the words of Raymond Isidore and Rolling Mountain Thunder in her assertion: "I was a throwaway, thrown away by both sides of the family, and raised by even a third race. I've learned, and I've applied what I've learned, from all of them."[19] She seems to have picked up a lot of manual skills in particular. During her years in Newark, she worked at repair jobs, theater lighting, and construction; the skills she learned would benefit her in her own building project.

The inspiration for Tawana's ark may have dated back to her childhood crossing from Japan, a two-week journey spent crammed into a cargo hold on an overcrowded transport ship. "When they let us up out of that stinking hole, I made myself a promise: No one would ever lock me below the hatches again."[20] The ark may have been her effort to master the memory of that traumatic experience, to relive it as captain of her own ship. But the ark also seems like a metaphor for rootlessness or, more particularly, for the precariousness of her position in society. There is "no place safe on land," she reportedly said in early 1987.[21] By comparison, Tawana's ship was built to last—she was determined that it should be seaworthy. It was constructed according to principles found in old shipbuilding manuals, supplemented by some hands-on experience at Brooklyn boatyards. She built a timber frame some 86 feet long, 20 feet wide, and 28 feet high (25.8 by 6 by 8.4 meters), with a hand-hewn keel and ribs joined by mortise and tenon. The bulkhead was reinforced with iron, and there were five waterproof compartments in the hold to assure that the ship would float.

Tawana had begun cladding the hull when the city inter-

125. *Kea Tawana (b. c. 1935). Ark, begun 1982, destroyed 1988, Newark, New Jersey. Photo: Camilo José Vergara, 1987.*

vened, evicting her from the land on which she was building. Over a four-day period in June 1986, Tawana moved the ark alone, using telephone poles and jacks to roll it to the parking lot of the Humanity Baptist Church next door. She was welcomed by the congregation and became caretaker of the church. But the city would not relent. In Tawana's mind, she was being persecuted for reporting shoddy construction in some city-sponsored condominiums going up nearby. Local opinion was typically varied. While some people interpreted her ark as an elegy for the lost communities of the Central Ward or as an emblem of hope in a blighted neighborhood, others saw only junk that would keep property values low. Some admired her independence, others were disturbed by her unconventionality. For one city official in particular, the fact that she had passed as a man in many eyes for thirty years was simply too much to bear. "Why isn't *anybody* looking into her *gender?*" snapped the mayor's spokesperson in late 1987.[22]

Like Rodia's towers, Tawana's ark was condemned as unsafe and immediate demolition was ordered, although no structural flaws were proved. Moreover, it was never determined whether the construction was a building, a vehicle, or a vessel, and thus to what codes it had to conform. Tawana took her battle to save the ark to court, where she was represented by Newark lawyer Fred Zemel. He argued for preservation by defining the ark as art and as an expression of free speech, and by suggesting that it had educational value as a community museum and as a demonstration of shipbuilding techniques. In May 1987 the demolition order was delayed by a state superior court judge while efforts were made to reach a compromise with the city. But Newark officials were determined to be rid of Tawana and her ark, and in September 1987 she signed an agreement to move or to demolish her ship. Unable to find another location for it, she began sawing the ark

apart, working alone yet again. By the summer of 1988 demolition was complete.

Tawana's sense of the precariousness of her situation, embodied in the language of the ark, turned out to be more true than even she might have feared. Even after the demolition of the ark, the city continued to hound her, destroying her makeshift dwellings. She eventually found refuge in the home of a friend and continued for a time to repair houses in the city, but eventually moved south. Like Rodia in his later years, she stopped talking about her creation. "The good life has passed me by," she told a *Daily News* reporter in 1987, as she began destroying the ark. "I strove so hard to build that ship. I wasn't stealing. I took what nobody else wanted. I studied for years to learn how to build a ship. It was my statement that I am something besides a grubby little bum that lives in a shack."[23]

Tawana provides a particularly vivid example of the struggle for self-esteem and psychic survival in conditions of extreme adversity. The widespread phenomenon of the African American yard show provides another. Across the country, from the rural south to the urban north and west, houses and gardens of African Americans can be found "dressed" with all manner of things: bottles and jars, tires and hubcaps, root sculptures and dolls, scrap metal and lumber, rock circles and mirrors. On the face of it, these yard shows seem to be little different from the yard art of some white Americans. Indeed, yard art shares some characteristics across different groups, especially in the south, where black and white communities have coexisted for upwards of three centuries. But among African Americans, yard art is especially pervasive and shows some distinguishing characteristics, notably a creolized visual language that fuses forms and ideas from both European and African traditions.

African American yard shows look outwardly chaotic and seemingly purposeless. But recent scholarship has stressed a subtle consistency of structure and intent in these forests of found objects.[24] In the recycled refuse of family, friends, and neighbors can be glimpsed narratives of personal and community history that serve as affirmations of individual and collective identity. Found objects are used to create what artist and curator Judith McWillie calls the "transfigured, radiantly sanctified, material environment."[25]

The art historian Robert Farris Thompson has noted several recurring visual principles in these gardens. Among them are "*motion* (wheels, tires, hubcaps, pinwheels); *containment* (jars, jugs, flasks, bottles, especially on trees and porches); *figuration* (plaster icons, dolls, root sculptures, metal images); and *medicine* (special plantings of healing herbs by the door or along the sides of the house)." To Thompson's structural devices, the anthropologist Grey Gundaker has recently added several others, including the use of filters against unwelcome influences, such as irregular pathways, sieves, and brooms; emblems of communication, like antennae and electronic devices; and representations of power or authority, exemplified by special seats or thrones. The elements of the typical yard show are not mere decorations but go-betweens intended to summon a world of benevolent spirits and banish hostile ones. As Thompson writes, "Icons in the yard show may variously command the spirit to move, come in, be kept at bay, be entertained with a richness of images or be baffled with their density."[26]

Few of the creators of African American yard shows explicitly link the form or content of their work to African sources. Nevertheless, Thompson convincingly traces their spiritual origins

126. *Yard show by Lonnie Holley (b. 1950), Birmingham, Alabama, begun c. 1979. Photo: Judith McWillie.*

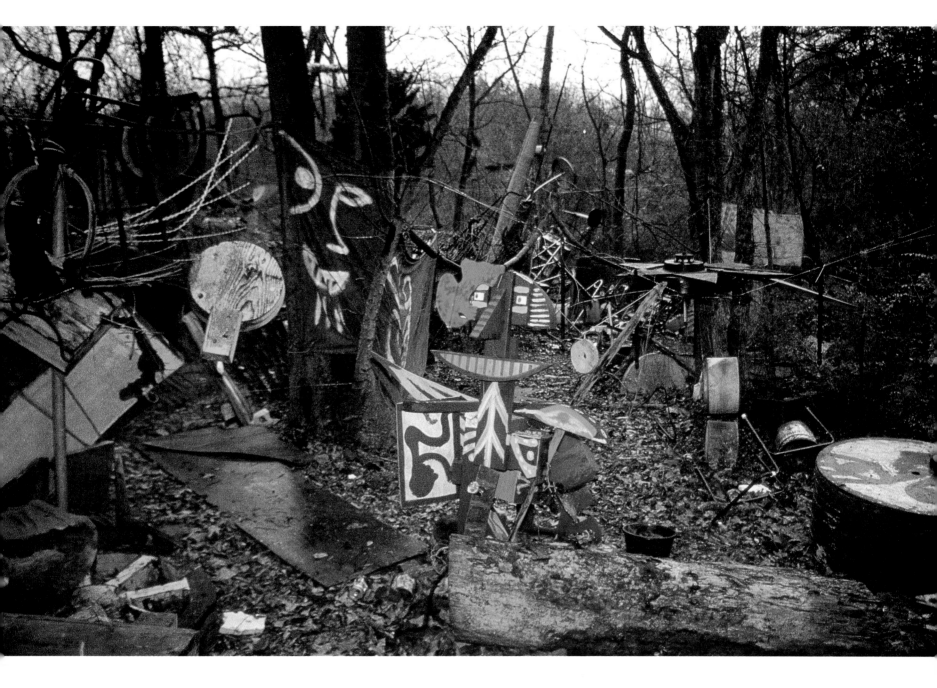

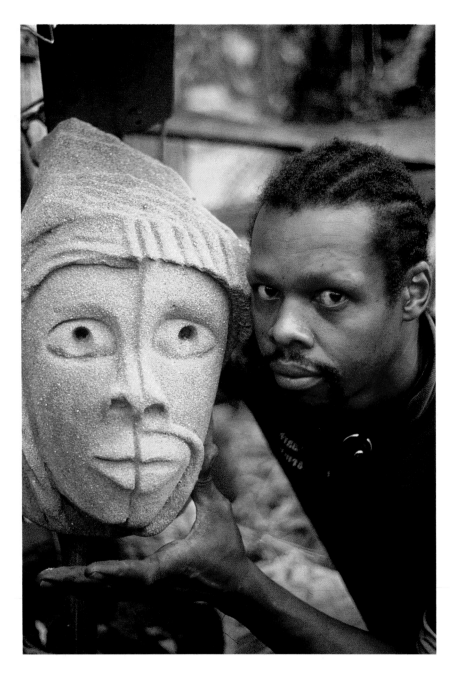

to Africa, especially to the classic religious practices of the central-African Kongo region. There, protective charms placed around the house—shells, bones, rags, roots, bits of broken pottery—ward off evil spirits, while ritual circles and plantings of special herbs provide a more affirmative medicine. He also relates yard shows to traditional Kongo ritual objects called *minkisi* (*nkisi* in the singular), which consist typically of natural materials—including grave dirt and other substances associated with the dead—concealed within a cloth or sometimes within a sculpture. Spirits are embedded in these *minkisi;* they can be activated by a diviner or an adjudicator to punish transgressors or heal supplicants.

One of the most celebrated of recent African-American yard shows is the work of an artist named Lonnie Holley, who lives outside of Birmingham, Alabama (plate 127). A sketch of Holley's biography can only begin to allude to the difficulties of his personal circumstances. He was born in 1950, the seventh of an astonishing twenty-seven children eventually born to his mother. He spent most of his youth in foster homes until he was adopted by his grandmother at age fourteen. A gravedigger by trade, she provided his moral and social education on matters ranging from the Bible to rummaging through dumps for items to sell at flea markets. It was during his recovery from a suicide attempt in 1979 that he made his first art: "It was a baby tombstone," he later recalled. "I didn't know it was art. My sister had lost two of her children in a house fire and it seemed that you couldn't calm her down or keep her from thinking. . . . It was the moment that I saw a vision of myself working."[27] Holley went on to become a painter, sculptor, and environmentalist, creating what he calls "one square acre of art" in the yard of his house on the edge of Birmingham.

127. Lonnie Holley with a sandstone self-portrait. Photo: Judith McWillie.

Holley's continuously evolving yard show features sandstone and wire sculptures, mixed-media assemblages, and paintings displayed beside piles of scavenged materials awaiting transformation (plates 126 and 128). His subjects include tributes to black cultural and political leaders, war, gang violence, drug abuse, pollution, ancient Africa, technology, and the coming social order. "My yard deals with everything from the cradle to the grave," he recently said.[28] While his art would thus seem to be bound largely by present-day social concerns, Holley testifies to other dimensions as well. In his mind, his materials—starting with the earth he works on—mediate between the present and the past, the living and the dead. "The earth is made up of the dust of the ancestors," he says. "We are living off their bodies." Similarly, salvaged objects mediate between matter and spirit. They are sanctified by the labor of those who made them and those who used them. "I dig through what other people have thrown away . . . to get the gold of it—to know that grandmother had that skillet and stood over that heat preparing that meal, so when I go home with that skillet, I've got grandmother."

Holley's capacity to recognize the spiritual resonances in what others see as junk casts him—in his mind and in the minds of some of his neighbors—in the role of diviner, healer, and prophet. He is known as "the Sandman," in part for his carvings in discarded industrial sandstone, in part for his capacity to conjure a palpable dream. He has conferred upon his environment an exhortatory character and sees his work as the expression of collective hopes for a better world. As he said recently, his aim is to "save the children—to inspire them to do better." He describes himself as "a giant spider for life. The web is my environment."

128. A detail of Lonnie Holley's "square acre of art," begun c. 1979.
Photo: Judith McWillie.

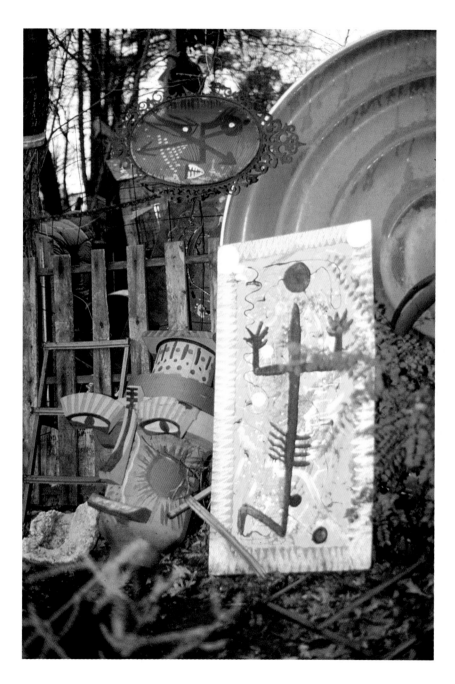

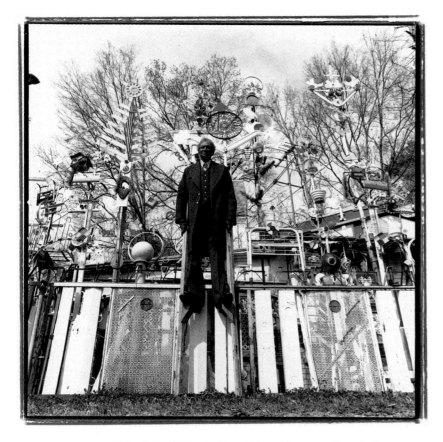

129. Felix "Fox" Harris (d. 1985) on his tom walkers in front of his yard show in Beaumont, Texas. Photo: Keith Carter.

Given another start in life, Holley realizes, he might have played another role. "But I couldn't read like a preacher. I couldn't write like a preacher. So I did it in my art."[29] Like Howard Finster, Holley attributes a sacred message to his collection of cast-off materials, a message of hope and transformation. But he speaks in a language that is inflected with the traditions of both African and Christian spiritualism.

Some of the same African American idioms can be seen in the yard show created by Felix "Fox" Harris in Beaumont, Texas, in the two decades before his death in 1985. Harris's work was the consequence of a familiar visionary experience, in which God grants a second chance at life. As retold by writer Pat Carter, who became a friend of Harris's: "God appeared to him one night in a vision, holding in one hand a sheet of brown paper and in the other hand a sheet of white paper. God spoke to him of the sorrows and struggles of his life, which were symbolized by the brown paper. God laid that paper aside, telling Fox that his old life would be laid aside also. Then He told Fox that he would receive the gift of new life, and he held out the white paper as a sign." Harris summarized the dream this way: "God took nothin' and made somethin'."[30]

Harris's statement had relevance both to his personal life and to his art. His wife had long since died, and he had survived a serious bout with drinking. "I've been lower than a grease spot on the floor," he said, but his appetite for alcohol disappeared with his vision ("God took the taste right out of my mouth"). Like Rodia's towers, Harris's work seems in part to have been the expression of reconstructed self-esteem. As he took nothing and made something of his life, so did he make his art, finding various kinds of industrial and domestic discards and fashioning them into a forest of spirits, a dense and colorful assemblage of treelike totems created from cutout scrap metal and wood.

Harris's environment displayed a number of the principles of the classic African American yard show, including motion, in the form of hubcaps, wheels, and moving parts; figuration, both in cut metal and in found objects like jack-o-lanterns; and communication, in the recurrence of bristling antennae and grills. Its spiritual dimension, however, is not entirely clear. In conversation Harris was evidently less explicit than Holley about this

aspect of his work, despite its origins in a divine revelation. According to Carter, his environment was "a very personal communication between him and God." It seems that his spirituality was at least as much Christian as African; she remembers his fondness for telling Bible stories. But some of the elements express familiar idioms of African American ritualism. He called one assemblage with cutout hands and arms his "Mojo Hands" (plate 130). The term refers to the medium through which spiritual changes—hexes or healing—are worked in the practice of voodoo, a religious sect derived from Africa and still pervasive in the Mississippi delta.

Harris seems to have had a strong sense of his own spiritual powers. Carter describes his "tremendous self-confidence and wonderful serenity." This was perhaps best exemplified by his practice of walking around the yard on stilts, which he called his "tom walkers" (plate 129). While this had a practical function, enabling him to complete the tops of his totems in place and survey his creation from on high, it also suggests a connection with authority figures, especially a Caribbean stilt-dancing carnival character with African origins known as "Moco Jumbie." The name is probably derived from a combination of the Kongo word *moko,* meaning doctor or healer, and the Manding phrase *mumbo jumbo,* referring to a magician who protects his people from evil.[31] So Harris's practice of stilt walking may have been a deeply coded expression of his self-image as a diviner or healer.

The fact that African American yard shows are so little understood—coupled with the relative political and economic powerlessness of blacks—makes these creations even more ephemeral than most environments. Few outlive their makers. A list of notable yard shows from ten years ago would have included those by David Butler of Patterson, Louisiana; Sam Doyle of

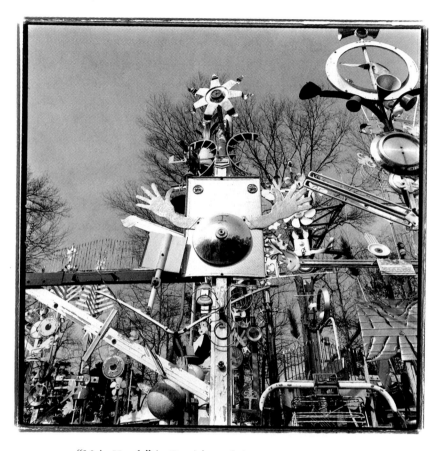

130. *"Mojo Hands" in Harris's yard show.* Photo: Keith Carter.

Saint Helena Island, South Carolina, and Nellie Mae Rowe of Vinings, Georgia; along with Fox Harris.[32] All four artists have since died; the environments of Butler, Doyle, and Rowe are gone. That of Harris survives in part, thanks to a great-nephew who helped arrange its transfer to the Art Museum of Southeast Texas in Beaumont, where a portion of it is displayed in an enclosed courtyard. Meanwhile, Holley's yard show is threatened by the planned expansion of the nearby Birmingham airport. Like

Kea Tawana's ark, still others have fallen victim to bureaucratic hostility, such as Tyree Guyton's Heidelberg Project.

In the mid-1980s Guyton was an unrecognized artist working in the basement of his grandfather's house on the 3600 block of Heidelberg Street on Detroit's east side. Guyton had grown up in the neighborhood, now an impoverished area of weed-filled vacant lots and abandoned houses, with nine siblings and a mother who scraped by on welfare. He was well aware of the residents' eternal struggle to make a decent life for themselves in a context of relentless disadvantage and crime. He had already made small assemblages of cast-off materials, but now he took them to the streets. He began furiously collecting debris, using it first to construct several large sculptures in a vacant lot. Then he went to work on the abandoned dwelling next door to the home of his grandfather, Sam Mackey.

This was the first of five houses in the Heidelberg Street neighborhood that Guyton, with the help of his grandfather and his wife, Karen, would transform into giant works of assemblage art. "You'll think I'm crazy," he recounts, "but the houses began to speak to me—because of what was happening. Things were going down. You know, we're taught in school to look at problems and think of solutions. This was my solution."[33] The houses virtually disappeared under the cumulative weight of wheels, tires, signs, dolls, suitcases, discarded appliances, and automobile parts, brightened with polka dots, stripes, and splashes of paint. As with the environments of both Holley and Harris, Guyton's work displayed many of the familiar devices of African American yard shows, including motion, containment, figuration, and communication (one house incorporated an old phone booth and working radios and televisions). Guyton also created an imaginative variation on the bottle tree: he hung shoes, a window frame, even a bicycle in the branches of a polka-dotted tree.

In all, Guyton's constructions evoked the tradition in which spirits of the dead are summoned to protect the living. Given the character of his Heidelberg Street neighborhood, he had particularly powerful reasons to want to call forth friendly forces and banish hostile ones: the abandoned dwellings were not merely symbols of decay; they were also being used as crack houses. The attention focused on Guyton's work—crowds began to gather, especially after it was featured in *People* and *Connoisseur* magazines in mid-1989 and on the NBC nightly news that autumn—began to drive away the drug dealers. The Heidelberg Project was thus both literally and figuratively transformative, representing the power of individuals to confront their circumstances and try to make the best of them. Guyton wasn't just celebrating his own resilience: one construction was called Fun House (plate 131)—a tribute, he says, to the irrepressible spirits of the people who had lived there, even in the worst of times.

Guyton is not entirely a self-taught artist. Born in 1955, he completed high school and received some training in art at Detroit's Center for Creative Studies and at Detroit's Marygrove College. Although his academic experience should put him outside the scope of this study, his link to the popular tradition of the African American yard show demands that he be included. Indeed, his formal schooling was not the most important part of his education as an artist. He was inspired as much by his grandfather, a house painter who gave Guyton his first paintbrush and who encouraged his artistic inclinations from an early age. He recalls talking with his grandfather about the idea of transforming the derelict houses and not starting work until the older man, then in his late eighties, signaled his approval and even agreed to help.

131. Tyree Guyton (b. 1955), Fun House, begun c. 1985, destroyed 1991, Detroit. Photo: Ted Degener.

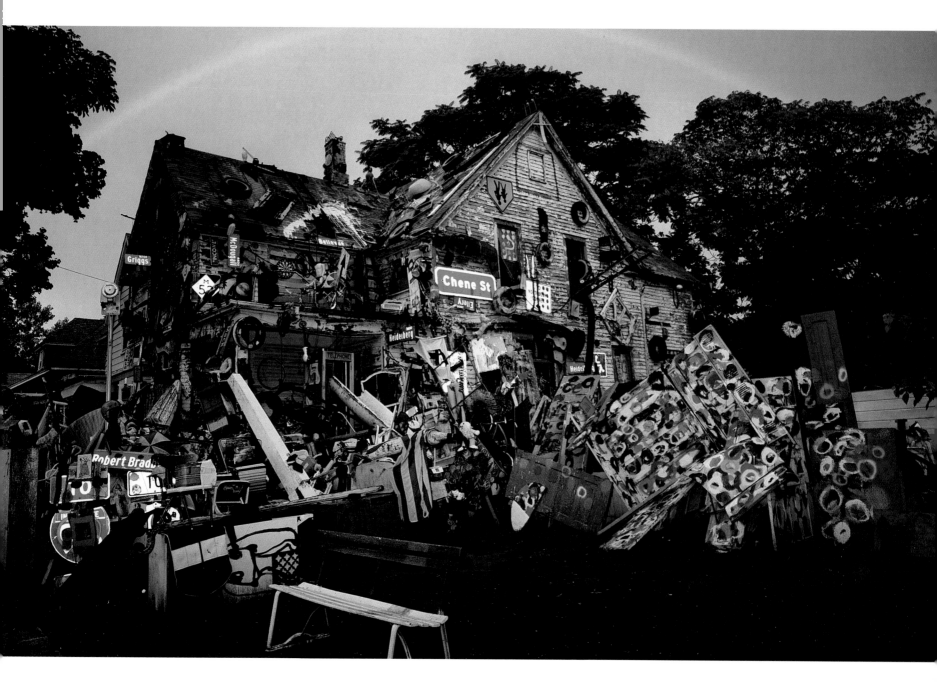

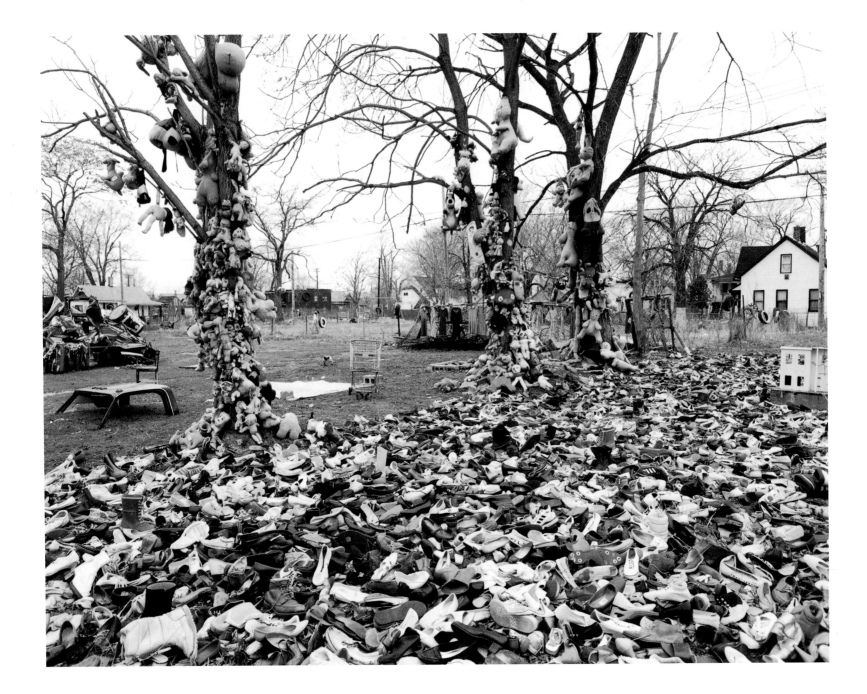

Guyton also warrants attention for the way in which he confirms that the boundaries in art—between high and low, or fine and popular—are becoming increasingly permeable: the Heidelberg Project is a Dada yard show or a bebop version of Kurt Schwitters's *Merzbau.* Moreover, his work is testimony to the ever more creolized character of contemporary American art. In particular, Guyton reveals the way in which people with distinct ethnic traditions are reasserting them as part of a larger process of cultural self-affirmation. "Underground" styles—typically involving parody, reversals of meaning, or exaggerated stereotypes—are often used as expressions of resistance to a cultural mainstream that seems largely indifferent to the political, cultural, or economic plight of marginalized groups.

Indeed, official antagonism was blatant in Guyton's case, as it had been in Tawana's. Perhaps this was inevitable, given that he too had appropriated public land for his personal artistic use. One of his houses was demolished by the city in 1989; four others were destroyed without warning early one Saturday morning in November 1991. Notwithstanding the fact that Tyree and Karen Guyton had received the "Spirit of Detroit Award" from the City Council in 1989 and an exhibition at the Detroit Institute of Arts in 1990, the city bureaucracy was unwilling to let the Heidelberg Project stand as an emblem of spiritual resilience in an especially hostile environment. Perhaps not coincidentally, the second demolition took place just two weeks after the project was visited by Detroit's then-mayor Coleman Young, who did not disguise his disdain.[34]

But Guyton began rebuilding almost at once from the ruins, on the same block of Heidelberg Street. "I felt a lot of anger at the city," he admits, "so I decided to create something even better." He has done several installations on the street and in vacant lots—trees hung with dolls; towers of salvaged materials; and vast collections of shoes representing the legions of displaced and homeless people (plate 132). He has also transformed three more houses, one of which was polka-dotted at the instructions of his grandfather, who has since died. (At his request, he was buried in a polka-dotted casket.) Like other creators of yard shows, Guyton has become something of an authority figure in his community. He tells the story of enlisting the help of some neighborhood kids to make over a house near Heidelberg Street. They were stopped by the police, who demanded to know who gave them permission. "The voodoo man," they replied. The kids went back to work, and the name stuck. Guyton himself feels elected in some way: he is often motivated by dreams. And he remembers going to a revival with his mother, a Pentecostalist, some years before starting work on the project. "There were hundreds of people there," he recalls. "But the preacher pointed right at me and said, 'God has anointed your hands.'"

Some neighbors even see Guyton's work as an intermediary between the living and the dead. A woman recently reported seeing Guyton's brother, shot and killed two years before, examining one of the new houses. Guyton, too, feels the spiritual presence of his brother, represented by an exchange that took place shortly before his death. His brother gave him one of his shoes, half of a brand-new pair. "What am I supposed to do with this?" Guyton asked. "You're an artist," his brother replied. "You know what to do with it." In a classic instance of double meaning, his brother's soul was commended to his care.

132. An installation by Guyton on Heidelberg Street, Detroit, in honor of displaced and homeless people. Photo: Ted Degener.

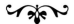

Guyton and his brother enacted an exchange that goes on day by day between him and the people of Heidelberg Street. They bring him junk and donate their time and labor to his effort; in return, he works a material and spiritual transformation on their neighborhood. They engage in a particularly elevated form of commerce—an exchange of gifts. Their activity constitutes an alternative, even underground economy that is pervasive among creators of visionary environments. Holley has a sign in his yard that announces, "To you adults this is art My gift to you. Learn to read it and you will [love] to see it. . . . It may help you love life that you can perform miracles." Similarly, when Rodia deeded his property to a neighbor and moved away, he too made a gift of his art. While he apparently left because of ill health and vandalism, he had no interest in selling the towers or in receiving money for his achievement. Several members of the committee established to preserve the towers who tried to give him cash reported that he responded in some variation on the statement "No money. Let it be for a sentimental."[35]

In the context of art, the gift exists in several senses. As explored by Lewis Hyde in his book *The Gift: Imagination and the Erotic Life of Property*, these include the sense of a talent or an inspiration given to the artist and the sense of a reciprocal offering from the artist to an audience or a community. "We may not have the power to profess our gifts as the artist does," Hyde writes, "and yet we come to recognize, and in a sense to receive, the endowments of our being through the agency of [the artist's] creation. We feel fortunate, even redeemed."[36] Visionary artists confirm these dimensions of the gift, while adding several others of their own. They often give witness to an unbidden talent or inspiration, sometimes explicitly in the language of the gift. Walter Flax declared, "I'm gifted thataway. Sometime you got something you can do—other people can't do."[37] Moreover,

motivating visions frequently record the gift of a second chance in life, as in the cases of Rolling Mountain Thunder, St. EOM, and Fox Harris.

Whereas most artists buy their materials, visionary artists generally find theirs or are given them. At other times, they buy them with donations of cash. This endows their materials with a special worth, to which Grandma Prisbrey testified. "Some time ago," she wrote in her narrative about Bottle Village, "a woman gave me a doll and only last week she was here and asked if I still had it. . . . I said, 'Didn't you give her to me?' She replied 'yes I did.' 'Well,' I retorted, 'I don't sell the things people give me. I think more of them when they are given to me.'" By accepting these gifts, visionary artists incur special obligations that they generally discharge by insisting on giving something back to their communities, regardless of how it might be received. The reciprocal gift takes many forms: a place of popular piety, in the case of artist-priests; a park for all the people, in the case of Fred Smith; a place to learn about Native American history, in the case of Ed Galloway; and a place to find shelter and faith, in the case of Rolling Mountain Thunder.

All art deserving of the name partakes in some measure in this gift exchange. But most art exists in the market as well. Only one of these economies is essential to art. "A work of art can survive without the market," Hyde maintains, "but where there is no gift there is no art." Indeed, when art becomes a commodity, it often does so to the detriment of its worth as a gift. "If it is true," Hyde speculates, "that in the essential commerce of art a gift is carried by the work from the artist to the audience, if I am right to say that where there is no gift there is no art, then it may be possible to destroy a work of art by converting it into a pure commodity."[38] Hyde here defines what to me is an essential problem for art: how to reconcile these two modes of exchange, the

sale and the gift; how to balance their competing, even mutually exclusive demands and rewards.

To my mind, visionary environments, more than most art, partake of what Hyde calls "the essential commerce of art." They have almost no commodity value—not because they can't be bought and sold, but because their makers typically withdraw them from the market. This allows them to stand as clearer representations of the gift and thus—potentially at least—to contribute more plainly to what Hyde terms the "wider spirits" of their communities.

> *A circulation of gifts nourishes those parts of our spirit . . . that derive from nature, the group, the race, or the gods. . . . Where we maintain no institutions of positive reciprocity, we find ourselves unable to participate in those "wider spirits" I just spoke of—unable to enter gracefully into nature, unable to draw community out of the mass, and, finally, unable to receive, contribute toward, and pass along the collective treasures we refer to as culture and tradition.*[39]

Finally, this may be the most compelling irony of visionary environments. They are often intended as gifts to nourish the spiritual life of the group, but they are typically not recognized as such—because they are offered in an idiosyncratic form by people with limited access to the usual opportunities for public address. They are alternative worlds, but they carry significant public meanings—if only we would make the effort to read them. Though highly personal, their languages are not entirely anomalous: they are laced with cultural references to which we all are heir—references to politics, religion, popular history, community, and ethnic and regional concerns. Likewise, they offer a sometimes pointed commentary on the broader social life that we all share.

Visionary environments express a physical and cultural isolation that is in some measure voluntary, but that also reveals a failure in our society to welcome everyone into its embrace. They are often a manifestation of unequal economic and educational opportunity and of unequal access to social approval—for immigrants, African Americans, and other marginalized groups especially. Precisely because their makers labor so determinedly under such difficult circumstances, visionary environments suggest an emotional or spiritual way out of social dilemmas—a way to affirm self-worth, to transcend the limitations of circumstance, to create a better life, and to rediscover faith in whatever religious, moral, or philosophical values might sustain us.

Still more, I think these gardens reveal the uneasy relationship between the individual and the community that is one of our deepest social paradoxes. While the nation was founded on the principles of individual liberty, private property, and freedom of speech and religion, it strikes me that we have never been entirely comfortable with some of the more extreme ways in which these principles have found expression—even when harmless to others. Our general inability to come to terms with visionary environments seems to me another symptom of the fact that we value the notions of liberty and free speech but find their more unorthodox forms disconcerting if not antisocial. If these visionary gardens provoke us into contemplating the unresolved, even paradoxical, relationship between the individual and the community, between freedom and conformity, then this is the measure both of their power as art and of their larger cultural significance.

These environments are the gifts of magical thinkers who recycle the waste materials and shared myths of our culture for the common benefit. Theirs is a private labor with a public aim:

to find an extraordinary way to share their convictions with the world. It is consequently not to be dismissed as some form of crazy behavior but embraced instead as a positive challenge to both our artistic and our social norms—to the limits of our tolerance, to our determination to construct a more democratic culture, and to our capacity to acknowledge the marvelous.

Yet I have to admit to feeling that there is something poignant, even hopeless in these environments. The physical collapse of many of them strikes me as emblematic of their failure to have much of an impact on the larger culture. In the absence of some collective effort to comprehend the message of these environments, they seem like a rearguard action against the spiritually deprived mass culture that has an increasing stranglehold on the American soul. As commodity triumphs, spiritual life dwindles. The inspired tinkering of these *bricoleurs* seems to be losing ground, along with the myths they sustain—myths of tolerance in diversity, of a more just life on earth, and of the coming of the kingdom of heaven.

Notes

❧

In the interests of space, these notes have been kept to a minimum. For fuller information on sources, see the version of this text submitted as a dissertation with the same title to the Graduate School of Arts and Sciences, University of Virginia, 1994.

INTRODUCTION:
GARDENS OF REVELATION

1. For academic definitions of folk art, see especially John Michael Vlach, "Properly Speaking: The Need for Plain Talk about Folk Art," in Vlach and Simon J. Bronner, eds., *Folk Art and Art Worlds* (Ann Arbor, Mich.: UMI Research Press, 1986), pp. 13–26.

2. Notwithstanding the fact that visionary environments do not fit comfortably within academic definitions of folk art, my commitment to exploring their social and cultural contexts has been strengthened by recent studies in folk art. See especially Ken Ames, "Folk Art: The Challenge and the Promise," in Ian M. G. Quimby and Scott Swank, eds., *Perspectives on American Folk Art* (New York: W. W. Norton, 1980), pp. 293–324; and Eugene Metcalf, "Confronting Contemporary Folk Art," in Metcalf and Michael D. Hall, eds., *The Ties That Bind: Folk Art in Contemporary American Culture* (Cincinnati: Contemporary Arts Center, 1986), pp. 10–28.

3. Maynard Mack, *The Garden and the City* (London: Oxford University Press; Toronto: University of Toronto Press, 1969), p. 232.

4. Given the importance of biography in understanding these environments, it is a matter of some frustration to me that the documentation of the artists' lives is so imprecise. It is often drawn from casual newspaper accounts or local hagiographies; the artists who are still alive can be evasive. As much as possible, I have tried to determine the broad outlines of biographical truth, while allowing for myth-creation in the details.

5. My reading of the perceptual and psychological effects of visionary environments, while shaped by the ideas of Breton, is also indebted to Robert Harbison, *Eccentric Spaces*, reprint ed. (Boston: David R. Godine, 1988), especially chaps. 1 and 2; and to E. H. Gombrich on the grotesque, "The Edge of Chaos," in *The Sense of Order: A Study in the Psychology of Decorative Art* (London: Phaidon, 1979).

6. See the introduction by Martin Friedman in *Naives and Visionaries* (Minneapolis: Walker Art Center; New York: E. P. Dutton, 1974) and the preface by Victor Musgrave in *Outsiders* (London: Arts Council of Great Britain, 1979).

7. John Dixon Hunt, "'Curiosities to Adorn Cabinets and Gardens,'" in *The Origins of Museums: The Cabinet of Curiosities in Sixteenth- and Seventeenth-Century Europe*, ed. Oliver Impey and Arthur MacGregor (Oxford: Clarendon Press, 1985), p. 198.

8. Disney publicity, quoted by Michael Sorkin in "See You in Disneyland," in his anthology *Variations on a Theme Park* (New York: Hill and Wang, 1992), p. 206. Sorkin critiques the ways in which the theme park is replacing more valuable and substantial versions of public space in America. My sense of the corrosiveness of commercialized mass culture has been shaped by other writers as well; see especially Christopher Lasch, "Mass Culture Reconsidered," *Democracy* 1 (October 1981): 7–22.

9. Lasch, "Mass Culture Reconsidered," p. 9.

10. Tressa Prisbrey, in *Grandma and Her Village* (Simi Valley, Calif.: privately printed, c. 1960), p. 3. Available from Preserve Bottle Village, Box 1412, Simi Valley, California 93062.

11. Fred Smith, in Don Howlett and Sharron Howlett, "Folk Heroes Cast in Concrete," *Historic Preservation* 31 (May–June 1979): 36.

12. On the phenomenon of the farmer-preacher and on the nature of evangelism more generally, see Sydney Ahlstrom, *A Religious History of the American People* (New Haven, Conn.: Yale University Press, 1972), especially chaps. 20 and 27. On sectarianism, see chap. 29.

13. For an environment that deals explicitly with damnation, see Sal Scalora, "W. C. Rice: The Cross Man," *Folk Art Messenger* 6 (summer 1993): 1, 3.

14. Ahlstrom, *Religious History*, p. 387.

15. Ralph Waldo Emerson, "Nature," in *Selected Writings of Ralph Waldo Emerson* (New York: Modern Library, 1968), p. 3.

16. Paul Klee, in Reinhold Heller, "Expressionism's Ancients," in *Parallel Visions: Modern Artists and Outsider Art* (Los Angeles: Los Angeles County Museum of Art; Princeton, N.J.: Princeton University Press, 1992), p. 78.

17. For the impact of Prinzhorn's book on the Parisian Surrealists, see John MacGregor, *The Discovery of the Art of the Insane* (Princeton, N.J.: Princeton University Press, 1989), pp. 279–81. See also his interview with Jean Dubuffet, "Art Brut chez Dubuffet," *Raw Vision*, no. 7 (summer 1993): 42–43.

18. André Breton, in Roger Cardinal, "Surrealism and the Paradigm of the Creative Subject," in *Parallel Visions*, p. 95.

19. Breton, "Manifesto of Surrealism," in *Manifestoes of Surrealism*, translated from the French by Richard Seaver and Helen R. Lane (Ann Arbor: University of Michigan Press, 1969), pp. 9, 14, 26.

20. There is some debate about why Breton did not acknowledge mediumism in the manifesto; Cardinal speculates that "perhaps . . . he was fearful that overt mention of spiritualism might taint Surrealism's atheistic image." (Cardinal, "Surrealism and the Paradigm of the Creative Subject," p. 96.)

21. Jean Dubuffet, *Asphyxiating Culture and Other Writings*, trans. Carol Volk (New York: Four Walls and Eight Windows, 1988), pp. 40–41, 48. The discussion of rawness as a tendency comes on pp. 69–70.

22. Michel Thévoz, *Art Brut* (New York: Rizzoli, 1976), pp. 9–10. See also Roger Cardinal, *Outsider Art* (New York: Praeger Publishers, 1972).

23. Michael D. Hall, "Memory and Mortar: Fred Smith's Wisconsin Concrete Park," in *Stereoscopic Perspective: Reflections on American Fine and Folk Art* (Ann Arbor, Mich.: UMI Research Press, 1988), p. 174.

1. "THE MARVELOUS PRECIPITATE OF DESIRE"

1. Ferdinand Cheval, letter to a M. Lacroix, 1897, in Claude Prévost and Clovis Prévost, *Les Bâtisseurs de l'imaginaire* (Jarville-la-Malgrange, France: Editions de l'Est, 1990), pp. 12–18. I am grateful to Carolyn Forche for help with the translation.

2. Cheval, from an unpublished diary quoted in Jacques Brunius, "Palais Idéal," *Architectural Review* 80 (October 1936): 147–48.

3. Biographical details are from Claude Boncompain, *Le Facteur Cheval, piéton de Hauterives* (Valence, France: Le Bouquin–Peuple Libre, 1988), pp. 13–15.

4. Cheval in his diary, in Brunius, "Palais Idéal," p. 147.

5. Cheval, from the 1897 letter in Prévost and Prévost, *Les Bâtisseurs de l'imaginaire*.

6. John Dixon Hunt, "'Curiosities to Adorn Cabinets and Gardens,'" in *The Origins of Museums: The Cabinet of Curiosities in Sixteenth- and Seventeenth-Century Europe*, ed. Oliver Impey and Arthur MacGregor (Oxford: Clarendon Press, 1985), p. 198.

7. André Breton, "Le Message automatique," in *Minotaure*, vol. 1 (New York: Arno Press, 1968), p. 65. First published in *Minotaure*, nos. 3–4, December 1933.

8. Cheval, in Roger Cardinal, *Outsider Art* (New York: Praeger Publishers, 1972), p. 147.

9. The notion of convulsive beauty was being formulated before Breton's encounter with the Palais Idéal; it is anticipated in the last pages of his 1928 book *Nadja*. But it was considerably refined and elaborated after, in a 1934 essay that became the first chapter of *L'Amour fou* in 1937. (André Breton, "La Beauté sera convulsive . . . ," *Minotaure*, no. 5 [1934]: 9–16; this essay became the first chapter of *L'Amour fou* [Paris: Gallimard, 1937].) *L'Amour fou* was translated by Mary Ann Caws and published as *Mad Love* (Lincoln: University of Nebraska Press, 1987); unless otherwise noted, the quotations from *L'Amour fou* that follow are taken from this source, pp. 8–19.

10. André Breton, "Facteur Cheval," from *Le Revolver à cheveux blancs* (1932); reprinted in *Poems of André Breton: A Bilingual Anthology*, trans. and ed. Jean-Pierre Cauvin and Mary Ann Caws (Austin: University of Texas Press, 1982), pp. 66–69. Reprinted by permission of the author and University of Texas Press; copyright © 1982.

11. Breton, *Mad Love*, p. 32.

12. Lawrence Durrell, "In Praise of Fanatics," originally published in *Holiday* in August 1962; reprinted in Durrell, *Spirit of Place* (New York: E. P. Dutton, 1969), 316.

13. Paul Shepard, "Objets Trouvés," in Mark Francis and Randolph T. Hester, eds., *The Meaning of Gardens* (Cambridge, Mass.: MIT Press, 1990), p. 148.

14. Claude Lévi-Strauss, *La Pensée sauvage* (Paris: Librairie Plon, 1962), translated and published in English as *The Savage Mind* (Chicago: University of Chicago Press, 1966). Quotation from the latter source, p. 17.

15. Unless otherwise noted, all quotations from Raymond Isidore are from Prévost and Prévost, *Les Bâtisseurs de l'imaginaire*, pp. 125–49. Translated for me by Ingrid Castro. Many of the same quotations can be found in Maarten Kloos, *Le Paradis terrestre de Picassiette* (Paris: Encre, 1979), which gathers together in the form of an interview various statements made by Isidore to the different writers who visited him.

16. The chronology of Isidore's life is from Maïthé Vallès-Bled, *Picassiette: A Visitor's Guide* (Chartres, France: Friends of the Chartres Museum, n.d.), pp. 6, 28–29.

17. Roger Cardinal offered this extended translation of "Picassiette" in a letter to me of November 26, 1993: "As 'pique-assiette' it might translate as 'one who nicks (pinches, steals) plates,' the slang verb *piquer*. Note that the past participle 'piqué' denotes 'touched, crazy, loopy.' But my old 1951 Petit Larousse also gives as a common phrase 'un pique-assiette' meaning simply 'parasite, sponger.'"

18. Unless otherwise noted, Robert Garcet quotations are from a lengthy statement in Prévost and Prévost, *Les Bâtisseurs de l'imaginaire*, pp. 186–220. Translated for me by Ingrid Castro.

19. Garcet's interpretation of the stones of Ebenezer and the relevance of the story to his tower was related by him to me in conversation, June 1992.

20. See the illustrations of "figured stones" in *The Age of the Marvelous* (Hanover, N.H.: Hood Museum of Art, Dartmouth College, 1991), pp. 88–89.

21. Garcet, letter to author, July 27, 1992.

22. The recollections of Helen Martins's sister Annie were recounted in Susan Imrie Ross, "The Owl House," *Raw Vision*, no. 5 (winter 1991–92): 28.

23. Ibid., pp. 28–29.

24. Ibid., p. 30.

25. Quotations from Athol Fugard come from a taped interview conducted by Scarlet Cheng in Washington, D.C., on August 6, 1989. I am grateful to Ms. Cheng for making a tape of the interview available to me and for permission to quote from it.

26. Nek Chand, in Bennett Schiff, "A Fantasy Garden by Nek Chand Flourishes in India," *Smithsonian* 15 (June 1984): 128.

27. S. S. Bhatti, "The Rock Garden of Chandigarh," *Raw Vision*, no. 1 (spring 1989): 22.

28. Chand, ibid., pp. 30, 25.

29. Chand's account of the discovery of his garden by the authorities is from a letter to me dated August 31, 1993. This letter is also the primary source of biographical information.

30. For the connections between Chand's garden and local architectural traditions, see Bhatti, "Rock Garden of Chandigarh," p. 25.

31. Chand to author, August 31, 1993.

2. FOR GOD AND COUNTRY

1. The report from the *Kansas City Star* is quoted in "Grassroots Artist: S. P. Dinsmoor," *Kansas Grassroots Art Association News* 8, no. 3 (1989): 2. Confirmation of the dating is supplied in Dinsmoor's guidebook. He dates the flag over the scorpion to fifteen years before the booklet was written in 1927—that is, to 1912. Early photographs in the booklet suggest that this was one of the last sculptures added to the north side of the garden, as it is not present in some of them. In any event, the latest date for both the mausoleum and most of the cement sculptures on the west and north seems to be 1917: Dinsmoor's first wife, who died in 1917, is buried in the mausoleum, and a photograph in the guidebook dated January 1, 1918, shows the north and west sculptures completed along with the mausoleum. The 1918 photograph does not show the Goddess of Liberty or the Crucifixion of Labor, which must date to the late 1910s or early 1920s.

2. Unless otherwise noted, quotations from Dinsmoor are from his *Pictorial History of the Cabin Home in Garden of Eden, Lucas, Kansas* (Lucas, Kans.: privately printed, c. 1927). Dinsmoor's pamphlet has been reprinted and is available at the Garden of Eden.

3. My analysis of visionary environments in the framework of civil religion owes much to the ideas of Robert Bellah, especially his book *The Broken Covenant: American Civil Religion in Time of Trial* (New York: Seabury Press, 1975).

4. A copy of Dinsmoor's obituary from the July 27, 1932, *Lucas Independent* is available at the Garden of Eden.

5. Dinsmoor's political views were researched in local papers and reported in an unpublished essay by Bob Voth called "S. P. Dinsmoor and His Populist Garden of Eden" (1971). Voth's findings are summarized in "Grassroots Artist: S. P. Dinsmoor," p. 2.

6. On the speculation about a connection between Dinsmoor and Dr. Brinkley, see "Concrete 'Garden of Eden' Is Monument to Kansas 'Heretic,'" *Topeka Daily Capital Sunday Magazine*, March 28, 1954, p. 9A. Additional details are provided in Jennie A. Chinn, "The 'Second Adam' and His 'Garden,'" in Daniel Franklin Ward, ed., *Personal Places: Perspectives on Informal Art Environments* (Bowling Green, Ohio: Bowling Green State University Popular Press, 1984), p. 84.

7. Howard Finster's self-descriptions are taken from writings that recur with great frequency on his paintings. For reproductions of his work, see especially Howard Finster (as told to Tom Patterson), *Howard Finster: Stranger from Another World* (New York: Abbeville Press, 1989) and John F. Turner, *Howard Finster, Man of Visions* (New York: Alfred A. Knopf, 1989). The biographical details that follow are taken largely from *Stranger from Another World*.

8. Finster's vision about his garden is recounted in his own words in *Stranger from Another World*, pp. 106–7; the vision about painting sacred art is on pp. 123–24.

9. Finster, in John Turner and Judith Dunham, "Howard Finster: Man of Visions," *Folklife Annual* (Library of Congress) (1985): 164.

10. On the reactions to Finster's garden, see Finster, *Stranger from Another World*, pp. 116–21.

11. On preservation plans for Finster's garden, see Daniel C. Prince, "Howard Finster's Paradise Garden: A Plan for the Future," *Clarion* 13 (winter 1988): 56–57.

12. Variations on this quotation from Fred Smith about his motivation can be found in several places in the literature on him. See especially Judith Hoos and Gregg Blasdel, "Fred Smith's Concrete Park," in *Naives and Visionaries* (Minneapolis: Walker Art Center, 1974), p. 59; and Don Howlett and Sharron Howlett, "Folk Heroes Cast in Concrete," *Historic Preservation* 31 (May–June 1979): 38. For a more recent source, see Lisa Stone and Jim Zanzi, *The Art of Fred Smith* (Phillips, Wisc.: Price County Forestry Department, 1991), p. 10.

13. Smith's notion of a park for all the people is described in Howlett and Howlett, "Folk Heroes," p. 38.

14. Ibid.

15. On Mrs. Pope's Museum, see Tom Patterson, "A Strange and Beautiful World," *Brown's Guide to Georgia* 9 (December 1981): 44–46; on Old Trapper's Lodge, see Daniel C. Prince, "Environments in Crisis," *Clarion* 13 (winter 1988): 44–48; on Herman Rusch, see Judith Hoos, "Herman Rusch: Prairie Moon Museum and Garden," in *Naives and Visionaries*, pp. 70–75.

16. Biographical details on Ed Galloway are from a conversation with his daughter-in-law, Joy Galloway, May 1993. They are substantially the same as those in Mary Ann Anders, "Celebrating the Individual: Ed Galloway's Park," in *Personal Places*, pp. 124–32. The carved tree trunk is at the Sand Springs Home in Oklahoma; another of Galloway's early sculptures, a lion in a cage carved from a single piece of wood, is at the petting zoo in Springfield, Missouri.

17. Ed Galloway confirmed the identification of these figures in a letter to the Oklahoma State Chamber of Commerce and Development Council, dated October 7, 1961. Statistics on the height and diameter of the tower, as well as the number of carved images on its surface, are also from this letter. A copy of the letter was provided to me by the Rogers County Historical Society.

18. Galloway, letter to the Oklahoma State Chamber of Commerce.

19. Rolling Mountain Thunder, in Bill Childress, "Rolling Mountain Thunder," *Nevada Magazine* 36, no. 2 (1976): 42. Biographical details are mostly from this source.

20. Many of the details of his parents' life were obtained from Dan Van Zant, the oldest son of Rolling Mountain Thunder and his first wife.

21. Rolling Mountain Thunder, in Childress, "Rolling Mountain Thunder," p. 42.

22. This vision is recounted in the film *The Monument of Rolling Mountain Thunder,* by Allie Light and Irving Saraf, which was filmed in 1980–81 and released in 1983. The film is available from Light-Saraf Films, 264 Arbor Street, San Francisco, California 94131.

23. Rolling Mountain Thunder, in Jocelyn Gibbs, "Visions of Home: Preserving America's Folk Art Environments," *Whole Earth Review,* no. 52 (fall 1986): 108.

24. Quoted in Allie Light and Irving Saraf, *The Monument of Rolling Mountain Thunder.*

25. Rolling Mountain Thunder, in Childress, "Rolling Mountain Thunder," p. 40.

3. GROTTOES OF THE HOLY BOOK

1. Father Louis Greving, speaking of Father Paul Dobberstein, in Duane Hutchinson, *Grotto Father: Artist-Priest of the West Bend Grotto* (Lincoln, Neb.: Foundation Books, 1989), p. 25. In a letter to me of November 4, 1991, Father Greving elaborated on what he meant by calling Father Dobberstein "a prophet without honor in his own country": "People here in West Bend like the Grotto, but from a distance. Some have never even taken a tour through the Grotto with a guide. It is just here. The priests of the Diocese? Well, some like it, see its worth, and give me a pat on the back from time to time. Others have never seen the Grotto, but they belittle it with cynical remarks. I just smile at them. Thank God they do not judge me in ways that will affect my eternal destiny."

2. Quoted in Hutchinson, *Grotto Father,* pp. 4–5. Unless otherwise noted, biographical material on Dobberstein is from this source.

3. Greving to author, November 4, 1991. Greving arrived in West Bend as Dobberstein's assistant in 1946 and took over as parish priest when Dobberstein died in 1954.

4. Greving, in Hutchinson, *Grotto Father,* p. 29.

5. There are officially nine grottoes at West Bend, which are collectively known as the Grotto of the Redemption; seven are by Dobberstein. Two of these spaces are called grottoes although they are open to the sky: the Garden of Eden and the Stations of the Cross. Two were added by Greving after Dobberstein's death: the Grotto of the Stable of Bethlehem and the Home of Nazareth. Greving also completed the thirteenth station at the top of the mount and the white marble arch over the entrance to the Grotto of the Trinity.

6. Rev. Paul M. Dobberstein, *An Explanation of the Grotto of the Redemption* (c. 1936), revised and expanded by Rev. L. H. Greving (West Bend, Iowa: privately printed, n.d.), p. 5; it is available in the grotto gift shop.

7. Greving to author, November 4, 1991.

8. Later figures, such as those of Christ, Judas, and the comforting angel in the Grotto of Gethsemane, are signed "Daprato Statuary, Chicago and New York." These were apparently made to order for Dobberstein, who specified the poses.

9. Dobberstein's correspondence with the National Geographic Society is mentioned in Hutchinson, *Grotto Father,* p. 17.

10. This story is told on a taped tour of the grottoes by Greving, available in the grotto gift shop.

11. The annual number of visitors to the Grotto of the Redemption is from the *Des Moines Register Picture Magazine,* July 28, 1963, cover; a similar figure is given in Dobberstein, *An Explanation of the Grotto of the Redemption,* p. 25.

12. Greving to author, November 4, 1991.

13. Dobberstein's discussion of the devotional use of mountain caves was published in Dobberstein, *An Explanation of the Grotto of the Redemption,* pp. 9–11. His homily on caves is mentioned in Hutchinson, *Grotto Father,* p. 11.

14. An excellent source of information on the various types of pilgrimage sites to be found today in Europe, and the different forms of devotion they inspire, is Mary Lee Nolan and Sidney Nolan, *Christian Pilgrimage in Modern Western Europe* (Chapel Hill: University of North Carolina Press, 1989).

15. On Sacro Monte, see Rudolph Wittkower, "Sacri Monti in the Italian Alps," in *Idea and Image: Studies in the Italian Renaissance* (London: Thames and Hudson, 1978), pp. 175–83. I am grateful to John Dixon Hunt for drawing my attention to Sacro Monte and to Miroslava Benes for providing me with bibliographic information.

16. Nolan and Nolan, *Christian Pilgrimage,* pp. 31–32. They note "a strong Germanic propensity toward a type of religious behavior specifically conceptualized as pilgrimage."

17. The baldacchino from San Paulo fuori le Mura was replicated for the Pontifical High Mass at the Twenty-eighth International Eucharistic Congress at Soldier Field, Chicago, on June 21, 1926. This replica may have inspired Dobberstein and other artist-priests of the Midwest. See Lisa Stone and Jim Zanzi, *Sacred Spaces and Other Places* (Chicago: School of the Art Institute of Chicago Press, 1993), p. 35.

18. I am grateful to James Pierce for pointing out to me the various connections between Dobberstein's work and Baroque architecture. See Pierce's "Visual and Auditory Space in Baroque Rome," *Journal of Aesthetics and Art Criticism* 18 (summer 1959): 55–67.

19. Many of Dobberstein's other creations are documented in Stone and Zanzi, *Sacred Spaces.*

20. Greving to author, November 4, 1991.

21. This dating is reported in the guidebook *Grotto and Shrines, Dickeyville, Wisconsin,* available at the grotto gift shop.

22. For the two accounts of Wagner's visit to Lourdes, see *Milestones and Memories: An Autobiography by Rev. P. J. Wagner* (Rudolph, Wisc.: privately printed, c. 1957), pp. 78–79, 137–39. This book is available in the grotto gift shop.

23. The reactions of Wagner's parishioners are recorded in the grotto guidebook, *Father Philip J. Wagner and the Grotto Shrine,* pp. 1–3. It is available in the grotto gift shop. The quotation from the bishop of LaCrosse comes from Stone and Zanzi, *Sacred Spaces,* p. 55.

24. Edmund Rybicki (1918–1991) stayed on to work with Wagner's successor, Father Garlan Muller; together they refurbished the shrines and added the Shrine of the Annunciation (planned by Wagner) as well as a sunken garden and pool and the Stations of the Cross. Muller was especially fond of dahlias, which now grow in profusion on the Wonder Cave.

25. Information on the source of the glass is from the grotto guidebook, p. 4.

26. The details of Brother Joseph's life come from John Morris, *Miniature Miracle: A Biography of Brother Joseph Zoetl, O.S.B.* (Huntsville, Ala.: Honeysuckle Imprint, 1991).

27. Ibid., p. 30.

28. The involvement of the landscape architect William Cowls Dickson is reported in Rev. Malachy Shanaghan, "Lay People in Grotto History," *Saint Bernard Times* 4 (fall 1984), and mentioned in Morris, *Miniature Miracle,* p. 40.

29. The source of funds for the grotto is reported in the guidebook to the Ave Maria Grotto, *Sermons in Stone* (Cullman, Ala.: privately printed, n.d.), which is available in the grotto shop. In a letter to me of April 20, 1993, Father Thomas Schnurr, O.S.B., said that the grotto "was financed by the community."

30. Speculation on the source of the statuary comes from Schnurr's letter of April 20, 1993. See also *Miniature Miracle,* p. 36.

31. What we know of Rodriguez's biography was compiled by Julie Vosmik from interviews with his assistant, Maximo Cortez of San Antonio, and from correspondence between Rodriguez and Hinds. Vosmik, now with the Virginia Office of Historic Preservation, worked in the same capacity in Arkansas and wrote the nominations for both the Arkansas and Memphis sites to the National Register of Historic Places. I have drawn my account of Rodriguez's life from this source.

32. I am grateful to Gwynne Keathley, who, as a student in my 1992 seminar in the landscape architecture program at the Harvard Graduate School of Design, researched Hinds's scrapbooks and correspondence for me.

33. The Pool of Hebron is not explicitly mentioned in Genesis. It turns up in 2 Samuel 4:12 as the place where David hung the bodies of the men who killed his rival Ishbaal, son of Saul. The typescript "History of Memorial Park" (revised May 1990), available at the cemetery, connects the Pool of Hebron with the reservoirs that, according to legend, were built by Solomon to bring water to Jerusalem. These pools, however, were not at Hebron. Katherine Smyth acknowledged that Hinds was "no Bible scholar" and said that he may have confused Solomon's Pools with the Pool of Hebron. (Conversation with author, November 1993.)

34. Eldon Roark, "Strolling with Eldon Roark," *Memphis Commercial Appeal,* June 20, 1935.

35. John Richmond, interviewed by Katherine Smyth, March 25, 1983, in Julie Vosmik, "The Sculptures of Dionicio Rodriguez at Memorial Park Cemetery," sec. 8, p. 5, in National Register of Historic Places Registration Form, on file at the National Park Service, Department of the Interior, Washington, D.C.

36. This letter from Hinds was brought to my attention by Gwynne Keathley.

37. See John O. West, "Folk Grave Decoration along the Rio Grande," in Francis Edward Abernethy, ed., *Folk Art in Texas* (Dallas: Southern Methodist University Press, 1985), p. 46.

38. For an artist apparently inspired by Father Dobberstein, see Steve Ohrn, "Visual History and Biography on Jolly Ridge: The Inspirations of Paul Friedlein," in Daniel Franklin Ward, ed., *Personal Places* (Bowling Green, Ohio: Bowling Green State University Popular Press, 1984), pp. 31–40; for an environment inspired by the Ave Maria Grotto, see the discussion of L. C. Carson's City in Tom Stanley, "Two South Carolina Folk Environments," in Ward, ed., *Personal Places*, pp. 62–71. Numerous other grotto environments are documented in Stone and Zanzi, *Sacred Spaces*. For a discussion of Holyland USA, one of the nation's largest collections of religious replicas, see Daniel C. Prince, "Environments in Crisis," *Clarion* 13 (winter 1988): 50–51.

4. LOVING WELL AND LIVING RIGHT

1. Edward Leedskalnin, "Ed's Sweet Sixteen," in Leedskalnin, *A Book in Every Home* (Homestead, Fla.: privately printed, 1936),

p. 1. Along with Leedskalnin's other writings, this booklet is available in the shop at Coral Castle.

2. This is the recollection of Leola Williams, who visited Coral Castle as a child. She is quoted in the guidebook *Coral Castle: An Engineering Feat Almost Impossible to Believe!* (Homestead, Fla.: Coral Castle, 1988), p. 3.

3. E. L. Lawrence, in *Coral Castle*, p. 4.

4. Edward Leedskalnin, *Mineral, Vegetable and Animal Life* (Homestead, Fla.: privately printed, 1945), p. 3.

5. Harry Andrews, *Chateau Laroche* (Loveland, Ohio: privately printed, c. 1981), p. 1. Available at Chateau Laroche.

6. Information on Andrews's life is from Thomas A. Michel, "Harry Andrews and His Castle: A Rhetorical Study," in Daniel Franklin Ward, ed., *Personal Places* (Bowling Green, Ohio: Bowling Green State University Popular Press, 1984), pp. 114–15. Additional details were provided by Nick Kurzynski, one of the current officers of the Knights of the Golden Trail, custodians of Chateau Laroche.

7. Several of these episodes are detailed in the *Golden Grail* of August 1975 and October 1978; another was told by Andrews to Thomas A. Michel and recounted in his essay "Harry Andrews and His Castle," in *Personal Places*, p. 121. All subsequent references to Andrews's writings are from the latter source.

8. Speculation on the effect of his war experience on Harry Andrews was offered by Nick Kurzynski during my visit to Chateau Laroche in June 1993.

9. Tom Patterson, introduction to St. EOM (as told to Tom Patterson), *St. EOM in the Land of Pasaquan: The Life and Times and Art of Eddie Owens Martin* (Winston-Salem, N.C.: Jargon Society, 1987), p. 30.

10. The motivating vision is recounted in St. EOM, ibid., pp. 168–69.

11. Ibid., p. 113.

12. Ibid., p. 160.

13. St. EOM's visions are recounted ibid., pp. 166–69.

14. St. EOM's views on hair can be found ibid., pp. 169–72. They also formed the main subject of a conversation I had with him on a visit to the Land of Pasaquan in 1981.

15. The vision that commanded him to go home is recorded in a handwritten manuscript composed by St. EOM and copied by one of his assistants, Jimmy Milner. It was sent with a letter to Herbert W. Hemphill, Jr., in 1977 and can be found in the Hemphill Papers at the Archives of American Art. A briefer version of the vision is given in *St. EOM in the Land of Pasaquan*, p. 206.

16. St. EOM detailed the sources and the meaning of some of his iconography in the manuscript found with the Hemphill Papers. See also *St. EOM in the Land of Pasaquan*, pp. 207–9 and 215–16.

17. St. EOM, letter to Herbert W. Hemphill, Jr., 1977, Hemphill Papers, Archives of American Art.

18. On St. EOM's desire to be in his own world, see *St. EOM in the Land of Pasaquan*, p. 219; on the possibility of establishing a cult, see pp. 216–17.

19. Jeff McKissack, *How You Can Live 100 Years . . . and Still Be Spry* (Houston: privately printed, 1960; reprinted by Orange Show Foundation, n.d.), p. 3.

20. I am grateful to Kimberly Neuhaus, a student in my spring 1992 seminar in the Department of Landscape Architecture at the University of Pennsylvania, for drawing this note to my attention. The results of her research into McKissack's work were published in the newsletter of the Orange Show, November–December 1992.

21. McKissack, in William Martin, "What's Red, White, and Blue . . . and Orange All Over?" *Texas Monthly* 5 (October 1977): 123.

22. Some of the details of Tressa Prisbrey's life, including these observations on her marriage, are given in her words in *Grandma's Bottle Village*, a film by Allie Light and Irving Saraf. The film is available from Light-Saraf Films, 264 Arbor Street, San Francisco, California 94131. Other biographical information comes from documents provided by Preserve Bottle Village Committee, Box 1412, Simi Valley, California 93062. The most recent detailed account of Prisbrey's life and work is Verni Greenfield, "Tressa Prisbrey: More Than Money," *Raw Vision*, no. 4 (spring 1991): 46–51.

23. Details of Prisbrey's life in Simi Valley can be found in her autobiography, *Grandma and Her Village* (Simi Valley, Calif.: privately printed, c. 1960), available from the Preserve Bottle Village Committee.

24. Prisbrey, in Maureen Michelson, "Bottle Village: Divine Disorder," *Glass Magazine* 10 (January–March 1983): 36.

5. THE FOREST OF SPIRITS, THE ARK OF DREAMS

1. Sam Rodia, in Jules Langsner, "Sam of Watts," *Arts and Architecture* 68 (July 1951): 23.

2. Biographical information is chiefly from Leon Whiteson, *The Watts Towers* (Oakville, Canada: Mosaic Press, 1989). Whiteson drew on interviews with and documents provided by the Rodia family. In recent years Simon has often been used as Rodia's given name. Whiteson traces this to an April 28, 1937, article in the *Los Angeles Times* called "Glass Towers and Demon Rum."

3. Rodia's career as itinerant laborer has given rise to some speculation that he worked on the Grotto of the Blessed Virgin in Dickeyville. Rodia himself suggested this: he had a postcard of the grotto and once told an interviewer it was one of the "jobs I did in Wisconsin." See Jeanne Morgan, "Rodia's Towers," in Daniel Franklin Ward, ed., *Personal Places* (Bowling Green, Ohio: Bowling Green State University Popular Press, 1984), p. 81. However, the chronology makes this unlikely. Rodia was settled in Long Beach by 1918 and Watts by the early 1920s, but construction on the Dickeyville grotto did not begin until 1924.

4. Information on structure and materials at the Watts Towers are from Arloa Paquin-Goldstone and N. J. Bud Goldstone, "A Tour of the Watts Towers," in Whiteson, *Watts Towers*, pp. 41–45.

5. I. Sheldon Posen and Daniel Franklin Ward, "Watts Towers and the *Giglio* Tradition," *Folklife Annual* (Library of Congress) (1985): 143–57. Quotations are from p. 157.

6. Samuel Calicura, husband of Rodia's sister, in Calvin Trillin, "A Reporter at Large: I Know I Want to Do Something," *New Yorker*, May 29, 1965, p. 116. Whiteson (*Watts Towers*, p. 12) gives his name as Sam Colacurcia, but confirms his low regard for Rodia.

7. Trillin, "Reporter at Large," p. 113; Whiteson, *Watts Towers*, p. 16.

8. On Rodia's political views, see especially Whiteson, *Watts Towers*, pp. 16–17; and Trillin, "Reporter at Large," pp. 102–3, 112–13.

9. Trillin, "Reporter at Large," p. 114; Rodia, in Langsner, "Sam of Watts," p. 25.

10. Rodia, in the 1953 film *The Towers*, by William Hale, available from Creative Film Society, 8435 Geyser Avenue, Northridge, California.

11. For Rodia's heroes, see Langsner, "Sam of Watts," p. 25, and Trillin, "Reporter at Large," pp. 102–3.

12. Rodia, in Trillin, "Reporter at Large," pp. 84, 100.

13. Joseph Thorburn, "Tunnel Artist Builds Cave Resort," *Fresno Bee*, May 3, 1924, p. 7.

14. Information on Baldasare Forestiere's marital ambitions comes from a script given to former tour guides at the Underground Gardens, quoted in Kathan Brown, "The Underground Gardens of Baldasare Forestiere," *Vision* 1 (Oakland, Calif.: Crown Point Press, 1975), pp. 64–65.

15. Rick and Lorraine Forestiere, letter to author, December 22, 1993. The family questions whether Forestiere truly intended to open a restaurant; they suspect that he may have invented this as an alibi for his unorthodox activities.

16. Walter Flax, in Elinor Lander Horwitz, *Contemporary American Folk Artists* (Philadelphia: J. B. Lippincott Co., 1975), p. 116.

17. For additional information on Leslie Payne, see Jane Livingston, John Beardsley, and Regina Perry, *Black Folk Art in America* (Oxford, Miss.: University Press of Mississippi; Washington, D.C.: Corcoran Gallery of Art, 1982), especially pp. 41–42, 110–15.

18. Kea Tawana, in Chip Brown, "The Ark and the Hopeful Voyager," *Washington Post*, March 29, 1987, p. F4.

19. Tawana, in Holly Metz, *Two Arks, a Palace, Some Robots, and Mr. Freedom's Fabulous Fifty Acres* (Newark, N.J.: City Without Walls Gallery, 1989), p. 9. Unless otherwise noted, biographical details are from this source.

20. Tawana, in Linda Yglesias, "A Tall Ship, and a Star to Steer Her By," *New York Daily News Magazine*, December 6, 1987, p. 16.

21. Tawana, in Metz, *Two Arks*, p. 9.

22. Pam Goldstein, in Yglesias, "Tall Ship," p. 18. On Tawana's passing as a man, see Daniel C. Prince, "Environments in Crisis," *Clarion* 13 (winter 1988): 48.

23. Tawana, in Yglesias, "Tall Ship," p. 20.

24. For recent studies of African American yard shows, see Robert Farris Thompson, "The Song That Named the Land: The Visionary Presence of African-American Art,"

in *Black Art—Ancestral Legacy: The African Impulse in African-American Art* (Dallas: Dallas Museum of Art, 1989), pp. 123–35; Judith McWillie, essay in *The Migrations of Meaning* (New York: INTAR Gallery, 1992); and Grey Gundaker, "Tradition and Innovation in African-American Yards," *African Arts* 26 (April 1993): 58–71. For a study that places yard shows in the larger context of African American vernacular gardens, see Richard Westmacott, *African-American Gardens and Yards in the Rural South* (Knoxville: University of Tennessee Press, 1992). Westmacott departs from the other authors in being rather more cautious in detecting evidence of specifically African spiritual traditions in these gardens.

25. McWillie, essay in *Migrations of Meaning*, p. 9. This catalog also contains information on the work of African American yard artists Bennie Lusane and West Lathern.

26. Thompson, "The Song That Named the Land," in *Black Art—Ancestral Legacy*, p. 124; Gundaker, "Tradition and Innovation," pp. 63–66, 68–71. Thompson's essay provides a good overview not only of yard art but also of other forms of African American visionary art, including spirit writing and the use of ideograms and *minkisi* (charms).

27. Lonnie Holley, in Judith McWillie, "Lonnie Holley's Moves," *Artforum* 30 (April 1992): 80. McWillie's essay is based on extensive taped interviews with the artist; unless otherwise noted, subsequent quotations are from this source.

28. Holley, in Melinda Shallcross, "The Poetry of Lonnie Holley," *Folk Art Messenger* 6 (spring 1993): 1.

29. Quotations from Holley in this paragraph are from my interview with the artist, Birmingham, November 1993.

30. Pat Carter, "'Fox' Harris: A Forest of the Spirit," *Spot* (Houston Center for Photography) 10 (spring 1991): 12. The following quotations from Carter come from my conversation with her in August 1993.

31. For more on Moco Jumbie, see John W. Nunley and Judith Bettelheim, *Caribbean Festival Arts* (Saint Louis: Saint Louis Art Museum, 1988), pp. 89–92.

32. On Butler, Doyle, and Rowe, see Livingston, Beardsley, and Perry, *Black Folk Art in America*.

33. Unless otherwise noted, quotations from Tyree Guyton are from my conversations with the artist, Detroit, August and September 1993.

34. See Joy Hakanson Colby, "Deconstructionism," *Detroit News*, November 26, 1991, pp. C1, C12; and William Kleinknecht and Patricia Montemurri, "Young Says If Suburbs Like Guyton's Art, They Can Have It," *Detroit Free Press*, November 26, 1991, p. 2A.

35. See Jeanne Morgan, "Rodia's Towers," in Ward, ed., *Personal Places*, pp. 75–76.

36. Lewis Hyde, *The Gift: Imagination and the Erotic Life of Property* (New York: Vintage Books, 1983), p. xii.

37. Walter Flax, in Horwitz, *Contemporary American Folk Artists*, p. 117.

38. Hyde, *The Gift*, pp. xi, xiii.

39. Ibid., p. 38.

Organizations Dedicated to Environments by Visionary Artists

Some of the following organizations are involved with just one site; others with several. All welcome public support.

Collection de l'Art Brut
11, avenue des Bergières
1004 Lausanne
Switzerland

Folk Art Society of America
Box 17041
Richmond, Virginia 23226

Heidelberg Project
Box 07458
Detroit, Michigan 48207

Intuit: The Center for Intuitive and Outsider Art
Box 10040
Chicago, Illinois 60610

Kansas Grassroots Art Association
Box 221
Lawrence, Kansas 66044

Kohler Foundation
104 Orchard Road
Kohler, Wisconsin 53044

Marion County Historical Society
Box 427
Buena Vista, Georgia 31803

The Orange Show Foundation
2402 Munger Street
Houston, Texas 77023

The Outsider Archive
213 South Lambeth Road
London SW8 1XR
England

Preserve Bottle Village
Box 1412
Simi Valley, California 93062

Rogers County Historical Society
Box 774
Claremore, Oklahoma 74018

SPACES (Saving and Preserving Arts and Cultural Environments)
1804 North Van Ness
Los Angeles, California 90028

APPENDIX 2

Locations of Selected Environments

For additional sites, see listings in the bibliography for various state and regional publications.

BELGIUM

La Tour Eben-Ezer
Eben-Emael
See plates 26–28

The site is not regularly open to the public. For information on possible visits, write M. Robert Garcet, rue Istahelle 9, B 4690 Eben-Emael, Belgique, or fax 041-86-12-97.

FRANCE

Maison Picassiette
22, rue du Repos, Chartres
Phone: 37-34-10-78
See plates 18 and 23–25

Open every day except Tuesday, November through March, 10 A.M. to 12 P.M. and 2 P.M. to 5 P.M.; April through October, 10 A.M. to 6 P.M. Closed January 1, May 1, November 1 and 11, and December 25. For additional information, contact Musée des Beaux-Arts, 29 Cloître Notre-Dame, 28000 Chartres, phone 37-36-41-39 or fax 37-23-41-99.

Palais Idéal
26390 Hauterives, Drôme
Phone: 75-68-81-19
Fax: 75-68-88-15
See plates 16 and 19–22

Open every day except December 25 and January 1. April through September, 9 A.M. to 7 P.M.; October, November, February, and March, 9:30 A.M. to 6 P.M.; December and January, 10 A.M. to 5 P.M.

For additional sites in France, consult Claude Arz, *Guide de la France insolite*.

INDIA

Nek Chand's Rock Garden
Chandigarh (U.T.)
Phone: 0172-40545
Fax: 0172-43073
See plates 1 and 34–37

On the edge of sector 1, along the road from Sukhna Lake to Punjab Engineering College. Open every day, 9 A.M. to 6 P.M., winter; 9 A.M. to 7 P.M., summer.

SOUTH AFRICA

Camel Yard and Owl House
Nieu Bethesda
See plates 29–33

The Owl House Museum is on New Street in Nieu Bethesda, in eastern Cape Province. Open every day, 9 A.M. to 5 P.M.

UNITED STATES

ALABAMA

Ave Maria Grotto
1600 St. Bernard Drive S.E.
Cullman 35055
Phone: (205) 734-8291
See plates 68, 83, 85, and 86

Just east of Cullman on U.S. 278. Open 8 A.M. to 5 P.M. every day except Christmas.

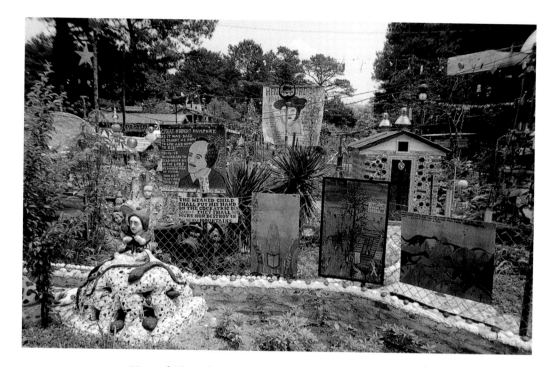

133. Howard Finster's Paradise Garden, near Summerville, Georgia.

Lonnie Holley's Square Acre of Art
See plates 126–28

At the request of the artist, the exact location of this environment is not being published. He is currently living and working on the north side of Birmingham, near the airport. However, he will soon have to move, as the airport is expanding. For those who would like to visit him, he offers this scriptural exhortation: "Seek and ye shall find."

W. C. Rice's Cross Garden
Prattville

Hundreds of signs, crosses, and a chapel along State Route 43, northwest of Montgomery.

ARKANSAS

Concrete sculptures by Dionicio Rodriguez
T. R. Pugh Memorial Park ("The Old Mill")
North Little Rock
See plates 87–91

At the intersection of Fairway Avenue and Lakeshore Drive in the Lakewood subdivision. Just north of that is Lakewood Park, with a large tree-trunk shelter and other works by Rodriguez. For further information, contact North Little Rock Parks Department at (501) 758-2445.

CALIFORNIA

Bottle Village
4595 Cochran Street
Simi Valley
See plates 4, 109–111

Bottle Village is under restoration and not regularly open to the public, but some of it is visible from the street. Visits can be arranged in exchange for some volunteer work. For inquiries, write Preserve Bottle Village, Box 1412, Simi Valley 93062, or phone (805) 583-1627.

Desert View Tower/Boulder Park Caves
Box 301
Jacumba 92034
Phone: (619) 766-4612
See plates 58 and 59

Off I-8 in Imperial County, six miles east of Jacumba on the In-ko-pah Park Road. Open every day, 8:30 A.M. to 5 P.M.

Forestiere Underground Gardens
5021 West Shaw Avenue
Fresno
See plates 120 and 121

Approximately two blocks east of the intersection of Highway 99 and Shaw Avenue. Open for tours. Call (209) 271-0734, or write Forestiere Underground Gardens, Box 5942, Fresno 93755.

Romano Gabriel's Wooden Garden
Eureka
See plates 122 and 123

Now displayed under cover on Second Street between D and E in Old Town Eureka.

Old Trapper's Lodge
See plate 57

Parts of John Ehn's creation, originally on the grounds of a motel near Burbank, are now on the campus of Los Angeles Pierce College, Woodland Hills.

Watts Towers
1765 East 107th Street
Los Angeles
See plates 3, 17, and 114–18

Exit Harbor Freeway at Century Boulevard; east to Central Avenue; south to 103d; east to Graham; south to 107th. The towers are open for tours on Saturdays and Sundays, 10 A.M. to 4 P.M. Call the Watts Towers Art Center to arrange a visit: (213) 847-4646.

CONNECTICUT

Holyland USA
Waterbury

The site, on a hill overlooking downtown, is presently closed.

DISTRICT OF COLUMBIA

Throne of the Third Heaven of the Nations Millennium General Assembly
See plates 13 and 14

Much of this environment is on permanent exhibition at the National Museum of American Art, Smithsonian Institution, located at Eighth and G Streets, N.W.

FLORIDA

Coral Castle
28655 South Dixie Highway
Homestead 33030
Phone: (305) 248-6344
See plates 92–97

Approximately twenty-five miles south of downtown Miami at the intersection of U.S. 1 and s.w. 286th Street; or take Florida Turnpike (821) south to s.w. 137th Avenue, south to s.w. 288th Street, west to Route 1, then two blocks north to site. Open 9 A.M. to 6 P.M. daily.

GEORGIA

Howard Finster's *Paradise Garden*
Summerville
See plates 2, 46–50, and 133

In the Pennville community, a few miles north of Summerville on Highway 27. Going north, turn right between Jim's Auto Supply and Penn Auto, go three blocks to Paradise Garden on the right.

St. EOM's Land of Pasaquan
Buena Vista
See page 2 and plates 100–104

Just east of Columbus, seven miles north of Buena Vista on County Road 78, between State Routes 41 and 137. Open Saturday, 10 A.M. to 6 P.M.; Sunday 1 to 5 P.M.; weekdays by appointment. Call (912) 649-9444. Additional information can be obtained by calling Mr. M. W. McMichael at (912) 649-4769 or the Buena Vista Chamber of Commerce at (800) 647-2842.

ILLINOIS

Jubilee Rock Garden
Brimfield

Built by Bill Notzke northwest of Peoria along U.S. 150 a few miles east of Brimfield. The site includes a rock garden built in the 1930s and a stone-encrusted post-and-lintel shrine to his wife, built in 1963, that is illuminated from within. The site is privately owned; if the gate is open, visitors are welcome; if it is closed, please respect the privacy of the owners and view the site from the road.

IOWA

Grotto of the Redemption
Box 376
West Bend 50597
Phone: (515) 887-2371
See plates 69, 71–75, and 77

On the grounds of the Church of Saints Peter and Paul in West Bend, which is northwest of Fort Dodge at the intersection of State Highway 15 and County Route B63. Open every day. Tours available May 1–October 15, 9 A.M. to 5 P.M. The grotto is illuminated after dark until 11 P.M.

KANSAS

S. P. Dinsmoor's *Garden of Eden*
Lucas
Phone: (913) 525-6395
See plates 10, 38, 39, and 41–43

Lucas is on K-18, sixteen miles north of I-70 via K-232 from Wilson. The Garden of Eden is at the corner of Second and Kansas Streets. Open daily 10 A.M. to 6 P.M., March 1 through November 31; winter months, 1 to 4 P.M.

MICHIGAN

Heidelberg Project
Detroit
See plates 131 and 132

This continuously changing environment can be found in and around the 3600 block of Heidelberg Street, off Gratiot Avenue (Route 3) three blocks south of Mack, just east of downtown Detroit. For current information, write the Heidelberg Project, Box 07458, Detroit 48207.

NEVADA

Thunder Mountain Monument
Imlay
See plates 11 and 64–67

On the south side of I-80 at Exit 145; Imlay is thirty miles southwest of Winnemucca. Open every day, 7 A.M. to 5 P.M., for self-guided tour. Phone curator Mike Flansaas for guided tour, (902) 538-7402.

NEW MEXICO

Rancho Bonito and Shaffer Hotel
Mountainair
See plates 60 and 61

Mountainair is southeast of Albuquerque on U.S. 60 at Route 55. The Shaffer Hotel, with a rock garden by Pop Shaffer, is still in operation as a bed and breakfast on Main Street. Call (800) 293-2888. To visit Rancho Bonito, write for an appointment to Dorothy Cole, RR 1 Box 4, Mountainair 87036.

NORTH CAROLINA

Occoneechee Trapper's Lodge
Garysburg
Phone: (919) 536-3985

A stone-and-log cabin containing and covered with natural history exhibits, built by Q. J. Stephenson near the Roanoke River in northeastern North Carolina. Exit I-95 at Garysburg, just north of Roanoke Rapids.

Henry Warren's Shangri-La
Prospect Hill

A village of some twenty-seven miniature stone buildings including a mill, a church, shrines, houses, a motel, a dance hall, and a replica of the Watergate Hotel, built between 1968 and 1977 northwest of Durham. On Route 86 about three miles south of the intersection with Route 119 between Hightowers and Prospect Hill; next door to the Prospect Hill Fire Department.

Vollis Simpson's Wind Machines
Route 1, Box 362
Lucama 27851
Phone: (919) 239-0679

A group of enormous whirligigs off Route 301 between Wilson and Lucama. From Wilson, go south on 301 to Contentnia Creek. Just over the bridge (and just before Route 117), turn right on Wiggins Mill Road. Go six or seven miles to environment on left, at intersection of five roads.

OHIO

Harry Andrews's Castle (Chateau Laroche)
Loveland
See plates 98 and 99

Just northeast of Cincinnati on the Little Miami River. From I-275, take Montgomery Road (Highways 22 and 3) north to Fields Ertle Road. Go east (right) to Rich Road; right to Mulberry; left to the bottom of the hill; then right on Shore Road to the castle. Open daily April through September, 11 A.M. to 5 P.M.; weekends only the rest of the year. Call

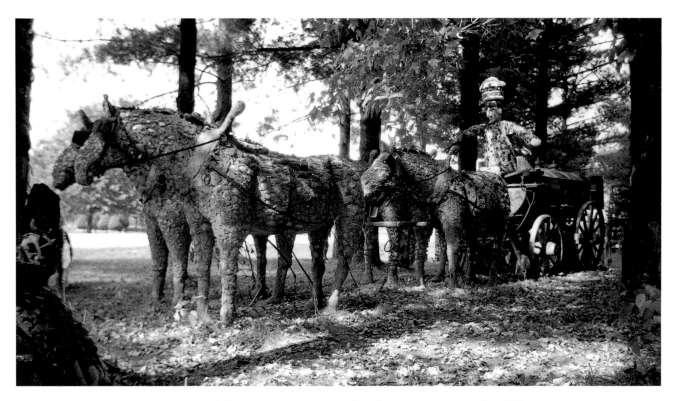

134. Kerosene delivery wagon, Fred Smith's Wisconsin Concrete Park, Phillips.

(513) 683-4686 for alternative directions or to arrange group tours.

OKLAHOMA

Ed Galloway's Totem Pole Park
Foyil
See plates 62 and 63
 The site is northeast of Tulsa off Route 66, approximately three miles east of Foyil on State Route 28A. Open daily.

OREGON

Rasmus Petersen's Rock Garden
7930 S.W. Seventy-seventh Street
Redmond 97756
Phone: (503) 382-5574
 Miniature buildings and bridges encrusted with unusual minerals, along with patriotic elements and floral displays. Off the Old Redmond Highway between Bend and Redmond; watch for directional signs. Open daily.

TENNESSEE

Concrete sculptures by Dionicio Rodriguez
Memorial Park Cemetery
5668 Poplar Avenue
Memphis 38187-0338
See plates 87 and 90–91
 At Poplar Avenue and Yates Road, just west of the intersection of Poplar and I-240 on the east side of Memphis. Open daily, 8:30 A.M. to 4:30 P.M.

TEXAS

Felix "Fox" Harris
See plates 129 and 130

Elements of his environment can now be found at the Art Museum of Southeast Texas, Beaumont.

The Orange Show
2401 Munger Street
Houston 77023
See plates 15 and 105–8

From downtown, take I-45 south to Telephone Road; three blocks to Munger on the right; one block to Orange Show on the left. Open noon to 5 P.M. Saturdays and Sundays from mid-March to mid-December; from Memorial Day to Labor Day, also open weekdays, 9 A.M. to 1 P.M. For tour information or to use the library, call (713) 926-6368.

Houston is also home to a number of unorthodox dwellings. They include the late John Milkovisch's Beer Can House, at 222 Malone; The Flower Man's House, created by Cleveland Turner at 3317 Sampson at Francis; the Fan Man's House, Drew at Napoleon, the work of Bob Harper; and Pigdom, Victoria Herberta's collection of signs and pig memorabilia at Crawford and Eagle.

WASHINGTON

Walker Rock Garden
5407 Thirty-seventh Avenue s.w.
Seattle

Miniature mountains and lakes and a twenty-foot (six-meter) tower built of stones, crystal, and glass by Milton and Florence Walker between 1959 and 1980. Open by appointment from April through Labor Day, and on occasional open days. Call (206) 935-3036 to arrange a visit.

WISCONSIN

Grotto of the Blessed Virgin and Holy Ghost Park
305 West Main Street / Box 427
Dickeyville 53808
Phone: (608) 568-7519
See plates 12, 78, and 79

On Highways 35 and 61, just north of the intersection with U.S. 151, approximately ten miles northeast of Dubuque. Open year round.

Grotto Gardens and Wonder Cave
6957 Grotto Avenue
Rudolph 54475
Phone: (715) 435-3120
See plates 80–82

On the grounds of St. Philip's parish church, Second Street and Grotto Avenue. Rudolph is about ten miles north of Wisconsin Rapids, at the intersection of County Route C and State Highway 34. Gardens open year round; gift shop and Wonder Cave open daily 10 A.M. to 5 P.M., Memorial Day through Labor Day.

Herman Rusch's Prairie Moon Museum and Garden
See plate 56

This site has recently been acquired by the Kohler Foundation and is awaiting restoration. For information on possible visits, contact the Kohler Foundation, 104 Orchard Road, Kohler 53044. Phone: (414) 458-1972.

St. Rose Grotto
St. Rose Convent
715 South Ninth Street
La Crosse

A particularly nice example of Father Dobberstein's many smaller variations on the Grotto of the Redemption, at the intersection of Market and Ninth. The convent grounds are open year round, Monday to Saturday, 9 A.M. to noon and 1 to 3:30 P.M.; Sunday, 1 to 3:30 P.M.

Fred Smith's Wisconsin Concrete Park
Phillips
See plates 51–54 and 134

Just south of town on State Highway 13 in north-central Wisconsin. Open year-round during daylight hours. For more information, write Price County Tourism Department, Phillips 54555.

Paul and Matilda Wegner Grotto
(The Glass Chapel)
Cataract

About ten miles north of Sparta on State Highway 71, just west of the intersection with Highway 27. Open year-round during daylight hours, though some of the sculptures are covered in the winter months. For more information, contact Monroe County Local History Room, Route 2, Box 21, Sparta 54656.

Acknowledgments

WE ALL STAND on the shoulders of others. I could not have written this book without the dedicated efforts of a group of venturesome cultural explorers who have labored diligently over the years to identify, study, and preserve the environments of visionary artists. Among the pioneers I particularly want to acknowledge are Gregg Blasdel, Barbara Brackman, Roger Cardinal, Martin Friedman, Michael D. Hall, Lynda Roscoe Hartigan, Herbert W. Hemphill, Jr., Bernard Lassus, Judith McWillie, Roger Manley, Ann Oppenheimer, Tom Patterson, Seymour Rosen, Lisa Stone, Julie Vosmik, Daniel Franklin Ward, and Jim Zanzi. I have leaned on all of them—many in person, some through their writings. Virtually without exception, those with whom I have been in communication have been remarkably generous with their time, their knowledge, and their support.

This book owes its inception to a series of life-changing encounters with visionary artists in the company of Jane Livingston during the early 1980s, when we were organizing the exhibition *Black Folk Art in America*. It first began to take shape in a lecture given at Dumbarton Oaks at the invitation of John Dixon Hunt in 1991. Jane and John have both continued to provide crucial insights and encouragement, and I cannot thank them enough. I owe the same measure of gratitude to my instructors and later colleagues and friends at the University of Virginia, especially Roger Stein, Daniel Bluestone, Reuben Rainey, and Elizabeth Meyer. Roger and Dan in particular have labored long and hard with me over this text and contributed a great deal to its intellectual substance.

The surviving artists and their families have patiently answered my many queries, including Nek Chand Saini; Howard and Pauline Finster; Rick, Lorraine, and Nicholas Forestiere; Joy Galloway; Robert Garcet; Tyree and Karen Guyton; Lonnie Holley; and Daniel Van Zant. The present owners, directors, or caretakers of other sites have been equally helpful, and I want to express my thanks to Rt. Rev. Victor Clark, O.S.B., Abbot, and Father Thomas Schnurr, O.S.B., Saint Bernard Abbey; Dorothy Cole, Rancho Bonito; Fred Fussell and Mulkey McMichael, Marion County (Georgia) Historical Society; Rev. L. H. Greving, Grotto of the Redemption; Mark Greenfield, Watts Towers Art Center; John Hachmeister, Garden of Eden, Inc.; Laura E. Kohler, Kohler Foundation; Wanda Moore, Rogers County (Oklahoma) Historical Society; Katherine Hinds Smyth and Clay Smyth, Memorial Park Cemetery; Rev. Francis J. Steffen, Grotto of the Blessed Virgin; Susanne Theis, Orange Show Foundation; Christine Willfahrt, Grotto Gardens and Wonder Cave; and Janice Wilson, Preserve Bottle Village.

James Pierce deserves a special note of thanks. An artist and former art history professor at the University of Kentucky, he began photographing visionary environments on a grant from the National Endowment for the Humanities in 1976 and continued into the 1980s. Not only did he throw open his remarkable archive of unpublished photographs to me, but he also shared years of anecdote and information. Together, his photographs and his ideas provided a crucial foundation for my text. Unless otherwise noted, all photographs in this book are his. Several other photographers were equally generous with their materials; they are credited in the captions that accompany their respective images. Photographs of Helen Martins's Camel Yard and

Owl House are courtesy of The Penguin Group, from *The Owl House* by Anne Emslie.

My editor at Abbeville Press, Nancy Grubb, has once again proved herself receptive to material that others find confounding. I am most grateful to her for seeing the deeper attraction in a superficially difficult subject. I am also fortunate to have had Patricia Fabricant as the designer of this book; she has a firsthand knowledge of some of the environments and is thus particularly well suited to the task.

Many others have lent encouragement over the years, providing introductions or writing letters of recommendation, including J. B. Jackson, John Hallmark Neff, and Kirk Varnedoe. Bella Simonds and Ingrid Castro have facilitated my research and communications in Europe. I am grateful to the Graham Foundation for Advanced Study in the Fine Arts for their support of this project.

My wife, Stephanie Ridder, and our children, Sam and Emily, have given the most essential form of encouragement, seeing me off to places we could barely find on the map and welcoming me home with a keen interest in finding out what—and whom—I'd seen there. They provided the right remedy for flagging spirits, reminding me that if this book hadn't required perseverance and faith, it would not have been worthy of its subject.

Selected Bibliography

THIS IS A SELECTIVE rather than an exhaustive listing, focusing on the titles that have been most helpful to me in shaping my approach to the material, together with some of the standard reference works on the subject. Much of the primary source material is still available at the various environments. Copies of some of it can be found in the Herbert Waide Hemphill, Jr., Papers, at the Archives of American Art, Smithsonian Institution, Washington, D.C.; these papers also include a few letters from artists. Also at the Archives of American Art are taped interviews conducted by Willem Volkersz with many prominent folk and visionary artists, along with papers pertaining to several self-taught environmental artists.

In addition to the secondary source material listed below, interested readers will want to consult *L'Art Brut*, the serial publications of Jean Dubuffet's Compagnie de l'Art Brut, which became the Collection de l'Art Brut in Lausanne; *Raw Vision*, the international journal of outsider art published in London; the *Clarion* (now *Folk Art Magazine*), published by the Museum of American Folk Art, New York; *Folk Art Messenger*, the publication of the Folk Art Society of America, Richmond; *Intuit*, a periodical from the Center for Intuitive and Outsider Art, Chicago; and the newsletters of the preservation groups SPACES (Los Angeles) and the Kansas Grassroots Art Association (Lawrence), all of which regularly carry articles on environments. In addition to the resources at the Archives of American Art, libraries, slide collections, and archives are available at SPACES, the KGAA, the Folk Art Society of America, the Orange Show Foundation, Houston, and the Outsider Archive, London. See the appendices in this volume for addresses.

Bibliographies for individual artists discussed at length in the text follow the general listing.

GENERAL

Abernethy, Francis Edward, ed. *Folk Art in Texas*. Dallas: Southern Methodist University Press, 1985. Includes essays on the Orange Show, on yard art, and on grave decoration, among other topics.

American Folk Art: The Herbert Waide Hemphill, Jr. Collection. Milwaukee: Milwaukee Art Museum, 1981.

Ames, Kenneth L. *Beyond Necessity: Art in the Folk Tradition*. New York: W. W. Norton, 1977.

Another Face of the Diamond: Pathways Through the Black Atlantic South. New York: INTAR Gallery, 1988. Essays by Judith McWillie, John Mason, and Robert Farris Thompson.

Arz, Claude. *Guide de la France insolite*. Paris: Guides Hachette, 1990.

Barrett, Didi. *Muffled Voices: Folk Artists in Contemporary America*. New York: Museum of American Folk Art, 1986.

Bihalji-Merin, Oto, and Tomasevic Nebojsa-Bato. *World Encyclopedia of Naive Art*. London: Frederick Muller, 1984.

Bishop, Robert. *American Folk Sculpture*. New York: E. P. Dutton, 1974.

Blasdel, Gregg. "The Grass Roots Artist." *Art in America* 56 (September–October 1968): 24–41.

———. *Earthly Delights: Visionary Dwellers on the American Landscape*. Waitsfield, Vt.: Concepts Publishing, 1994.

Blasdel, Gregg, and William Lipke. *Clarence Schmidt*. Burlington: University of Vermont, 1975.

Brackman, Barbara. "Top Ten U.S. Sites." *Raw Vision*, no. 3 (summer 1990): 46–52.

————. "Enchanted Kingdoms." *Americana* 19 (July–August 1991): 41–47.

Breton, André. "Le Message automatique," pp. 55–65 in *Minotaure*. New York: Arno Press, 1968, vol. 1. First published in *Minotaure*, nos. 3–4, December 1933.

————. "Autodidacts Called 'Naives'" (1942). In *Surrealism and Painting*, trans. Simon Watson Taylor. London: Macdonald and Co., 1972. First published as *Le Surréalisme et la peinture* (Paris: Gallimard, 1965).

Bronner, Simon, ed. "Investigating Identity and Expression in Folk Art." *Winterthur Portfolio* 16 (spring 1981): 65–83.

————. *American Folk Art: A Guide to Sources.* New York: Garland Publishing, 1984.

Cardinal, Roger. *Outsider Art.* New York: Praeger Publishers, 1972.

Carraher, Ronald. *Artists in Spite of Art.* New York: Van Nostrand Reinhold, 1970.

Cat and a Ball on a Waterfall: Two Hundred Years of California Folk Painting and Sculpture. Oakland, Calif.: Oakland Museum, 1986. Includes an essay by Seymour Rosen and Louise Jackson, "Folk Art Environments in California."

Crease, Robert, and Charles Mann. "Backyard Creators of Art That Says 'I Did It, I'm Here.'" *Smithsonian* 14 (August 1983): 82–91.

Dewhurst, C. Kurt; Betty MacDowell; and Marsha MacDowell. *Religious Folk Art in America.* New York: Museum of American Folk Art; E. P. Dutton, 1983.

Dubuffet, Jean. *L'Art Brut.* Paris: Musée des Arts Décoratifs, 1967.

————. *Prospectus et tous écrits suivants.* Ed. Hubert Damisch. Paris: Gallimard, 1967.

————. *Asphyxiating Culture and Other Writings.* Trans. Carol Volk. New York: Four Walls and Eight Windows, 1988. First published as *Asphyxiante Culture* (Paris: Jean-Jacques Pauvert, 1968).

Ferris, William, ed. *Afro-American Folk Art and Crafts.* Jackson: University Press of Mississippi, 1983.

"Folk Art Environments," special issue. *Spot* (Houston Center for Photography) 10 (summer 1991). Essays by Tom Patterson, Seymour Rosen, Susanne Demchak Theis, and Pat Carter.

Folk Art in Oklahoma. Oklahoma City: Oklahoma Museums Association, 1981. Includes Ed Galloway and other environmental artists.

Francis, Mark, and Randolph T. Hester, Jr., eds. *The Meaning of Gardens: Idea, Place, and Action.* Cambridge, Mass.: MIT Press, 1990. Includes an essay on bricolage, "Objets Trouvés," by Paul Shepard.

Gibbs, Jocelyn. "Visions of Home: Preserving America's Folk Art Environments." *Whole Earth Review*, no. 52 (fall 1986): 106–12.

Glassie, Henry. *Pattern in the Material Folk Culture of the Eastern United States.* Philadelphia: University of Pennsylvania Press, 1968.

Grave, Alexandra. *Three Centuries of Connecticut Folk Art.* New Haven: Art Resources of Connecticut, 1979. Includes Clark Coe; John Greco's Holyland USA.

Gundaker, Grey. "Tradition and Innovation in African American Yards." *African Arts* 26 (April 1993): 58–71.

Hall, Michael D. *Stereoscopic Perspective: Reflections on American Fine and Folk Art.* Ann Arbor, Mich.: UMI Research Press, 1988.

Hartigan, Lynda Roscoe. *Made with Passion: The Hemphill Folk Art Collection.* Washington, D.C.: Smithsonian Institution Press, 1990.

Hemphill, Herbert W., Jr., and Julia Weissman. *Twentieth-Century American Folk Art and Artists.* New York: E. P. Dutton, 1974.

Horwitz, Elinor Lander. *Contemporary American Folk Artists.* Philadelphia and New York: J. B. Lippincott Co., 1975.

Jakovsky, Anatole. *Damonen und Wunder.* Cologne: Verlag M. DuMont Schauberg, 1963.

Jones, Barbara. *Follies and Grottoes* (1953). 2d ed. London: Constable and Co., 1974.

Jones, Michael Owen. *Exploring Folk Art: Twenty Years of Thought on Craft, Work, and Aesthetics.* Ann Arbor, Mich.: UMI Research Press, 1987.

Kaprow, Allan. *Assemblage, Environments, and Happenings.* New York: Harry N. Abrams, 1965.

Lassus, Bernard. *Jardins imaginaires: Les Habitants-paysagistes.* Paris: Presses de la Connaissance, 1977.

Livingston, Jane; John Beardsley; and Regenia Perry. *Black Folk Art in America.* Oxford: University Press of Mississippi; Washington, D.C.: Corcoran Gallery of Art, 1982.

Lycett Green, Candida. *Brilliant Gardens.* London: Chatto and Windus, 1990. Includes a number of English sites, such as the

concrete menagerie by James Beveridge, Branxton, Northumberland, and the shell gardens by Jack Miles at Downton, Wiltshire, and by George Howard at Southbourne, Dorset.

MacGregor, John. *The Discovery of the Art of the Insane*. Princeton, N.J.: Princeton University Press, 1989.

———. "Art Brut chez Dubuffet." *Raw Vision*, no. 7 (summer 1993): 40–51.

Manley, Roger. *Signs and Wonders: Outsider Art inside North Carolina*. Raleigh: North Carolina Museum of Art; University of North Carolina Press, 1989.

Marling, Karal Ann. *The Colossus of Roads: Myth and Symbol along the American Highway*. Minneapolis: University of Minnesota Press, 1984.

Metcalf, Eugene, and Michael D. Hall, eds. *The Ties That Bind: Folk Art in Contemporary American Culture*. Cincinnati: Contemporary Arts Center, 1986.

———. *The Artist Outsider: Creativity and the Boundaries of Culture*. Washington, D.C.: Smithsonian Institution Press, 1994.

Metz, Holly. *Two Arks, a Palace, Some Robots, and Mr. Freedom's Fabulous Fifty Acres: Grassroots Art in Twelve New Jersey Communities*. Newark, N.J.: City Without Walls Gallery, 1989.

The Migrations of Meaning. New York: INTAR Gallery, 1992. Includes African American yard artists Bennie Lusane and West Lathern; essayists include Judith McWillie, Robert Farris Thompson, and John F. Szwed.

Missing Pieces: Georgia Folk Art, 1770–1976.

Atlanta: Georgia Council for the Arts and Humanities, 1976. Includes a section on environmental folk art.

Naives and Visionaries. Minneapolis: Walker Art Center; New York: E. P. Dutton, 1974. Introduction by Martin Friedman.

Outsiders: An Art without Precedent or Tradition. London: Arts Council of Great Britain, 1979. Preface by Victor Musgrave; essay by Roger Cardinal.

Owen, Jane. *Eccentric Gardens*. London: Pavilion, 1990.

Parallel Visions: Modern Artists and Outsider Art. Los Angeles: Los Angeles County Museum of Art; Princeton, N.J.: Princeton University Press, 1992.

Patterson, Tom. "A Strange and Beautiful World." *Brown's Guide to Georgia* 9 (December 1981): 44–58.

———. *Ashe: Improvisation and Recycling in African-American Visionary Art*. Winston-Salem, N.C.: Diggs Gallery at Winston-Salem State University, 1993.

———. *Not By Luck: Self-Taught Artists in the American South*. Milford, N.J.: Lynne Ingram Southern Folk Art, 1993.

Patterson, Tom, and Roger Manley. *Southern Visionary Folk Artists*. Winston-Salem, N.C.: Jargon Society, 1985.

Pioneers in Paradise: Folk and Outsider Artists of the West Coast. Long Beach, Calif.: Long Beach Museum of Art, 1984. Includes Calvin and Ruby Black; Romano Gabriel.

Prévost, Claude, and Clovis Prévost. *Les Bâtisseurs de l'imaginaire*. Jarville-la-Malgrange, France: Editions de l'Est, 1990.

Prince, Daniel C. "Environments in Crisis." *Clarion* 13 (winter 1988): 44–51.

Quimby, Ian M. G., and Scott Swank, eds. *Perspectives on American Folk Art*. New York: W. W. Norton, 1980.

Rosen, Seymour. *In Celebration of Ourselves*. San Francisco: California Living Books, 1979.

Rosenak, Chuck, and Jan Rosenak. *Museum of American Folk Art Encyclopedia of Twentieth-Century American Folk Art and Artists*. New York: Abbeville Press, 1990.

Scalora, Sal. "Visionare Gesamtkunstwerke." *Kunstforum* (Cologne), no. 112 (March–April 1991): 236–57.

Schuyt, Michael; Joost Elffers; and George R. Collins. *Fantastic Architecture*. New York: Harry N. Abrams, 1980.

Sellen, Betty-Carol, with Cynthia J. Johanson. *Twentieth-Century American Folk, Self-Taught, and Outsider Art*. New York: Neal-Schuman, 1993. A resource book and annotated bibliography.

A Separate Reality: Florida Eccentrics. Fort Lauderdale, Fla.: Museum of Art, 1987. Includes Edward Leedskalnin.

"Spontaneous Construction," special issue. *Public Art Review* 4 (summer–fall 1992). Includes essays by Joanne Cubbs, Gregg Blasdel, Judith McWillie, Tom Patterson, Lynda Roscoe Hartigan, Holly Metz, and Willem Volkersz.

Stone, Lisa, and Jim Zanzi. *Sacred Spaces and Other Places: A Guide to Grottos and Sculptural Environments in the Upper Midwest*.

Chicago: School of the Art Institute of Chicago Press, 1993.

Szeemann, Harald. *Der Hang zum Gesamt-kunstwerk: Europaische Utopien seit 1800.* Aarau, Switzerland: Verlag Sauerlander, 1983. Includes Ferdinand Cheval; Robert Garcet.

Thévoz, Michel. *Art Brut.* New York: Rizzoli, 1976. First published in French (Geneva: Albert Skira, 1975).

Thompson, Robert Farris. *Flash of the Spirit: African and Afro-American Art and Philoso-phy.* New York: Random House, 1983.

———. "The Song That Named the Land: The Visionary Presence of African-Amer-ican Art," pp. 97–141. In *Black Art—Ancestral Legacy: The African Impulse in African-American Art.* Dallas: Dallas Mu-seum of Fine Arts, 1989.

Transmitters: The Isolate Artist in America. Phil-adelphia: Philadelphia College of Art, 1981.

Vlach, John Michael. *The Afro-American Tra-dition in Decorative Arts.* Cleveland: Cleve-land Museum of Art, 1978.

———. "American Folk Art: Questions and Quandaries." *Winterthur Portfolio* 15 (win-ter 1980): 345–55.

Vlach, John Michael, and Simon J. Bronner, eds. *Folk Art and Art Worlds.* Ann Arbor, Mich.: UMI Research Press, 1986.

Wampler, Jan. *All Their Own: People and the Places They Build.* Cambridge, Mass.: Schenkman, 1977.

Ward, Daniel Franklin, ed. *Personal Places: Perspectives on Informal Art Environments.* Bowling Green, Ohio: Bowling Green State University Popular Press, 1984.

Weissman, Julia. "Environmental Folk Art." *Clarion* (winter 1982–83): 32–37.

Yelen, Alice Rae. *Passionate Visions of the American South: Self-Taught Artists from 1940 to the Present.* New Orleans: New Or-leans Museum of Art, 1993.

INDIVIDUAL ARTISTS
Shortened references appear in full in the gen-eral section of the bibliography.

Harry Andrews

Andrews, Harry. *Chateau Laroche.* Loveland, Ohio: privately printed, c. 1980.

Michel, Thomas A. "Harry Andrews and His Castle: A Rhetorical Study," pp. 111–23. In Daniel Franklin Ward, ed., *Personal Places.*

Nek Chand

Bhatti, S. S. "The Rock Garden of Chandi-garh." *Raw Vision,* no. 1 (spring 1989): 22–30.

Howe, Desson. "Artist of Garden Variety." *Washington Post,* August 28, 1985, pp. B1, B11.

Schiff, Bennett. "A Fantasy Garden by Nek Chand Flourishes in India." *Smithsonian* 15 (June 1984): 126–35.

Ferdinand Cheval

Boncompain, Claude. *Le Facteur Cheval, piéton de Hauterives.* Valence, France: Le Bouquin–Peuple Libre, 1988.

Brunius, Jacques. "Palais Idéal." *Architectural Review* 80 (October 1936): 147–50.

Cardinal, Roger. *Outsider Art,* pp. 146–53.

Durrell, Lawrence. "In Praise of Fanatics." In *Spirit of Place,* pp. 307–22. New York: E. P. Dutton, 1969. First published in *Holiday* (August 1962).

Jouve, Jean-Pierre; Claude Prévost; and Clo-vis Prévost. *Le Palais idéal du Facteur Che-val.* Paris: Editions du Moniteur, 1981.

Melly, George. "The Palais Idéal of Facteur Cheval. *Raw Vision,* no. 4 (spring 1991): 28–35.

Prévost, Claude, and Clovis Prévost. *Les Bâ-tisseurs de l'imaginaire,* pp. 11–47.

Szeemann, Harald. *Der Hang zum Gesamt-kunstwerk,* pp. 207–14.

Samuel Perry Dinsmoor

Blasdel, Gregg, and Philip Larson. "S. P. Dinsmoor's Garden of Eden." In *Naives and Visionaries,* pp. 33–41.

"Built His Own Eden—In Kansas." *Saint Louis Post-Dispatch Sunday Magazine,* July 31, 1927, p. 4.

Chinn, Jennie A. "The 'Second Adam' and His 'Garden.'" In Daniel Franklin Ward, ed., *Personal Places,* pp. 83–97.

"Concrete 'Garden of Eden' Is Monument to Kansas 'Heretic.'" *Topeka Daily Capital Sunday Magazine,* March 28, 1954, p. 9A.

Dinsmoor, S. P. *Pictorial History of The Cabin Home in Garden of Eden, Lucas, Kansas.* Lucas, Kans.: privately printed, c. 1927.

"Grassroots Artist: S. P. Dinsmoor." *Kansas Grassroots Art Association News* 8, no. 3 (1989): 1–2.

Greene, Peggy. "Concrete 'Garden of Eden' at Lucas Almost Forgotten." *Topeka Daily Capital,* June 4, 1950, p. 15C.

Muecke, Joseph. "A Strange Concrete 'Eden' in Kansas." *Kansas City Times*, July 11, 1958, p. 40.

Father Paul Dobberstein

Dobberstein, Rev. Paul M. *An Explanation of the Grotto of the Redemption, West Bend, Palo Alto County, Iowa.* C. 1936. Revised and expanded by Rev. L. H. Greving. West Bend, Iowa: privately printed, n.d.

Greving, Father Louis H. *A Pictorial Story of the Grotto of the Redemption.* West Bend, Iowa: privately printed, 1993.

Hutchinson, Duane. *Grotto Father: Artist-Priest of the West Bend Grotto.* Lincoln, Neb.: Foundation Books, 1989.

Lamberto, Nick. "In Stone, the Story of God's Love." *Des Moines Register Picture Magazine*, July 28, 1963, cover, p. 10.

Stone, Lisa. "Concrete Visions: The Midwestern Grotto Environment." *Image File* (Lake County Museum, Illinois) 6, no. 2 (1990): 3–6.

Stone, Lisa, and Jim Zanzi. *Sacred Spaces and Other Places*, pp. 6–27.

Thornton, Francis Beauchesne. *Catholic Shrines in the United States and Canada*, pp. 317–18. New York: Wilfred Funk, 1954.

Howard Finster

Currents: Reverend Howard Finster. New York: New Museum of Contemporary Art, 1982. Essay by Jesse Murry.

Finster, Howard. *Howard Finster, Man of Visions.* Atlanta: Peachtree Publishers, 1989.

————— (as told to Tom Patterson). *Howard Finster, Stranger from Another World, Man of Visions Now on This Earth.* New York: Abbeville Press, 1989.

Howard Finster: Man of Visions. The Garden and Other Creations. Philadelphia: Philadelphia Art Alliance, 1984.

Howard Finster: Painter of Sermons. Lexington: Folk Art Society of Kentucky, 1988. Essay by James Pierce.

Murry, Jesse. "Reverend Howard Finster: Man of Vision." *Arts Magazine* 55 (October 1980): 161–64.

Prince, Daniel C. "Howard Finster's Paradise Garden: A Plan for the Future." *Clarion* 13 (winter 1988): 56–57.

Sermons in Paint: A Howard Finster Folk Art Festival. Richmond, Va.: University of Richmond, 1985.

Turner, John, and Judith Dunham. "Howard Finster, Man of Visions." *Folklife Annual* (Library of Congress) (1985): 158–73.

Turner, John F. *Howard Finster, Man of Visions.* New York: Alfred A. Knopf, 1989. Includes extensive sections taken verbatim from taped interviews with the artist.

—————. "Paradise Garden: Howard Finster, Man of Visions." *Raw Vision*, no. 2 (winter 1989–90): 8–15.

The World's Folk Art Church: Reverend Howard Finster and Family. Bethlehem, Pa.: Ralph Wilson Gallery, Lehigh University, 1986.

Baldasare Forestiere

Brown, Kathan. "The Underground Gardens of Baldasare Forestiere." *Vision*, no. 1, pp. 62–67, Oakland, Calif.: Crown Point Press, 1975.

Thorburn, Joseph. "Tunnel Artist Builds Cave Resort." *Fresno Bee*, May 3, 1924, p. 7.

Ed Galloway

Anders, Mary Ann. "Celebrating the Individual: Ed Galloway's Park." In Daniel Franklin Ward, ed., *Personal Places*, pp. 124–32.

Robert Garcet

Prévost, Claude, and Clovis Prévost. *Les Bâtisseurs de l'imaginaire*, pp. 181–221.

Szeemann, Harald. *Der Hang zum Gesamtkunstwerk*, pp. 409-12.

Tyree Guyton

Darrach, Brad, with Maria Leonhauser. "Scene: With Blight Spirit, Tyree Guyton Transforms Trash into Murals and Crack Houses into Ghetto Galleries." *People*, August 15, 1988, pp. 58–60.

Goldberg, Vicki. "Art by the Block." *Connoisseur* 219 (March 1989): 124–27.

McWillie, Judith. "(Inter)Cultural (Inter)-Connections: Eddie Williamson, Tyree Guyton and the Cosmogonic Crossroads." *Public Art Review* 4 (summer–fall 1992): 14–15.

Miro, Marsha. "For Grandpa: A New Beginning on Heidelberg Street." *Detroit Free Press*, July 30, 1993, pp. 1D, 9D.

Tyree Guyton. Detroit: Detroit Institute of Arts, 1990. Essay by Marion E. Jackson.

James Hampton

Gould, Stephen Jay. "James Hampton's Throne and the Dual Nature of Time." *Smithsonian*

Studies in American Art 1 (spring 1987): 47–57.

Hartigan, Lynda Roscoe. *The Throne of the Third Heaven of the Nations Millennium General Assembly*. Montgomery, Ala.: Montgomery Museum of Fine Arts, 1977.

————. "From Garage to Gallery: James Hampton's Capital Monument." *Public Art Review* 4 (summer–fall 1992): 20–21.

Quigley, Michael Allen. "The Throne of the Third Heaven of the Nations Millennium General Assembly." Unpublished paper, 1971, on deposit in the vertical files, library, National Museum of American Art, Washington, D.C.

Felix "Fox" Harris

Carter, Pat. "'Fox' Harris: A Forest of the Spirit." *Spot* (Houston Center for Photography) 10 (summer 1991): 12–13.

Lonnie Holley

McWillie, Judith. "Lonnie Holley's Moves." *Artforum* 30 (April 1992): 80–84.

Murphy, Jay. "Cultural Recycling: The Work of Lonnie Holley." *Raw Vision*, no. 7 (summer 1993): 20–23.

Shallcross, Melinda. "The Poetry of Lonnie Holley." *Folk Art Messenger* 6 (spring 1993): 1, 3.

Raymond Isidore

Kloos, Maarten. *Le Paradis terrestre de Picassiette*. Paris: Encre, 1979.

Prévost, Claude, and Clovis Prévost. *Picassiette*. Paris: Editions du Chêne, 1978.

————. *Les Bâtisseurs de l'imaginaire*, pp. 125–49.

Edward Leedskalnin

Coral Castle: An Engineering Feat Almost Impossible to Believe! Homestead, Fla.: Coral Castle, 1988.

Leedskalnin, Edward. *A Book in Every Home*. Homestead, Fla.: privately printed, 1936.

————. *Magnetic Current*. Homestead, Fla.: privately printed, 1945.

Jeff McKissack

Holmes, Ann. "In Tribute to the Orange." *Houston Chronicle Texas Magazine*, February 19, 1978, pp. 18–22.

Lomax, Joseph. "The Orange Show." In Francis Edward Abernethy, ed., *Folk Art in Texas*, pp. 38–45.

Martin, William. "What's Red, White, and Blue . . . and Orange All Over?" *Texas Monthly* 5 (October 1977): 120–23, 224–25.

Rust, Carol. "The Orange Show." *Houston Chronicle Texas Magazine*, November 26, 1989, pp. 6–13.

Helen Martins

Cheng, Scarlet. "The Artist in Search of Her Private Mecca." *Washington Post*, August 20, 1989, pp. G1, G12.

Emslie, Anne. *The Owl House*. Johannesburg: Viking Penguin, 1991.

Ross, Susan Imrie. "The Owl House at Nieu Bethesda." In Barry Jones and Joy Cameron-Dow, eds., *Landmarks: An Exploration of the South African Mosaic*. Radio South Africa, 1991.

————. "The Owl House." *Raw Vision*, no. 5 (winter 1991–92): 26–31.

Leslie Payne

"Old Airplane Builder Home-made": The Art of Leslie J. Payne. Richmond: Anderson Gallery, Virginia Commonwealth University, 1987.

Tressa Prisbrey

Greenfield, Verni. "Silk Purses from Sow's Ears: An Aesthetic Approach to Recycling." In Daniel Franklin Ward, ed., *Personal Places*, pp. 133–47.

————. "Tressa Prisbrey: More Than Money." *Raw Vision*, no. 4 (spring 1991): 46–51.

Lubas, Ken. "Admirers Move to Preserve Bottle Village." *Los Angeles Times* (San Fernando Valley Western edition), August 12, 1979, pp. T1, T8.

McCoy, Esther. "Grandma Prisbrey's Bottle Village." In *Naives and Visionaries*, pp. 77–86.

Michelson, Maureen. "Bottle Village: Divine Disorder." *Glass Magazine* 10 (January–March 1983): 30–40.

Pfeifer, Tom. "Folk Art Site: Colorful History." *Simi Valley Enterprise*, September 9, 1984, pp. 1, 2.

Prisbrey, Tressa. *Grandma and Her Village*. Simi Valley, Calif.: privately printed, c. 1960.

Sam (Simon) Rodia

Bryan, Robert. "Sam Rodia and the Children of Watts." *Westways* 59 (August 1967): 3–6.

Goldstone, Norman J. "Structural Test of a

Hand-Built Tower." *Experimental Mechanics*, January 1963, pp. 8–13.

Langsner, Jules. "Sam of Watts." *Arts and Architecture* 68 (July 1951): 23–25.

Morgan, Jeanne. "Rodia's Towers: Nuestro Pueblo, a Gift to the World." In Daniel Franklin Ward, ed., *Personal Places*, pp. 72–82.

"Popular Art: Sam of Watts." *Architectural Review* 111 (March 1952): 201–2.

Posen, I. Sheldon, and Daniel Franklin Ward. "Watts Towers and the *Giglio* Tradition." *Folklife Annual* (Library of Congress) (1985): 143–57.

Rosen, Seymour. *Simon Rodia's Towers in Watts: A Photographic Exhibition.* Los Angeles: Los Angeles County Museum, 1962.

Seitz, William. *The Art of Assemblage.* New York: Museum of Modern Art, 1961.

Trillin, Calvin. "A Reporter at Large: I Know I Want to Do Something." *New Yorker*, May 29, 1965, pp. 72–120.

Ward, Daniel Franklin. *Simon Rodia and His Towers in Watts: An Introduction and Bibliography.* Monticello, Ill.: Vance Bibliographies, 1986.

Whiteson, Leon. *The Watts Towers of Los Angeles.* Oakville, Canada: Mosaic Press, 1989.

Dionicio Rodriguez

"History of Memorial Park." Unsigned typescript, revised May 1990, available at the offices of Memorial Park, Memphis.

Kazas, Tom. "Looks Like Wood." *Americana* 17 (October 1989): 54–58.

Roark, Eldon. "Strolling with Eldon Roark." *Memphis Commercial Appeal*, June 20, 1935.

Vosmik, Julie. "The Arkansas Sculptures of Dionicio Rodriguez." National Register of Historic Places Registration Form, on file at the National Park Service, Department of the Interior, Washington, D.C.

———. "The Sculptures of Dionicio Rodriguez at Memorial Park Cemetery." National Register of Historic Places Registration Form, on file at the National Park Service, Department of the Interior, Washington, D.C.

Rolling Mountain Thunder

"A Roadside Chat with Chief Thunder." *Salt Flat News* (Wendover, Nev.) 3 (May 1975): 4–5.

Childress, Bill. "Rolling Mountain Thunder." *Nevada Magazine* 36, no. 2 (1976): 40–42.

St. EOM (Eddie Owens Martin)

Patterson, Tom. "A Strange and Beautiful World."

———. "St. EOM's Pasaquan: A Promising Future." *Clarion* 13 (winter 1988): 52–55.

St. EOM [Eddie Owens Martin] (as told to Tom Patterson). *St. EOM in the Land of Pasaquan: The Life and Times and Art of Eddie Owens Martin.* Winston-Salem, N.C.: Jargon Society, 1987.

Fred Smith

Bielskis, William H. "North Woods Picasso." *Chicago Tribune Magazine*, May 3, 1964, pp. 32–34.

Hall, Michael D. "Memory and Mortar: Fred Smith's Wisconsin Concrete Park." In Hall, *Stereoscopic Perspective*, pp. 173–84.

Hoos, Judith, and Gregg Blasdel. "Fred Smith's Concrete Park." In *Naives and Visionaries*, pp. 52–59.

Howlett, Don, and Sharron Howlett. "Folk Heroes Cast in Concrete." *Historic Preservation* 31 (May–June 1979): 35–38.

Stone, Lisa, and Jim Zanzi. *The Art of Fred Smith: The Wisconsin Concrete Park.* Phillips, Wisc.: Price County Forestry Department, 1991.

———. *Sacred Spaces and Other Places*, pp. 104–23.

Kea Tawana

Brown, Chip. "The Ark and the Hopeful Voyager." *Washington Post*, March 29, 1987, pp. F1, F4–F5.

Metz, Holly. *Two Arks, a Palace, Some Robots*, pp. 8–11.

———. "The Ark of the Broken Covenant: How the City of Newark Sunk Kea Tawana's Dreams." *Public Art Review* 4 (summer–fall 1992): 22–23.

Parisi, Albert. "Newark Ark Faces Need to Move Again." *New York Times*, October 18, 1987, sec. 11, pp. 8–9.

Prince, Daniel C. "Environments in Crisis," pp. 48–50.

Vergara, Camilo. "Why Newark's Ark Should Be Saved." *New York Times*, April 26, 1987, sec. 11, p. 30.

———. "Kea, the New Ark, and Newark." *SPACES*, no. 7 (winter 1988): 1.

Yglesias, Linda. "A Tall Ship, and a Star to Steer Her By." *New York Daily News Magazine*, December 6, 1987, pp. 12–20.

Father Philip J. Wagner

Stone, Lisa, and Jim Zanzi. *Sacred Spaces and Other Places*, pp. 46–57.

Wagner, Rev. P. J. *Milestones and Memories: An Autobiography by Rev. P. J. Wagner*. Rudolph, Wisc.: privately printed, c. 1957.

Father Mathias Wernerus

Stone, Lisa. "Concrete Visions: The Midwestern Grotto Environment." *Image File* (Lake County Museum, Wauconda, Illinois) 6, no. 2 (1990): 3–6.

Stone, Lisa, and Jim Zanzi. *Sacred Spaces and Other Places*, pp. 28–45.

Thornton, Francis Beauchesne. *Catholic Shrines in the United States and Canada*, pp. 311–13. New York: Wilfred Funk, 1954.

Brother Joseph Zoetl

Morris, John. *Miniature Miracle: A Biography of Brother Joseph Zoetl, O.S.B.* Huntsville, Ala.: Honeysuckle Imprint, 1991.

Sermons in Stone: The Life and Work of Brother Joseph. Cullman, Ala.: privately printed, n.d.

Index